FRAUDS, MYTHS, AND MYSTERIES

FRAUDS, MYTHS, AND MYSTERIES

Science and Pseudoscience in Archaeology

THIRD EDITION

KENNETH L. FEDER
Central Connecticut State University

Mayfield Publishing Company
Mountain View, California
London • Toronto

For Lissa

Copyright © 1999, 1996, 1990 by Mayfield Publishing Company

All rights reserved. No portion of this book may be reproduced in any form or by any means without written permission of the publisher.

Library of Congress Cataloging-in-Publication Data

Feder, Kenneth L.

Frauds, myths, and mysteries: science and pseudoscience in archaeology / Kenneth L. Feder. —3rd ed.

p. cm.

Includes bibliographical references (p.) and index.

ISBN 0-7674-0459-9

1. Forgery of antiquities. 2. Archaeology. I. Title.

CC140.F43 1998

930.1—dc21

98-17114 CIP

Mayfield Publishing Company 1280 Villa Street Mountain View, CA 94041

Manufactured in the United States of America

10 9 8 7 6 5 4 3 2

Sponsoring editor, Janet M. Beatty; production editor, Melissa Kreischer; manuscript editor, Kay Mikel; design manager, Jean Mailander; text designer, Donna Davis; cover designer, Jean Mailander; art editor, Amy Folden; illustrators, John and Judy Waller; cover photo, Joshua Max Feder; manufacturing manager, Randy Hurst. The text was set in 10/12.5 Palatino by Thompson Type and printed on acid-free 45# Highland Plus by Malloy Lithographing, Inc.

This book is printed on recycled paper.

Preface

Frauds, myths, and supposed mysteries about humanity's past are moving targets for those of us committed to the scientific investigation of human antiquity. When eliminated in one place by careful scientific analysis, they merely pop up somewhere else in other guises. Creationists willing to accept, for example, that giant human footprints could *not* have been found in the same strata as dinosaur footprints will go on to declare that an actual piece of Noah's Ark has been discovered. Atlantis aficionados may admit that the geology of the Atlantic seabed precludes the existence of a submerged continent there, but then maintain that there are massive submarine structures, walls, and roads in the Caribbean. When archaeological testing finds no confirming data to support claims of an ancient European presence in New Enlgand, self-styled archaeologists argue that the *lack* of physical evidence validates a European presence; such sites must have been ritually cleaned, they say.

Consequently, archaeologists are obliged to be ever at the ready to respond to new—and venerable, but repackaged—frauds, myths, and mysteries about the human past. But the purpose of this text is not primarily to "debunk" a series of unsubstantiated claims about human antiquity. Instead, the utility of *Frauds*, *Myths*, *and Mysteries* rests in its use of interesting and often hilarious archaeological hoaxes, myths, and mysteries to show how we can *truly* know things about the past through science.

What's New in the Third Edition?

With this in mind, each chapter has been extensively rewritten and updated. In particular:

Chapter 1: Science and Pseudoscience

Includes a new survey of student understanding of the human past

Chapter 2: Epistemology: How You Know What You Know

- Presents a new example of the scientific method in action: the history of the interpretation of meteors
- A cheap, but effective, card trick shows how easy it is to be fooled by what you think you are seeing and hearing

Chapter 3: The Goliath of New York: The Cardiff Giant

• Expands the discussion of the biblical claim of the existence of giants

Chapter 4: Dawson's Dawn Man: The Hoax at Piltdown

 Adds Martin Hinton to the list of possible suspects and reconsiders the possible role of Arthur Smith Woodward in the Piltdown hoax

Chapter 5: Who Discovered America?

- Discusses the point of view of Native American creationists who reject the Bering Land Bridge migration model
- Updates the discussion of the archaeology of the first Americans

Chapter 6: After the Indians, Before Columbus?

- Adds the Martin Frobisher and Francisco Vazquez de Coronado expeditions to and through the New World as models for the archaeological consequences of the movement of alien groups through another people's territory
- Includes a new discussion of the Vinland map

Chapter 7: The Myth of the Moundbuilders

- Adds discussions of the Walum Olum and the Newark Holy Stones
- Includes new material on the origins of mound building and the Adena/Hopewell

Chapter 8: Lost: One Continent—Reward

 Places in a modern context the meaning of the Atlantis story as Plato intended

Chapter 9: Prehistoric E.T.: The Fantasy of Ancient Astronauts

- Addresses new (and ever more bizarre) claims of von Däniken, who
 has been at it again with a new book and video
- Includes the newest information about the so-called Mars Face

Chapter 10: Good Vibrations: Psychics, Dowsers, and Photo-Fields

- Updates the section on archaeological survey
- Expands the section on water dowsing
- Includes an entirely new current perspectives section that focuses on non-invasive methods in archaeology

Chapter 11: Old Time Religion—New Age Harmonics

Expands the historical context of the biblical flood story

- Includes a broader discussion of modern creationism and the attempt by creationists to influence high school biology curricula
- Presents new sections on the most recent Noah's Ark discovery hoax and non-Christian guises of creationism

Chapter 12: Real Mysteries of a Veritable Past

• Includes rewritten and updated sections on the Upper Paleolithic and Stonehenge

Frequently Asked Questions

I have taught a course that covers the topics discussed in *Frauds* since 1978. A generation of students has consistently asked questions related to the main issues in the text. In an attempt to address these significant side issues, every chapter now has a **Frequently Asked Questions** section with brief discussions. **Readers:** if you have a question that you would like to see answered in the fourth edition of *Frauds*, please feel free to e-mail me at feder@ccsu.edu.

Best of the Web

The explosion of the Internet has been a decidedly mixed blessing in terms of the frauds, myths, and mysteries in archaeology. The informal, uncontrolled, unfiltered, and freewheeling context of the web has exciting implications for the dissemination of information about the human past. These same qualities of the Internet, however, also mean that more misinformation about the past can be spread to a far greater number of people far more quickly. A rumor about the discovery of Noah's Ark or the excavation of extraterrestrial alien bodies beneath an Egyptian pyramid can appear on anyone's computer anywhere in the world virtually the instant such stories are fabricated. Tall tales about the human past no longer need rely on unscrupulous publishers or word of mouth to be spread; anyone with a computer, a modem, and an Internet provider can shout such nonsense to the world.

The good news here is that archaeologists can shout back. There are many fine web sites presenting genuine archaeological discoveries and some that respond explicitly to the nonsense that dogs our discipline. Each chapter of *Frauds* presents a short list under the title **Best of the Web** where a selection of web sites (and their Internet addresses) put up by museums, individual archaeologists (amateur and professional), anthropology departments, and others is provided. Don't look for the bizarre, absurd, extreme, or nonsensical on my lists. These sites are produced by people who conduct field research, analyze artifacts and sites, and who are committed to the scientific interpretation of the human past.

The Frauds Home Page

To make it easier to locate and scan the Best of the Web sites, there now is a *Frauds* home page on the Internet. Every web site listed in the Best of the Web sections of *Frauds* is linked to and accessible through the *Frauds* page. Instead of having to type in the URLs, you need only access the *Frauds* page. From there, click on any of the *Frauds* chapters and you will call up the addresses for the Best of the Web sites. Then, simply click on any site's URL and you will be transported to that site. The *Frauds* page Internet address is: http://wwwas.ccsu.ctstateu.edu/depts/anth/fraudsweb/frauds.htm

Critical Thinking Exercises

Each chapter provides **Critical Thinking Exercises.** In these, I attempt to challenge the reader to apply the scientific method and scientific reasoning to the general issues raised in the specific archaeological examples at the core of each chapter. In answering the questions posed or in carrying out the specific exercise, the reader must be able to synthesize and apply the most important messages of the chapter.

Reality Check

How can a reader assess the validity of an extraordinary claim that appears in popular media? To help readers make more informed assessments, I've added a checklist of questions on the inside cover to consider when evaluating fantastic claims.

Acknowledgments

The great generosity of my colleagues and friends never ceases to amaze and gratify. There are many who have contributed to this volume: in sharing ideas and by making suggestions; by providing greatly appreciated support and by dishing out deserved but always (well, almost always) gentle criticism; by sending reprints, transmitting those yet-to-be-published articles as e-mail attachments, and by providing photographs for use in the book. I am forever in your debt. In particular, I would like to thank the following people whose special assistance has made an enormous contribution to the third edition of *Frauds:* Joyce Arthur, Gordon Scott Bernstein, Niccolo Caldararo, Melvin Fowler, Harry Gove, Sonja Gray, William Iseminger, Alice Kehoe, Brad Lepper, Walter McCrone, Joe Nickell, Mike Park, Ronald Potvin, Robert Sanford, Michael Shermer, Dirk Spinnemann, and Marvin Yagoda (owner of Marvin's Marvelous Mechanical Museum).

Thanks to my father, Dr. Murray H. Feder for his historical insights and splendid photographs. Special thanks to Gerrell Drawhorn for generously sharing his insights on the Piltdown hoax. Also, many thanks are due to Andrew Bayuk for the use of his photograph of the Bent Pyramid and for producing a spectacular web site focusing on the genuine achievements of ancient Egypt (http:guardians.net/egypt).

I'm particularly grateful for the insightful comments of the reviewers of this edition: George Gumerman, Northern Arizona University; Sarah Neusius, Indiana University of Pennsylvania; David Stothers, University of Toledo; and Paul Welch, Queens College.

Of course I have to thank the folks at Mayfield Publishing. Jan Beatty took a risk in originally signing this book in 1989 when so many other publishers—more than a dozen, but who's counting—had turned it down. I am truly and forever in Jan's debt. Melissa Kreischer has been my production editor now for the past two editions. She has done a terrific job, has parts of the book committed to memory, and laughs even when my jokes are lame. My copy editor Kay Mikel was a joy to work with, always gentle in taking my already perfect prose and making it, perhaps, a bit more perfect.

In the first edition of this book, I mentioned that the task had been so all-consuming, one of my young son Josh's first intelligible sequences of words had been "Dada work, book." Almost a decade later, Josh is now nearly twelve and his sentences have become quite a bit more complex. In fact, Josh became something of a research assistant for me on this project. His computer expertise was put to good use in finding the Best of the Web sites, he contributed one of the Frequently Asked Ouestions, and his remarkable photograph of Stonehenge graces the cover for this edition of the book. Thanks Josh! Though not quite ready to help out, our younger son, four-year-old Jacob, has been very cooperative in allowing me to spend our afternoons together working on books; as he has patiently explained to me, this gives him time to watch his "beloved cartoons." Finally, an author's acknowledgment of the contribution of a spouse often seems merely obligatory. I hope that my "thank you" to my wife Melissa is different. Her love and support are what make the whole enterprise—our lives as well as working on books—not just possible, but "insanely great."

Contents

Science and Pseudoscience Belief in the Unbelievable 2 The Morning of the Magicians Pseudoscience and Archaeology

Why I Wrote This Book 10

Frequently Asked Questions 13
Critical Thinking Exercises 13

Best of the Web 14

2 Epistemology: How You Know What You Know 15

Knowing Things 15

Preface

1

Collecting Information: Seeing Isn't Necessarily Believing 16

Collecting Information: Relying on Others 18

Science: Playing by the Rules 19

There Is a Real and Knowable Universe 20

The Universe Operates According to Understandable Laws 22

The Laws Are Immutable 22

The Laws Can Be Understood

The Workings of Science 24
The Case of Childbed Fever 26

Science and Nonscience: The Essential Differences 28

A Cheap—But Effective—Trick **29** A Rule in Assessing Explanations **30**

The Art of Science 32 Where Do Hypotheses Come From? 32
Testing Hypotheses 34
The Human Enterprise of Science 35
Science and Archaeology 37
Frequently Asked Questions 38
Best of the Web 39
Critical Thinking Exercises 39

3 The Goliath of New York: The Cardiff Giant 40

The Cardiff Giant 42

The Discovery 42

The Beginning of the End 46

Hull's Confession 48

The End of the Giant 49

Why Did They Do It? 50

Current Perspectives: Frauds 52

Frequently Asked Questions 53

Best of the Web 54

Critical Thinking Exercise 54

4 Dawson's Dawn Man: The Hoax at Piltdown 55

The Evolutionary Context 56
A Remarkable Discovery in Sussex 59
The Piltdown Enigma 65
Unmasking the Hoax 67
Whodunnit? 68

Suspect: Charles Dawson 68
Suspect: Arthur Smith Woodward 69
Suspect: Pierre Teilhard de Chardin 70
Suspect: Sir Arthur Keith 71
Suspect: Martin A. C. Hinton 71
Suspect: Sir Grafton Elliot Smith 72
Suspect: W. J. Sollas 72
Suspect: Lewis Abbott 73

Suspect: Sir Arthur Conan Doyle 73
The Lesson of Piltdown 74

Current Perspectives: Human Evolution 74
Frequently Asked Questions 77
Best of the Web 78
Critical Thinking Exercises 78

5 Who Discovered America? 79

The Discovery of a New World 80

Biblical Exegesis and American Indians 84

American Indians: From Israelites to Atlanteans 85

Joseph de Acosta and Gregoria Garcia 86

Tracing the Movement of Ancient People 8'

Tracing People by Their Culture 87

Tracing People by Their Biology 89

Tracing People by Their Materials 89

Out of Asia 90

An "American Genesis"? 90

Current Perspectives: The Peopling of the Americas 92

Frequently Asked Questions 96

Best of the Web 97

Critical Thinking Exercise 97

6 After the Indians, Before Columbus? 98

A Trail of Artifacts: Sixteenth-Century Visitors to the New World 99

Martin Frobisher and Francisco Vasquez de Coronado 99

The Spanish Entrada into the American Southeast 100

St. Brendan and His Ox-Hide Boat 102

Fusang: The Chinese Discovery of America? 103

Prince Madoc and Welshmen in the New World 104

Africans in Ancient America? 105

Afrocentrism 110

Africans in Ancient America: The Verdict 110

America B.C.? 111

Linguistics 112

Inscriptions 112

Architecture 113

The Archaeological Verdict 115

The Viking Discovery of America 119

A New Found Land 122

Where Was Vinland and Who Were the Skraelings? 124

The Vinland Map 124

Archaeological Evidence of the Viking Presence 125

The Newport Tower 126

Current Perspectives: The Norse Discovery of America 127

Frequently Asked Questions 131

Critical Thinking Exercise 131

Best of the Web 132

7 The Myth of the Moundbuilders 133

The Myth of a Vanished Race 137
Who Were the Moundbuilders? Identifying the Vanished Race 139
The Walum Olum 140
The Archaeology of the Myth 140
The Moundbuilder Mystery Solved 143

Rationale for the Myth of a Vanished Race
Current Perspectives: The Moundbuilders
Frequently Asked Questions
157
158

Best of the Web 158

Critical Thinking Exercise 158

8 Lost: One Continent—Reward 159

Atlantis: The Source of the Legend 160

The Timaeus Dialogue 160
The Critias Dialogue 162

The Source and Meaning of Timaeus and Critias 163

Who Invented Atlantis? 164

Where Did Plato Get the Story? A Minoan Source 165

After Plato 168

Ignatius Donnelly: The Minnesota Congressman 169

Atlantis After Donnelly 178

Current Perspectives: Atlantis 179
Frequently Asked Questions 182

Critical Thinking Exercise 182

Best of the Web 183

9 Prehistoric E.T.: The Fantasy of Ancient Astronauts 184

Gods in Fiery Chariots 184

Hypothesis 1 185

Hypothesis 2 193

Hypothesis 3 195

Ancient Egypt 195

Von Däniken's Response 200

More Mysteries of Ancient Egypt? 202

More Ancestors, More Dummies 203

Extraterrestrial Calendars? 203
Extraterrestrial Aliens in the Pacific?

The Archaeology of Mars 207

Current Perspectives: The von Däniken Phenomenon 212

Frequently Asked Questions 214
Best of the Web 215
Critical Thinking Exercise 215

10 Good Vibrations: Psychics, Dowsers, and Photo-Fields 216

Psychic Archaeology 218

The Roots of Psychic Archaeology 219

Psychic Site Location 220

Psychic Excavation 221

Psychic Cultural Reconstruction 223

Psychic Archaeology: The Verdict 227

Dowsing Instead of Digging 227

Testing the Dowsers 228

Electromagnetic Photo-Fields 229

Current Perspectives: Archaeology Without Digging 231

Frequently Asked Questions 232

Best of the Web 234

Critical Thinking Exercise 234

11 Old Time Religion—New Age Harmonics 235

Scientific Creationism 236

Noah's Ark 238

Footprints in Time 245

Other Guises of Creationism 248

The Shroud of Turin 249

Testing the Shroud **253**

New Age Prehistory 258

Arizona in the New Age 259

Current Perspectives: Religions Old and New 261

Frequently Asked Questions 263

Critical Thinking Exercise 263

Best of the Web 264

12 Real Mysteries of a Veritable Past 265

The Ice Man 265

The Cave Painters of Europe 267

Explaining the Cave Paintings 269

The Civilization of the Maya 271

Explaining the Maya 272

Stonehenge 275

Explaining Stonehenge 279

Circular Reasoning About Stonehenge 281

An Ancient Astronomy? 282

Why Was Stonehenge Built? 283

Conclusion: A Past We Deserve 284

Frequently Asked Questions 285

Critical Thinking Exercise 285

Best of the Web 286

References 287 Index 305

Science and Pseudoscience

Extrasensory perception. Astrology. Thought-photography. Faith healing. Close encounters with extraterrestrial aliens. Precognitive dreams. Palmistry. Reincarnation. Pyramid power. Ancient astronauts. If all of the claims related to these and other supposed phenomena were true, this world would be an extraordinarily strange place, far different from what orthodox science would suppose.

Cats would be psychic and children could bend spoons with the power of their minds. Aliens from outer space would regularly fly over the earth, kidnap people, and perform medical examinations on them. They also would flatten farmers' wheat crops, leaving monumentally scaled, perplexing, but beautiful designs in their fields.

People could read minds, and by shuffling and dealing a special deck of playing cards (called Tarot), your future could be predicted. Sleeping under a pyramid-shaped bedframe would be conducive to good health, and wearing a quartz crystal suspended on a chain around your neck would make you more energetic.

Furthermore, the precise locations of enormously distant celestial bodies at the instant of your birth would determine your personality as well as your future. People could find water, treasure, and even archaeological sites with forked sticks or bent coat hangers. You could learn to levitate by taking a course. In the strange world we are pondering here, Elvis would still be alive, visiting shopping malls and making regular midnight runs to convenience stores for Slim Jims and Moonpies.

Beyond this, if all of the claims were true, people living today would actually have lived many times in the past and could remember when they were kings or artists (few would remember being ordinary). And hundreds of boats and planes and thousands of people would have disappeared under mysterious circumstances in the dreaded "Bermuda Triangle."

Also, plants would think and have feelings, dolphins would write poetry, and cockroaches and even fertilized chicken eggs would be clairvoyant. Some people would spontaneously burst into flames for no apparent reason; and tiny ridges on your hands, bumps on your head, and even the shape of your behind could be used to understand your personality. People could have sex with ghosts or the devil.

In this extraordinary view of the world, it might not be a bad idea to insure yourself against the possibility of being abducted by extraterrestrial aliens. I personally am covered for \$10 million (for the low, low price of \$19.95, as offered by an insurance agency in Florida). It's difficult to collect the money; you need the signature of an "authorized alien," and even then they will only pay out \$1 per year for ten million years. But you can never be too careful.

In this world of infinite possibilities, all your problems could be solved by a stranger at the other end of a 1-900 psychic hot line. Finally, in this most peculiar world, human prehistory could best be understood as the result of supernatural occurrences, enormous cataclysms, and the interference of extraterrestrial space aliens.

It would be a strange world indeed, and the list of extreme, mysterious, and occult claims goes on and on (Figure 1.1). For many of you, some of these claims (all of which have actually been published—even the clairvoyant chicken eggs!) might seem to be interesting to think about. Maybe you watch one of the growing list of television shows (*The X-Files* or *Sightings*, for instance) that blur the distinction between fantasy and fiction. Perhaps you have dialed a 1-900 phone number, looking for psychic insights into your future. Maybe you believe that it's good to have an open mind and that some of the remarkable claims listed here are plausible.

Belief in the Unbelievable

If you find yourself in embarrassed agreement with some of these claims, rest assured, you are not alone. Not long ago, an entertainment/news television show conducted a survey among watchers concerning their opinions on some controversial claims. More than a quarter of those responding believed in the accuracy of dreams in foretelling the future, 12 percent believed in the utility of astrological forecasts, and 22 percent accepted the reality of clairvoyance in predicting the future. In the same sample, 3 percent of those responding also expressed confidence in the accuracy of predictions contained in fortune cookies!

In a more scientific polling of 1,236 adults (Gallup and Newport 1991), it was determined that about 50 percent believed in extrasensory perception, 25 percent believed in astrology, another 25 percent believed in ghosts, and 27 percent believed that extraterrestrial aliens have visited the earth in the past.

CON MEN SELLING ORANGUTANS TO DESPERATE COUPLES—AS HUMAN BABIES!

UNBORN BABY SINGS IN MOM'S WOMB

PHARAOH'S CURSE KILLS THREE

Fireman swallows kitten by mistake

STUDYING DOESN'T MAKE YOU SMARTER!

PREHISTORIC APE MEN ARE FOUND ALIVE!

ALIEN COMPUTER FOUND UNDER STONEHENGE NEW NASA PHOTO PROVES HUMANS LIVED ON MARS!

MAN STUFFS TAMPONS UP HIS NOSE TO STOP SNORING—AND IT KILLS HIM!

Figure 1.1 Actual headlines as they appeared in issues of various tabloid or "supermarket" newspapers.

One might think that people who watch "infotainment" TV are naive and that the American public is generally gullible. One might also think, however, that bright, highly educated college students are probably a lot less likely to fall for such claims. But I have taken four surveys of college

students at various institutions (Feder 1984, 1987, 1995b, 1998), and the results show no marked difference between this group and the general public on the kinds of claims listed (Figure 1.2). For example, 27 percent of my 1984 students believed in the prehistoric visitation of our planet by extraterrestrial aliens (see Chapter 9), in 1994, 31 percent believed it, and in 1998 belief fell back to 15 percent. In 1984, 1994, and 1998, belief in the existence of the Lost Continent of Atlantis held steady at 29 percent. Between 1984 and 1994, belief that a curse on the tomb of Egyptian pharaoh Tutankhamun actually killed people doubled—jumping from 12 percent to 24 percent. In 1998 about 14 percent expressed belief in Tut's curse (see Frequently Asked Questions section of Chapter 9). Between 1984 and 1994, there seems to have been polarization among students on these claims related to the human past, with fewer admitting ignorance and more willing to come down on one side or the other. Just four years later, the 1998 survey shows a higher level of disbelief in ancient astronauts and Atlantis, but less skepticism about Tut's curse.

Is it only American students who are so accepting of claims about which scientists are extremely skeptical? Not at all. For example, in 1996 Dirk Spennemann at Charles Stuart University in New South Wales, Australia, distributed a similar questionnaire to 142 of his university students. His results were quite similar to those we derived from the American sample in 1984 (Spennemann 1996).

You might reasonably ask if the kinds of beliefs or claims mentioned here can be dismissed so easily. "Science" is a process of understanding the world around us through the application of logical thought. In contrast, "pseudoscience" abandons logic, and claims are made and conclusions reached that cannot be verified or proven (see Chapter 2). Most of us like to think of ourselves as scientifically minded, but is science always right? Science has scoffed at things in the past that eventually turned out to be true (see the discussion of meteors in Chapter 2). Maybe there is more to some of these claims than closed-minded scientists are willing to admit. There must be something to UFOs, ESP, astrology, reincarnation, palmistry, biorhythms, fortune telling, dowsing, ancient astronauts, and so on; magazines, television, and movies flaunt these topics frequently. They can't all be fake, can they?

I have a confession to make. I used to read books on flying saucers and psychic power. I owned a Ouija board and a pendulum, and I analyzed handwriting and conducted ESP tests. I felt that there had to be some truth to these interesting ideas.

But it bothered me that the results of my ESP tests never really deviated from chance expectations, and my Ouija board didn't work at all. I owned a small telescope and spent a lot of time looking at the nighttime sky, but I never saw anything that did not have some natural or ordinary explanation (an airplane, helicopter, blimp, bird, satellite, star, planet, or whatever). Yet I kept searching. Like most people, I wanted to believe in these fascinating possibilities rejected by orthodox science.

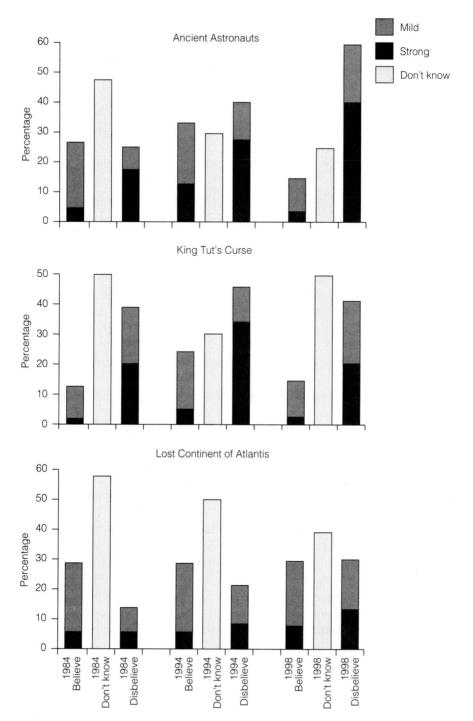

Figure 1.2 Student responses (strongly believe, mildly believe, don't know, mildly disbelieve, strongly disbelieve) to the following statements: "Aliens from other worlds visited the earth in the prehistoric past." "An ancient curse placed on the tomb of the Egyptian Pharaoh, King Tut, actually killed people." "There is good evidence for the existence of the Lost Continent of Atlantis." From surveys conducted by the author at Central Connecticut State University (Feder 1984, 1995b, and 1998).

In the late 1960s, lured by the promise of four books for a dollar in the introductory offer, I signed up for a book club catering to occult tastes. In return, I received *The Complete, Illustrated Book of the Psychic Sciences; Yoga, Youth, and Reincarnation; The Black Arts;* and *The Morning of the Magicians*. The first three contained interesting little tidbits that seemed perfectly reasonable to me at the time: evidence of "real" hauntings and prophetic dreams, the usefulness of astrology, testimony about people's subconscious memories of past lives, and so on. The yoga book, along with some strange claims about reincarnation, actually taught some healthy exercises.

It was the fourth book, though, that really opened my eyes. Without their knowing it, the authors of this marvelous collection of outrageous claims, Louis Pauwels and Jacques Bergier (1964), played an important role in converting me from a completely credulous individual, open to all sorts of absolutely absurd ideas, to a scientific rationalist, still open to the possibility of all sorts of absolutely absurd ideas, but demanding substantial evidence that, unfortunately, their claims all seemed to lack.

The Morning of the Magicians

Remarkable claims about things scientists were trying to hide from the public filled *The Morning of the Magicians*—evidence for reincarnation, levitation, ghosts, and so on. As always when I read most of these books, the first claim left me excited and fascinated. The second claim provided almost the same sense of intellectual exhilaration. But the third, fourth, fifth, and sixth were just more of the same. I slowly began to lose the ability to be surprised by the authors' claims of effective magical incantations, telepathy, the mystically engineered transformation of lead to gold, and the like. As exciting as any one of these claims might have been, the cumulative effect was simply a buildup of an intellectual resistance to surprise. I became immune to the claims. I was bored.

In skimming through the book, I found a section on remarkable discoveries in prehistoric archaeology related to the occult. It surprised me that there was any archaeology in the book at all; I had never considered connections between the occult and archaeology. Fascinated by the possibilities, I immediately began to read that section.

I was absolutely appalled by what I read. I knew quite a bit about the archaeological topics they discussed, and what they said was incredible. Their claims about Egyptian pyramids; the massive, carved stone heads of Easter Island; the ancient culture of Peru; and other archaeological artifacts, sites, and cultures were based on misinformation, twisted facts, and misrepresentation of archaeological data and the study of the past.

At their very best, the authors' claims showed extreme ignorance. For example, their assertions about the supersophistication of prehistoric

metallurgy in South America were misleading. Their insistence that this industry was somehow mysterious showed a gross ignorance of very well-documented, sixteenth-century eyewitness accounts by Spanish explorers of the native metal-making process.

Their claims about advanced information exhibited in the dimensions of the Egyptian pyramids—the distance from the earth to the sun, for example, and the precise value of pi—had been made years before. Such claims were invariably based on incorrect measurements, miscalculation, and not just a little wishful thinking.

The authors' extraordinarily strange view of the past is best summed up in their own words:

It is possible that our civilization is the result of a long struggle to obtain from machines the powers that primitive man possessed, enabling him to communicate from a distance, to rise into the air, to liberate the energy of matter, abolish gravitation, etc. (Pauwels and Bergier 1964:109)

In other words, according to the authors of *The Morning of the Magicians*, today we are simply rediscovering abilities that prehistoric people had—the ability to fly, to harness the energy of the atom, and to communicate electronically, for example. Although today we do so with machines, prehistoric people apparently could do it with their minds. Pauwels and Bergier were honest enough; they had entirely, openly, and unabashedly abandoned a skeptical approach: "No hypothesis is excluded: an atomic civilization long before what we call the prehistoric era; enlightenment received from the inhabitants of Another World, etc." (p. 105).

On simple facts, they were consistently wrong. These were things that might not be noticed by a nonarchaeologist. For example, they stated that the Toltecs built the Pyramid of the Sun at the Mexican site of Teotihuacán (p. 115). That's like saying the seventeenth-century Dutch settlers of New York City built Yankee Stadium; the Toltecs culture did not come onto the scene until at least two hundred years after Teotihuacán was abandoned.

In South America, the authors noted with amazement, archaeologists have found statues of camels, "which are unknown in South America" (p. 114), implying some sort of ancient mystery. Yet camels originated in South America, where four separate, camel-like species still exist (llama, alpaca, vicuña, and guanaco). The authors of *The Morning of the Magicians* also stated that there were prehistoric statues of dinosaurs in South America, though science tells us that the last of the dinosaurs became extinct some 60 million years ago (see Chapter 11 in this book).

They stated that the Maya civilization of Mesoamerica is "far older than that of Greece" (p. 115). Yet classical Greece dates to well over 2,500 years ago, whereas the Maya civilization was at its peak more than a thousand years later, barely 1,500 years ago.

How, I wondered, could authors who seemed so well informed about physics, psychology, chemistry, biology, and history be so confused when it came to my own field of archaeology? How could they so eloquently "prove" the existence of all sorts of occult things related to these other fields of science and be so lacking in their knowledge of the human past?

Then it struck me. Of all of the disciplines discussed in *The Morning of the Magicians*, archaeology was the only one with which I had more than just a passing familiarity. The more I thought about it, the clearer it became. The often-bizarre claims in *The Morning of the Magicians* that were related to physics, chemistry, biology, psychology, and history seemed reasonable to me primarily because I did not have the knowledge necessary to assess them intelligently.

It was a valuable lesson indeed. The authors had not mysteriously abandoned scholarly research and the scientific method (see Chapter 2 of this book) only in the one field in which I was well versed. As I looked further into their claims, it became obvious that they had ignored the truth in just about every phenomenon they had described.

I began to read a number of books written by scientists in various fields who had been similarly appalled by the extreme claims made by occultists like Pauwels and Bergier. Again and again, I saw reactions and arguments that mirrored mine after reading the prehistory section of *The Morning of the Magicians*. When astronomers analyzed claims about extraterrestrial life, astrology, and UFOs; when psychologists examined telepathy and clairvoyance; when physicists and chemists investigated alleged evidence for perpetual motion machines or alchemy, they were nearly unanimous in their skepticism. In other words, claims that may have sounded good to me could easily be discounted, disproven, and disposed of by people who knew more than just a little bit about them. All those interesting occult claims that had fascinated me could be shown to be, at best, highly speculative and unproven or, at worst, complete nonsense.

Pseudoscience and Archaeology

I then began to search out more of the unsubstantiated, occult, and speculative claims that were being made about the prehistoric past by people who, it seemed, were wholly ignorant of modern archaeology. I have been doing this ever since, and it has been a surprisingly fruitful, if depressing, search. Little did I realize when I began to read *The Morning of the Magicians* how popular archaeological occultism and fraud is.

No one can deny that archaeology generates a great deal of public interest. People are fascinated by subjects like pyramids, cave paintings, human evolution, Stonehenge, and the Aztecs. Archaeology survives because people are interested enough in it to take courses, go to museums, visit sites, and buy books about it.

Sadly, unscrupulous people try to take advantage of this interest by making unsupported claims about the discoveries made in this fascinating field. *The Morning of the Magicians* was not the first, and it certainly will not be the last, of the published, printed, spoken, filmed, or televised attempts to twist and pervert the discoveries made in archaeology.

Because professional archaeologists spend the bulk of their time writing and talking to each other about their discoveries, the public often learns about archaeology from mass market paperbacks written by people whose major motivation is not to educate the public but rather to prove some pet theory or make a lot of money. The result is a public interested in the human past but often grossly misinformed about it.

Archaeology is a fascinating field that has, ironically, suffered because of its popularity. There are lots of interesting, sometimes hilarious, examples of the misuse of archaeology. Book publishers, movie makers, magazines, and tabloids like the *Weekly World News* and the *Sun* have fed us a steady diet of ancient astronauts, psychic archaeology, Bigfoot, Atlantisology, and so on. And there is nothing new about it.

An important question to ask is "Why?" From the tales related in this book, six basic motives or explanations are revealed:

- 1. Money, undeniably, can be a major motivating factor. The public's interest in archaeology is so great that many people willingly fork over their hard-earned cash to see artifacts or read about sites. The opportunities for charlatans to take advantage of an interested audience through book deals, lecture tours, T-shirts, commemorative mugs, and assorted other bric-a-brac are virtually limitless. Quite a bit of money has been and will continue to be made from people's great curiosity about human antiquity.
- Fame is another consideration. The desire to find the oldest site or the one that shows everybody else to be wrong has motivated many, including some professional archaeologists. This desire for fame and notoriety has unfortunately led more than a few to alter or exaggerate their data.
- 3. Nationalism is a broader sort of fame that has also served as a motive for extreme or unsubstantiated archaeological claims. The desire to prove some sort of nationalistic or racial claim through archaeology has been common. Wanting to show that "we" were here first or that "we" were civilized before "you" has led some to play fast and loose with the archaeological facts. The Nazis provide a particularly odious example of this. In the 1930s and 1940s many artifacts discovered outside of Germany proper were interpreted by Nazi archaeologists as belonging to ancient Germanic people. The presence of these ostensible "Germanic" artifacts was viewed as evidence of previous German ownership of these other territories, providing at least part of the rationale for evicting or even slaughtering

- the non-Germans living there. An article by Bettina Arnold (1992) provides a chilling account of this kind of misuse of archaeology to prop up a racist nationalism.
- 4. Unfortunately, religion has also played a role in archaeological fraud. Many religions have their roots in remote antiquity. Some of their adherents dabble in archaeology, trying to prove the validity of their religious beliefs or claims through the discovery of archaeological evidence. Martin Luther, leader of the Protestant Reformation in the sixteenth century, asked, "What harm would it do if a man told a good strong lie for the sake of the good and for the Christian Church . . . a useful lie, a helpful lie, such lies would not be against God; he would accept them" (cited in Arthur 1996:88). Perhaps for some, an archaeological fraud that led people to the church might be just such a "useful lie."
- 5. The desire for a more "romantic" past also plays a role. For some, lost continents, ancient astronauts, and psychic archaeologists seem more interesting than the discoveries of genuine archaeology. The quest for a more romantic past is the cause of at least some of the public's desire and willingness to believe claims that, if given some thought, could be easily disposed of.
- 6. Finally, and put bluntly, some of the extreme, unproven, bizarre, silly, and crazy claims made about the human past can be traced to the mental instability of their proponents. In other words, crazy claims often originate in crazy minds.

Why I Wrote This Book

My purpose in writing this book is to give you the perspective of a professional archaeologist on unsubstantiated claims made about the prehistoric past, as well as on extreme claims made concerning how we can learn about that past.

The nonarchaeological topics I mentioned earlier in this chapter (UFOs, ESP, etc.) have been discussed at length by experts in the relevant scientific fields. They will not be the focus here. However, I hope that through reading this book you will come to understand that ancient astronauts, psychic archaeology, extreme diffusionism (the view that most important ideas were developed by one great culture and were "borrowed" by others), and the other claims to be discussed are the archaeological equivalents of these. Two excellent journals present articles where paranormal or extreme claims made in the name of science are skeptically assessed (*The Skeptical Inquirer* and *Skeptic*). Also, I have provided a brief list of books focusing on these non-archaeological topics (Table 1.1).

 Table 1.1
 Skeptical Publications on Extreme Claims Not Directly Related to Archaeology

Topic General	Author Gordon Stein (editor)	Book Title The Encyclopedia of the Paranormal	Year 1996	Publisher Prometheus Books
	Simon Hoggart and Mike Hutchinson	Bizarre Beliefs	1995	Richard Cohen Books
	Ted Schultz (editor)	The Fringes of Reason: A Whole Earth Catalog	1989	Harmony Books
UFOs	Steuart Campbell	The UFO Mystery Solved	1994	Explicit Books
	Philip J. Klass	UFOs: The Public Deceived	1983	Prometheus Books
	Philip J. Klass	UFO Abductions: A Dangerous Game	1989	Prometheus Books
	Kal K. Korff	The Roswell UFO Crash	1997	Prometheus Books
	Curtis Peebles	Watch the Skies: A Chronicle of the Flying Saucer Myth	1994	Smithsonian Institution Press
	Robert Scheaffer	The UFO Verdict	1986	Prometheus Books
ESP	Joe Nickell	Psychic Sleuths	1994	Prometheus Books
	James Randi	The Magic of Uri Geller	1975	Ballentine Books
	C. E. M. Hansel	The Search for Psychic Power	1989	Prometheus Books
	Richard Wiseman	Deception and Self- Deception: Investigating Psychics	1997	Prometheus Books
	Henry Gordon	Extrasensory Deception	1987	Prometheus Books
Astrology	Roger B. Culver and Philip A. Ianna	Astrology: True or False	1988	Prometheus Books
	Lawrence E. Jerome	Astrology Disproved	1977	Prometheus Books
	J. V. Stewart	Astrology: What's Really in the Stars	1997	Prometheus Books
	Bart Bok and Lawrence Jerome	Objections to Astrology	1976	Prometheus Books
Bermuda Triangle	Larry Kusche	The Bermuda Triangle Mystery Solved	1995	Prometheus Books
				(continued)

Table 1.1 Skeptical Publications on Extreme Claims Not Directly Related to Archaeology (continued)

			• /	D 11' 1
Topic	Author	Book Title	Year	Publisher
Faith	James Randi	The Faith Healers	1989	Prometheus
Healing and	Lee Niekell	Looking for a Miracle	1993	Books Prometheus
Miracles	Joe Nickell	Looking for a intracte	1993	Books
Medical	James Harvey	American Health Quackery	1992	Princeton
Quackery	Young			University Press
Hand-	Barry and Dayle	The Write Stuff:	1992	Prometheus
writing Analysis	Beyerstein	Evaluations of Graphology		Books
Loch Ness	Steuart Campbell	The Loch Ness Monster:	1991	Aberdeen
Monster		The Evidence		University Press
	Ronald Binns	The Loch Ness Mystery	1984	Prometheus
		Solved		Press
Bigfoot	Daniel Taylor-İde	Something Hidden Behind the Range: A Himalayan Quest	1995	Mercury House
Satanic Cults	Mike Hertenstein and Jon Trott	Selling Satan: The Tragic History of Mike Warneke	1993	Cornerstone Press
	Robert Hicks	In Pursuit of Satan: The Police and the Occult	1991	Prometheus Books
Crystal	Lawrence	Crystal Power: The	1989	Prometheus
Power	Jerome	Ultimate Placebo Effect		Books

In this book, I present a discussion of the scientific method (Chapter 2) and then go on to detail popular frauds in the field of prehistoric archaeology—the Cardiff Giant (Chapter 3) and Piltdown Man (Chapter 4). Next, I explore the controversy concerning the origin of the American Indians (Chapter 5), the debate over who discovered the Americas after the Indians (Chapter 6), and the historical argument over the source of the so-called Moundbuilder culture of North America (Chapter 7). Next, I delve into some unsubstantiated claims about the prehistoric archaeological record—the Lost Continent of Atlantis (Chapter 8), the ancient astronaut hypothesis (Chapter 9), psychic archaeology (Chapter 10), and alleged archaeological evidence for particular religious beliefs (Chapter 11). Finally, some genuine archaeological mysteries will be assessed in Chapter 12. Throughout, the theme will be how the methodology of science allows us to assess claims made in the name of the science of archaeology.

There is a reason for focusing on the history of the misuse and misinterpretation of the archaeological record as well as on individual misadventures. Only, for example, by seeing the contemporary claims of the Swiss author Erich von Däniken (see Chapter 9) as what amounts to our modern version of the Cardiff Giant (Chapter 3), only by realizing that the claims of the "scientific" Creationists (Chapter 11) have been around for close to two hundred years and discredited for almost that long, and only by seeing that the public has been gullible about archaeology almost from its inception can we hope to understand the entire phenomenon in its proper context. And only by understanding it can those of us committed to the study of the human past hope to deal with it.

→ frequently asked questions �

1. What's the harm in believing pseudoscientific or nonscientific claims about the world?

It must be admitted that the impact of belief in at least some unsubstantiated claims may be minor. You may, for example, find yourself out some money by purchasing a device (to improve gas mileage or to help lose weight) that simply does not work. On the other hand, there are people who do not obtain appropriate medical intervention for serious illnesses—opting for unproven remedies and dying prematurely as a result. In extreme cases, charismatic leaders have led their gullible followers—some of whom believed in the psychic powers of the leader (the Reverend Jim Jones of the People's Temple) or the extraterrestrial connections of the leader (Marshall Applewhite of Heaven's Gate)—to their deaths. Belief in nonsense can be dangerous.

2. Will science ever eliminate superstition and pseudoscience?

No, it likely never will. Human beings have an enormous capacity to understand the world around us, but that understanding brings with it a sometimes heavy burden. Comfortable fables may not reflect the way things actually work, but they may help us all—even the scientists among us—to deal with the more terrible and frightening things that afflict our lives. Science can only show what works and what does not. It is then up to each of us to accept or ignore science's conclusions.

→ CRITICAL THINKING EXERCISES ◆

- 1. What are the differences between a supermarket weekly and a regular newspaper? Are they always different?
- 2. Which of the topics listed in Table 1.1 (UFOs, ESP, and the rest) do you accept as genuine phenomena? On what basis do you accept those claims?

Best of the Web

CLICK HERE

http://wheel.dcn.davis.ca.us/~btcarrol/skeptic/dictcont.html

http://www.csicop.org/

http://www.skeptic.com/

http://www.public.iastate.edu/~edis/skeptic_biblio.html

http://activemind.com/Mysterious/index.html

http://wwwas.ccsu.stateu.edu/depts/anth/fraudsweb/frauds.htm

Epistemology: How You Know What You Know

Knowing Things

The word *epistemology* means the study of knowledge—how you know what you know. Think about it. How does anybody know anything to be actual, truthful, or real? How do we differentiate the reasonable from the unreasonable, the meaningful from the meaningless—in archaeology or in any other field of knowledge? Everybody knows things, but how do we really know these things?

I know, for example, that there is a mountain in a place called Tibet. I know that the mountain is called Everest, and I know that it is the tallest land mountain in the world (there are some a bit taller under the ocean). I even know that it is precisely 29,028 feet high. But I have never measured it; I've never even been to Tibet. Beyond this, I have not measured all of the other mountains in the world to compare them to Everest. Yet I am quite confident that Everest is the world's tallest peak. But how do I know that?

On the subject of mountains, there is a run-down stone monument on the top of Bear Mountain in the northwestern corner of Connecticut. The monument was built toward the end of the nineteenth century and marks the "highest ground" in Connecticut (Figure 2.1). When the monument was built to memorialize this most lofty and auspicious of peaks—the mountain is all of 2,316 feet high—people knew that it was the highest point in the state and wanted to recognize this fact with the monument.

There is only one problem. In recent times, with more accurate, sophisticated measuring equipment, it has been determined that Bear Mountain is not the highest point in Connecticut. The slope of Frissell Mountain, which

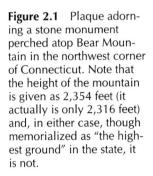

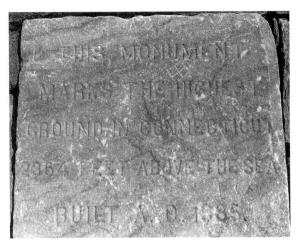

actually peaks in Massachusetts, reaches a height of 2,380 feet on the Connecticut side of the border, eclipsing Bear Mountain by about 64 feet.

So, people in the late 1800s and early 1900s "knew" that Bear Mountain was the highest point in Connecticut. Today we *know* that they really did not "know" that, because it was not true—even though they thought it was and built a monument saying so.

Now, suppose that I read in a newspaper, hear on the radio, or see on television a claim that another mountain has been found that is actually 10 (or 50, or 10,000) feet higher than Mount Everest. Indeed, just a few years ago, new satellite data convinced a few, just for a while, that a peak neighboring Everest was, in actuality, slightly higher. You and I have never been to Tibet. How do we know if these reports are true? What criteria can we use to decide if the information is correct or not? It all comes back to epistemology. How indeed do we know what we think we "know"?

Collecting Information: Seeing Isn't Necessarily Believing

In general, people collect information in two ways:

- 1. Directly through their own experiences
- 2. Indirectly through specific information sources such as friends, teachers, parents, books, TV, and so forth

People tend to think that obtaining firsthand information—what they see or experience themselves—is always the best way. Unfortunately this is a false assumption because most people are poor observers.

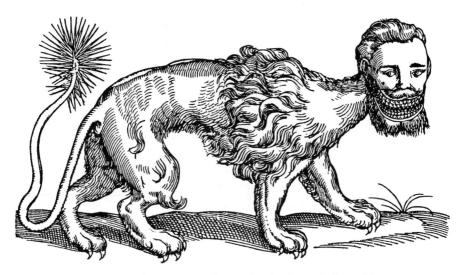

Figure 2.2 A seventeenth-century rendition of a clearly mythological beast—a *Mantichora*. The creature was considered to be real, described as being the size of a wild ass, as having quills on its tail that it could hurl at adversaries, and as having a fondness for human flesh.

For example, the list of animals alleged to have been observed by people that turn out to be figments of their imaginations is staggering. It is fascinating to read Pliny, a first-century thinker, or Topsell, who wrote in the seventeenth century, and see detailed accounts of the nature and habits of dragons, griffins, unicorns, mermaids, and so on (Byrne 1979). People claimed to have seen these animals, gave detailed descriptions, and even drew pictures of them (Figure 2.2). Many folks read their books and believed them.

Neither are untrained observers very good at identifying known, living animals. A red or "lesser" panda escaped from the zoo in Rotterdam, Holland, in December 1978. Red pandas are very rare animals indigenous to China, Tibet, Nepal, and Burma, not Holland. They are distinctive in appearance and cannot be readily mistaken for any other sort of animal. The zoo informed the press that the panda was missing, hoping the publicity would alert people in the area of the zoo and aid in its return. Just when the newspapers came out with the panda story, it was found, quite dead, along some railroad tracks adjacent to the zoo. Nevertheless, over one hundred sightings of the panda *alive* were reported to the zoo from all over the Netherlands *after* the animal was obviously already dead. These reports did not stop until several days after the newspapers announced the discovery of the dead panda (van Kampen 1979). So much for the absolute reliability of firsthand observation.

Collecting Information: Relying on Others

When we explore the problems of secondhand information, we run into even more complications. Now we are not in place to observe something firsthand; we are forced to rely on the quality of someone else's observations, interpretations, and reports—as with the reported height of Mount Everest.

In assessing someone else's report, you need to ask yourself several questions: How did they obtain the information in the first place: revelation, intuition, science? What are their motives for providing this information? What agenda—religious, philosophical, nationalistic, or otherwise—do they have? What is their source of information, and how expert are they in the topic?

Most people obtain information about the world and current events from established sources such as television news, books, or newspapers. Let's look at the last of these.

Not all newspapers are equally accurate and believable. The *New York Times* has a reputation for factual reporting and carries the following promise in its masthead: "All the News That's Fit to Print." No one, not even their publishers, would characterize tabloid papers like the *Enquirer*, the *Star*, the *Examiner*, the *Weekly World News*, or the *Sun* in those same terms (Bird 1992). When asked about the accuracy of some of the more bizarre stories that appear in his paper, the editor of the *Weekly World News* has been quoted as responding, "For heaven's sake, we entertain people. We make people feel better" (Johnson 1994:27). Notice there is nothing in that response that defends or maintains the accuracy of the stories.

The *Sun* is even more revealing in its masthead: "*Sun* stories seek to entertain and are about the fantastic, bizarre, and paranormal. . . . The reader should suspend belief for the sake of enjoyment." I presume they mean "the reader should suspend *disbelief* for the sake of enjoyment." In other words, leave your skepticism behind because this isn't serious stuff; even we don't believe most of it. Just read these weird and improbable stories for the entertainment value in them.

In fact, most people follow that advice. In her wonderful anthropological study of the tabloids, S. Elizabeth Bird (1992) shows that most people who read the tabloids regularly do so for the celebrity gossip (which often turns out to be true) and for the uplifting human interest stories that are ignored by the popular press, as well as for the more bizarre material that adorns the pages of these publications. In terms of the latter, regular readers believe some (usually the stuff that reinforces previously held beliefs), but discard most of the rest, viewing it with a combination of interest and humor.

Anthropological topics do attract quite a bit of attention from the tabloids (see Figure 1.1). Mark Allen Peterson (1991), a writer with back-

grounds in anthropology and journalism, classifies tabloid stories about anthropology into four categories:

- 1. Aliens and ape men—These stories usually assert some alleged connection between an isolated group of people and extraterrestrial aliens or Bigfoot.
- 2. Whacky savages—These stories focus on the "bizarre" (that term shows up a lot) antics of a tribal or "primitive" people. Sexual and marriage practices are closely scrutinized in these articles.
- 3. Whacky anthropologists—These are usually upbeat stories about anthropologists who are viewed as peculiar and eccentric intellectuals who travel to awful places to study odd, but nevertheless interesting, things.
- 4. Silly studies—These stories are somewhat similar in terms of topic to those included in number 3, but the perspective is quite different, being highly critical of the tax money "wasted" in supporting the frivolous studies conducted by those "whacky anthropologists."

Tabloid stories often are absurd, and few of the writers or even the readers believe them. This still leaves us with the broader question: How do we know what to believe? This is a crucial question that all rational people must ask themselves, whether talking about medicine, religion, archaeology, or anything else. Again, it comes back around to epistemology; how do we know what we think we know, and how do we know what or whom to believe?

Science: Playing by the Rules

There are ways to knowledge that are both dependable and reliable. We might not be able to get to absolute truths about the meaning of existence, but we can figure out quite a bit about our world—about chemistry and biology, psychology and sociology, physics and history, and even prehistory. The techniques used to get at knowledge we can feel confident in—knowledge that is reliable, truthful, and factual—are referred to as *science*.

In large part, science is a series of techniques used to maximize the probability that what we think we know really reflects the way things are, were, or will be. Science makes no claim to have all the answers or even to be right all the time. On the contrary, during the process of the growth of knowledge and understanding, science is often wrong. The only claim that we do make in science is that if we honestly, consistently, and vigorously pursue knowledge using some basic techniques and principles, the truth will eventually surface and we can truly know things about the nature of the world in which we find ourselves.

The question then is, What exactly is science? If you believe Hollywood, science is a mysterious enterprise wherein old, white-haired, rather eccentric, bearded gentlemen labor feverishly in white lab coats, mix assorted chemicals, invent mysterious compounds, and attempt to reanimate dead tissue or invent time machines: Doctor Frankenstein (Figure 2.3) and Dr. Brakish Okun of *Independence Day* come to mind.

So much for Hollywood. Scientists are not misfits without practical concerns or interests beyond their specialties. We are just people trying to arrive at some truths about how the world and the universe work. Although the application of science can be a slow, frustrating, all-consuming enterprise, the basic assumptions we scientists hold are very simple. Whether we are physicists, biologists, or archaeologists, we all work from four underlying principles. These principles are quite straightforward, but equally quite crucial.

- 1. There is a real and knowable universe.
- 2. The universe (which includes stars, planets, animals, and rocks, as well as people, their cultures, and their histories) operates according to certain understandable rules or laws.
- 3. These laws are immutable—that means they do not, in general, change depending on where you are or "when" you are.
- 4. These laws can be discerned, studied, and understood by people through careful observation, experimentation, and research.

Let's look at these assumptions one at a time.

There Is a Real and Knowable Universe

In science we have to agree that there is a real universe out there for us to study—a universe full of stars, animals, human history, and prehistory that exists whether we are happy with that reality or not.

Recently, it has become fashionable to deny this fundamental underpinning of science. A group of thinkers called *deconstructionists*, for example, believe that all science and history are merely artificial constructs, devoid of any objective reality or truth. As scientists Kurt Gottfried and Kenneth Wilson (1997:545) state, the deconstructionists claim that "scientific knowledge is only a communal belief system with a dubious grip on reality." Deconstructionists try to take apart common beliefs in an attempt to show that much of what we think we know is purely subjective and culturally based.

To some deconstructionists, there is no absolute reality for science to observe or explain; there are only cultural constructs of the universe that are different among people in different societies, and even different between

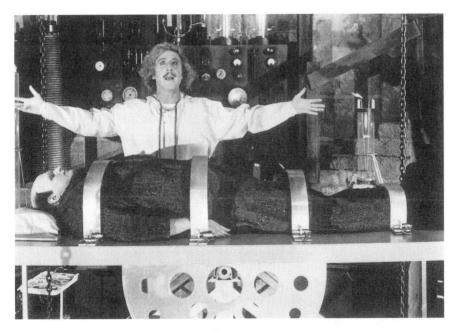

Figure 2.3 Gene Wilder depicted a stereotypical—and quite hilarious—mad scientist in the movie *Young Frankenstein*. As funny as his character was, it reflects a common, though quite mistaken, view of what real scientists are like and how they go about their research. (Motion Picture and TV Photo Archive)

men and women within the same culture. There is not one reality but many, and all are equally valid.

Deconstructionists describe science as a purely Western mode of thought, a mechanistic, antinature pattern based on inequality, capitalist exploitation, and patriarchy. The objective observation and understanding at the heart of the scientific approach are impossibilities; the things we see and the explanations we come up with are informed by who we are. (See Paul R. Gross and Norman Levitt's [1994] disturbing book *Higher Superstition: The Academic Left and Its Quarrel with Science* for a detailed criticism of the deconstructionists.) Science, to the deconstructionists, is merely the Western "myth"; it is no more objective and no more "real" than nonscientific myths.

As Theodore Schick and Lewis Vaughn (1999) point out, however, if there is no such thing as objective truth, then no statements, including this one, are objectively true. We could know nothing because there would be nothing to know. This is not a useful approach for human beings. Science simply is not the same as myth or oral tradition. Science demands rigorous testing and retesting, and it commonly rejects and discards previous conclusions about the world as a result of such testing. The same cannot be said for nonscientific explanations about how things work.

I suppose one could attempt to demonstrate the culturally subjective nature of the physical principle that two things cannot occupy the same place at the same time by, say, standing in front of a moving train. You probably will not see any deconstructionist attempting this anytime soon.

The Universe Operates According to Understandable Laws

In essence, what this means is that there are rules by which the universe works: stars produce heat and light according to the laws of nuclear physics; nothing can go faster than the speed of light; all matter in the universe is attracted to all other matter (the law of gravity).

Even human history is not random but can be seen as following certain patterns of human cultural evolution. For example, development of complex civilizations in Egypt, China, India/Pakistan, Mesopotamia, Mexico, and Peru was not based on random processes (Haas 1982; Lamberg-Karlovsky and Sabloff 1995). Their evolution seems to reflect similar general patterns. This is not to say that all of these civilizations were identical, any more than we would say that all stars are identical. On the contrary, they existed in different physical and cultural environments, and so we should expect that they would be different. However, in each case the rise to civilization was preceded by development of an agricultural economy and socially stratified societies. In each case, civilization was also preceded by some degree of overall population increase as well as increased population density in some areas (in other words, the development of cities). Again, in each case we find monumental works (pyramids, temples), evidence of longdistance trade, and development of mathematics, astronomy, and methods of record keeping (usually, but not always, in the form of writing). The cultures in which civilization developed, though some were unrelated and independent, shared these factors because of the nonrandom patterns of cultural evolution.

The point is that everything operates according to rules. In science we believe that by understanding these rules or laws we can understand stars, organisms, and even ourselves.

The Laws Are Immutable

That the laws do not change under ordinary conditions is a crucial concept in science. A law that works here, works there. A law that worked in the past will work today and will work in the future.

For example, if I go to the top of the Leaning Tower of Pisa today and simultaneously drop two balls of unequal mass, they will fall at the same rate and reach the ground at the same time, just as they did when Galileo

performed a similar experiment in the seventeenth century. If I perform the same experiment countless times, the same thing will occur because the laws of the universe (in this case, the law of gravity) do not change through time. They also do not change depending on where you are. Go anywhere on the earth and perform the same experiment—you will get the same results (try not to hit any pedestrians or you will see some other "laws" in operation). This experiment was even performed by U.S. astronauts on the moon. A hammer and a feather were dropped from the same height, and they hit the surface at precisely the same instant (the only reason this will not work on earth is because the feather is caught by the air and the hammer, obviously, is not). We have no reason to believe that the results would be different anywhere or "anywhen" else.

If this assumption of science, that the laws do not change through time, were false, many of the so-called historical sciences, including prehistoric archaeology, could not exist.

For example, historical geologists are interested in knowing how the various landforms we see today came into being. They recognize that they cannot go back in time to see how the Grand Canyon was formed. However, because the laws of geology that governed the development of the Grand Canyon have not changed through time, and because these laws are still in operation, historical geologists can study the formation of geological features today and apply what they learn to the past. The same laws they can directly study operating in the present were operating in the past when geological features that interest them first formed.

In the words of nineteenth-century geologist Charles Lyell, the "present" we can observe is the "key" to understanding the past that we cannot. This is true because the laws or rules that govern the universe are constant—those that operate today operated in the past. This is why science does not limit itself to the present but makes inferences about the past and even predictions about the future (listen to the weather report for an example of this). We can do so because we can study modern, ongoing phenomena that work under the same laws that existed in the past and will exist in the future.

This is where science and theology are often forced to part company and respectfully disagree. Remember, science depends on the constancy of the laws that we can discern. In contrast, advocates of many religions, though they might believe that there are laws that govern things (and which, according to them, were established by a Creator), usually (but not always) believe that these laws can be changed at any time by their God. In other words, if God does not want the apple to fall to the ground but instead to hover, violating the law of gravity, that is precisely what will happen. As a more concrete example, scientists know that the heat and light given off by a fire results from the transformation of mass (of the wood) to energy. Physical laws control this process. A theologian, however, might agree with this ordinarily but feel that if God wants to create a fire that does not consume

any mass (like the "burning bush" seen by Moses in the Old Testament), then this is exactly what will occur. Most scientists simply do not accept this assertion. The rules are the rules. They do not change, even though we might sometimes wish that they would.

The Laws Can Be Understood

This may be the single most important principle in science. The universe is knowable. It may be complicated, and it may take years and years to understand even apparently simple phenomena. Each attempt at understanding leads us to collect more data and to test, reevaluate, and refine our proposed explanations—for how planets formed, why a group of animals became extinct while another thrived, or how a group of ancient people responded to a change in their natural environment, contact with an alien group of people, or adoption of a new technology. We rarely get it right the first time and are continually collecting new information, abandoning some interpretations while refining others. We constantly rethink our explanations. In this way, little by little, bit by bit, we expand our knowledge and understanding. Through this kind of careful observation and objective research and experimentation, we can indeed know things.

So, our assumptions are simple enough. We accept the existence of a reality independent of our own minds, and we accept that this reality works according to a series of unchanging laws or rules. We also claim that we can recognize and understand these laws or at least recognize the patterns that result from these universal rules. The question remains then: How do we do science—how do we explore the nature of the universe, whether our interest is planets, stars, atoms, or human prehistory?

The Workings of Science

We can know things by employing the rules of logic and rational thought. Scientists—archaeologists or otherwise—usually work through a combination of the logical processes known as *induction* and *deduction*. The dictionary definition of induction is "arguing from specifics to generalities," whereas deduction is defined as the reverse, arguing from generalities to specifics.

What is essential to good science is objective, unbiased observations—of planets, molecules, rock formations, archaeological sites, and so on. Often, on the basis of these specific observations, we induce explanations called *hypotheses* for how these things work.

For example, we may study the planets Mercury, Venus, Earth, and Mars (each one presents specific bits of information). We then induce gen-

eral rules about how we think these inner planets in our solar system were formed. Or, we might study a whole series of different kinds of molecules and then induce general rules about how all molecules interact chemically. We may study different rock formations and make general conclusions about their origin. We can study a number of specific prehistoric sites and make generalizations about how cultures evolved.

Notice that we cannot directly observe planets forming, the rules of molecular interaction, rocks being made, or prehistoric cultures evolving. Instead, we are inducing general conclusions and principles concerning our data that seem to follow logically from what we have been able to observe.

This process of induction, though crucial to science, is not enough. We need to go beyond our induced hypotheses by testing them. If our induced hypotheses are indeed valid—that is, if they really represent the actual rules according to which some aspect of the universe (planets, molecules, rocks, ancient societies) works—they should be able to hold up under the rigors of scientific hypothesis testing.

Observation and suggestion of hypotheses, therefore, are only the first steps in a scientific investigation. In science we always need to go beyond observation and hypothesizing. We need to set up a series of "if . . . then" statements; "if" our hypothesis is true "then" the following deduced "facts" will also be true. Our results are not always precise and clear-cut, especially in a science like archaeology, but this much should be clear—scientists are not just out there collecting a bunch of interesting facts. Facts are always collected within the context of trying to explain something or in trying to test a hypothesis.

As an example of this logical process, consider the health effects of smoking. How can scientists be sure that smoking is bad for you? After all, it's pretty rare that someone takes a puff on a cigarette and immediately drops dead. The certainty comes from a combination of induction and deduction. Observers have noticed for about three hundred years that people who smoked seemed to be more likely to get certain diseases than people who did not smoke. As long ago as the seventeenth century, people noticed that habitual pipe smokers were subject to tumor growths on their lips and in their mouths. From such observations we can reasonably, though tentatively, induce a hypothesis of the unhealthfulness of smoking, but we still need to test such a hypothesis. We need to set up "if . . . then" statements. If, in fact, smoking is a hazard to your health (the hypothesis we have induced based on our observations), then we should be able to deduce some predictions that must also be true. Sure enough, when we test specific, deduced predictions such as

- 1. Smokers will have a higher incidence of lung cancer than nonsmokers
- 2. Smokers will have a higher incidence of emphysema

- 3. Smokers will take more sick days from work
- 4. Smokers will get more upper respiratory infections
- 5. Smokers will have diminished lung capacity
- 6. Smokers will have a shorter life expectancy

we see that our original, induced hypothesis—cigarette smoking is hazardous to your health—is upheld.

That was easy, but also obvious. How about an example with more mystery to it, one in which scientists acting in the way of detectives had to solve a puzzle to save lives? Carl Hempel (1966), a philosopher of science, provided the following example in his book *The Philosophy of Natural Science*.

The Case of Childbed Fever

In the 1840s things were not going well at the Vienna General Hospital, particularly in ward 1 of the Maternity Division. In ward 1 more than one in ten of the women brought in to give birth died soon after of a terrible disease called "childbed fever." This was a high death rate even for the 1840s. In one year 11.4 percent of the women who gave birth in ward 1 died of this disease. It was a horrible situation and truly mystifying when you consider the fact that in ward 2, another maternity division in the *same* hospital at the *same* time, only about one in fifty of the women (2 percent) died from this disease.

Many people tried to induce hypotheses to explain these facts. It was suggested that more women were dying in ward 1 because of "atmospheric disturbances" or "cosmic forces." However, no one had considered the deductive implications of the various hypotheses—those things that would necessarily have been true if the proposed, induced explanation were in fact true. No one, that is, until a Hungarian doctor, Ignaz Semmelweis, attacked the problem in 1848.

Semmelweis made some observations in the maternity wards at the hospital. He noted some differences between wards 1 and 2 and induced a series of possible explanations for the drastic difference in the mortality rates. Semmelweis suggested:

- 1. Ward 1 tended to be more crowded than ward 2. The overcrowding in ward 1 was the cause of the higher mortality rate there.
- 2. Women in ward 1 were from a lower socioeconomic class and tended to give birth lying on their backs, whereas in ward 2 the predominant position was on the side. Birth position was the cause of the higher mortality rate.
- 3. There was a psychological factor involved; the hospital priest had to walk through ward 1 to administer the last rites to dying patients in

- other wards. This sight so upset some women already weakened by the ordeal of childbirth that it contributed to their deaths.
- 4. There were more student doctors in ward 1. Students were rougher than experienced physicians in their treatment of the women, unintentionally harming them and contributing to their deaths.

These induced hypotheses all sounded good. Each marked a genuine difference between wards 1 and 2 that might have caused the difference in the death rate. Semmelweis was doing what most scientists do in such a situation; he was relying on creativity and imagination in seeking out an explanation.

Creativity and imagination are just as important to science as good observation. But being creative and imaginative was not enough. It did not help the women who were still dying at an alarming rate. Semmelweis had to go beyond producing possible explanations; he had to test each one of them. So, he deduced the necessary implications of each:

- 1. If hypothesis 1 were correct, then alleviating the crowding in ward 1 should reduce the mortality rate. Semmelweis tried precisely that. The result: no change. So the first hypothesis was rejected. It had failed the scientific test; it simply could not be correct.
- 2. Semmelweis went on to test hypothesis 2 by changing the birth positions of the women in ward 1 to match those of the women in ward 2. Again, there was no change, and another hypothesis was rejected.
- 3. Next, to test hypothesis 3, Semmelweis rerouted the priest. Again, women in ward 1 continued to die of childbed fever at about five times the rate of those in ward 2.
- 4. Finally, to test hypothesis 4, Semmelweis made a special effort to get the student doctors to be more gentle in their birth assistance to the women in ward 1. The result was the same; 10 or 11 percent of the women in ward 1 died compared to about 2 percent in ward 2.

Then, as so often happens in science, Semmelweis had a stroke of luck. When a doctor acquaintance of his died, the way he died provided Semmelweis with another possible explanation for the problem in ward 1. Though Semmelweis's friend was not a woman who had recently given birth, he did have precisely the same symptoms as did the women who were dying of childbed fever. Most important, this doctor had died of a disease similar to childbed fever soon after accidentally cutting himself during an autopsy.

Viruses and bacteria were unknown in the 1840s. Surgical instruments were not sterilized, no special effort was made to clean the hands, and doctors did not wear gloves during operations and autopsies. Semmelweis had another hypothesis; perhaps the greater number of medical students in ward 1 was at the root of the mystery, but not because of their inexperience.

Instead, these students, as part of their training, were much more likely than experienced doctors to be performing autopsies. Supposing that there was something bad in dead bodies and this something had entered Semmelweis's friend's system through his wound—could the same bad "stuff" (Semmelweis called it "cadaveric material") get onto the hands of the student doctors, who then might, without washing, go on to help a woman give birth? Then, if this "cadaveric material" were transmitted into the woman's body during the birth of her baby, this material might lead to her death. It was a simple enough hypothesis to test. Semmelweis simply had the student doctors carefully wash their hands after performing autopsies. The women stopped dying at a higher rate in ward 1. Semmelweis had solved the mystery.

Science and Nonscience: The Essential Differences

Through objective observation and analysis, a scientist, whether a physicist, chemist, biologist, psychologist, or archaeologist, sees things that need explaining. Through creativity and imagination, the scientist suggests possible hypotheses to explain these "mysteries." The scientist then sets up a rigorous method through experimentation or subsequent research to deductively test the validity of a given hypothesis. If the implications of a hypothesis are shown not to be true, the hypothesis must be rejected and then it's back to the drawing board. If the implications are found to be true, we can uphold or support our hypothesis.

A number of other points should be made here. The first is that for a hypothesis, whether it turns out to be upheld or not, to be scientific, it must be testable. In other words, there must be clear, deduced implications that can be drawn from the hypothesis and then tested. Remember the hypotheses of "cosmic influences" and "atmospheric disturbances"? How can you test these? What are the necessary implications that can be deduced from the hypothesis "More women died in ward 1 because of atmospheric disturbances"? There really aren't any, and therefore such a hypothesis is not scientific—it cannot be tested. Remember, in the methodology of science, we ordinarily need to:

- 1. Observe
- 2. Induce general hypotheses or possible explanations for what we have observed
- 3. Deduce specific things that must also be true if our hypothesis is true
- 4. Test the hypothesis by checking out the deduced implications

As Michael Shermer (1997:19) points out, "Science, of course, is not this rigid, and no scientist consciously goes through 'steps.' The process is a constant interaction of making observations, drawing conclusions, making predictions, and checking them against evidence."

Testing a hypothesis is crucial. If there are no specific implications of a hypothesis that can then be analyzed as a test of the validity or usefulness of that hypothesis, then you simply are not doing and cannot do "science."

For example, suppose you observe a person who appears to be able to "guess" the value of a playing card picked from a deck. Next, assume that someone hypothesizes that "psychic" ability is involved. Finally, suppose the claim is made that the "psychic" ability goes away as soon as you try to test it (actually named the "shyness effect" by some researchers of the paranormal). Such a claim is not itself testable and therefore not scientific.

Beyond the issue of testability, another lesson is involved in determining whether an approach to a problem is scientific. Semmelweis induced four different hypotheses to explain the difference in mortality rates between wards 1 and 2. These "competing" explanations are called *multiple working hypotheses*. Notice that Semmelweis did not simply proceed by a process of elimination. He did not, for example, test the first three hypotheses and—after finding them invalid—declare that the fourth was necessarily correct because it was the only one left that he had thought of.

Some people try to work that way. A light is seen in the sky. Someone hypothesizes it was a meteor. We find out that it was not. Someone else hypothesizes that it was a military rocket. Again this turns out to be incorrect. Someone else suggests that it was the Goodyear Blimp, but that turns out to have been somewhere else. Finally, someone suggests that it was the spacecraft of people from another planet. Some will say that this must be correct because none of the other explanations panned out. This is nonsense. There are plenty of other possible explanations. Eliminating all of the explanations we have been able to think of except one (which, perhaps, has no testable implications) in no way allows us to uphold that final hypothesis. You will see just such an error in logic with regard to the Shroud of Turin artifact discussed in Chapter 11.

A Cheap—But Effective—Trick

Let me explain a card trick I perform with Dr. Michael Park—a friend and colleague—to show why this process of elimination doesn't work. I ask a student in class to select a card from a deck, showing the face of the card to me and all the other students in the room while my colleague sits comfortably in his home office twenty miles away. From the classroom, I then call Mike on the phone and "telepathically" transmit the face of the card across the telephone wires. We can get it right every time; our years of collaborative work

have left us incredibly tuned-in to each other psychically. Or so we would have our audience believe.

Are you a skeptic? If so, you might ask:

- 1. Is it a fixed or "gimmicked" deck?
- 2. Is there a hidden mini-camera or microphone in the classroom with a feed to Mike's house?
- 3. Is the student who selects the card a plant, a co-conspirator in the magic trick?

All good questions, but the answer is "no" each time. Based on your three incorrect suggestions, would it make sense to conclude that what you saw was not a trick at all but an example of real "supernatural magic" or telepathy? Wouldn't it make more sense simply to admit that you do not have the expertise to come up with a more reasonable hypothesis?

You are not suposed to reveal the secret behind a magic trick, but just this once I'll break that rule. After all, it's an old, not particularly sophisticated trick—and it has been widely published. It is actually quite simple. When I call Mike on the phone, in the seemingly innocuous chatter that transpires between us as he attempts to "read my mind," I simply tell him which card it is. "But," you object, "don't students pick up on this?" No, they don't, because our conversation is in a simple, but pretty much impenetrable, predetermined code.

It works like this. When I call, I address Mike using the code we both know. If I say "Hello Mike," that indicates that it's a red card, but if I say "Hi Michael," it's a black card. Suppose I say "Hi Michael" (indicating the card is black), and next I say "Are you ready?" In our code that means it's a club, but if instead I say "We are ready here," it's a spade. Everything else I say is based on the code and identifies the card to my accomplice: picture card versus number, even the actual value of the card. The key to the code is that everything I say is something that would be expected in our conversation; it all sounds like reasonable, ordinary, harmless banter wholly unrelated to his "psychically reading" the card. Mike doesn't even need to memorize the code—he can have it written down on a piece of paper.

Now, wouldn't you feel a bit foolish if, on the basis of this silly little trick, you changed your worldview and began believing in telepathy or magic? You should feel foolish, but don't feel bad—you would not be the first to have fallen for this kind of trick.

A Rule in Assessing Explanations

Finally, there is another rule to hypothesis making and testing. It is called *Occam's Razor* or *Occam's Rule*. In thinking, in trying to solve a problem, or in attempting to explain some phenomenon, "Entities are not to be multiplied

Figure 2.4 An 1827 lithograph of a fossil quarry in the Tilgate Forest, Sussex, England. Workers are extracting a dinosaur bone from a large rock fragment. (From Mantell's *Geology of Sussex*)

beyond necessity." In other words, the explanation or hypothesis that explains a series of observations with the fewest other assumptions or leaps—the hypothesis that does not multiply these entities beyond necessity—is the best explanation. Galileo adhered to his own version of this, asserting that the simplest explanations for astronomical observations were the best.

Here is an actual example of Occam's Razor at work. During the eighteenth and nineteenth centuries, huge, buried, fossilized bones were found throughout North America and Europe (Figure 2.4). One hypothesis, the simplest, was that the bones were the remains of animals that no longer existed. This hypothesis simply relied on the assumption that bones do not come into existence by themselves but always serve as the skeletons of animals. Therefore, when you find bones, there must have been animals who used those bones. However, another hypothesis was suggested: the bones were deposited by the Devil to fool us into thinking that such animals existed (Howard 1975). This hypothesis "multiplied" those "entities" Occam warned us about. This explanation demanded many more assumptions about the universe than did the first: there is a Devil, that Devil is interested

in human affairs, he wants to fool us, he has the ability to make bones of animals that never existed, and he has the ability to hide them under the ground and inside solid rock. That is quite a number of unproven (and largely untestable) claims to swallow. Thus, Occam's Razor says the simpler hypothesis, that these great bones are evidence of the existence of animals that no longer exist—in other words, dinosaurs—is better. The other explanation raises more questions than it answers.

The Art of Science

Don't get the impression that science is a mechanical enterprise. Science is at least partially an art. It is much more than just observing the results of experiments.

It takes great creativity to recognize a "mystery" in the first place. In the apocryphal story, countless apples had fallen from countless trees and undoubtedly conked the noggins of multitudes of stunned individuals who never thought much about it. It took a fabulously creative individual, Isaac Newton, to even recognize that herein lay a mystery. Why did the apple fall? It could have hovered in midair. It could have moved off in any of the cardinal directions. It could have gone straight up and out of sight. But it did not. It fell to the ground as it always had, in all places, and as it always would. It took great imagination to recognize that in this simple observation (and in a bump on the head) rested the eloquence of a fundamental law of the universe.

Where Do Hypotheses Come From?

Coming up with hypotheses is not a simple or mechanical procedure. The scientific process requires creativity. Hypotheses arrive as often in flashes of insight as through plodding, methodical observation. Consider this example.

My field crew and I had just finished excavating the 2,000-year-old Loomis II archaeological site in Connecticut where a broad array of different kinds of stones had been used for making tools. Some of the "lithics" came from sources close to the site. Other sources were located at quite a distance, as much as a few hundred miles away. These nonnative "exotic" lithics were universally superior; tools could be made more easily from the nonlocal materials, and the edges produced were much sharper.

At the time the site was being excavated, I noticed that there seemed to be a pattern in terms of the size of the individual tools we were recovering. Tools made from the locally available and generally inferior materials of quartz and basalt were relatively large, and the pieces of rock that showed no evidence of use—archaeologists call these discarded pieces *debitage*—were also relatively large. In contrast, the tools made from the superior materials—one kind of flint and two kinds of chert—that originated at a great

distance from the site were much smaller. Even inconsequential flakes of exotic stone—pieces you could barely hold between two fingers—showed evidence of use, and only the tiniest of flakes was discarded without either further modification for use or evidence of use, such as for scraping, cutting, or piercing.

I thought it was an interesting pattern but didn't think much of it until about a year later when I was cleaning up the floor of my lab after a class in experimental archaeology where students were replicating stone tools. We used a number of different raw materials in the class, and just as was the case for the site, stone of inferior quality was readily available a few miles away, whereas more desirable material was from more distant sources.

As I cleaned up, I noticed that the discarded stone chips left by the students included perfectly serviceable pieces of the locally available, easy to obtain stone, and only the tiniest fragments of flint and obsidian. We obtained flint in New York State from a source about 80 miles from campus, and we received obsidian from Wyoming. Suddenly it was clear to me that the pattern apparent at the archaeological site was repeating itself nearly two thousand years later among my students. More "valuable" stone—functionally superior and difficult to obtain—was used more efficiently, and there was far less waste than in stone that was easy to obtain and more difficult to work. I could now phrase this insight as a hypothesis and test it using the site data: more valuable lithic materials were used more efficiently at the Loomis II archaeological site (Feder 1981). In fact, by a number of measurements, this turned out to be precisely the case. The hypothesis itself came to me when I wasn't thinking of anything in particular; I was simply sweeping the floor.

It may take great skill and imagination to invent a hypothesis in the attempt to understand why things seem to work the way they do. Remember, ward 1 at the Vienna General Hospital did not have written over its doors, "Overcrowded Ward" or "Ward with Student Doctors Who Don't Wash Their Hands After Autopsies." It took imagination, first, to recognize that there were differences between the wards and, second, to hypothesize that some of the differences might logically be at the root of the mystery. After all, there were in all likelihood many, many differences between the wards: their compass orientations, the names of the nurses, the precise alignment of the windows, the astrological signs of the doctors who worked in the wards, and so on. If a scientist were to attempt to test all of these differences as hypothetical causes of a mystery, nothing would ever be solved. Occam's Razor must be applied. We need to focus our intellectual energies on those possible explanations that require few other assumptions. Only after all of these have been eliminated can we legitimately consider others. As summarized by that great fictional detective, Sherlock Holmes:

It is of the highest importance in the art of detection to be able to recognize, out of a number of facts, which are incidental and which are vital. Otherwise, your energy and attention must be dissipated instead of being concentrated. (Doyle 1981:275)

Semmelweis concentrated his attention on first four, then a fifth possible explanation. Like all good scientists he had to use some amount of what we can call "intuition" to sort out the potentially vital from the probably incidental. Even in the initial sorting we may be wrong. Overcrowding, birth position, and psychological trauma seemed like very plausible explanations to Semmelweis, but they were wrong nonetheless.

Testing Hypotheses

Finally, it takes skill and inventiveness to suggest ways for testing the hypothesis in question. We must, out of our own heads, be able to invent the "then" part of our "if . . . then" statements. We need to be able to suggest those things that must be true if our hypothesis is to be supported. There really is an art to that. Anyone can claim there was a Lost Continent of Atlantis (Chapter 8), but often it takes a truly inventive mind to suggest precisely what archaeologists must find if the hypothesis of its existence was indeed to be valid.

Semmelweis tested his hypotheses and solved the mystery of childbed fever by changing conditions in ward 1 to see if the death rate would change. In essence, testing each hypothesis was an experiment. In archaeology, testing hypotheses often must be done in a different manner. There is a branch of archaeology called, appropriately enough, "experimental archaeology" that involves experimental replication and utilization of prehistoric artifacts in an attempt to figure out how they were made and used. In general, however, archaeology is largely not an experimental science. Archaeologists more often need to create "models" of some aspect of cultural adaptation and change. These models are simplified, manipulable versions of cultural phenomena.

For example, James Mosimann and Paul Martin (1975) created a computer program that simulated or modeled the human migration into America some twelve thousand years ago. By varying the size of the initial human population and their rate of growth and expansion, as well as the size of the big-game animal herds in the New World, Mosimann and Martin were able to test their hypothesis that these human settlers caused the extinction of many species of game animals. The implications of their mathematical modeling can be tested against actual archaeological and paleontological data.

Ultimately, whether a science is experimentally based or not makes little logical difference in testing hypotheses. Instead of predicting what the results of a given experiment must be if our induced hypothesis is useful or valid, we predict what new data we must be able to find if a given hypothesis is correct.

For instance, we may hypothesize that long-distance trade is a key element in the development of civilization based on our analysis of the ancient

Maya. We deduce that if this is correct—if this is, in fact, a general rule of cultural evolution—we must find large quantities of trade items in other parts of the world where civilization also developed. We might further deduce that these items should be found in contexts that denote their value and importance to the society (for example, in the burials of leaders). We must then determine the validity of our predictions and, indirectly, our hypothesis by going out and conducting more research. We need to excavate sites belonging to other ancient civilizations and see if they followed the same pattern as seen for the Maya relative to the importance of trade.

Testing a hypothesis is not easy. Sometimes errors in testing can lead to incorrectly validating or rejecting a hypothesis. Some of you may have already caught a potential problem in Semmelweis's application of the scientific method. Remember hypothesis 4? It was initially suggested that the student doctors were at the root of the higher death rate in ward 1 because they were not as gentle in assisting in birthing as were the more experienced doctors. This hypothesis was not borne out by testing. Retraining the students had no effect on the mortality rate in ward 1. But suppose that Semmelweis had tested this hypothesis instead by removing the students altogether prior to their retraining. From what we now know, the death rate would have indeed declined, and Semmelweis would have concluded incorrectly that the specific hypothesis was correct. We can assume that once the retrained students were returned to the ward (gentler, perhaps, but with their hands still dirty) the death rate would have jumped up again because the students were indeed at the heart of the matter, but not because of their presumed rough handling of the maternity patients.

This should point out that our testing of hypotheses takes a great deal of thought and that we can be wrong. We must remember: we have a hypothesis, we have the deduced implications, and we have the test. We can make errors at any place within this process—the hypothesis may be incorrect, the implications may be wrong, or the way we test them may be incorrect. Scientists are not perfect, and biases and preconceptions can interfere with this process. Certainty in science is a scarce commodity. There are always new hypotheses, alternative explanations, and more deductive implications to test. Nothing is ever finished, nothing is set in concrete, nothing is ever defined or raised to the level of religious truth.

The Human Enterprise of Science

Kurt Gottfried and Kenneth Wilson (1997:545) make the distinction between "science-as-knowledge" and "science-as-practice." Of course, there is a real, objective truth that we all aspire to obtain; science is the knowledge that we gain in the process. Science, however, also is a very human endeavor practiced by imperfect human beings. Scientists are not isolated from the cultures and times in which they live. They share many of the same prejudices

and biases of other members of their societies. Scientists learn from mentors at universities and inherit their perspectives. It often is quite difficult to go against the scientific grain, to question accumulated wisdom, and to suggest a new approach or perspective.

Consider the case of meteors. Today we take it for granted that sometimes quite large, extraterrestrial, natural objects go streaking across the sky and sometimes even strike the ground (then they are called meteorites). You may even be aware that major meteor showers can be seen twice a year: the Leonid Shower in August and the Perseid Shower in December. Perhaps you have been lucky enough to see a major meteor or "bolide," an awesome example of nature's fireworks. But until about two hundred years ago the notion that solid stone or metallic objects originating in space regularly enter the earth's atmosphere and sometimes strike the ground was controversial and, in fact, rejected by most scientists. In 1704 Sir Isaac Newton categorically rejected the notion that there could be meteors because he did not believe there could be any cosmological source for them.

The quality of an argument and the evidence marshalled in its support should be all that matters in science. The authority or reputation of the scientist should not matter. Nevertheless, not many scientists were willing to go against the considered opinion of as bright a scientific luminary as Isaac Newton. Nevertheless, a few brave thinkers risked their reputations by concluding that meteors really did originate in outer space. Their work was roundly criticized, at least for a time. But science is "self-corrective." Hypotheses are constantly being refined and re-tested as new data are collected.

In 1794, over the skies of Siena, Italy, there was a spectacular shower of about 3,000 meteors, seen by tens of thousands of people (Cowen 1995). Even then, a nonmeteoric explanation was suggested. By coincidence, Mount Vesuvius had erupted just eighteen hours before the shower, and some tried to blame the volcano as the source for the objects flaming in the skies over Italy.

Critics did what they could to dispel the "myth" of an extraterrestrial source for the streaks of light over Siena, but they could not succeed. Further investigation of subsequent major meteor falls in the late 1700s and early 1800s, as well as examination of the chemical makeup of some of the objects that had actually fallen from the sky (an iron and nickel alloy not found on earth), convinced most by the early nineteenth century that meteors are what we now know them to be—extraterrestrial chunks of stone or metal that flame brightly when they enter our planet's atmosphere.

Philosopher of science Thomas Kuhn (1970) has suggested that the growth of scientific knowledge is not neatly linear, with knowledge simply building on knowledge. He maintains that science remains relatively static for periods and that most thinkers work under the same set of assumptions—the same *paradigm*. New ideas or perspectives, like those of Semmel-

weis or Einstein, that challenge the existing orthodoxy are usually initially rejected. Only once scientists get over the shock of the new ideas and start testing the new frameworks suggested by these new paradigms are great jumps in knowledge made.

That is why in science we propose, test, tentatively accept, but never prove a hypothesis. We keep only those hypotheses that cannot be disproved. As long as a hypothesis holds up under the scrutiny of additional testing through experiment and is not contradicted by new data, we accept it as the best explanation so far. Some hypotheses sound good, pass the rigors of initial testing, but are later shown to be inadequate or invalid. Others—for example, the hypothesis of biological evolution—have held up so well (all new data either were or could have been deduced from it) that they will probably always be upheld. We usually call these very well-supported hypotheses theories. However, it is in the nature of science that no matter how well an explanation of some aspect of reality has held up, we must always be prepared to consider new tests and better explanations.

We are interested in knowledge and explanations of the universe that work. As long as these explanations work, we keep them. As soon as they cease being effective because new data and tests show them to be incomplete or misguided, we discard them and seek new ones. In one sense, Semmelweis was wrong after all, though his explanation worked at the time—he did save lives through its application—we now know that there is nothing inherently bad in "cadaveric material." Dead bodies are not the cause of childbed fever. Today we realize that it is a bacteria that can grow in the flesh of a dead body that can get on a doctor's hands, infect a pregnant woman, and cause her death. Semmelweis worked in a time before the existence of such things was known. Science in this way always grows, expands, and evolves. See Table 2.1 for a number of works that discuss the method of science.

Science and Archaeology

The study of the human past is a science and relies on the same general logical processes that all sciences do. Unfortunately, perhaps as a result of its popularity, the data of archaeology have often been used by people to attempt to prove some idea or claim. Too often, these attempts have been bereft of science.

Archaeology has attracted frauds and fakes. Myths about the human past have been created and popularized. Misunderstandings of how archaeologists go about their tasks and what we have discovered about the human story have too often been promulgated. As I stated in Chapter 1, my purpose is to describe the misuse of archaeology and the nonscientific application of the data from this field. In the chapters that follow, the perspective of

Author Stephen Carey	Book Title A Beginner's Guide to Scientific Method	Year 1994	Publisher Wadsworth
Howard Kahane	Logic and Contemporary Rhetoric: The Use of Reason in Everyday Life	1992	Wadsworth
Dasie Radner and Michael Radner	Science and Unreason	1982	Wadsworth
Milton Rothman	The Science Gap: Dispelling Myths and Understanding the Reality of Science	1992	Prometheus Books
Carl Sagan	The Demon Haunted World	1996	Random House
Michael Shermer	Why People Believe Weird Things	1997	W. H. Freeman
Theodore Schick, Jr. and Lewis Vaughn	How to Think About Weird Things: Critical Thinking for a New Age	1999	Mayfield
Lewis Wolpert	The Unnatural Nature of Science	1993	Harvard University Press

science will be applied to frauds, myths, and mysteries concerning the human past.

→ Frequently asked questions �

1. Can science answer all of our questions?

No, but it never promised to. Science is a process, a way to approach questions about the physical world (including people and their cultures), not the metaphysical world. Scientists endeavor to understand how the universe works. The search for meaning is valuable and we all do it: Why are we here in this universe? What is the point of our existence? How should we behave toward one another? How should we treat the planet on which we live? Though science can provide the framework for a worldview or philosophy, the answers to these philosophical questions are not discovered through science.

2. Doesn't scientific truth change in every generation?

In a sense, this is true. But our understanding of the world is not simply cyclical. We do not build an edifice of knowledge today only to tear it down tomorrow. The knowledge accumulated by each generation of scientists is refined and built upon by each subsequent generation. We really do know more today about how the solar system formed, the constituents of atoms, earth history, the etiology of disease, and the evolution of our species than we knew a century, a decade, or even a year ago.

Best of the Web

CLICK HERE

http://www.sonoma.edu/cthink/ncect.nclk

http://www.sonoma.edu/cthink/University/default.html

- 1. Most of you have probably seen the televised "documentary" called "The Alien Autopsy." This grainy, poorly focused film is purported to depict the genuine autopsy of an extraterrestrial alien killed in a crash, presumably at Roswell, New Mexico, more than forty years ago. Using Occam's Razor, how would you explain such a film? What kind of evidence would be needed before you would accept the claim that the alien autopsy shown in the film represents the genuine examination of the corpse of an extraterrestrial alien? After answering these questions, visit the website http://www.trudang.com/autopsy.html for the perspective of a group of Hollywood special effects experts.
- 2. Now go back and look at the topics listed in Table 1.1 in Chapter 1. How would you test each of these topics scientifically—in other words, how would you test the validity of UFOs as extraterrestrial spacecraft, the reality of ESP, and the rest?

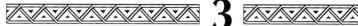

The Goliath of New York: The Cardiff Giant

Myths and fairy tales are filled with stories of giant human beings. From the rough customer Jack ran into at the top of the Beanstalk to Paul Bunyan, giants have been used by legend makers to teach lessons to children or simply to entertain.

Sometimes legends, myths, or fairy tales have some basis in reality. After all, there really are "giants," aren't there? Every NBA team has at least one 7-footer in its ranks, and by the standards of any human population, 7 feet is enormously tall—in fact, "gigantic." Most of these basketball players are "normal." That is, their great height is not the result of any medical condition—they are just tall, teetering at the high end of human height variation. The stature of some even taller individuals, however, is the result of one of a number of different medical pathologies. For example, some people develop tumors on their pituitary glands resulting in a condition called acromegaly. Their ailment is marked by oversized extremities, a massive and misshapen head, a very deep voice, and a short life span, as well as great height. Some acromegalics are well over 7 feet tall. The late professional wrestler and occasional actor André the Giant (he was in the movie The Princess Bride) had this condition. Some "pituitary giants" have attained documented heights of over 8 feet. In the medical literature Mr. Robert Wadlow—he was called "the Alton Giant"—was actually measured at 8 feet 11 inches.

But here we are not talking about the rare, exceptionally tall individual or the occasional result of an uncommon medical pathology. In the centuries before our own, many people accepted the existence in antiquity of an entire race of giant people 8, 9, or 10 feet tall—or even taller. They believed this because the Bible clearly stated that giant people inhabited the earth in ancient times. The Book of Genesis in the Old Testament makes it clear: "There were giants in the earth in those days" (Genesis 6:4). A computer search of the Bible produces eighteen specific references to giant people, including the entire Kingdom of Og in a place called Bashan (part of modern Syria). There are several other biblical references to "the valley of the giants" and a few allusions to the "remnants of the giants"—it seems that even in biblical times the feeling was that the giants' tenure on earth had already passed, and there were only a few of them left.

There is an explicit description of one of these remaining "giants" in the Bible's Book of Samuel. In relating the famous story of David and Goliath, the writers provide this very detailed description of Goliath's truly mammoth proportions:

And there went out a champion out of the camp of the Philistines named Goliath of Gotha whose height was six cubits and a span. And he had a helmet of brass upon his head, and he was armed with a coat of mail, and the weight of the coat was five thousand shekels of brass . . . his spear's head weighed six hundred shekels of iron. . . . (1 Samuel 17:4–7)

We do not measure things in *cubits*, *spans*, or *shekels*, so you'll need some help here. A cubit, the distance from the tip of the middle finger to the elbow, has had a number of slightly varying definitions in different cultures and times. The range has been between 17 and 21 inches. The nearest guess for biblical times is taken from ancient Egypt of the same period, where a cubit was a bit more than 20 inches. A span is defined as the distance between your thumb and pinky with your palm spread, or about 9 inches. A shekel, an ancient Hebrew measurement of weight, was about one-half of one of our ounces.

If we translate Goliath's measurements into our modern system, we can calculate that, according to the authors of the Old Testament, Goliath stood 10 feet 9 inches in height, his armor weighed over 150 pounds, and his spear head alone tipped the scales at close to 19 pounds.

Remember, in the nineteenth century the literal truth of everything in the Bible was believed not by just a small minority of zealous fundamentalists. For many, claims made in the Bible were not viewed as hypotheses to be tested against data. They were not seen as legends, myths, or allegorical tales. They were instead viewed as revelations simply to accept and believe as historical truths. For many there was no question about it; Adam and Eve really were the first human beings, Jonah really was swallowed by a whale, and a 10-foot-tall giant by the name of Goliath actually had existed. Although we may all know that a race of 10-foot-tall giants never existed, many God-fearing people in Europe and North America before this century probably did believe in giants.

Not surprisingly, during this time rumors were circulated concerning the discovery of evidence of ancient giant men (along with tales of the discovery of Noah's Ark, pieces of the true cross, and so on). No one believed that the Bible needed validation, but the discovery of things that seemed to uphold the truth of any of the Bible's stories was considered helpful in assisting people to better understand the Holy Word (see Chapter 11).

Stories were spread of giant fossil bones found in burial mounds in midwestern North America (see Chapter 7). In New York State there was a rumor that the skeletons of five enormous human beings had been found during the building of a railroad grade (Silverberg 1989). In the early 1700s Cotton Mather, who previously had helped inspire the Salem witch trials, claimed that some huge bones sent to him by the governor of Massachusetts were the remains of "sinful giants" drowned in Noah's Flood (Howard 1975).

So, it was clear. The Bible said there had been a race of giants in the old days, and there could be no question about it—there really had been giants. Any artifacts or finds that would help support such a biblical claim were accepted unquestioningly by many.

The Cardiff Giant

Thus was the public's imagination sparked when the story began to spread in October 1869 of the discovery of the fossilized remains of a giant man in the little farming village of Cardiff in upstate New York (see Franco 1969 for a detailed accounting of the Cardiff Giant story). Unlike other eighteenth-and nineteenth-century rumors of the archaeological discovery of prehistoric giants, the mystery of this find was solved soon after its "discovery." We even still have the Giant himself to admire. His "petrified" remains continue to inspire wonder as they did in the late 1860s, but in a different sense—today we wonder how people accepted such a transparent fake.

The Discovery

On Saturday, October 16, 1869, Mr. Stub Newell hired some men to dig a well behind the barn on his farm in Cardiff, New York, just south of Syracuse. While digging, the workmen came across something very hard and large at a depth of about 3 feet. Though curious, Newell was said to be "annoyed and perplexed" by the discovery—it was reported in the *Syracuse Daily Journal* of Wednesday, October 20, 1869, that he had even suggested filling up the pit and keeping the whole thing quiet. Nevertheless, Newell had the workers expand their excavations. When they were done, the group of men looked down with amazement on their thoroughly remarkable discovery. Lying at their feet in the pit was a man of enormous size and proportions whose body, it seemed, had turned to stone (Figure 3.1). He indeed appeared to be a man over 10 feet in height, with 21-inch-long feet, and 3-foot-wide shoulders. He seemed to be "petrified" like the trees in Petrified Forest National Park in eastern Arizona.

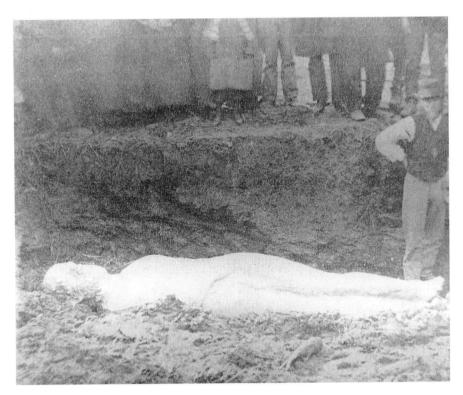

Figure 3.1 An 1869 photograph of the Cardiff Giant in its place of discovery on the Stub Newell farm. An unidentified digger stands to the right of the Giant, and curious onlookers gaze down on the remarkable discovery. (Courtesy of the New York State Historical Association, Cooperstown)

More than 200 million years ago, trees growing in Arizona in what was then a marshland were buried by sediment rich in minerals, in particular, silica. The silica leached into the trees, filling in the spaces both between and within the individual cells of wood, solidifying and replacing the wood as it decayed away. In some cases the silica faithfully reproduced the appearance of the original tree rings and even the actual cells of the ancient trees. If it could happen to trees, so the argument went, perhaps it could have happened to a person. Thus was the "discovery" of the Cardiff Giant made and the legend of a petrified giant man born.

The potential value of the discovery was an immediate topic of conversation among the discoverers and a growing group of curious neighbors. One neighbor proffered Newell \$50 for a one-quarter share of the giant. Another offered to do all the work in removing the giant and preparing it for exhibition for a one-half share. According to a *Syracuse Daily Journal* article (The Lafayette Wonder, October 20, 1869), a couple of local farmers were so

certain of the potential profits to be made that they offered to give Newell their farms in exchange for the giant! In that same article, an offer of \$10,000 is mentioned. Yet Newell, ostensibly just a simple country farmer, turned down these remarkable offers.

Word quickly spread in the sleepy little town of a few hundred and soon, that very afternoon and the next day in fact, local people were gazing with astonishment at the spectacular find in the bottom of the pit behind Stub Newell's barn. As a reporter for the *Syracuse Daily Journal* put it, "Men left their work, women caught up their babies, and children in numbers all hurried to the scene where the interest of that little community centered" (The Lafayette Wonder, October 20, 1869).

Newell then exhibited a remarkable degree of business acumen as well as surprising intuition concerning the marketability of the unique discovery on his property. No more than two days passed before Newell obtained a license to exhibit the Giant and purchased and erected a tent over the slumbering, petrified man. He then began to charge fifty cents for a peek, and the paying public came in droves (Figure 3.2).

From all over New York State, the Northeast, and even beyond, 300 to 500 people daily flocked to the Newell farm. On the first few weekends after its discovery, thousands showed up, all more than ready to wait in line and pay their half-dollar to get a brief glimpse of the petrified "Goliath" of Cardiff (it was actually called that in advertisements). All thoughts of farming on the Newell homestead were abandoned as the crowd of carriages carrying the curious from the train station in Syracuse to the Newell farm increased. The entire farm was transformed virtually overnight into a highly profitable tourist enterprise, with a food tent, carriage service, cider stand, and, of course, the center of attraction—the awe-inspiring Giant himself (Figure 3.3). One of Newell's relatives, Mr. George Hull, estimated in a later report that appeared in the *Ithaca Daily Journal* (The Cardiff Giant, January 4, 1898) that by not quite three weeks after the discovery Newell had collected approximately \$7,000 in admission fees—a remarkable sum even by today's standards.

Stub Newell was not the only one profiting from this lucky discovery on his property. Although the two small hotels in town were benefiting from a great influx of business, Cardiff was simply too small to accommodate the incredible surge of tourists who were making the trek to see the Giant. These people needed to be fed and housed, and that job fell to the businessmen of nearby Syracuse. In a very short time, the Cardiff Giant became a major factor in the economy of that city. Pilgrims streamed into town to pay homage to the Giant and, at the same time, to pay their dollars for the services such a tourist attraction demanded.

The economic impact of the Giant on Syracuse cannot be underestimated and was enough to convince a consortium of Syracuse businessmen and professional people to make Stub an offer he couldn't refuse. Although

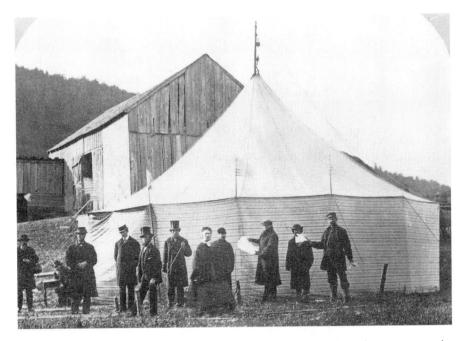

Figure 3.2 Just days after his "discovery," Stub Newell forgot about farming, erected a tent over the giant petrified man, and began charging people fifty cents to view its remains. (Courtesy of the Onondaga Historical Association, Syracuse)

a number of attempts to purchase shares in the Giant previously had been rebuffed, on October 23, just one week after its discovery, these astute people paid Newell \$30,000 for a three-fourths interest in the Giant. By today's standards that figure would almost certainly be in the millions of dollars. By purchasing a controlling share in the Giant, these businessmen were ensuring that it would stay near Syracuse, where it could continue to boost the local economy. At the same time they were assuring themselves a part of the enormous profits the Giant seemed certain to produce.

They were almost right. Between October 23 and November 5, the Syracuse investors had already made back \$12,000 of their investment exhibiting the Giant at the Newell farm (Franco 1969:431). I'll save you the math—at fifty cents admission and three-fourths ownership of the Giant and its profits, in that short period about 32,000 people paid for the privilege of seeing the Cardiff Giant.

With no sign of "Giant mania" abating, and with visions of dollar signs dancing in their heads, the Syracuse businessmen decided to move the Giant to Syracuse itself, where it would be easier for even greater numbers of people to see it. With great pomp and ceremony, not to mention free publicity through local newspaper coverage, the Giant was disinterred and transported to an exhibition hall in Syracuse. Among its admirers was the circus

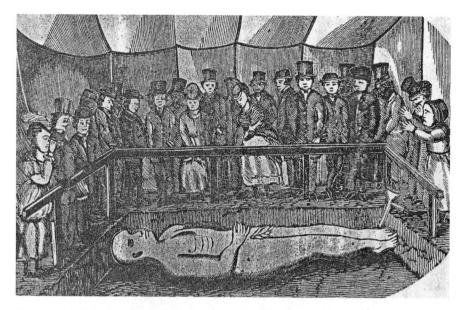

Figure 3.3 From *The Onondaga Giant,* a pamphlet published in 1869, this engraving shows a crowd of people viewing the Giant in the tent on the Newell farm. Note the strategically placed fig leaf.

entrepreneur P. T. Barnum, who made an attempt to buy the Giant but was turned down. According to the *Ithaca Daily Journal* article mentioned earlier, Barnum then offered the syndicate of owners \$60,000 merely for the use of the Giant for three months. Again he was rebuffed. Barnum was not to give up trying to make a circus attraction out of the Giant, however. His unique solution to the problem will be discussed later.

The Beginning of the End

Everything seemed to be going well. Newspapers were printing feature articles about the Giant. The local railroad even made a regular, 10-minute stop across the street from where it was being exhibited in Syracuse to enable people just passing through to run in to see the giant petrified man. People continued to come in great numbers to see the miraculously preserved, petrified giant man from before Noah's Flood.

But all was not well. Slowly at first, but then at an accelerating rate, rumors began to surface that the Giant was a fake. A local resident, Mr. Daniel Luce, provided a detailed report, recounted in the *Syracuse Standard* (The Stone Giant, November 1, 1869) of an extremely large wagon, carrying a sizable and obviously heavy load, that he remembered traveling toward Cardiff the previous year. Some wondered out loud whether the very large wagon had been carrying a fraudulent, giant statue of a man.

There is also some testimony, as indicated in the *Ithaca Daily Journal* article already cited, that Stub Newell had begun bragging to relatives about the profitable fraud he had perpetrated on the American public.

Beyond this—and this is very important—professional scientists, including geologists and paleontologists who had traveled to Cardiff or Syracuse to examine the Giant in detail, almost without exception immediately declared it to be at best a statue and at worst a fraud. Dr. J. F. Boynton, a geologist at the University of Pennsylvania, stated after carefully examining the Giant:

It is positively absurd to consider this a fossil man. It has none of the indications that would designate it as such, when examined by a practical chemist, geologist, or naturalist. (The Lafayette Wonder, *Syracuse Daily Journal*, October 20, 1869).

At first Boynton thought the Cardiff Giant might have been an actual historical artifact of some antiquity, a statue produced by a community of Jesuits who had lived in the area between 1520 and 1760. The well-known sculptor, Eratus Dow Palmer, examined the Giant and identified the marks of a sculptor's tools on its surface. Boynton was suspicious, however, after noting the presence of fresh plant material mixed in with the soil from above the Giant, indicating a probable recent burial.

Following a more detailed analysis of the Giant, Boynton declared to a reporter for *Harper's Weekly* magazine (The Cardiff Giant, December 4, 1869) that it was carved of a soft stone called gypsum. He went on to say in that same article that the soft nature of the stone and the amount of weathering on its surface suggested that the Giant had been buried *not more than three years* previous to its disinterment. He even went on to calculate that the Giant had most likely been in the ground only a little more than one year (approximately 370 days), based on his precise analysis of the rate of weathering of the gypsum from which it was made. As we will see, Boynton's calculation was amazingly accurate.

Othniel C. Marsh, a professor at Yale University and one of the most famous paleontologists of his time, probably was the most important of the scientific skeptics. Marsh examined the Giant and declared it to be "very remarkable." When asked by one of the Giant's owners if they could quote Marsh on that, Marsh is supposed to have said, "No. You may quote me on this though: a very remarkable fake!" (Howard 1975:208).

Like Boynton, Marsh correctly noted that the Giant was made of gypsum, a soft stone that would not last long in the wet soil of the Newell farm. (Gypsum is a sedimentary rock and exhibits layering, unlike petrified wood.) And like the sculptor Palmer, Marsh identified tool marks on the alleged petrified man.

The skepticism of so highly respected a scientist as Marsh had some impact, and a number of the New York City newspapers (in particular, the *New York Herald*) that had previously praised the Giant now changed their

minds. But the statements of Marsh and other, less well-known scientists could not alone dissuade the public from the notion that the Cardiff Giant was a real, petrified man whose existence supported biblical stories of human giants before Noah's Flood.

Hull's Confession

The meteoric rise to fame of the Cardiff Giant was cut short, and his fall from grace was just as quick. A previously shadowy figure involved with promoting the Giant confessed in December 1869 to perpetrating a fraud on the American public. George Hull, a distant relation of Stub Newell, unburdened his soul, and the Giant's value dropped from that of a spectacular archaeological find to that of one slightly worn chunk of gypsum.

George Hull was a cigar manufacturer in Binghamton, New York. Ironically, he also was a devout atheist. He revealed the entire story toward the end of his life in an interview he gave to the *Ithaca Daily Journal* (The Cardiff Giant, January 4, 1898).

During a visit to his sister's house in Iowa in 1866, Hull had a long and heated conversation with a Methodist minister traveling through the area. Apparently, the conversation focused on extraordinary biblical stories, like those mentioned at the beginning of this chapter concerning the existence of an ancient race of giant men. Hull suggested to the minister that the Bible was filled with such tall tales, impossibilities that only the gullible would believe. The minister took strong exception to this characterization, maintaining the literal truth of every Bible story. At midnight Hull retired to bed and, in his own words: "I lay wide awake wondering why people would believe those remarkable stories in the Bible about giants, when I suddenly thought of making a stone giant, and passing it off as a petrified man" (The Cardiff Giant, Ithaca Daily Journal, January 4, 1898).

In a subsequent visit to the Midwest in June 1868, Hull purchased a large block of gypsum in Fort Dodge, Iowa. He then had it shipped to Chicago, where, swearing them to secrecy, he hired sculptors to produce a statue of a giant, slumbering man.

After work had gone on for a couple of months, the Giant was almost complete. On viewing it, however, Hull was unhappy. Initially, the face of the giant statue looked just like George Hull's own! The sculptors had even given the Giant hair and a beard to match Hull's. The stoneworkers could not be blamed. After all, this rather strange, secretive man had requested that they create a statue of a giant, naked, recumbent man—not the usual kind of request.

Obviously, it would not satisfy Hull's plan to have the Giant bear any resemblance whatsoever to its creator. It would not have been very convenient if any of the Giant's investigators had noticed the rather astonishing similarity between the face of the petrified man and that of Stub Newell's mysterious cousin.

But all was not lost. Hull first had the sculptors remove the hair on the head and face. However, he still was unsatisfied. He next got some blocks of wood into which he hammered a bunch of darning or knitting needles so that their points stuck out of the faces of the blocks. Hull proceeded to pound on the Giant with these blocks. You can imagine the expression on the faces of the sculptors, seeing this madman attack the artistic creation he had just paid them to produce. Hull liked the effect though; it gave the surface of the statue the porelike appearance of skin. As if this weren't enough, Hull next rubbed acid all over the sculpture, which further reinforced its ancient appearance.

After all this, Hull finally was satisfied. The Giant now looked nothing like him. Better still, it looked very old. The scene at last was set for the great archaeological fraud.

Hull had the Giant shipped in a wooden box by railroad to Union, New York. In November 1868 it was finally brought by wagon to his cousin Stub Newell's farm and secretly buried behind the barn (with Newell's knowledge and cooperation). To make certain that no one would connect the shipment with the discovery of the Giant, it was left to lie in the ground for about a year—nearly the exact length of time geologist J. F. Boynton had suggested. Then, according to plan, nearly twelve months later, Hull instructed Newell to hire a crew of men to dig a well where they were both very much aware that the Giant would be discovered. The rest is embarrassing history. It should finally be pointed out that it was apparently Newell's bragging to friends and relatives about the fraud that induced Hull to come clean before the whole thing blew up in their faces.

The other owners of the Giant, the businessmen of Syracuse who were benefiting from the Giant's presence, and the ministers who had included reference to the Giant's discovery in their Sunday sermons were not pleased by Hull's revelations. It did not seem likely that people were going to go out of their way and pay to see a gypsum statue that was $1\frac{1}{2}$ years old. Beyond this, religious support for a fraud could damage the credibility of the religious leaders involved.

The syndicate of owners initially tried to quash the confession or at least discredit it. They claimed that Hull had been put up to it by the people of the surrounding towns because they were jealous of the discovery in Cardiff and the successful exploitation of it by Syracuse. But Hull's story was too detailed and reasonable to ignore. When the sculptors in Chicago came forward to verify Hull's confession, the Giant's days as a major tourist attraction were at an end.

The End of the Giant

The Giant's demise was not without its ironies. After P. T. Barnum had been turned down in his initial attempt to purchase the Giant, he simply went out and had a plaster duplicate made. He even billed the statue as the "real"

Cardiff Giant. In other words, Barnum was charging people to see the Cardiff Giant, but his Cardiff Giant was a fake; it was, put bluntly, a fake of a fake! After revenues dropped as a result of the Hull confession, the owners of the "real" fake took the Giant on the road, hoping to drum up some business and maybe even turn the whole fiasco of the confession to their advantage (Figure 3.4). Coincidentally, the real fake and Barnum's fake of the fake were both displayed at the same time in New York City—and Barnum's copy outdrew the real Cardiff Giant.

Mark Twain was so amused by the whole mess that he wrote a short story about it. "A Ghost Story" concerns a man who takes a room at a hotel in New York City and is then terrorized by the ghost of a poor, tormented, giant man. The ghost turns out to be, in fact, the spirit of the Cardiff Giant. The Giant's soul has been condemned to wander the earth until his physical remains are once again laid to rest. He nightly wanders the halls of the hotel as his fossilized body is cruelly displayed in the exhibit hall across the street. But, as luck would have it, the poor tormented soul of the Giant has made a grievous error. As the hotel resident informed him, "Why you poor blundering old fossil, you have had all your trouble for nothing—you have been haunting a plaster cast of yourself." The ghost of the poor Giant was haunting Barnum's fake. Even he was fooled.

Why Did They Do It?

The motive for the perpetration of the Cardiff Giant fraud was, of course, money. George Hull and Stub Newell made far more money displaying the Giant than they ever could have through selling cigars or farming—their usual professions. Money continued to motivate those who benefited from the Giant but who played no part in perpetrating the fraud in the first place. The businessmen of Syracuse grew rich as a result of the Giant, and a small town in rural New York was put on the map. We do not know if any in the syndicate of owners or if any of the other benefiting businessmen of Syracuse had questions about the authenticity of the Giant.

There also is an explanation for why people with no monetary investment wished to believe that the Cardiff Giant was genuine. Certainly, the religious element behind the public's desire to believe in the validity of the Giant cannot be overestimated. When publications in 1869 referred to the discovery as a "Goliath," they were not making a simple analogy; they were making a serious comparison between the Cardiff discovery and the biblical story of Goliath of Gotha.

Moreover, I would also include the romance of mystery as an explanation for why people chose to accept the Giant even though scientists who studied it declared it to be, at best, a statue and, at worst, a fraud. Whether the Giant lent proof to a biblical claim or not, perhaps it was the simple ro-

For a few days only. HIS DIMENSIONS. 10 feet, 4 1-2 inches. Length of Body, Length of Head from Chin to Top of Head, 21 Length of Nos3. Across the Nostrila. 3 1.2 5 Width of Mouth. Circumference of Neck. 37 Shoulders, from point to point, 3 feet, 1 1-2 Length of Right Arm, Across the Wrist. Across the Palm of Hand. 7 8 Length of Second Finger. 6 feet, 3 1-2 Around the Thighs. 13 Diameter of the Thigh, Through the Calf of Leg. 1-2 Length of Foot. 21 Across the Ball of Foot. 8 2990 pounds. Weight.

ALBANY. November 19th. 1969

THE GREAT

Figure 3.4 The Giant on tour. After serious questions were raised regarding the Giant's authenticity, the consortium of owners decided to take their show on the road. This handout advertised the Giant's appearance in Albany, New York, on November 29, 1869. (Courtesy of the New York State Historical Association, Cooperstown)

mance of such an amazing discovery that played at least a secondary role in convincing people to part with their hard-earned money to see what was clearly a gypsum statue.

The lesson of the Cardiff Giant is one that you will see repeated in this book. Trained observers such as professional scientists had viewed the Giant and pronounced it to be an impossibility, a statue, a clumsy fraud, and just plain silly. Such objective, rational, logical, and scientific conclusions, however, had little impact. A chord had been struck in the hearts and minds of many otherwise levelheaded people, and little could dissuade them from believing in the truth of the Giant. Their acceptance of the validity of the Giant was based on their desire, religious or not, to believe it.

Even today, many Creationists (see Chapter 11) claim that every word in the Bible is literally true. Just as many in previous centuries believed the literal, historical accuracy of biblical stories (including those of Adam and Eve, the Flood, and even giants), so do the modern Creationists. Their belief in biblical giants has led some to claim that they have discovered enormous "mantracks"—the alleged footprints of human giants from "before the Flood." Some go even further, claiming, for example, that the ancient skeleton of a man 11 feet 6 inches tall was found in Italy in 1856 (Baugh 1987). Of course, when the so-called footprints are examined scientifically (see Chapter

11), they turn out not to be human footprints at all. The evidence exists, apparently, only in the minds of the claimants; not a single bone has been provided as evidence for this claim.

Thus, belief in giants has not disappeared in the twentieth century, but has continued among this group of religious fundamentalists. As you will see in greater detail in Chapter 11, once again the desire to believe something that is clearly false has overridden rationality.

Finally, after laughing at all those silly people who in 1869 paid fifty cents to see the Giant, you can now all laugh at me; I recently paid several dollars to see him (along with a very fine museum). The poor, tortured Giant has at last found a final resting place at the Farmers' Museum in Cooperstown, New York. Finally the Giant has found his peace. Do I detect a hint of a smile on his face? I guess the Cardiff Giant has the last laugh after all (Figure 3.5).

→ CURRENT PERSPECTIVES &

Frauds

A clumsy fraud like the Cardiff Giant didn't fool scientists in the nineteenth century and certainly would fool no one today. But frauds related to the human past have greatly increased in sophistication since that time. Frauds frequently can no longer be detected by simple, visual inspection. Today, scientists may have to apply a broad arsenal of scientific and high-tech weapons in their assessment of questionable artifacts to determine whether they are authentic or fraudulent.

For example, when the *Holly Oak pendant* was discovered in the middle of the nineteenth century, many accepted its authenticity. That artifact, found in Delaware, appeared to be an incised drawing of a prehistoric woolly mammoth. It reminded many of the Paleolithic cave paintings and carvings of Europe of 20,000 years ago, convincing some of the existence of a similar—and similarly ancient—artistic tradition in North America.

More recently, however, the shell on which the drawing was made has been age-tested using the technique of *radiocarbon dating* (Griffin, Meltzer, and Smith 1988). In this procedure, the remains of once-living things (bones, wood, seeds, antlers, hide, nuts, shell) can be dated by reference to the amount of a radioactive isotope of carbon (carbon 14) left in the object. Carbon 14 decays at a regular, known rate and thus serves as a sort of atomic clock. It is quite useful to archaeologists when dating objects more than a few hundred and less than 50,000 years old.

The Holly Oak pendant, if genuine, should have dated to more than 10,000 years ago, since that is about the time that woolly mammoths became extinct—obviously, people would not have been drawing mammoths long

Figure 3.5 In silent repose, the Giant has at last found his eternal rest at the Farmers' Museum in Cooperstown, New York. (K. L. Feder)

after they had disappeared. In fact, the shell turned out to be only about 1,000 years old. The artifact was a fake, carved on an old piece of shell.

In later chapters a number of other famous, and some not so famous, archaeological and historical hoaxes will be discussed. Piltdown Man (Chapter 4), the Vinland Map (Chapter 6), the Davenport Tablets (Chapter 7), the giant "man-tracks" of the Paluxey River and the Shroud of Turin (Chapter 11) all have in common the fact that they were frauds perpetrated to fool people about some aspect of the past. They also have in common the fact that they were exposed by the application of the scientific method.

🖒 frequently asked questions 🍕

1. The Cardiff Giant was a hoax, but can a human body turn to stone?

No, not really. Wood cells are resilient enough, under the right circumstances, to preserve long enough for minerals to penetrate them, solidify, and take on their appearance. Bones, including human bones, can become mineralized in much the same way. Soft tissue—skin and muscle—simply is too soft for this process to work on it.

Best of the Web

CLICK HERE

http://www.cardiffgiant.com/cardiff.shtml

http://www.gazetteonline.com/history/gen001.htm

http://www.roadsideamerica.com/attract/NYCOOgiant.html

http://www.lhup.edu/~dsimanek/cardiff.htm

2. Can human bodies be preserved for long periods of time?

Yes, under the right, very rare circumstances, they can be preserved for thousands of years. The bodies of the so-called Bog People of Denmark were preserved for more than 3,000 years by moisture and a combination of natural chemicals in the peat in which they were buried. Also, natural mummification under very dry conditions (in either warm or very cold climates) has preserved bodies for millennia. Ancient bodies have been found in Greenland and in the higher elevations of the Andes in South America. Waterlogged human brain tissue was preserved for more than seven thousand years at the Windover site in Florida. The key to the preservation of animal (including human) bodies rests in keeping away those organisms that ordinarily would recycle them. Bacteria that eat dead flesh do not do well under very cold, very wet (waterlogged), or very dry conditions. Keep bacteria away and human bodies can preserve for millennia.

3. Whatever happened to Barnum's fake of the Cardiff Giant?

Barnum's copy has turned up and can be seen at Marvin's Marvelous Mechanical Museum in Farmington Hills, Michigan. Further, it turns out that there is a replica of Barnum's copy (making it a fake of a fake of a fake) at Circus World Museum in Baraboo, Wisconsin. I thought you might like to know.

→ Critical thinking exercise �

Which groups of people were immediate believers in the Cardiff Giant? On what did they base their acceptance of the "petrified man"? Which groups of people were immediately skeptical? On what did they base their skepticism? How can we explain the Giant's acceptance by the former groups and its rejection by the latter? What lessons in this story are applicable to other instances of frauds or hoaxes in science?

Dawson's Dawn Man: The Hoax at Piltdown

On a recent trip to England I visited the British Museum of Natural History in London. There I hoped to see the actual remains of "Piltdown Man," almost certainly the most famous fraud in the history of archaeology and human paleontology. The British Museum had been intimately involved with Piltdown Man from its discovery to its exposure as a hoax, and I knew the fossil was in their possession. So, rather naturally, I assumed that this most famous of frauds would be prominently displayed.

When I had trouble finding the fossil in a museum case, I approached a woman at the front desk, asking where I might see the Piltdown remains. "Oh, that is not on display sir," and went on to inform me, rather condescendingly, "It was all rubbish, you know." Well, I guess I knew that. It seems that the Piltdown Man fossil is a literal skeleton in the closet of prehistoric archaeology and human paleontology. (To be fair, it is brought out occasionally, as it was for an exhibit on archaeological fakes in 1990.)

This single specimen seemed to turn our understanding of human evolution on its head and certainly did turn the heads of not just a few of the world's most talented scientists. The story of Piltdown has been presented in detail by Ronald Millar in his 1972 book The Piltdown Men, by J. S. Weiner in his 1955 work The Piltdown Forgery, in 1986 by Charles Blinderman in The Piltdown Inquest, in 1990 by Frank Spencer in Piltdown: A Scientific Forgery, and most recently by John E. Walsh in 1996 in Unraveling Piltdown: The Science Fraud of the Century and Its Solution. The story is useful in its telling if only to show that even scientific observers can make mistakes. This is particularly the case when trained scientists are faced with that which they are not trained to detect—intellectual criminality. But let us begin before the beginning, before the discovery of the Piltdown fossil.

The Evolutionary Context

We need to turn the clock back to Europe of the late nineteenth and early twentieth centuries. The concept of evolution—the notion that all animal and plant forms seen in the modern world had descended or evolved from earlier, ancestral forms—had been debated by scientists for quite some time (Greene 1959). It was not until Charles Darwin's *On the Origin of Species* was published in 1859, however, that a viable mechanism for evolution was proposed and supported with an enormous body of data. Darwin had meticulously studied his subject, collecting evidence from all over the world for more than thirty years in support of his evolutionary mechanism called *natural selection*. Darwin's arguments were so well reasoned that most scientists soon became convinced of the explanatory power of his theory. Darwin went on to apply his general theory to humanity in *The Descent of Man*, published in 1871. This book was also enormously successful, and more thinkers came to accept the notion of human evolution.

Around the same time that Darwin was theorizing about the biological origin of humanity, discoveries were being made in Europe and Asia that seemed to support the concept of human evolution from ancestral forms. In 1856 workmen building a roadway in the Neander Valley of Germany came upon a piece of a remarkable-looking skull. Though just a "skull cap" lacking the face or jaws, it clearly was no ape, but it was no modern human either. Though no smaller than a modern human's, the top of the skull was much flatter, the bone was thicker and heavier, and there was a massive ridge of bone across the eyebrows of a size unseen in modern populations. Around the same time, other, similar-looking but more complete fossils were found in Belgium and Spain. As well as being flat and massive and bearing thick brow ridges, these skulls exhibited sloping foreheads and jutting, snoutlike faces, quite distinct from those of modern human beings. However, the postcranial bones (all the bones below the skull) of these fossils were similar to those of modern humans.

There was some initial confusion about how to label these specimens. Some scientists concluded that they simply represented pathological freaks. Rudolf Virchow, the world's preeminent anatomist, explained the curious bony ridges above the eyes as the result of "stupendous blows" to the foreheads of the creatures (Kennedy 1975). Eventually, however, scientists realized that these creatures, then and now called *Neandertals* after the Neander Valley, represented a primitive and ancient form of humanity.

The growing acceptance of Darwin's theory of evolution and the discovery of primitive-looking, though humanlike, fossils combined to radically shift people's opinions about human origins. In fact, the initial abhorrence many felt concerning the entire notion of human evolution from lower, more primitive forms was remarkably changed in just a few decades (Greene 1959). By the turn of the twentieth century, not only were many people comfortable

with the general concept of human evolution but there actually was also a feeling of national pride concerning the discovery of a human ancestor within one's borders.

The Germans could point to their Neandertal skeletons and claim that the first primitive human being was a German. The French could counter that their own Cro-Magnon—ancient, though not as old as the German Neandertals—was a more humanlike and advanced ancestor; therefore, the first true human was a Frenchman. Fossils had also been found in Belgium and Spain, so Belgians and Spaniards could claim for themselves a place within the story of human origin and development. Even so small a nation as Holland could lay claim to a place in human evolutionary history; in 1891 a Dutchman, Eugene Dubois, had discovered the fossilized remains of a primitive human ancestor in Java, a Dutch-owned colony in the western Pacific.

However, one great European nation did not and could not participate fully in the debate over the ultimate origins of humanity. That nation was England. Very simply, by the beginning of the second decade of the twentieth century, no fossils of human evolutionary significance had been located in England. This lack of fossils led French scientists to label English human paleontology mere "pebble-collecting" (Blinderman 1986).

The English, justifiably proud of their cultural heritage and cultural evolution, could point to no evidence that humanity had initially developed within their borders. The conclusion reached by most was completely unpalatable to the proud English—no one had evolved in England. The English must have originally arrived from somewhere else.

At the same time that the English were feeling like a people with no evolutionary roots of their own, many other Europeans were still uncomfortable with the fossil record as it stood in the first decade of the twentieth century. Although most were happy to have human fossils in their countries, they generally were not happy with what those fossils looked like and what their appearance implied about the course of human evolution.

Java Man (now placed in the category *Homo erectus* along with Peking Man), with its small cranium—its volume was about 900 cubic centimeters (cc), compared to a modern human average of about 1,450 cc—and large eyebrow ridges, seemed quite apelike (Figure 4.1). Neandertal Man, with his sloping forehead and thick, heavy brow ridges appeared to many to be quite ugly, stupid, and brutish. The skulls of these fossil types were clearly not those of apes, but they were equally clearly not fully human. In contrast, the femur (thigh bone) of Java Man seemed identical to the modern form. Although some emphasized what they perceived to be primitive characteristics of the postcranial skeleton of the Neandertals, this species clearly had walked on two feet; and apes do not.

All this evidence suggested that ancient human ancestors had primitive heads and, by implication, primitive brains, seated atop rather modern-looking bodies. This further implied that the human body evolved first,

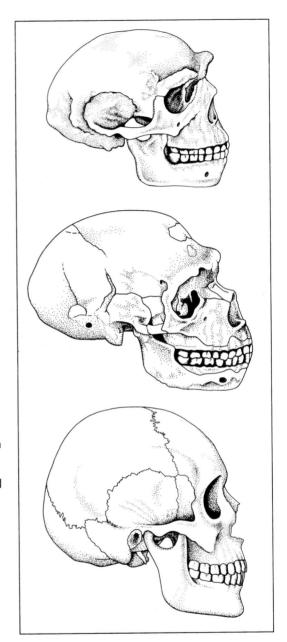

Figure 4.1 Drawings showing the general differences in skull size and form between Homo erectus (Peking man—500,000 years ago [top]), Neandertal Man (100,000 years ago [center]), and a modern human being (bottom). Note the large brow ridges and forward-thrusting faces of Homo erectus and Neandertal, the rounded outline of the modern skull, and the absence of a chin in earlier forms. (Carolyn Whyte)

followed only later by the development of the brain and associated human intelligence.

Such a picture was precisely the opposite of what many people had expected and hoped for (Feder 1990). After all, it was argued, it is intelligence that most clearly and absolutely differentiates humanity from the rest of the

animal kingdom. It is in our ability to think, to communicate, and to invent that we are most distant from our animal cousins. This being the case, it was assumed that such abilities must have been evolving the longest; in other words, the human brain and the ability to think must have evolved first. Thus, the argument went, the fossil evidence for evolution should show that the brain had expanded first, followed by the modernization of the body.

Such a view is exemplified in the writings of anatomist Grafton Elliot Smith. Smith said that what most characterized human evolution must have been the "steady and uniform development of the brain along a well-defined course" (as quoted in Blinderman 1986:36). Arthur Smith Woodward, ichthyologist and paleontologist at the British Museum of Natural History, later characterized the human brain as "the most complex mechanism in existence. The growth of the brain preceded the refinement of the features and of the somatic characters in general" (Dawson and Woodward 1913).

Put most simply, many researchers in evolution were looking for fossil evidence of a creature with the body of an ape and the brain of a human being. What was being discovered, however, was the reverse; both Java and Neandertal Man seemed more to represent creatures with apelike, or certainly not humanlike, brains but with humanlike bodies. Many were uncomfortable with such a picture.

A Remarkable Discovery in Sussex

Thus was the stage set for the initially rather innocuous announcement that appeared in the British science journal *Nature* (News, December 5, 1912), concerning a fossil find in the Piltdown section of Sussex in southern England. The notice read, in part:

Remains of a human skull and mandible, considered to belong to the early Pleistocene period, have been discovered by Mr. Charles Dawson in a gravel-deposit in the basin of the River Ouse, north of Lewes, Sussex. Much interest has been aroused in the specimen owing to the exactitude with which its geological age is said to have been fixed. (p. 390)

In *Nature* two weeks later (Paleolithic Man, December 19, 1912), further details were provided concerning the important find:

The fossil human skull and mandible to be described by Mr. Charles Dawson and Dr. Arthur Smith Woodward at the Geological Society as we go to press is the most important discovery of its kind hitherto made in England. The specimen was found in circumstances which seem to leave no doubt of its geological age, and the characters it shows are themselves sufficient to denote its extreme antiquity. (p. 438)

According to the story later told by those principally involved, in February 1912 Arthur Smith Woodward at the British Museum received a letter

Figure 4.2 Drawn reconstruction of the Piltdown skull. The portion of the skull actually recovered is shaded. As reconstructed, the cranium shows hominid (human) traits and the mandible shows pongid (ape) traits. Compare this drawing to those in Figure 4.1. With its humanlike head and apelike iaw, the overall appearance of the Piltdown fossil is far different from Homo erectus. Neandertal, or modern humans. (From Essays on the Evolution of Man, Grafton Elliot Smith, Oxford University Press)

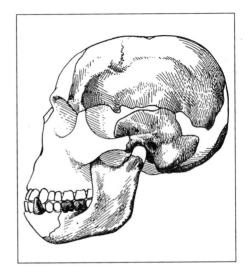

from Charles Dawson, a Sussex lawyer and an amateur scientist. Woodward had previously worked with Dawson and knew him to be an extremely intelligent man with a keen interest in natural history. Dawson informed Woodward in the letter that he had come upon several fragments of a fossil human skull. The first piece had been discovered in 1908 by workers near the Barcombe Mills manor in the Piltdown region of Sussex, England. In 1911, a number of other pieces of the skull came to light in the same pit, along with a fossil animal bone and tooth.

In the letter to Woodward, Dawson expressed some excitement over the discovery and claimed to Woodward that the find was quite important and might even surpass the significance of Heidelberg Man, an important specimen found in Germany just the previous year.

Because of bad weather, Woodward was not immediately able to visit Piltdown. Dawson, undaunted, continued to work in the pit, finding fossil hippo and elephant teeth. Finally, in May 1912, he brought the fossil to Woodward at the museum. What Woodward saw was a skull that matched his own expectations and those of many others concerning what a human ancestor should look like. The skull, stained a dark brown from apparent age, seemed to be modern in many of its characteristics. The thickness of the bones of the skull, however, argued for a certain primitiveness. The association of the skull fragments with the bones of extinct animals implied that an ancient human ancestor indeed had inhabited England. By itself this was enormous news; at long last England had a human fossil (Figure 4.2).

Things were to get even more exciting for English paleontologists. On June 2, 1912, Woodward arrived at Piltdown and together with Dawson and Pierre Teilhard de Chardin—a Jesuit priest with a great interest in geology, paleontology, and evolution whom Dawson had met in 1909—visited the

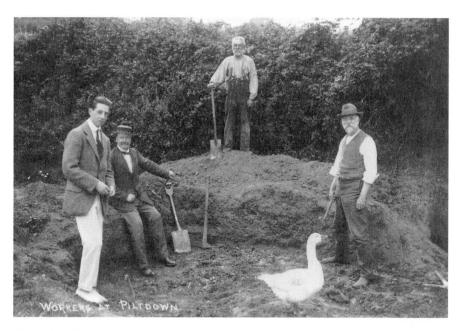

Figure 4.3 Paleontological excavations proceed at Piltdown. From left to right: Robert Kenward Jr., a tenant of Barcombe Mills Manor; Charles Dawson; workman Venus Hargreaves; the goose "Chipper"; and Arthur Smith Woodward. (From the Archives of the British Museum [Natural History])

site of the fossil discovery. Along with a workman, the three excavated unsuccessfully for several hours when, at last, Dawson found another fragment of the skull. Very soon thereafter, Teilhard recovered an elephant tooth.

Woodward was so impressed by their success that he decided to spend the remainder of his summer weekends at Piltdown, excavating alongside Dawson (Figure 4.3). Though work went slowly, in the ensuing weeks the pair found four large pieces of the cranium, along with some possible stone tools, animal teeth, and a fossilized deer antler. The apparent age of the fossils based on comparisons to other sites indicated not only that Piltdown was the earliest human fossil in England but also that, at an estimated age of 500,000 years, the Piltdown fossil represented potentially the oldest known human ancestor in the world.

Then, to add to the excitement, Dawson discovered half of the mandible. Though two key areas—the chin and the condyle, where the jaw connects to the skull—were missing, the preserved part did not look anything like a human jaw. The upright portion or *ramus* was too wide, and the bone was too thick. In fact, the jaw looked remarkably like that of an ape (Figure 4.4). Nonetheless, and quite significantly, the two intact molar teeth exhibited humanlike wear. The human jaw, lacking the large canines of apes, is free to move from side to side while chewing. The molars can grind in a sideways

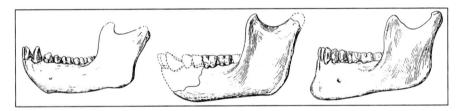

Figure 4.4 Comparison of the mandibles (lower jaws) of a young chimpanzee (left), modern human (right), and Piltdown (center). Note how much more similar the Piltdown mandible is to that of the chimp, particularly in the form of the reconstructed chin. The presence of a chin is a uniquely human trait. (From Dawson and Woodward, 1913, The Geological Society of London)

motion in a manner impossible in monkeys or apes. The wear on human molars is, therefore, quite distinct from that of other primates. The Piltdown molars exhibited humanlike wear in a jaw that was otherwise entirely apelike.

That the skull and the jaw had been found close together in the same geologically ancient deposit seemed to argue for the obvious conclusion that they belonged to the same ancient creature. But what kind of creature could it have been? There were no large brow ridges like those of Iava or Neandertal Man. The face was interpreted as having been flat as in modern humans and not snoutlike as in the Neandertals. The profile of the cranium was round as it is in modern humans, not flattened as it appeared to be in the lava and Neandertal specimens (see Figures 4.1 and 4.2). According to Woodward, the size of the skull indicated a cranial capacity or brain size of about 1,070 cc (Dawson and Woodward 1913), much larger than Java Man and within the lower range of modern humanity. Anatomist Arthur Keith (1913) suggested that the capacity of the skull was actually much larger, as much as 1,500 cc, placing it close to the modern mean. But the jaw, as described above, was entirely apelike. Therefore, although only two molar teeth were recovered initially. Woodward reconstructed the Piltdown jaw with large, projecting canine teeth, similar to those of the apes.

The conclusion drawn first by Dawson, the discoverer, and then by Woodward, the professional scientist, was that the Piltdown fossil—called *Eoanthropus dawsoni*, meaning Dawson's Dawn Man—was the single most important fossil find yet made anywhere in the world. Concerning the Piltdown discovery, the *New York Times* headline of December 19, 1912, proclaimed "Paleolithic Skull Is a Missing Link." Three days later the *Times* headline read "Darwin Theory Is Proved True."

The implications were clear. Piltdown Man, with its modern skull, primitive jaw, and great age, was the evidence many human paleontologists had been searching for: an ancient man with a large brain, a modern-looking head, and primitive characteristics below the important brain. An anatomist G. E. Smith summarized it:

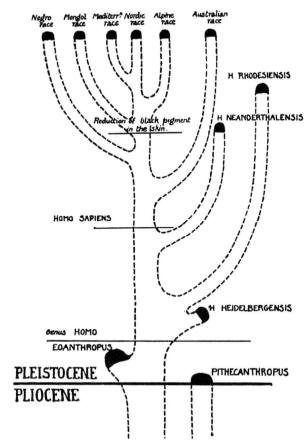

Figure 4.5 Among its supporters, Eoanthropus (Piltdown Man) was seen as more directly ancestral to modern humanity than either Homo erectus-here labeled Pithecanthropus and depicted as an entirely separate evolutionary pathway-or Neandertal, shown here as a short-lived diversion off the main branch of human evolution. (From Essays on the Evolution of Man, Grafton Elliot Smith, Oxford University Press)

The brain attained what may be termed the human rank when the jaws and face, and no doubt the body also, still retained much of the uncouthness of Man's simian ancestors. In other words, Man at first, so far as his general appearance and "build" are concerned, was merely an Ape with an overgrown brain. The importance of the Piltdown skull lies in the fact that it affords tangible confirmation of these inferences. (Smith 1927:105–6)

If Piltdown were the evolutionary "missing link" between apes and people, then neither Neandertal nor Java Man could be. Because Piltdown and Java Man lived at approximately the same time, Java might have been a more primitive offshoot of humanity that had become extinct. As Neandertal was much more recent than Piltdown, yet looked more primitive where it really counted (that is, the head), Neandertal must have represented some sort of primitive throwback, an evolutionary anachronism (Figure 4.5).

By paleontological standards the implications were breathtaking. In one sweeping blow Piltdown had presented England with its first ancestral

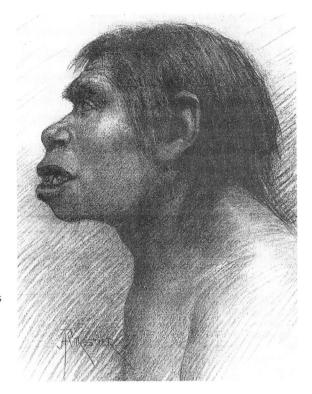

Figure 4.6 Artist's conception of Piltdown Man. Note how the illustrator has depicted the lower part of the face, with jaw thrust forward, just like an ape. (From the *Illustrated London News*, January 11, 1913, New York edition)

human fossil, it had shown that human fossils found elsewhere in the world were either primitive evolutionary offshoots or later throwbacks to a more primitive type, and it had forced the rewriting of the entire story of human evolution. Many paleontologists, especially those in England, were enthralled by the discovery in Sussex. An artist's conception of "the first Englishman" was published in a popular weekly magazine, *The Illustrated London News* (Figure 4.6).

In March 1913, Dawson and Woodward published the first detailed account of the characteristics and evolutionary implications of the Piltdown fossil. In their discussion they repeatedly pointed out the modern characteristics of the skull and the simian appearance of the mandible. Their comments regarding the modernity of the skull and the apelike characteristics of the jaw, as you will see, turned out to be accurate in a way that few suspected at the time.

Additional discoveries were made at Piltdown. In 1913 a right canine tooth apparently belonging to the jaw was discovered by Teilhard de Chardin. It matched almost exactly the canine that had previously been proposed by Woodward for the Piltdown skull and that appeared in the reconstruction produced at the British Museum of Natural History. Its apelike form and wear

were precisely what had been expected: "If a comparative anatomist were fitting out *Eoanthropus* with a set of canines, he could not ask for anything more suitable than the tooth in question," stated Yale University professor George Grant MacCurdy (1914:159).

Additional artifacts, including a large bone implement, were found in 1914. Then, in January of 1915, Dawson wrote Woodward announcing spectacular evidence confirming the first discovery; fragments of another fossil human skull were found on Netherhall Farm, about two miles from Piltdown. This skull, dubbed Piltdown II, looked just like the first with a rounded profile and thick cranial bones. Though no jaw was discovered, a molar recovered at the site bore a similar pattern of wear as that seen in the first specimen.

Dawson died in 1916 and, in part due to a serious illness suffered by his own son, Woodward held back announcement of the second discovery until the following year. When the existence of a second specimen became known, many of those skeptical after the discovery of the first Piltdown fossil became supporters. As Henry Fairfield Osborn, president of the American Museum of Natural History, suggested:

If there is a Providence hanging over the affairs of prehistoric man, it certainly manifested itself in this case, because the three minute fragments of this second Piltdown man found by Dawson are exactly those which we should have selected to confirm the comparison with the original type. (1921:581)

The Piltdown Enigma

There was no unanimity of opinion, however, concerning the significance of the Piltdown discoveries. The cranium was so humanlike and the jaw so apelike that some scientists maintained that they simply were the fossils of two different creatures; the skeptics suggested that the association of the human cranium and the ape jaw was entirely coincidental. Gerrit S. Miller Jr. (1915) of the Smithsonian Institution conducted a detailed analysis of casts of Piltdown I and concluded that the jaw was certainly that of an ape (see Figure 4.4). Many other scientists in the United States and Europe agreed. Anatomy professor David Waterston (1913) at the University of London, King's College, thought the mandible was that of a chimpanzee. The very well-known German scientist Franz Weidenreich concluded that Piltdown I was "the artificial combination of fragments of a modern-human braincase with an orangutan-like mandible and teeth" (1943:273).

Though some viewed the combination of a humanlike cranium and an apelike jaw as "an improbable monster" (Spencer 1990:113), the only other possibility being considered seemed even more improbable. As anatomist Grafton Elliot Smith put it:

This [other possibility] would involve the supposition that a hitherto unknown and extremely primitive ape-man, and an equally unknown manlike ape, died on the same spot, and that one of them left his skull without the jaw and the other his jaw without the skull. (in Spencer 1990:101)

This seemed a strong argument against the hypothesis that Piltdown represented the accidental and coincidental discovery in precisely the same place of the remains of more than one creature.

Coincidentally or not, after Dawson's death no further discoveries were made in either the Piltdown I or II localities. Elsewhere in the world, however, human paleontology became an increasingly exciting and fruitful endeavor. Beginning in the late 1920s as many as forty individuals of a species now called *Homo erectus* were unearthed at Zhoukoudian, a cave near Beijing in China (see Figure 4.1). Ironically, Davidson Black, anatomist at the Peking Union Medical College, who was instrumental in obtaining financial support for the excavation, had visited Grafton Elliot Smith's laboratory in 1914 and had become fascinated by the Piltdown find (Shapiro 1974). Further, Teilhard participated in the excavation at the cave. The Zhoukoudian fossils were estimated to be one-half million years old. Also, on Java, another large group of fossils (close to twenty) were found at Sangiran; these were similar to those from Zhoukoudian.

Also in the 1920s, in Africa, the discovery was made of a fossil given the name *Australopithecus africanus*. It was initially estimated to be more than one million years old. In the 1930s and 1940s additional finds of this and other varieties of *Australopithecus* were made. In Europe the number of Neandertal specimens kept increasing; and even in England, in 1935, a fossil human ancestor was discovered at a place called Swanscombe.

Unfortunately for *Eoanthropus*, all of these discoveries seemed to contradict its validity. The Chinese and Sangiran *Homo erectus* evidence pointed to a fossil ancestor with a humanlike body and a primitive head; these specimens were similar to Java Man in appearance (Java Man is also now considered to belong to the species *Homo erectus*), possessing large brow ridges, a flat skull, and a thrust-forward face while being quite modern from the neck down. Even the much older australopithecines showed clear evidence of walking on two feet; their skeletons were remarkably humanlike from the neck down, though their heads were quite apelike. Together, both of these species seemed to confirm the notion that human beings began their evolutionary history as upright apes, not as apelike people. *Eoanthropus* seemed more and more to be the evolutionary "odd man out."

How could Piltdown be explained in light of the new fossil evidence from China, Java, Europe, and Africa? Either Piltdown was the one, true human ancestor, rendering all the manifold other discoveries members of extinct offshoots of the main line of human evolution, or else Piltdown was the remarkable coincidental find of the only known ape fossil in England within a few feet of a rather modern human skull that seemed to date back 500,000 years. Neither explanation sat well with many people.

Unmasking the Hoax

This sort of confusion characterized the status of Piltdown until 1949, when a newly rediscovered dating procedure was applied to the fossil. A measurement was made of the amount of the element fluorine in the bones. This was known to be a relative measure of the amount of time bone had been in the ground. Bones pick up fluorine in groundwater; the longer they have been buried, the more fluorine they have. Interestingly, Woodward knew of such a technique and, in fact, championed its use in a number of other cases. Woodward would not allow its use in this instance, however.

Kenneth Oakley of the British Museum of Natural History conducted the test. The fossil animal bones from the site showed varying amounts of fluorine, but they exhibited as much as ten times more than did either the cranium or the jaw of the fossil human. Piltdown Man, Oakley concluded, based on comparison to fluorine concentrations in bones at other sites in England, was no more than 50,000 years old (Oakley and Weiner 1955).

Although this cast Piltdown in a new light, the implications were just as mysterious; what was a fossil human doing with an entirely apelike jaw at a date as recent as 50,000 years ago? Then, in 1953, a more precise test was applied to larger samples of the cranium and the jaw. The results were conclusive; the skull and jaw were of entirely different ages. The cranium possessed 0.10 percent fluorine, the mandible less than 0.03 percent (Oakley 1976). The inevitable conclusion was reached that the skull and the jaw must have belonged to two different creatures.

As a result of this determination, a detailed reexamination of the fossil was conducted, and the sad truth was finally revealed. The entire thing had been a hoax. The skull was that of a modern human being. Its appearance of age was due, at least in part, to its having been artificially chemically stained. It has been suggested that the thickness of the bone may have been due to a pathological condition (Spencer 1984) or the result of a chemical treatment that had been applied, perhaps to make it appear older than it was (Montague 1960).

Those scientific supporters of *Eoanthropus* who previously had pointed out the apelike character of the jaw were more right than they could have imagined; it was, indeed, an ape jaw, probably that of an orangutan. When Gerrit Miller of the Smithsonian Institution had commented on the broken condyle of the mandible by saying, "Deliberate malice could hardly have been more successful than the hazards of deposition in so breaking the fossils as to give free scope to individual judgement in fitting the parts together" (1915:1), he was using a literary device and not suggesting that anyone had purposely broken the jaw. But that is likely precisely what happened. An

ape's jaw could never articulate with the base of a human skull, and so the area of connection had to be removed to give "free scope" to researchers to hypothesize how the cranium and the jaw went together. Otherwise the hoax would never have succeeded. Beyond this, the molars had been filed down to artificially create the humanlike wear pattern. The canine tooth had been stained with an artist's pigment and filed down to simulate human wear; the pulp cavity had been filled with a substance not unlike chewing gum.

It was further determined that at least one of the fragments of the Pilt-down II skull was simply another piece of the first one. Oakley (1976) further concluded that all the other paleontological specimens had been planted at the site; some were probably found in England, but others had likely originated as far away as Malta and Tunisia. Some of the ostensible bone artifacts had been carved with a metal knife.

The verdict was clear; as Weidenreich (1943) put it, Piltdown was like the chimera of Greek mythology—a monstrous combination of different creatures. The question of Piltdown's place in human evolution had been answered; it had no place. That left still open two important questions: Who did it, and why?

Whodunnit?

The most succinct answer to the question "whodunnit?" is "No one knows." Many of those directly involved with the discoveries made at Piltdown or the analysis of the fossils—and even some who were very indirectly connected to the site—have been accused as perpetrators or co-conspirators in the hoax (Figure 4.7). Tobias (1992) lists twenty-one possible suspects. We can assess the cases against some of the more likely of them.

Suspect: Charles Dawson

Charles Dawson is an obvious suspect. He is the only person who was present at every discovery, including Piltdown II. Also, it should be mentioned that Dawson served as Steward on both Barcombe Mills Manor, where Piltdown I was discovered, and Netherhall Farm, the site of Piltdown II, so he had access to and familiarity with both locations of "discovery." This circumstantial evidence alone strongly implicates Dawson in the hoax. It would have required incredible luck for someone else to have planted the bones and, both times, to have Dawson find them. Dawson's motive may have been rooted in his desire for acceptance within the scientific community. He certainly gained notoriety; even the species name is *dawsoni*.

Beyond this, Dawson did indeed stain the bones with potassium dichromate. This gave the bones a more antique appearance. This is not a smoking gun, however, because such staining was widespread in the early

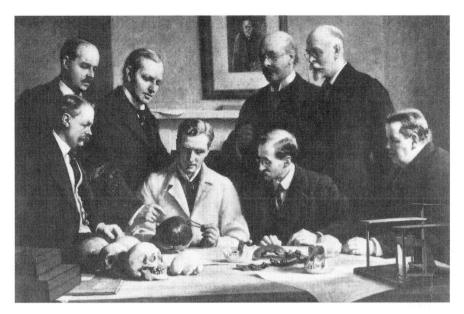

Figure 4.7 Portrait of scientists examining a number of specimens including *Eoanthropus* in 1915. From right to left, standing: A. S. Woodward, Charles Dawson, G. E. Smith, and F. O. Barlowe; from right to left, seated: E. R. Lankester, W. P. Pycraft, A. Keith, and A. S. Underwood. (From the Archives of the British Museum [Natural History])

twentieth century. It was thought that this chemical helped preserve fossil bone, and Dawson was quite open about having stained the Piltdown specimens. Nevertheless, Dawson claimed that the bones were already ironstained when he found them, indicating either that someone else had already stained the bones to make them look old and then planted them for Dawson to find or that Dawson was lying, hoping to convince skeptics that the bones were really very old.

It seems unlikely that Dawson was merely a "useful idiot" who some professional scientist exploited by having him find bones the professional had planted. Dawson almost certainly was involved, but questions remain concerning the amateur Dawson's ability to fashion a paleontological hoax that would successfully fool so many scientists. And where would Dawson have obtained an orangutan jaw, or even an extremely thick-boned human skull? Dawson must have had a co-conspirator with the motive and the ability to pull it off. But who?

Suspect: Arthur Smith Woodward

Arthur Smith Woodward possessed the opportunity and the expertise to pull off the fraud. Certainly he was the scientist most intimately involved with Piltdown, co-announcing its discovery, co-authoring the first scientific publication describing the find, and participating in the discovery of additional materials in later excavations at the site. His association with Dawson, who was present at every Piltdown discovery, can be traced for thirty years before Piltdown. Nevertheless, the likelihood that Woodward was a coconspirator in the hoax has been downplayed by most of those who have written about it (including me in previous editions of this book).

Recently, however, a strong circumstantial case against Woodward has been presented by biological anthropologist Gerrell Drawhorn (1994). He points out that Woodward may be directly connected to at least some of the fraudulent specimens recovered at the site, including several of the animal bones that were salted there. Drawhorn goes on to suggest a possible source for the cranial fragments that also implicates Woodward. Woodward had obtained, for the British Museum of Natural History, skulls of Ona Indians of Patagonia located in South America. Interestingly, remember that one presumably primitive trait displayed by the Piltdown skull was the extreme thickness of the bone. This bone thickening is a very rare trait in almost all recent human populations. But there is an exception; it is fairly common among the Ona Indians.

Why might Woodward have done it? It may have been done for notoriety. Woodward was an ichthyologist, well-respected among his peers as an expert in fossil fish. He hoped to become director of the British Museum of Natural History and may have felt that public as well as professional recognition was necessary to obtain the post. His involvement in the discovery and analysis of an extremely significant human fossil certainly provided a boost to his career and gave him the public recognition he may have felt he needed.

There are, as yet, no smoking guns proving that Woodward was involved. Nevertheless, Drawhorn's case seems at least as strong as—and perhaps quite a bit stronger than—the cases presented against most of the other suspects.

Suspect: Pierre Teilhard de Chardin

Pierre Teilhard de Chardin has come under scrutiny as well, most recently by Harvard paleontologist and chronicler of science, Stephen Jay Gould (1980). Teilhard is a reasonable suspect as he was present during many of the key discoveries at Piltdown. It is also the case, as Gould points out, that Teilhard's later reconstruction of the chronology of his involvement with Piltdown was suspicious; at one point he asserted that he had seen the remains of Piltdown II and had been taken to the site in 1913, which was two years before Dawson supposedly found them. It is also somewhat perplexing that, after the hoax was unmasked toward the end of his life, Teilhard became increasingly reluctant to comment on the entire affair or to clarify his role in it.

But the evidence implicating Teilhard is weak. When, late in life, he maintained that Dawson had taken him to the Piltdown II site, he may have been confusing it with another site with fossil material Dawson did take him to in 1913. Furthermore, he steadfastly defended Dawson and Woodward when they were accused as being the hoaxers; he wrote world-renowned paleoanthropologist Louis Leakey, "I know who was responsible for the Piltdown hoax and it was not Charles Dawson" (cited in Tobias 1992:247). If he were guilty, he would be eager to see someone else take the blame for the fraud.

The mere facts that Teilhard mentioned Piltdown but little in his later writings on evolution and was confused about the precise chronology of discoveries in the pit do not add up to a convincing case.

Suspect: Sir Arthur Keith

Anatomist Arthur Keith has been accused of participation in the hoax (Spencer 1990; Tobias 1992). According to Keith's own diary, on December 16, 1912, he had written an anonymous article describing events at Piltdown for the *British Medical Journal*. Curiously, this was two days *before* some of the events discussed took place (Spencer 1990:189). Also, the article contained information that, ostensibly, no one but Woodward, Dawson, and the hoaxer could have known. Further, Keith knew or at least had met Dawson before he told people he did, and later he destroyed his correspondence with Dawson.

This may show that Keith was guilty of obtaining additional information about the discovery from someone else (perhaps one of the workers at the excavation) and then of publishing it, but it is not substantial evidence of participation in the hoax. The rest seems attributable to a faulty memory and an innocent mistake in recording a date in a personal log. Again, there is no direct evidence of involvement.

Further, Keith's subsequent criticism of Woodward's reconstruction of the skull and his advocacy of a change in the fossil's designation from *Eoanthropus dawsoni* to *Homo piltdownensis* seem odd because the hoaxer would logically wish to distance himself from the entire affair, not thrust himself into the middle of it. Finally, Keith insistently disputed the apelike nature of the jaw, which makes no sense if he was the hoaxer, because it was, after all, an ape's jaw that was planted. The evidence implicating Keith is weak.

Suspect: Martin A. C. Hinton

Martin Hinton was a curator of zoology at the Natural History Museum in London. Hinton had worked under Arthur Smith Woodward at the time of the hoax, and some have claimed that before the Piltdown affair they had a falling out about payment for some work Hinton had done at the museum.

So, conceivably, Hinton may have had a motive for embarrassing Smith Woodward.

More important, some have pointed to what they consider to be a "smoking gun" with Hinton's fingerprints—a trunk found at the museum in the mid-1970s bearing Hinton's initials (Gee 1996). The trunk contained an assemblage of fossil hippopotamus and elephant teeth stained and carved in a fashion similar to the fake animal fossils found with Piltdown Man. In fact, the proportions of chemicals that had been used in staining the bones found in Hinton's trunk were the same as those used to make the Piltdown specimens look old.

However, there is no evidence that Hinton had been to Piltdown before Dawson's discovery, so there is no direct evidence of his having any opportunity to plant the bones. Beyond this, if Hinton played this trick to get back at some perceived slight on the part of Smith Woodward, (1) why would he plant bones at Piltdown, (2) how would he know that anyone would find them, (3) how would he know that the person who found them would know they were significant, and (4) how would he know that this person would take them to Smith Woodward? Hinton certainly is a viable suspect, but there does not appear to be definitive proof of his guilt.

Suspect: Sir Grafton Elliot Smith

The evidence for involvement by G. E. Smith in the hoax is slim, and all of it is circumstantial. Smith was born in Australia, and his arrival in England was followed relatively quickly by the appearance of the Piltdown skull; thus, a connection has been suggested. In Australia, he was involved in the debate over a controversial skull found there. Smith emphasized the primitive features of the so-called Talgai skull and viewed it as an extremely ancient and primitive representative of the human race. He was a supporter of Woodward's interpretation of Piltdown and, in fact, cited the Talgai skull in the debate. But Smith did not visit the Piltdown location until 1915–16 and would have had no opportunity to have planted the fossils. Similarly, he would have had no motive for doing so, save to support his fundamental perspective of human evolution. His view of the temporal priority of brain expansion in human evolution was similar to that of many of his colleagues, so this in no way distinguishes Smith from a multitude of scientists who welcomed the implications of Piltdown, but who had nothing to do with the hoax itself.

Suspect: W. J. Sollas

W. J. Sollas, a geology professor at Oxford and a strong supporter of Piltdown, has been accused from beyond the grave. In 1978, a tape-recorded

statement made before his death by J. A. Douglass, who had worked in Sollas's lab for some thirty years, was made public. The only evidence provided is Douglass's testimony that on one occasion he came across a package containing the fossil-staining agent potassium bichromate in the lab—certainly not the kind of evidence needed to convince a jury to convict.

Suspect: Lewis Abbott

Blinderman (1986) argues that Lewis Abbott, another amateur scientist and artifact collector, is the most likely perpetrator. He had an enormous ego and felt slighted by professional scientists. He claimed to have been the one who directed Dawson to the pit at Piltdown and may even have been with Dawson when Piltdown II was discovered (Dawson said only that he had been with a friend when the bones were found). Abbott knew how to make stone tools and so was capable of forging those found at Piltdown. Again, however, the evidence, though tantalizing, includes no "smoking gun."

Suspect: Sir Arthur Conan Doyle

Even Sir Arthur Conan Doyle has come under the scrutiny of would-be Piltdown detectives. Doyle lived near Piltdown and is known to have visited the site at least once. This provides him with the opportunity, but what would have been his motive to perpetrate the hoax?

Ironically, though Doyle was the creator of Sherlock Holmes, possessor of the most logical, rational mind in literature, Doyle himself was quite credulous when it came to spiritualism. He became an ardent supporter of two young English girls who claimed that fairies regularly visited their garden. They even concocted some outrageously bad photographs to prove their point, and Doyle accepted these obvious fakes without reservation. The movie *Fairy Tale: A True Story* is a fanciful version of this.

One of Doyle's chief critics in this arena was British anatomist and zoologist Ray Lankester. Lankester had been for some time publicly contemptuous of Doyle's belief in spirits and fairies. If Doyle were truly involved in the Piltdown hoax, Lankester would have been one obvious target. In this scenario, Doyle crafted the hoax hoping that Lankester would fall for it, and then be humiliated when Doyle revealed that it was all a fraud.

But this is all quite a stretch; after all, how would Doyle know that Lankester would become deeply involved in Piltdown? In fact, Lankester was not one of the key researchers; he was a follower, not a leader, at Piltdown, becoming a supporter of Woodward's interpretation of *Eoanthropus*. Finally, there is no direct evidence to implicate Doyle. In the final analysis, he is an unlikely suspect.

The Lesson of Piltdown

If the Piltdown tale were a detective mystery, the question of "whodunnit" would be at the core of the story. However, in his review of Frank Spencer's book accusing Sir Arthur Keith, British prehistorian Christopher Chippindale (1990) has expressed the opinion of many anthropologists in his title: *Piltdown: Who Dunit? Who Cares?* Chippindale doubts that definitive evidence of anyone's guilt exists and suggests that this is beside the point anyway.

Of far greater significance is the reason for Piltdown's acceptance by such a broad group of scientists. Piltdown provided validation for a preferred view of human evolution, one in which the development of the brain preceded all other aspects of human evolution. The hoaxer may never be known, but we do know that he or they almost certainly crafted the fraud to conform to this "brain-centered" perspective of human evolution. He or they gave people a fossil they would want to accept, and many fell into their trap.

A definitive answer to the question "whodunnit" may never be forth-coming. The lesson in Piltdown, though, is clear. Unlike the case for the Cardiff Giant where scientists were not fooled, here many were convinced by what appears to be, in hindsight, an inelegant fake. It shows quite clearly that scientists, though striving to be objective observers and explainers of the world around them, are, in the end, human. Many accepted the Piltdown evidence because they wished to—it supported a more comfortable view of human evolution. Furthermore, perhaps out of naivete, they could not even conceive that a fellow thinker about human origins would wish to trick them; the possibility that Piltdown was a fraud probably occurred to few, if any, of them.

Nevertheless, the Piltdown story, rather than being a black mark against science, instead shows how well it ultimately works. Even before its unmasking, Piltdown had been consigned by most to a netherworld of doubt. There was simply too much evidence supporting a different human pedigree than that implied by Piltdown. Proving it a hoax was just the final nail in the coffin lid for this fallacious fossil. As a result, though we may never know the hoaxer's name, at least we know this: if the goal was to forever confuse our understanding of the human evolutionary story, the hoax ultimately was a failure.

♠ CURRENT PERSPECTIVES ♦

Human Evolution

With little more than a handful of cranial fragments, human paleontologists defined an entire species, *Eoanthropus*, and recast the story of human evolution. Later, in 1922, on the basis of a single fossil tooth found in Nebraska, an ancient species of man, *Hesperopithecus*, was defined. It was presumed to be

as old as any hominid species found in the Old World and convinced some that then-current evolutionary models needed to be overhauled. The tooth turned out to belong to an ancient pig. Even in the case of Peking Man, the species was defined and initially named *Sinanthropus pekinensis* on the basis of only two teeth.

Today, the situation in human paleontology is quite different (Johanson, Johanson, and Edgar 1994). The tapestry of our human evolutionary history is no longer woven with the filaments of a small handful of gauzy threads. We can now base our evolutionary scenarios (Figure 4.8) on enormous quantities of data supplied by several fields of science (see Feder and Park 1997 for a detailed summary of current thinking on human evolution).

Australopithecus afarensis, for example, dating to about 4 million years ago, is represented by more than a dozen fossil individuals from East Africa. The most famous specimen, known as "Lucy," is more than 40 percent complete. Its discovery by a team led by paleoanthropologist Donald Johanson was far more exciting than any hoax possibly could have been (Johanson and Edey 1982). Lucy's pelvis is remarkably modern and provides clear evidence of its upright, and therefore humanlike, posture. Mary Leakey, Tim White, and their team in Tanzania (White and Suwa 1987) found further evidence of upright locomotion dating to nearly 4 million years ago. At a place called Laetoli, they discovered a pathway of fossilized Australopithecus footprints preserved in hardened volcanic ash. At least two individuals, walking in an entirely human pattern, crossed the soft ash, leaving an unmistakably human trail. The chemical makeup of the ash caused it to harden and preserve the footprints. The ash itself has been directly dated to more than 3.5 million years ago.

Though *Australopithecus* walked in a humanlike fashion, its skull was quite apelike and contained a brain the size of a chimpanzee's. The fossil evidence, contrary to Piltdown and the brain-centered view of evolution, shows quite clearly that human evolution proceeded from the feet up, not

the head down.

Alan Walker and Richard Leakey (1993) excavated the 80-percent-complete skeleton of a 12-year-old boy who died on the shore of a lake more than 1.5 million years ago. He clearly walked upright and possessed a brain far larger than *Australopithecus* and about two-thirds the modern human size. That the so-called Nariokotome boy exhibits evidence of physical immaturity at the age of 12 reflects how human he was. Compared to most other animals, human beings have an extended period of maturation during which we master the skills we need as creatures who rely on learned behavior to a far greater degree than physical characteristics or instinct. The Nariokotome boy is placed in the taxonomic category *Homo ergaster*. *Homo ergaster*'s Asian descendant, *Homo erectus*, is known from dozens of individuals—forty from Zhoukoudian alone, nearly twenty from Java, and more than a dozen from Africa.

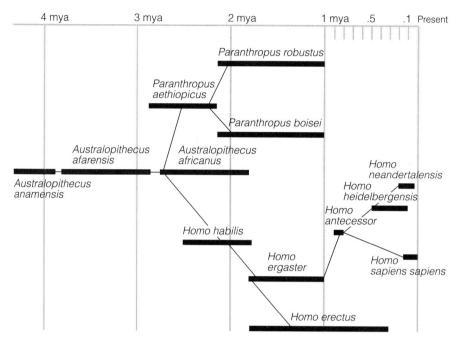

Figure 4.8 The chronology and connections of fossil hominids over the past 4.5 million years are depicted here. Each of the named species is represented by a number of fossil specimens. As can be seen, though many hominids existed in the past—and some lived at the same time—there currently is only a single species, *Homo sapiens sapiens*. All living people are members of this group.

Recovered Neandertal skeletons number in the hundreds, allowing detailed comparisons of this extinct form of human being and us (Stringer and Gamble 1993). In one of the most exciting results in paleoanthropological research in this century, an actual fragment of DNA has been extracted from a small Neandertal bone fragment, allowing scientists for the first time to compare the genetic instructions for an extinct form of humanity with the DNA of our own species. (Krings et al. [1997] is the technical publication; see Kahn and Gibbons [1997] for a nice summary.) Now, in our comparisons between Neandertals and modern human beings we can look at more than just bone; we can see the very genes. This "molecular archaeology" of the Neandertals shows that they were genetically quite distinct from modern humans. In the DNA segment recovered, there were more than three times the number of differences (about 27) between Neandertals and modern humans than are found when comparing any two groups of living human beings (with a mean of 8 differences). This degree of difference supports the hypothesis that the Neandertals were not our immediate ancestors but evolutionary cousins, plying their own, separate course through ancient history.

The fossil human record is rich and growing. Our evolutionary scenarios are based not on a handful of fragmentary bones but on the remains of hundreds of individuals. Grafton Elliot Smith, Arthur Smith Woodward, and the others were quite wrong. The abundant evidence shows very clearly that human evolutionary history is characterized by the precedence of upright posture and the tardy development of the brain. It now appears that although our ancestors developed upright posture and humanlike bodies more than 4 million years ago, the modern human brain size was not attained until as recently as 100,000 years ago.

It is to be expected that ideas will change as new data are collected and new analytical techniques are developed. Certainly our current views will be fine-tuned, and perhaps even drastic changes of opinion will take place. This is the nature of science. It is fair to suggest, however, that no longer could a handful of enigmatic bones that contradicted our mutually supportive paleontological, cultural, and genetic databases cause us to unravel and reweave our evolutionary tapestry. Today, the discovery of a Piltdown Man likely would fool few.

→ Frequently asked questions 🔮

1. Why didn't they just carbon date the Piltdown cranium and jaw to show how old they were?

Carbon dating was not developed until the 1950s, nearly forty years after Piltdown's discovery. If the Piltdown skull had been a genuine, million-year-old fossil, carbon dating would have been useless anyway. Carbon dating works only on organic material (all the organic material in fossilized bone has been replaced with minerals) and can be applied to specimens no more than about fifty thousand years old. After scientists realized that Piltdown had been a hoax, they did radiocarbon date the cranium; it was about six hundred years old. The jaw was only five hundred years old (Spencer and Stringer 1989).

2. Isn't the theory of human evolution based on the discovery of just a handful of tiny bone fragments that could mean just about anything?

Not at all. Paleoanthropologists have recovered thousands upon thousands of bones of our human ancestors. There are more than a dozen partial skeletons of *Australopithecus* and more than three hundred partial skeletons of Neandertals. Richard Leakey and Roger Lewin (1992) estimate that the remains of more than one thousand pre-human individuals have been recovered by scientists. Beyond this, some ancient skeletons—the Nariokotome boy from Africa and Jinniushan Man from China are two examples—are nearly complete, giving us a very detailed picture of what some of our

Best of the Web

CLICK HERE

http://www.unmuseum.mus.pa.us/piltdown.htm

http://www.tiac.net/users/cri/piltdown.html

http://www.tiac.net/users/cri/bibliog.html

http://www.tiac.net/users/cri/piltref.html

http://www.tiac.net/users/cri/drawhorn.html

http://lrs.ed.uiuc.edu/students/b-sklar/piltdown.html

extinct ancestors looked like. Modern scenarios of human evolution are based on a solid, large, and expanding database that includes DNA, ancient tools, and geology as well as bones, another reason why today a Piltdown hoax would be unlikely to fool anyone.

-> CRITICAL THINKING EXERCISES &-

Some claim that the Piltdown hoax shows how fallible science is. Others view the Piltdown story as an example of the self-corrective nature of science. What do you think?

The Cardiff Giant and Piltdown Man hoaxes were similar in that both related to archaeology and the study of human prehistory. However, they were quite different in terms of motives, the reasons for their success, and their impacts. Compare the motives for these two hoaxes. What were the goals of the hoaxsters? Compare the reasons each was successful. Why did people want to believe them? Compare the impacts of the Cardiff Giant and Piltdown hoaxes on the *scientific* understanding of the human past. Do you think archaeologists would be fooled by these hoaxes today? Can modern archaeologists be fooled by any hoaxes considering the modern technology we now have available to assess the legitimacy of artifacts and skeletons?

Who Discovered America?

Every October, on Columbus Day, pundits ponder the significance of the voyages of Christopher Columbus to the New World and whether, in fact, Columbus "discovered" America. Heated arguments ensue, and ink, if not blood, is spilled. But the issue of "who discovered America" is and should be a simple question of scientific fact. Did Columbus "discover" America? The only reasonable answer is, "No, certainly not."

The scientific facts are so clear it is perplexing that the point is argued at all. When Columbus arrived in the Caribbean in 1492, he found people already there. In fact, it is estimated that the New World was home to tens of millions of people whose languages and ways of life were more diverse than those of Europe. The New World was not the territory of a bunch of nomadic foragers who, as it has sometimes been grotesquely suggested, simply became the unfortunate victims of a cultural version of "survival of the fittest." The New World was home to myriad cultures including hunters and gatherers in the Alaskan arctic, pyramid-building farmers in the midwestern United States, mobile hunter-gatherers in the desert west, and corn-farming, town dwellers in the southeast. The New World also was home to a number of full-blown civilizations including the Aztec, Inca, and Maya. These cultures were, in the view of the conquering Spaniards themselves, the equal to any in the Old World. What the Aztec, Inca, Maya, and others were lacking, however, was gunpowder (a Chinese, not European, invention) and, even more significantly, immunity to European diseases, which killed more of them than did any conquistadors with swords or guns. So why do people argue the point at all? At least part of the reason this is still a political issue is good old European ethnocentrism.

At least 12,000 years ago—and possibly far earlier—small bands of northeastern Asians crossed a windswept plain exposed by a lowered sea and entered a world new to all of humanity. Within just a few thousand years, these people had spread across two continents, adapted to hundreds of different environments, invented agriculture, and developed complex civilizations with cities, pyramids, accurate calendars, and sophisticated writing and mathematical systems.

But there are no holidays memorializing these remarkable cultural achievements. The reason for this is reflected in an irony seen even in most modern natural history museums. Among the typical displays of most such museums, between the dodos and the dinosaurs, are dioramas depicting these original American societies. It is as if we still perceive Indian cultures and their many accomplishments not as part of the history of humanity but as part of the history of nature, which includes volcanoes, stuffed birds, and the bones of extinct animals. So even though it was Indians who discovered the Western Hemisphere, somehow that just doesn't count. This bias goes back as far as Columbus himself. In his log, Columbus provides a list for his Spanish benefactors of the "resources" contained in the islands he had explored. He includes the native people as one potentially valuable commodity—listing them between aloe wood and rhubarb.

The anthropological question that should concern us is not "Who discovered America?" but where did the Indians, who clearly were the first people to enter and settle America, come from? This very question was, in fact, asked by European scholars soon after they became aware of the existence of American Indians.

The Discovery of a New World

It has been said about Columbus that he was a man who, on beginning his great voyage, didn't know where he was going; on reaching his destination, didn't know where he was; and on returning, didn't know where he had been. For his trouble, the capital of Ohio is named for him.

This cynical view does not adequately recognize the enormity of his accomplishments nor his bravery and skills. Between 1492 and 1502–3, Columbus made four separate voyages to the New World (Figure 5.1). On the first and second of these he made landfalls on "San Salvador" (today identified as Watlings Island or, possibly, Samana Cay), Cuba, and Haiti (Marden 1986). On the third and fourth voyages, a landfall was made on the coast of South America, and a large section of the coast of Middle America (Panama, Costa Rica, and Honduras) was explored (Fernandez-Armesto 1974). His navigational skills and, just as important, his tenacity in the face of adverse circumstances allowed Columbus to succeed in trans-Atlantic crossings, where several Portuguese navigators who had attempted the trip before him had almost certainly failed (Morison 1940).

But, as great as Columbus's achievement was, he was not the first discoverer of America; the Indians were. When Columbus landed on San Sal-

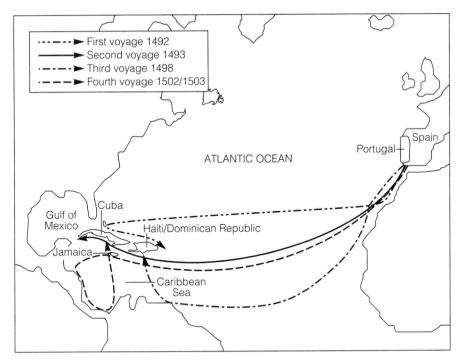

Figure 5.1 Routes taken by Columbus in his four voyages of exploration of the New World in 1492, 1493, 1498, and 1502–3. Columbus never gave up hope that he had discovered either the coast of Japan or China or lands immediately adjacent to the Orient.

vador, Cuba, Haiti, and virtually everywhere else he explored, he came into contact with large numbers of indigenous people (Figure 5.2). The source of American Indian populations, however, was not a major issue for Columbus or fifteenth-century scholars in general. As Huddleston has pointed out, "Columbus did not question the existence of men in the New World because he did not know it was a New World" (1967:5).

Remember, Columbus was seeking a route to the Orient. Despite the legend, most people in the fifteenth century did not still believe the world to be flat; there was little expectation Columbus would sail off the edge of the earth. As far back as the fourth century B.C., Greek philosopher Aristotle had determined that the world was round, and by the third century B.C., his countryman Eratosthenes had already calculated the circumference of this spherical earth, coming remarkably close to the actual value of a little more than 38,000 kilometers (about 25,000 miles).

A century later, another Greek thinker, Ptolemy, recalculated the size of the earth. Ptolemy's figure became the accepted value and was used by mapmaker Donnus Nicholas Germanus in producing a map of the world in 1474. This map was then used by the Dutch mapmaker Martin Behaim in 1492 to produce a representation of the world that was, in fact, in the form

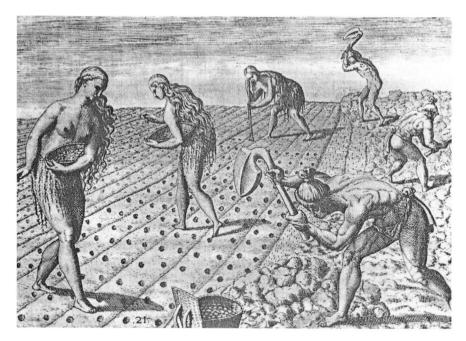

Figure 5.2 Columbus and those explorers who followed him to the New World all reported the presence of people previously unknown to Europeans—people whose existence demanded explanation within a biblical framework. Here sixteenth-century illustrator Theodore de Bry depicts natives of North America planting corn.

of a globe (Figure 5.3). We know that Columbus was aware of the Behaim globe before he set sail to discover a route to the Orient.

The irony in all this is that whereas Eratosthenes' calculation was extremely close to the actual size of the earth, Ptolemy incorrectly deflated the globe by about one-third—and it was on his figures that fifteenth-century European mapmakers and explorers based their considerations. In fact, Columbus was confident he could find Asia by sailing west because, based on Ptolemy's error, he thought the world was a sphere *one-third smaller* than it actually was.

To compound the irony, when Columbus did encounter land in the Caribbean, it was at about the right distance from Europe for it to be Asia based on Ptolemy's error. It should come as no surprise, therefore, that Columbus initially thought that the lands he explored in 1492 were part of the Asian continent.

Though he did not understand that he had accidentally discovered the Western Hemisphere during his first voyage, Columbus did come to realize that he had not successfully reached his hoped-for destination of Cathay (China) or Cipangu (Japan). For a short time during the first voyage, he thought Cuba was part of mainland Asia (Fuson 1987), but he soon concluded

Figure 5.3 Behaim's Globe, 1492. (Courtesy, Germanisches National Museum)

that it was, in fact, an island. Nevertheless, he remained convinced that Cuba and the other islands he explored lay in proximity to the Asian mainland.

Unfortunately, the three subsequent voyages by Columbus resulted in no indisputable Asian landfall and seemed to deflate the notion that China and Japan were just a little farther west. Columbus became so frustrated by his apparent failure to find a new route to the Orient as he had promised that, during the third voyage in 1498, he greatly overestimated (falsified?) the length of the coast of Cuba in his records. He went so far as to force his men to swear an oath stating that Cuba (called Juana in the log) was, in fact, not an island but a continental landmass and therefore a part of Asia (Fernandez-Armesto 1974:129).

Columbus, convinced he had at least explored a number of islands off the Asian mainland, thought the people he encountered were Asians. In one of the published accounts of his discoveries, the *Letter to Sanchez*, Columbus passes on a story of a tailed race of people in an area he did not visit (Major 1961:11). Nonetheless, everywhere else in his records, it is clear he believed the natives were ordinary Asians. Later, Columbus waffled on the location and nature of the lands he explored in his four voyages. In the final analysis, he simply wasn't sure what he had discovered. He spent his last days maintaining that he had, in fact, made landfalls on the coast of Asia.

Others in Europe, however, had become convinced that Columbus had discovered something far more intriguing than a western route to the Orient. There was growing sentiment that Columbus had discovered, as Amerigo Vespucci called it for the first time in print in 1503, "a new world, because none of these countries were known to our ancestors" (Vespucci 1904). When Magellan circumnavigated the globe in 1530 it became clear that Columbus had indeed discovered a "new world."

Biblical Exegesis and American Indians

If the lands explored by Columbus were not part of Asia, then the natives were not Asians, but some heretofore unknown group of people. This idea was problematical to sixteenth-century scholars and clerics. In their worldview, all people could be traced to Adam and Eve. Beyond this, all people could be more recently traced to Noah and his family (his wife, sons, and daughters-in-law), for all other descendants of the first couple had been wiped out in a great flood (see Chapter 11).

According to the Book of Genesis in the Old Testament, Noah had three sons, Shem, Ham, and Japheth. Biblical scholars had long since decided that each of the three sons represented the source for the three "races" of man recognized by Europeans: European, Oriental, and African. Japheth, apparently the best of the lot, was, naturally enough, considered to be the patriarch of the European people. Shem gave rise to the Asians, and Ham was the source for Africans. This was a neat enough arrangement for biblical literalists, but the recognition that the native people Columbus had encountered were not Chinese or Japanese created a problem. There simply was no *fourth son* of Noah to provide a source for a *fourth race* of people. Though some, like Isaac de la Peyrère in 1655, suggested that Indians were part of a separate "pre-adamite" creation that had been unaffected by the biblical flood (Greene 1959), notions of polygenesis were never particularly popular.

For most, Indians were ordinary human beings descended first from Adam and later from Noah. If any doubted that, Pope Paul III in a papal bull released in 1537 made the opinion of the Church clear when he stated that "the Indians are truly men and that they are not only capable of understand-

ing the catholic faith but, according to our information, desire exceedingly to receive it" (as cited in Hanke 1937:72).

That led to the only general conclusion possible: the natives of the New World must have reached its shores sometime after the Flood and could, therefore, be traced to one of Noah's sons through a historically known group of people. For some three hundred years, European thinkers speculated about who that group might be.

American Indians: From Israelites to Atlanteans

The biological study of American Indians has shown that they clearly are Asian in origin (Steward 1973; and see the "Current Perspectives" section of this chapter). Ironically, an early New World explorer noticed the physical similarity between the native people of the New World and Asians. Giovanni da Verrazano, an Italian navigator sailing for France in 1524, landed at what is today the border between North and South Carolina. He sailed north, looking for a sea route to the west and, it was hoped, a way past the New World and to Asia. He entered Delaware Bay and the mouth of the Hudson River, sailed along Connecticut's coast, entered and explored Narragansett Bay, followed the shore of Cape Cod, and then went home, unsuccessful in his attempt to find a passage to the west. Verrazano spent almost three weeks exploring the interior of Rhode Island and had an opportunity to examine local natives closely. He concluded:

They tend to be rather broad in the face. . . . They have big black eyes. . . . From what we could tell in the last two respects they resemble the Orientals. (Quuinn 1979:182)

In 1555 the Portuguese traveler Antonio Galvão (Galvão) cited China as the source for Indians. He noticed the physical similarities between Indians and Asians in terms of "their proportions, having small eies, flat noses, with other proportions to be seene" (Galvão 1962:19).

Though these explorers were quite perceptive in noticing these physical similarities, many others suggested different sources for the Native American population. In his *General and Natural History of the Indies* published in 1535, Spanish writer Oviedo (Huddleston 1967) suggested two possible sources for indigenous American populations: lost merchants from Carthage, a Mediterranean city-state of 2,000 years before, or the followers of King Héspero, a Spanish king who fled Europe in 1658 B.C. The latter hypothesis was appealing to the Spanish, who could therefore assert that Columbus had only rediscovered and reclaimed that which the Spanish had already discovered and claimed.

Speculation concerning the source of American Indians accelerated after 1550. As shown in Chapter 8, Lopez de Gomara believed they were a

remnant population from the Lost Continent of Atlantis. Historian Lee Huddleston (1967:32) maintains that, in terms of numbers of references to possible geographic sources in the middle years of the sixteenth century, Atlantis was the single most popular speculation.

In 1580 Diego Duran suggested that the New World natives were descendants of the so-called Lost Tribes of Israel—ten of the twelve Hebrew tribes mentioned in the Bible were historically "lost." Duran enumerated traits that he believed Indians and Jews had in common: circumcision, stories about plagues, long journeys, and the like.

It was not until Rabbi Manasseh ben Israel wrote *The Hope of Israel* in 1650, however, that the Lost Tribes hypothesis achieved widespread popularity (Huddleston 1967). *The Hope of Israel* was quite popular and spawned many similar volumes. In it, the practices, ceremonies, beliefs, stories, and even languages of individual groups of Indians were identified as being Jewish in origin. Ben Israel went so far as to claim that the Indians were still practicing Jews, but were keeping it secret from the Spanish, having heard of the Inquisition.

Joseph de Acosta and Gregoria Garcia

From our modern perspective, perhaps the most important work focusing on the origin of the Indians was *The Natural and Moral History of the Indies*, by Friar Joseph de Acosta, published in 1590. The book is a remarkably perceptive, scientific examination of the question of Indian origins.

Acosta spent seventeen years as a Jesuit missionary in Peru beginning in 1570. He recognized that however people came to the New World and wherever they came from, animals came with them. The Americas were teeming with animals. But this could have been no purposeful importation of animals because predators including wolves and foxes were present in the New World. People clearly would not have brought such animals with them. Acosta deduced that these animals must have traveled here by themselves.

Acosta then made a simple, yet significant deduction; if animals could migrate on their own to the New World from the Old—where they must have journeyed from after the Flood, since Noah's Ark came to rest on "the mountains of Ararat," somewhere in western Asia—then "the new world we call the Indies is not completely divided and separated from the other world" (Acosta, as cited in Huddleston 1967:50).

Thus the Old and New Worlds must be connected; animals could simply walk from the Old World to the New, and people would have come to the Americas the same way. Based on geographical knowledge of his day, Acosta even proposed where such a connection might be found—northeast Asia/northwest North America. Acosta suggested this almost 140 years before the Russian explorer Bering found that the Old and New Worlds are separated by less than 100 miles of water (Figure 5.4).

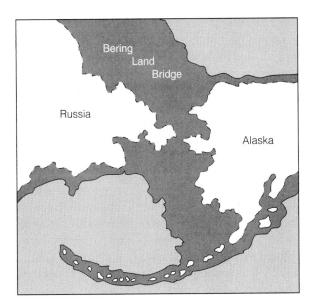

Figure 5.4 During parts of the Pleistocene Epoch, sea level dropped substantially as water evaporated from the world's oceans, fell as snow in northern latitudes and higher elevations, and did not melt but produced glaciers. This drop in sea level produced land connections like the Bering Land Bridge—a 1,500-kmwide platform of land connecting northeast Asia and northwest North America. The Bering Land Bridge provided access to the New World for animals and people in the Old World. (From Human Antiquity, Feder and Park, Mayfield Publishing)

Acosta's argument was remarkable for its objectivity and solid reasoning. Furthermore, it did not contradict a literal interpretation of the Bible—it was, after all, based on the assumption that all animals in the New World were descended from those saved on board the Ark.

Nevertheless, Acosta's book was not as popular as the work of a far more credulous colleague, Gregoria Garcia, who wrote his *Origins of the Indians* in 1607. Garcia listed sources for American Indians and seemed to accept them all: Lost Tribes of Israelites, ancient Spanish kings, homeless Atlanteans, not to mention globe-trotting Greeks, Norwegians, Chinese, Tartars, and Scythians. It made little apparent difference to Garcia; they *all* discovered America.

Rather than employing a deductive approach like Acosta, Garcia used a purely inductive method (see Chapter 2). He cited supposedly specific behaviors or practices of particular Asian, European, and African groups that were found in particular places in the New World and then hypothesized that Indians were descended from those Old World groups. No attempt was made to test this hypothesis.

Tracing the Movement of Ancient People

Tracing People by Their Culture

What Garcia, ben Israel, and most other European scholars based their tracing of American Indian cultures on were *trait list comparisons*. They hunted

through descriptions of Indian cultures, seeking practices, beliefs, and even linguistic elements that were reminiscent of those in some Old World group. Where similarities were found, it was thought that a source for the American population had been identified.

Certainly, there is some logic to cultural comparison. Within the context of American society, we recognize that immigrants and their descendants often maintain traditions from their homelands. Religious practices, holiday celebrations, craftwork, clothing, and even language may persist for generations. Jews speaking Yiddish, African Americans wearing *dashikis*, and Puerto Ricans living in the United States celebrating Three Kings' Day are all examples of such cultural persistence.

In these three examples and in the myriad others that could be presented, the connections between the practices of immigrants and those of their homelands are clear, specific, and detailed. Each occurs within an overall cultural context of many other persistent practices.

The evidence marshaled by European scholars in previous centuries regarding the source of American Indian populations is very different. Often, the similarities they saw were vague, generic, and biased. For example, Garcia contended that both Jews and Indians are cowardly, that neither believes in the miracles of Christ, that both are uncharitable, that they are ungrateful, that they love silver, and so on (as cited in Steward 1973). These aspersions, which reflect more on Garcia's attitudes than on either Native American or Jewish behavior, were taken as evidence of a connection between the two peoples.

Archaeologist David L. Clarke (1978:424) has suggested that trait list comparisons can be used to trace population movements only when certain requirements of the data are met. The traits must be specifically the same, not just vaguely similar. The traits being compared cannot be isolated behaviors. They must be part of entire complexes of traits, all of which are reflected in the supposed source and immigrant populations. The traits must co-occur repeatedly, both physically and chronologically. The similarities must be so complete that the likelihood that they resulted from coincidentally parallel development or functional necessity would be minimal.

For example, a simple trait like circumcision, practiced by Jews as well as the Inca, does not, by itself, necessarily prove anything. The cultural/religious context and meaning of the practice in the two groups turns out to be entirely different. It is such a general trait and so many people all over the world practice it that we would quickly run out of Lost Tribes if we tried to trace them to all world cultures that circumcised their male infants.

Archaeologist John Rowe (1966) performed a wonderful exercise that shows the inadequacy of trait list comparisons. He compiled a list of sixty practices and artifacts held in common by ancient South American civilizations and the kingdoms of Europe before the Middle Ages. Some of the common traits include animal sacrifice, belief in mythically combined animals,

sister marriage, cubical dice, copper tweezers, and eunuchs. Yet, there was no known contact between these cultures separated by thousands of miles of land and ocean. Rowe purposely selected traits extracted from their cultural contexts, practices dating from different time periods, and behaviors present in a few widely separated European groups and similarly few widely separated Native American groups. This is precisely the nature of the comparisons between Old and New World cultures made by the great majority of European thinkers in earlier centuries.

Tracing People by Their Biology

Another way that archaeologists and anthropologists can trace the movement of people is by the biological analysis of the people or their skeletal remains. The human species is polymorphic; we come in different colors, shapes, and sizes. There are variations in blood type, skeletal morphology, tooth shape, and so on.

These variations are not randomly distributed across the earth, but are geographically patterned. Some of the differences are due to the forces of natural selection; some are random. Although European scholars did not have a detailed understanding of human biological variation, some did notice the physical similarities between American Indians and Asians. For example, when Galvão (1962) traced Indians to China as a result of their "small eies," he almost certainly was referring to the presence of the *epicanthic fold* of skin on the eyelids of Asian peoples and American Indians, but absent in Europeans and Africans.

We now have many procedures for analyzing skeletons, blood proteins, and DNA. These can all help us trace immigrant populations to their biological/geographical sources (see also the "Current Perspectives" section of this chapter).

Tracing People by Their Materials

It also is possible to trace the movement of people—or, at least the movement of their objects—through physics. In many cases the raw materials people used to manufacture their stone, ceramic, or metal artifacts come from geographically limited and physically distinguishable sources. For example, in a technique called *neutron activation analysis*, trace amounts of impurities can be measured in stone, clay, or other raw materials. The precise amounts of these trace elements (often measured in parts per million) provide a sort of signature for different sources of raw material. Such signatures can be used to connect an artifact to a raw material source. For example, obsidian (natural, volcanic glass that was highly prized the world over for making very sharp stone tools) from Turkey and Idaho may look virtually identical

but will have extremely different trace element profiles. By using this technique, the movement of obsidian from its various sources has been traced in both the Old and New Worlds.

If American Indians had been from a lost Israelite tribe or from Rome or Egypt, archaeologists would likely have found artifacts brought by such peoples from their homelands and made from raw materials traceable to their Old World sources. That such a find has never been made is a strong argument against such a scenario.

Out of Asia

Ultimately, Acosta's reasoning in *The Natural and Moral History of the Indies* was so sound that it could not be ignored. Rather than relying on scattershot cultural comparisons or unverifiable transoceanic crossings, his theory was constructed on a solid geographical foundation. Slowly, as geographical knowledge of the northern Pacific grew, it gained acceptance.

In 1648 Russian explorer Semyon Dezhnev discovered that the Old and New Worlds were separated by a narrow strait, but his report was neglected for some eighty years. The proximity of northeast Asia and northwest North America became more widely known when Vitus Bering explored the region that was ultimately to bear his name. Though Bering sailed through the strait in 1728, bad weather prevented him from reaching the Alaskan coast. In a 1741 expedition, Bering finally made it to Alaska and fully comprehended, probably for the first time, how close the coasts of the Old and New Worlds were in this region.

By the middle of the eighteenth century, geography clearly argued for a northeast Asian source for New World aborigines. Added to the physical similarities between Asians and Native Americans, it became clear to many eighteenth-century scholars that the indigenous people of the New World were, in fact, descendants of Asians—just as the Spanish cleric Acosta had argued in the sixteenth century.

By 1794 Father Ignaz Pfefferkorn could say in reference to the narrow slip of water separating Asia from America, "It is almost certain that the first inhabitants of America really came by way of the strait" (as cited in Ives 1956:421). The people whom Columbus encountered had been Asians after all—but separated by thousands of miles and thousands of years from the people of Cathay and Cipangu.

An "American Genesis"?

The notion that American Indians came to the New World from Asia can be traced as far back as Acosta, who wrote nearly four hundred years ago.

Though archaeologists still argue about the timing of this migration, they virtually all agree that American Indians are Asians who came to the New World via the area today known as the Bering Straits. This narrow and shallow part of the Bering Sea is today a minor impediment to human movement between the Asian and North American mainlands. In the past, during the geological epoch known as the *Pleistocene* (Ice Age), travel between the two continents was even easier. During this epoch, marked by episodes of worldwide climate much colder than those that occur at present, large bodies of ice called glaciers covered much of the surface of North America and Europe. This ice came from water that had evaporated from the world's oceans. As a result, worldwide sea level dropped as much as 150 meters (450 feet), exposing large amounts of land previously and presently under water (Josenhans et al. 1997). A 1,500-kilometer-wide (almost 1,000 miles) land platform called *Beringia* or the Bering Land Bridge was exposed, connecting Asia and North America (see Figure 5.4). Animals and people from Asia crossed over Beringia into the New World. This scenario is well supported by geological, meteorological, biological, anthropological, and archaeological evidence (Hopkins et al. 1982; Meltzer 1989, 1993a, 1993b; West 1981).

Unfortunately, this well-supported theory has become controversial again, but for reasons that have little to do with science. Some Native Americans object strenuously to the Land Bridge scenario because, as one told me directly, "It makes us immigrants, no different from you and your ancestors." Maybe that is the case, but the most conservative scientific view places Native Americans in the New World more than 12,000 years ago—"immigrants" they may be, but certainly not latecomers! Besides, the same can be said for Europeans. Humanity evolved in Africa, and the first modern human beings in Europe came from Africa (see Chapter 4). Europeans, Asians, native Australians, as well as native North and South Americans—all are, ultimately, transplanted Africans.

Indian activist, author, and historian Vine Deloria Jr. (1995) has made this issue the core of his book *Red Earth, White Lies*. His argument is that the Bering Land Bridge model cannot be proven (despite all the evidence; see the "Current Perspectives" section of this chapter). Besides, Indian religion maintains that native people in the New World have always been here; they were created here and did not come from anywhere else. This is an argument based on religion and myth, not evidence or science. (For a detailed and scathing review of Deloria's book, see Whittaker [1997].)

Jeffrey Goodman (1981) also claims that Native Americans did not come from Asia, ostensibly on the basis of logic and archaeological evidence. In his book *American Genesis*, Goodman (1981) wrote that American Indians had not come from Asia by way of the Bering Land Bridge but that Asians and, ultimately, everyone else in the world had originated in North America—in California, to be precise, which Goodman suggests was the

location of the Garden of Eden (p. 4). Goodman asserts that modern human beings first appeared in California as much as 500,000 years ago, predating the earliest known modern-looking skeletal remains in the Old World by about 400,000 years. According to him, these first people spread out from California, populating the rest of the world (see Feder [1983] for a detailed critique).

Although in *American Genesis* Goodman states that all people are derived from American Indians, he never suggests where the Indians came from. After all, more conservative anthropologists provide evidence of previous forms of humanity and evolutionary processes in their discussion of human origins. Because the earliest and most primitive of our prehistoric forebears are found in Africa, that continent is proposed as the source of our species (see the "Current Perspectives" section of Chapter 4).

It is no wonder Goodman did not address this issue in *American Genesis*, though he does pose the question, "Was modern man's world debut the result of slow development or the result of a quantum leap inspired from some outside source?" (1981:91). He does not answer that question in *American Genesis*, but he does in an earlier book (Goodman 1977) that we will look at more closely in Chapter 10. There, discussing the inhabitants of an Arizona site that Goodman uses in *American Genesis* as key evidence that modern humanity originated in the New World some 500,000 years ago, Goodman passes on the information that the Arizona people came from the Lost Continent of Atlantis and its Pacific counterpart, Mu (1977:88). This hypothesis was at its peak in popularity in the sixteenth century. As I show in Chapter 8, Atlantis never existed; it was as much of a fantasy as Goodman's argument of an American genesis.

→ CURRENT PERSPECTIVES 《

The Peopling of the Americas

Biological Anthropology

Sixteenth-century explorers like Verrazano and Galvão recognized the physical similarities between Asians and Native Americans, and these similarities were used to hypothesize an Asian source for the indigenous human population of the New World. Today, biological anthropologists can test and verify this hypothesis through application of sophisticated analytical procedures.

For example, physical anthropologist Christy Turner examined some 200,000 teeth from the New World (Turner 1987) and found that American Indian teeth are most similar to the teeth of Asian people. Among American Indians, a particular form of incisor—so-called *shovel-shaped*—is found in between 65 and 100 percent of Indian populations in different parts of North and South America. The frequency of shovel-shaping in Africans and Euro-

peans has been measured at less than 20 percent. In eastern Asia, 65 to 90 percent of the people exhibit the trait.

Examination of other dental traits, including the number of cusps and roots on molar teeth, also shows the similarity of the teeth of Asians and Native Americans. Other features of the skeleton exhibit the same pattern; thus, archaeologists can be fairly certain that the skeletons excavated from prehistoric sites in the Americas are those of Indians and that Indians are derived from Asia on the basis of their possession of the Mongoloid or *sinodont* pattern (Turner 1987:6).

Recent comparisons of the DNA of modern Asians with that of mummies and bones of ancient Native Americans, as well as with modern Indians themselves, further cement the biological connections between native people on either side of the Bering Straits (Gibbons 1993, 1996; Stone and Stoneking 1993; Wallace, Garrison, and Knowler 1985). These scientists focused on a special kind of DNA—called mitochondrial DNA or mtDNA—found not in the nuclei but in the mitochondria (the energy factories) of cells. Modern techniques of DNA retrieval and analysis—like those used to compare Neandertals to modern human beings (see Chapter 4)—have determined that in a large sample of Native Americans (both living and deceased) there are four distinctly different mtDNA variants, called *haplogroups*, *all* of which also are found in Asia but *not* in Europe or Africa. These scientists have provided sophisticated biochemical evidence in support of the hypothesis Acosta proposed in 1590; the native people of the New World arrived here from Asia.

Archaeology

There no longer is any doubt about the geographical and biological source of the Native American population. There also is very little disagreement that the first Americans arrived more than 12,000 years ago. There is, however, some lingering debate about precisely how long before 12,000 Before Present (B.P.) the migration from Asia took place (Meltzer 1989, 1993a, 1993b).

We can state unhesitatingly that people were in South America by about 12,500 years ago at a place called Monte Verde, in Chile (Dillehay 1997, 1989, 1997; Dillehay and Collins 1988). The major cultural level at that site has produced spearpoints and a number of other stone tools. Organic preservation at the site is remarkable, with pieces of mastodon meat, wooden hut foundations, and plant remains recovered in the excavation. Nine of the carbon 14 dates for the main occupation date to more than 11,800 B.P.; some of the dates indicate the site is as much as 13,500 years old.

Another very old New World site is the Meadowcroft rockshelter in western Pennsylvania. At the base of the cave, the excavators recovered material that has produced arguably the oldest radiocarbon dates associated with humanmade material in eastern North America (Adovasio, Donahue, and Stuckenrath 1990). Sealed beneath a rockfall from the roof of the shelter

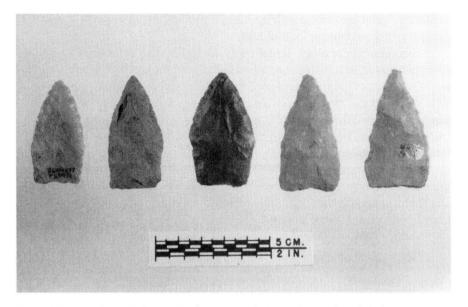

Figure 5.5 Finely crafted stone tools recovered at Meadowcroft rockshelter in western Pennsylvania, dated to close to 13,000 years ago. (Courtesy James Adovasio)

dated to 12,000 years B.P. were some four hundred lithic artifacts including blades, knives with retouched edges, and an unfluted, bifacial projectile point (Figure 5.5). Six dates in excess of 12,800 B.P. were derived from material at or below this level.

With the carbon dates for Monte Verde and Meadowcroft, it is obvious that the first human occupation of the New World must be pushed back further still. After all, Chile and Pennsylvania both are quite a distance away from the Bering Land Bridge entry point to the New World in western Alaska (16,000 kilometers [10,000 miles] and 8,000 kilometers [5,000 miles], respectively). Archaeologist David Meltzer (1997) has suggested that to allow people entering the New World from the Bering Land Bridge enough time to arrive at a site as far south as Monte Verde by 12,500 B.P. through normal processes of migration and population expansion, they probably first entered the New World by about 20,000 B.P.

If this scenario is correct, a trail of successively older sites should exist leading from Chile and western Pennsylvania back to the land bridge. Virtually all researchers would agree that such a trail—at least an unbroken trail—has yet to be discovered. There are candidates for some older sites leading back to Asia. For example, Bluefish Caves in western Canada has produced artifacts in a level that has been dated to between 15,000 and 12,000 years ago (Cinq-Mars 1978). A number of sites in central Alaska labeled as the Nenana Culture may be about 12,800 years old (Powers and Hoffecker 1989). Work continues, looking for additional such links in a chain

connecting Monte Verde, Meadowcroft, and other possible early sites back to the land bridge.

The archaeological record in the New World becomes far clearer and more detailed at about 11,500 years ago. Soon after that date, a people called the *Paleo-Indians*, at least partially reliant on the hunting of large game animals that flourished during the end of the Pleistocene, spread throughout North and South America. From Clovis, New Mexico (Haynes 1980), to Debert, Nova Scotia (MacDonald 1985), from the Vail site in Maine (Gramly 1982), to Fell's Cave at the southern tip of South America (Bird 1938), the evidence of their culture is well known to archaeologists.

Wherever they settled, they brought with them a stone tool called the fluted point, a beautifully fashioned stone spearpoint with channels or "flutes" (as in a fluted column) on both faces (Figure 5.6). Though there is

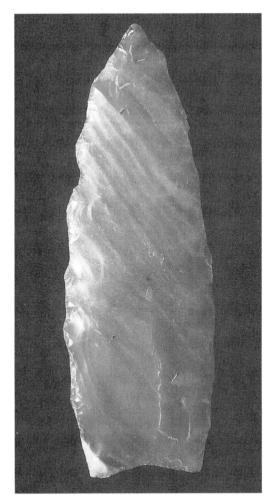

Figure 5.6 This particularly impressive fluted point was recovered at the Clovis Richey Cache site in Washington State, which has been dated to more than 11,000 years ago. (Great Lakes Artifact Repository; Michael Gramly)

some regional variation, fluted points from across the face of the New World are generally similar in their morphology.

A significant variation on the original fluted point form called *Clovis* is seen at sites dating to after 11,000 years ago. That form is called *Folsom*, after the site of Folsom, New Mexico. This new fluted point morphology includes a much longer channel in proportion to the length of the weapon and seems to represent a shift in the animals hunted by the point makers. In the west, Clovis points tend to be associated with the remains of extinct elephants, and Folsom points are found in association with the bones of an extinct form of bison.

Though it must be admitted that debate regarding the age of the earliest occupation of the New World has sometimes been acrimonious, at least those on either side, and those in between, recognize the same rules of evidence and attempt to live by them. There are no appeals to divine inspiration and no references to nonexistent lost continents. All the players in the game agree that the search for the first Americans is a worthwhile endeavor. And all abide by the rules of science.

♠ FREQUENTLY ASKED QUESTIONS <</p>

1. Were there multiple migrations to the New World across the Bering Land Bridge?

It was long thought, based on genetic and linguistic evidence, that there were three separate migrations of Asians across the land bridge: an early migration of the ancestors of most American Indians, a later migration of Eskimo-Aleuts, and an additional migration of the ancestors of Indians who now live on the northwest coast of North America. Many still believe this, but recent genetic data has led some to suggest that modern Native Americans are genetically so similar that they all may have descended from a single group of transplanted Asians (Gibbons 1996).

2. If there were one or only a very few migrations to the New World—all from the same place—how could there be so many different and diverse cultures in the Americas by the time Columbus arrived in 1492?

The great behavioral variation seen among the native people of the Americas is the result of cultural evolution over a period of as much as 20,000 years. As the population of the ancient immigrants grew and as they spread into new habitats, their survival required the development of new strategies. These strategies were as varied and diverse as the environments into which they moved. Add in the element of an enormous amount of time (20,000 years is a thousand human generations) and the result is the spectacular diversity seen in the native cultures of the New World.

Best of the Web

CLICK HERE

http://www.peak.org/csfa/csfa.html

http://www.peak.org/csfa/mthome.html

http://www.nationalgeographic.com/society/ngo/events/97/monteverde/dallas.html

http://www.ele.net/

http://www.nps.gov/bela/html/history.htm

-> CRITICAL THINKING EXERCISE

Using the deductive approach outlined in Chapter 2, how would you test these hypotheses? In each case, what archaeological and biological data must you find to conclude that the hypothetical statement is an accurate assertion, that it describes what actually happened in the ancient human past?

- The first discoverers of America were Asians who crossed over from the Old World via a land connection.
- The first Americans were big game hunters who entered the New World by following migratory herds of animals.

After the Indians, Before Columbus?

While preparing for the 500th anniversary of the first voyage of Christopher Columbus to America in 1492, a group of Latin-American representatives to the United Nations proposed a resolution to officially honor the great explorer for his achievement of discovering a new world and changing the course of history.

It was a simple, symbolic gesture in a body that had more concrete concerns. Nevertheless, it caused quite a stir. Initially, Ireland's ambassador objected, claiming that a sixth-century Irish monk discovered America first. The representative from Iceland chimed in, asserting that the Viking Leif Eriksson had sailed to the New World 500 years before Columbus. Next, African delegates asserted that prehistoric African navigators had also traversed the Atlantic, discovering the Americas long before Columbus. Though part of the debate was largely tongue-in-cheek, it can be said that as recently as the 1980s, even in the United Nations, and even in terms of a purely symbolic gesture, controversy erupts when the question is posed: Who discovered America?—after the Indians, of course.

The list of proposed pre-Columbian explorers of the New World is long, and there is no reason to presume that such voyages of exploration were impossible. Some writers have gone so far as to suggest that many European, Asian, and African groups regularly visited the Americas, settled here, and had commerce with the Indians long before Columbus (Gladwin 1947; Gordon 1974). The burden of proof, however, must be on those who support such hypotheses.

Many of the claims of discovery and settlement of America are based, ultimately, on interpretations of legends. Legends alone, however suggestive, are unsatisfying. The archaeological record, with its foundation in phys-

ical evidence, must be the ultimate arbiter of debates concerning who "discovered" the Americas after the Indians and before Columbus.

A Trail of Artifacts: Sixteenth-Century Visitors to the New World

In this chapter we will be looking at evidence for the exploration and even settlement of the New World by Europeans, Africans, and Asians sometime after the movement of people across the Bering Land Bridge (see Chapter 5) but before the voyages of Christopher Columbus. We know that exploration and settlement of the New World by these groups took place *after* Columbus. Examining the archaeological evidence available for these well-established, post-Columbus movements of people into and through the Americas can serve as models for what the archaeological record must provide to support as yet unproven "discoveries" and journeys of exploration *before* Columbus.

How can we recognize even the known, post-Columbus explorers of the New World just from the archaeological record? Each human group leaves a trail of physical evidence that is unique; different people use different raw materials and use the same raw materials differently. They make different styles of tools and different kinds of pottery. They build houses, throw away garbage, and bury their dead in ways that are culturally determined. Archaeological sites constitute the physical remains of these culture-specific practices and uniquely reflect the culture of the particular people who produced them. The tools made, used, and discarded by sixteenth-century Europeans don't look like those made by Native Americans from the same time period. They are recognizably "alien." Archaeologists are trained to be familiar with and to recognize these differences in *material culture*—in other words, the stuff people made, used, and threw away.

Martin Frobisher and Francisco Vasquez de Coronado

Sixteenth-century forays into the New World show this trail of culturally unique, physical evidence quite clearly. For example, Martin Frobisher was an English navigator who sailed to the New World in A.D. 1576, 1577, and 1578 (Fitzhugh and Olin 1993). Seeking the elusive "northwest passage" past the Americas to Asia, Frobisher sailed from England along a northerly route, reaching Labrador and Baffin Island in northern Canada. Finding no passageway to the west, Frobisher attempted to salvage the expedition by prospecting for gold. He found none, but in the process he and his men left physical traces of their expedition in the form of readily identifiable, latesixteenth-century English artifacts and features, particularly on Kodlunarn Island (Fitzhugh 1993). These remnants include raw and partially processed

iron "blooms" (produced as a step in the process of smelting iron), an iron nail, fragments of broken ceramic crucibles, bricks, ceramic roof tiles, and the remains of several structures built by the explorers. The artifacts are identifiable as belonging to the English "Elizabethan" age (when Queen Elizabeth I reigned—1558–1603) and represent definitive, physical evidence of an English presence in northeastern Canada in the 1570s. Had there been no historical record of Frobisher's voyage to the New World, we still would have known from the archaeological record on Kodlunarn Island that people bearing typical western European artifacts were in northeastern Canada in the late sixteenth century.

At the other corner of the continent, Francisco Vasquez de Coronado and his band of about three hundred Spanish soldiers spent two years traveling through the American Southwest between 1540 and 1542. Sixteenth-century Spanish artifacts including horse harnesses, metal buckles, and nails have been found all along the 4,000-mile route they traversed. In a spectacular find, archaeologist Don Blakeslee discovered a trove of metal crossbow arrow-tips in west Texas at a site located on Coronado's route (as cited in Hoversten 1996). Local natives did not use harnesses, metal buckles, iron nails, or crossbows, but Spaniards in 1540 did. This physical evidence means that either Coronado and his men visited the sites where these artifacts were found or the inhabitants traded for these objects with people who had been visited.

The Spanish Entrada into the American Southeast

Perhaps the best known sixteenth-century investigation of North America by Europeans was that of Hernando de Soto in A.D. 1538. His contingent of more than six hundred men made landfall on May 30 of that year on the west coast of Florida south of Tampa Bay. During the course of the next four years, members of this expedition passed through most of the southeastern United States, crossing more than 3,500 miles of territory. About half of the crew including their captain, de Soto, died, with 311 arriving in New Spain (Mexico) in 1543 (de la Vega 1988; Swanton 1985).

The archaeological evidence found to date in the American Southeast presents us with a virtual trail of the de Soto expedition. In archaeological sites, the discovery of Nueva Cadiz beads, brass bells, silver and gold disks, assorted iron objects (scissors, swords), and even dated coins shows the clear imprint of a Spanish presence in the Southeast in the early sixteenth century (Feder 1994b). For example, Nueva Cadiz beads have been found at the Little Egypt site in northwestern Georgia, a village probably visited by de Soto, as well as at the Martin site in Florida, identified as the Anhaica village of the Apalachee people, also visited by de Soto (Ewen 1989). Wrought-iron nails, chain-mail links, a crossbow dart, and five Spanish coins that date to an earlier Spanish expedition were also found at the Martin site (Ewen 1989). A brass bell has been found at the Parkin site in Arkansas, identified by

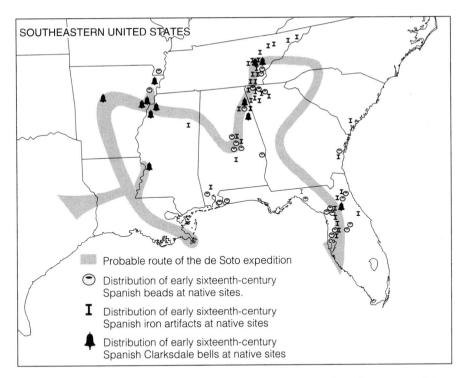

Figure 6.1 Map showing the historically documented route of the de Soto expedition through the American Southeast and locations where archaeological evidence of his, as well as previous and subsequent, Spanish expeditions has been found.

Mitchem (n.d.) as the main town visited by de Soto in what he called the Casqui province. Many other examples could be cited (Feder 1994b).

Compare the maps of the archaeological find spots of these artifacts and the actual route de Soto and his men followed (Figure 6.1). The message can be no clearer and the lesson for us no more obvious: foreign visitors bring with them a recognizable, foreign material culture. Their unique and alien material culture represents, in fact, a signature of their presence, and similar evidence should be found in any other case where such a presence is to be verified.

The beads, bells, swords, and coins attributable to the sixteenth-century de Soto *entrada* in the American Southeast, as well as the crossbow tips and harnesses of Coronado in the Southwest and the iron tools left behind by Frobisher in northeast Canada, show us the kind of physical evidence we should expect—and the kind of evidence we must, in fact, demand—if other explorers, other *entradas*, are to be accepted.

Let's now see how well the claims of pre-Columbus explorers stack up with the evidence for the post-Columbus expeditions of Frobisher, Coronado, and de Soto.

St. Brendan and His Ox-Hide Boat

St. Brendan was an Irish priest who lived during the late fifth and early sixth centuries A.D. According to legend, Brendan was supposed to have embarked on a seven-year trip westward into the Atlantic Ocean. Three centuries later, his adventures were recorded in a work called the *Navigatio* (Ashe 1971).

According to that work, Brendan encountered various animals, people, places, and phenomena in his voyages: sea-cats, pygmies, giant sheep, talking birds, sea-monsters, floating columns of crystal, curdled sea, smoking mountains, and a place called the "Land Promised to the Saints." Some of the descriptions, though fanciful, may reflect actual events, phenomena, and places (Figure 6.2).

The details of the crystal columns provided in the *Navigatio*, for example, indicate that they were icebergs. The smoking mountains likely were volcanoes. Some of the more mundane parts of the *Navigatio* seem to describe actual islands in the northern Atlantic; a few of these islands can be identified with a degree of confidence simply by reference to the descriptions provided in the *Navigatio* (Ashe 1971:34–38).

Based on documentary and archaeological evidence, it is clear that wandering Irish monks called *anchorites* had indeed accomplished some rather remarkable feats of navigation in the sixth through eighth centuries A.D. (see Figure 6.2). Searching for places of quiet solitude where they could worship God, they settled the Orkney Islands in A.D. 579, the Shetlands in 620, and the Faeroes in 670 (Ashe 1971:24). They even beat the Vikings to Iceland, settling it in A.D. 795; the Viking sagas to be discussed later in this chapter mention the presence of these monks upon the arrival of the Norse.

Much is uncertain, however, about Brendan and his itinerary. He probably was an actual person, and he likely was a proficient sailor. But it is not clear how much of the *Navigatio* story was of a real voyage by Brendan, how much was an amalgam of numerous other voyages by other priests, how much was hyperbole, and how much was purely fantasy.

It is Ashe's well-reasoned opinion that much of the *Navigatio* was factual, whether it related to a specific voyage of a specific monk or not. The descriptions of various islands and natural features, though clearly viewed through the prism of a sixth-century perspective of the world, are often reasonable and recognizable.

However, as Ashe points out, when the so-called *Land Promised to the Saints*, identified by some as America, is described in the *Navigatio*, the literary style and content change considerably. The description is far more vague than for other places mentioned and sounds fantastic in the literal sense of that word. Though an experiment showed that a *curragh*, the name given to the hide boats of the Irish, could traverse the Atlantic intact (Severin 1977), there is ultimately no evidence that Brendan actually landed on the shores

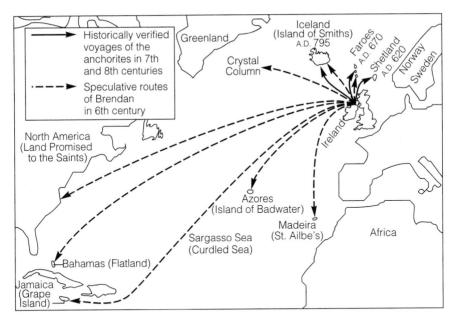

Figure 6.2 Map depicting the actual routes of exploration of Irish priests and proposed routes of Brendan in the sixth century A.D.

of America. No archaeological evidence has ever been discovered in the New World that indicates the presence in this hemisphere of sixth-century Irish monks. The examples provided in the cases of Frobisher, Coronado, and de Soto show that we should expect such physical evidence. But no artifacts attributable to sixth-century Irish monks—no crosses, no rings, no buttons—have ever been found in America. Without such evidence, the story of Brendan remains simply an interesting legend.

Fusang: The Chinese Discovery of America?

In 1973 a vessel dredging off the coast of California brought up a sizable rock, carved into the shape of a doughnut. In 1975, twenty or so similar stones were found by divers off the Palos Verdes peninsula in southern California. These discoveries generated a great deal of publicity at the time. Some suggested that the stones were identical to anchor stones used on Chinese sailing vessels as far back as A.D. 500. Reference was made to the Chinese legend of the land of *Fusang*, supposedly visited by a Buddhist monk about fifteen hundred years ago.

As Frost (1982) points out, Fusang was placed on the Asian coast by ancient Chinese mapmakers. Nevertheless, some have tried to identify

Fusang as America, carefully selecting elements of the legend that seem to reflect the biogeography of the California coast. Even some professional archaeologists suggested that the Palos Verdes anchor stones represented physical evidence of the ancient Chinese exploration of the west coast of North America—direct physical evidence like that seen in the examples provided by the expeditions of Frobisher, Coronado, and de Soto.

The Palos Verdes stones were examined by the geology department at the University of California, Santa Barbara, in 1980. Remember our discussion in Chapter 5 concerning tracing the raw materials from which ancient artifacts were made. If the anchor stones could be shown to have been made from rock present only in China, the case for a Chinese presence in the New World before Columbus would be much stronger. Unfortunately for the supporters of this hypothesis, it was determined that the alleged Chinese anchors were made of California rock (Frost 1982:26), most likely Monterey shale, a common local rock type.

The stones looked like Chinese anchors, however, because that is precisely what they were. Chinese American fishermen commonly trawled the waters of California in the nineteenth century. They sailed in their traditional craft, the junk. Indeed, the Palos Verdes stones are almost certainly the anchors, moorings, and net weights of these fishermen. They provide no help to those who wish to prove that Fusang is, in reality, ancient California because the anchors clearly were made locally by historically recognized Chinese sailors.

Prince Madoc and Welshmen in the New World

In the mid-1960s the Daughters of the American Revolution erected a historical marker on the shore of Mobile Bay in Alabama. It reads, in part: "In memory of Prince Madoc, a world explorer who landed on the shores of Mobile Bay in 1170 and left behind, with the Indians, the Welsh language."

Madoc himself appears to have been an actual historical personality who lived in the twelfth century A.D. He was a renowned or, more accurately, legendary sailor. In one of the stories about his exploits, he allegedly sailed westward from Wales in about A.D. 1170 and discovered a new land. Depending on which version of the story suits you, either he never returned, or he did come back, making several trips to this new land and bringing hundreds of Welsh settlers to the territory he had discovered.

This legend of discovery and colonization grew in popularity as northern Europeans began to settle the American Southeast and Midwest. Interestingly, as Richard Deacon (1966)—who accepts the historicity of Madoc's travels—admits, it was with the influx of Welsh emigrants to these very areas in North America that stories propagated of blue-eyed, light-skinned, Welsh-speaking Indians.

Unfortunately, many of the stories Deacon and other Madoc supporters relate are secondhand and contradict each other. We can read breathless accounts published in the eighteenth century of the Navajo, Cherokee, Aztec, or Mandan Indians being indistinguishable in culture, language, and skin tone from Welshmen. In many of these stories we see an underlying racist theme similar to that to be discussed in reference to the *Moundbuilder myth* in Chapter 7; where Indian villages are clean, where their houses are well made and streets neatly laid out, even where agriculture is the primary mode of subsistence, it is presumed that the Indians must really be Europeans. With a ready-made legend like that of the Welsh voyage(s), it was natural to associate those groups with Madoc and his band of travelers.

There is, however, one variety of physical, archaeological evidence presented by the Madoc supporters. These supposed confirming data consist of the ridgetop stone forts of Kentucky and Tennessee. In fact, Deacon (1966:202) attempts to trace Madoc's route in America from Mobile Bay, up the Alabama River into Kentucky and Tennessee, by the distribution of these sites.

Clearly the discovery of a single iron sword, a datable Welsh inscription, artifacts made from a raw material present in Wales, or the skeleton of a western European would have gone further in support of the Welsh hypothesis than would all the stories of Welsh-speaking, light-skinned Indians. But archaeologist Charles Faulkner (1971) found no physical evidence supporting the Welsh hypothesis when he excavated one of the better known forts in central Tennessee. Instead, the fort, which is really little more than a hilltop enclosed with a stone wall, contained artifacts made by American Indians, not Europeans. Included among the very few artifacts actually recovered were stone spearpoints and cutting and scraping tools. Carbon dates derived from charcoal found at the site and associated with its construction and use indicate that the stone fort was built and used sometime between A.D. 30 and 430.

If Madoc, indeed, did sail across the Atlantic into the Gulf of Mexico, into Mobile Bay, up the Alabama River, and eventually into Tennessee, he might have seen the stone forts credited to him and today presented as material evidence for his visits in the twelfth century. The Indians had already beaten him to it, having built them as much as one thousand years before. Here again, there is no physical evidence—no support in the archaeological record—for a Welsh presence in America before Columbus.

Africans in Ancient America?

Although not the first to suggest it, a professor of anthropology, Ivan Van Sertima (1976), has been the most eloquent proponent of the notion that African peoples discovered and settled in the Americas long before the voyages of Christopher Columbus.

In his book, *They Came Before Columbus*, Van Sertima supports his claim of an African presence in the pre-Columbian New World with various data. Among these are:

- 1. References in Columbus's writings to the presence of "black Indians" in the New World
- 2. The presence of a metal (*gua-nin*) purported to be African in origin, reported by Columbus
- 3. Pre-Columbian skeletons with "Negroid" characteristics
- 4. Artistic representations of black Africans at sites in the New World that predate the voyages of Columbus

While some of the kinds of evidence cited by Van Sertima are in line with the discussion in Chapter 5 concerning what is necessary to trace the prehistoric movement of people, the actual data presented fall far short of that needed for a convincing case.

For instance, Columbus does not claim to have seen black-skinned Indians; he merely passes along a story told to him by a group of Indians he did contact. Columbus also passed on the report of Indians with tails, so such evidence is highly suspect.

The report of the metal called *gua-nin* is similarly unconvincing. We do not have the metal to examine, none has ever been found in archaeological excavations in the New World, and we certainly cannot rely on five-hundred-year-old assays of the metal that Van Sertima maintains indicate its African identity.

As stated in Chapter 5, one way to trace the movement of prehistoric people focuses on skeletal analysis. Van Sertima cites analysis of a small number of skeletons found in the New World, particularly in Mesoamerica, that ostensibly have indicated the African origin of some individuals. Here again the evidence is quite weak, with either the African character of the skeletons being questionable or the dating of the bones uncertain. Europeans brought black slaves to the New World as early as the sixteenth century, and some of the skeletons found in the New World cited by Van Sertima are likely those of early, but post-Columbian, slaves.

Van Sertima's assertion that there is ample evidence of the presence of black Africans in the New World in the form of artistic representations of individuals who look African is, perhaps, the weakest link in an already weak chain of reasoning. The weakness lies in the subjective nature of the assertion. For example, Van Sertima points to the physiognomies of the so-called Olmec heads of lowland Mesoamerica—huge pieces of basalt carved into human heads between 3,200 and 2,900 years ago by the bearers of what is almost certainly the first complex culture in Mesoamerica (Stuart 1993) (Figure 6.3). Altogether, fewer than twenty of these carved heads have been found ranging from about 5 to 11 feet in height.

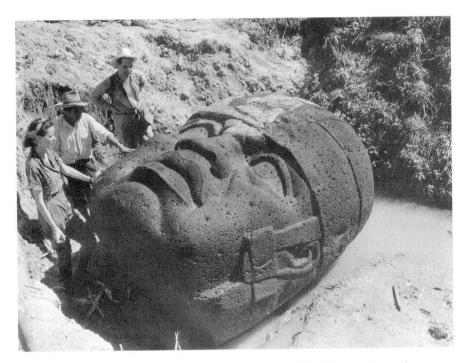

Figure 6.3 An example of a giant carved stone head of the Olmec culture of Mesoamerica. These 80-ton carvings in hard volcanic rock are evidence of an advanced society in Mesoamerica three thousand years ago. For some, the facial features of the Olmec heads are evidence of an African origin for that advanced culture. However, there is no evidence for an African presence in ancient Mesoamerica. (By Richard H. Stewart © 1947 National Geographic Society)

Van Sertima asserts that they are clearly African in appearance, and indeed they do possess full lips and broad noses. Van Sertima, however, ignores the fact that many of the Olmec heads also have flat faces like American Indians, not prognathic profiles (jutting-out lower faces) like Africans. He also chooses not to see what appear to be epicanthic folds on the eyelids of the statues—as mentioned in Chapter 5, these are typical of Old World Asians and American Indians. It is also the case that American Indians exhibit a broad range of features and some, in fact, have full lips and broad noses—at the same time they possess other, more typically Indian physical features (Sabloff 1989). Most archaeologists interpret the Olmec heads as stylized sculptures, perhaps representing the faces of their rulers or chiefs.

Many other specific responses could be provided to refute particular claims made by Van Sertima. It is more important, however, to point out the deductive implications of his hypothesis and the lack of confirming evidence. If Africans truly were present in the New World in large numbers

before Columbus and if they had a substantial impact on indigenous cultures, there should be ample evidence in the archaeological record of artifacts, raw materials, and skeletons—the kinds of cultural and biological evidence that archaeologists regularly find and analyze—to support this claim. We would find more than enigmatic statues and vague historical references. Archaeologists should find clear evidence of material remains reflecting an African rather than an Indian pattern in housing, tool-making, burial of the dead, ceremonies, and so on. Without such evidence, the claim of an African discovery and settlement of the New World remains unproven.

Interestingly, a large part of *They Came Before Columbus* focuses not on evidence of an African discovery of the New World but on the *capability* of ancient African peoples to have accomplished this feat. Van Sertima argues correctly that the cultural achievements of indigenous, black African cultures have been ignored by Western scientists for too long. Of course, we should all acknowledge the accomplishments of the peoples of ancient as well as modern Africa and the great contributions their cultures have made to the world (Connah 1987). Nevertheless, as certain as it is that a number of ancient African cultures possessed the political complexity, navigational skills, technology, and material culture necessary to have explored the New World, this is not proof that they did so.

What about the ancient Mesoamerican cultures themselves? Is there any indication that complex skills evidenced in the archaeological record—things like pyramid building, fine art, stone sculpting, or writing—appeared instantly and without any antecedents, as if introduced by outsiders like Van Sertima's seafaring Africans? The answer is a definitive "no."

For example, small agricultural communities had been developing in the Gulf Coast lowlands of Mesoamerica since about 5000 B.P. Archaeological evidence shows that as time passed, these small, egalitarian, and independent farming villages slowly became interconnected communities with stratified social systems led by great chiefs by about 3,250 years ago (Diehl 1989). This was an evolutionary process, resulting from internal patterns and processes at work for millennia.

Population growth and unequal access to rich farmland, not the presence of African explorers, provide an explanation for how this happened. The richest farmland was located along natural levees produced by rivers that flow through it. These rich lands attracted a relatively larger portion of the growing population in the tropical lowlands. Archaeologist Michael Coe (1968) has suggested that families that controlled these productive lands produced agricultural surpluses, allowing them to amass wealth and power. The powerful members of the evolving elite were able to mobilize large regional populations to produce monumental works to symbolize and legitimize their status (Lowe 1989).

Gulf Coast farming villages that were located on the best lands became regionally significant as the residences of this developing upper class. Three villages in particular—San Lorenzo, Tres Zapotes, and La Venta—became

ceremonial centers where a group of art motifs and architectural patterns developed to symbolize the power of the elite class. These motifs and patterns are what we now use to define and identify "Olmec":

- · Depictions of a half-human, half-jaguar god
- · The use of jade
- Iron ore mirrors
- Construction of large earthen platforms
- Construction of earthen pyramids (the pyramid at San Lorenzo is more than 32 meters [105 feet] high and contains more than 2 million cubic meters [75 million cubic feet] of earth)
- The carving of huge basalt boulders depicting Olmec rulers and weighing up to more than 18,000 kilograms (20 tons) each (the source of the basalt was more than 95 kilometers [60 miles] away from these Olmec centers)

The Olmec cultural system relied on the labor of tens of thousands of people living in farming villages in the area surrounding each ceremonial center to produce the fine art and monumental construction projects that characterize these sites (Adams 1991).

The Olmec were responsible for one more significant innovation; they produced the earliest writing in the New World. At Tres Zapotes, a carved monument called a *stela* bearing a hieroglyphic inscription was found. The writing on the stela can be read because the symbolic system used was the same as that used by the Maya (see Chapter 12). Stela C at Tres Zapotes bears the date corresponding to our year 31 B.C. This first Olmec writing bears no relationship whatsoever to any writing ever found in Africa, which is peculiar indeed if ancient Africans introduced civilization to the Olmec.

Again, to assess the origin of things like the huge Olmec sculptures, we must focus not on subjective assertions about what or who they may look like but on the cultural context of these artifacts within Olmec society. Artifacts like the basalt heads that Van Sertima cites as evidence of an African influence cannot be viewed in a vacuum. Surely such things demanded a level of technical competence, but they also required a complex social/ political/economic infrastructure. Labor had to be conscripted to quarry the stone, to transport it across many miles, and to carve it. Workers needed to be fed and housed, and their labor had to be organized and overseen. It is highly unlikely that a small group of interlopers, even if they had been present, could possibly have so altered a society over a short period of time to produce all of the manifold cultural systems needed to create the stone heads—and the pyramids, jade carvings, earthen platforms, and so on. Of necessity, the sculpted heads could have been produced only as one part of a complex pattern of behaviors and abilities that must have evolved together over a lengthy period of time.

This is precisely what the archaeological record shows. In fact, there is no physical evidence to validate the claimed presence of African visitors to Mesoamerica before Columbus. The notion that this unproven presence was a crucial factor in the development of complex societies in the New World flies in the face of a wealth of archaeological evidence that clearly shows the complex and independent evolution of those societies over a lengthy period of time.

Afrocentrism

Unfortunately, Van Sertima's claim of an African presence in Mesoamerica long before Columbus has become entrenched dogma among some espousing an "Afrocentrist" perspective of history. Afrocentrism has a laudable goal: to disclose the enormous but often ignored contributions made by African people to the sciences, medicine, philosophy, literature, and art. Unfortunately, in this effort some Afrocentrists ignore established historical and scientific fact and make claims of an African source for things that clearly can be shown to be non-African. Some Afrocentrists assert that much of European science and philosophy was literally "stolen" from African sources (James 1954). For example, it has been asserted that the Greek philosopher Aristotle secretly visited the Egyptian city of Alexandria and pillaged the great library there, taking the best ideas of African thinkers and presenting them to the world as his own. But this is an impossibility. Aristotle died in 322 B.C., and the library at Alexandria was not established until 297 B.C. twenty-five years after his death (Lefkowitz 1996). In fact, we know that the library was assembled by one of Aristotle's students and that most of the works there were written in Greek, not Egyptian.

The erroneous notion that the great civilizations of Mesoamerica were, at least in part, inspired by Africans has become part of Afrocentrist dogma along with the extraordinary claim that skin pigment itself imparts supernatural powers (the more pigment, the darker the skin and the greater the paranormal abilities—see Ortiz de Montellano 1991 and 1992 for an exposé on these claims). Sadly, some of these discredited claims have even been incorporated into public school curricula.

Africans in Ancient America: The Verdict

An interesting irony is inherent in Van Sertima's argument. Although he is quite concerned about the racism inherent in assumptions about the lack of skills of ancient African peoples, his assumptions about American Indian cultures are similarly suspect. After all, it is his contention that either a small group of invading Africans was the necessary catalyst for the development of civilization in the New World, or else a small group of Africans was

quickly able to take over and direct the development of an emerging New World civilization. His protestations to the contrary notwithstanding, bias appears inherent in either proposal.

As an anthropologist, Van Sertima clearly recognizes the sort of evidence necessary to validate his hypothesis; he is not a pseudoscientist. The evidence he provides is simply not strong enough to support his case.

America B.C.?

Reading the works of retired Harvard marine biologist Barry Fell (*America B.C., Saga America*, and *Bronze Age America*) brings to mind the approach of seventeenth-century Spanish Jesuit Gregoria Garcia, discussed in Chapter 5. Just as Garcia seemed to believe that virtually every Old World culture contributed to the population of the New World, Fell seems to describe the Atlantic as a freeway for exploration of the Americas long before Columbus.

Beginning with Libyan sailors in the fourth millennium B.C., Fell provides ostensible evidence, not just for the discovery but also for the exploration and colonization of the Americas by Iberians (people from Spain and Portugal) 3,000 years ago, Celts 2,800 years ago, Greeks 2,500 years ago, ancient Hebrews about 2,000 years ago, and Egyptians 1,500 years ago.

Fell's assertions lack scientific, skeptical, or deductive reasoning. He and adherents like Trento (1978) and Feldman (1977) do not claim that these various Old World groups simply discovered America or that they merely explored it. It is Fell's contention that these peoples settled the Western Hemisphere, apparently in large numbers, many years before Columbus. It is his further claim that there was a regular flow of commerce between the Old and New Worlds over many years and that the presence of these interlopers had a significant impact on indigenous peoples.

Virtually all archaeologists and historians in the New and Old Worlds who have had something to say concerning Fell's claims have been skeptical, and some have been downright hostile (Cole 1979; Daniel 1977; Dincauze 1982; Hole 1981; McKusick 1976; Ross and Reynolds 1978). And with good reason. Fell ignores much of the archaeological and ethnographic records of the New World.

The three categories of ostensible evidence he does provide in his books are:

- Alleged linguistic connections between American Indian languages and many different European tongues
- 2. Inscriptions found in the New World in many ancient European alphabets
- 3. Architectural similarities between stone structures mainly in New England and those in western Europe

Linguistics

Two scientists at the Smithsonian Institution have examined Fell's claims of linguistic similarities between American Indian and European languages such as Egyptian, Celtic, Norse, and Arabic (Goddard and Fitzhugh 1979). Fell's basic approach is to select words in particular Indian and European languages that sound alike (or can be made to sound alike) and can be interpreted as having similar meanings. He then concludes that the Indian language must be derived from that of the Old World group. Fell's approach here has long ago been discredited by linguists; it is little different from that of those speculative thinkers in Europe in the sixteenth through nineteenth centuries who attempted to trace American Indians to various Old World peoples (Chapter 5).

Goddard and Fitzhugh point out that such an approach is pointless; the correct pronunciation of many of the Indian words is very rarely known. Furthermore, merely comparing words ignores facts of grammar that are much more important in language comparisons. With relatively few common sounds making up the countless words of most human languages, coincidental similarities are bound to show up if you look hard enough. For example, as Mesoamericanist Pedro Armillas (personal communication) points out, the Latin word for "little eyes" is *ocelli*. "Little eyes" look like little spots and in Nahuatl, the language of the Aztecs, a spotted cat is an *ocelot*. Such word-by-word comparisons can show word similarities in many different languages with absolutely no historic connection. The Indian words that Fell claims are derived from European sources can be traced; they have a linguistic history within their own languages. There is no evidence that they suddenly entered a language, which would be expected if they had been borrowed from elsewhere.

Inscriptions

Fell, though trained in biology, also claims expertise in epigraphy (deciphering ancient inscriptions). He asserts that there are literally hundreds of examples of ancient inscriptions in various Old World alphabets scattered throughout the New World. Yet here Fell ignores definitive evidence concerning some of his important artifacts. For example, inscribed tablets from Davenport, Iowa, well known to be nineteenth-century fakes, are cited by Fell as positive evidence of the exploration of midwestern North America by a fleet of Egyptian ships, under the command of a Libyan skipper in the ninth century B.C. (1976:261–68). See Chapter 7 (Figure 7.5) for a description of the unmasking of the fakes (and see McKusick 1991 for a detailed accounting of the entire story).

Moreover, as Goddard and Fitzhugh maintain, among even those inscriptions where fraud cannot be proven, "all of the alleged ancient New World inscriptions examined by specialists to date have been found to contain linguistic or epigraphic errors or anomalies consistent with modern manufacture but inconsistent with a genuine ancient origin" (1979:167).

Beyond the fakes, Goddard and Fitzhugh point out that many of Fell's inscriptions are simply random marks on rock. Archaeologist Anne Ross and historian Peter Reynolds (1978) examined a sample of the marked stones translated by Fell. They point out that obvious marks on the stones that do not match Fell's alphabetic interpretations are simply ignored by him. They view many of the so-called inscriptions as simply the result of natural erosion or plow marks. A plow blade can repeatedly scratch a rock in the soil, leaving a series of lines. Fell interprets these lines as conveying meaningful messages in an alphabet called *Ogam*—a well-known alphabet based on Latin that dates to the fourth century A.D. in western Europe. It was used exclusively to write in early Old Irish.

Fell claims that the Ogamic inscriptions he has interpreted in New World locations are sometimes much older than this. He further claims the New World versions were written without vowels (one simply adds the "necessary" vowels), recording words in a number of different languages. Anne Ross, a British expert on Ogam who has examined many of the alleged Ogam inscriptions in New England, finds this to be a "semantic phantasy of the wildest nature" (Ross and Reynolds 1978:106).

As Goddard and Fitzhugh state, Ogam is, indeed, a record-keeping system that consists largely of simple strokes, so any process that produces lines in rock can superficially resemble Ogam. Then, as they state, in Fell's approach "it is a matter of little further difficulty to select words from this range of languages to match against the string of consonants which have been read" (1979:167).

More recently, Celtic scholar Brendan O Hehir performed a methodical analysis of one of Fell's translations, a so-called "Christmas message" inscribed on a rock in West Virginia. His is an incredibly detailed, line-byline, word-by-word, and even letter-by-letter analysis of the inscription and Fell's translation (O Hehir 1990). There is little doubt in his mind; O Hehir characterizes Fell's work as "a stupid and ignorant fraud" and "ignorant gibberish" (p. 1).

Architecture

A site that seems to be a cornerstone in Fell's argument is located in North Salem, New Hampshire (Goodwin 1946). Fell claims the site is the remnant of a 3,000-year-old settlement of migrants from western Europe. Fell and his supporters assert that the architecture of the stone structures at the site is the same as that of Europe during this period. At that time in western Europe, the so-called *Megalith* builders were busy working in stone, constructing monuments like Stonehenge in England (see Chapter 12), Carnac in

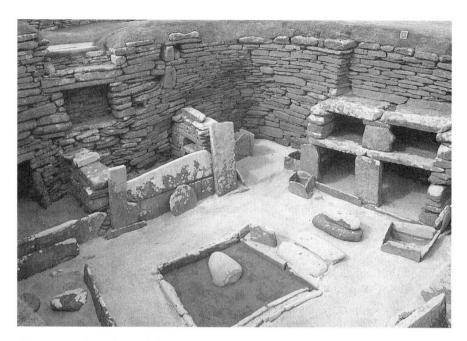

Figure 6.4 The village of Skara Brae on the main Orkney Island in northern Scotland was built more than four thousand years ago. The walls, hearths, and even the storage areas of the seven structures found there were constructed of stone. The style of architecture seen at Skara Brae only superficially resembles much later construction in the New World. (K. L. Feder)

France, and thousands of smaller sites. Their habitations, like Skara Brae on the Orkney Islands, were also built of large pieces of stone (Figure 6.4).

The New Hampshire site consists of numerous stone structures and features (Figure 6.5). William Goodwin, a retired insurance executive from Hartford, Connecticut, purchased the site in 1935 and spent the rest of his life rebuilding parts of it and trying to prove that it was the settlement of ancient Europeans—specifically Irish *Culdee* monks in the tenth century A.D. For years it was called *Mystery Hill*, though now the owners prefer the name *America's Stonehenge*.

The architecture at sites like Mystery Hill must be examined in an overall cultural context. The stone structures superficially resemble those found in ancient Celtic sites in England, Wales, Scotland, and Ireland, but is that enough to prove that ancient Celts settled the New World?

Archaeologist Robert R. Gradie (1981) provides a good argument for a negative answer to this question. He points out that there may indeed be a relationship between the stone structures in Great Britain and New England—but not as a result of pre-Columbian, seafaring Celts.

Gradie shows that in Europe, stone chamber building very much like that of the Megalith culture continued as so-called *vernacular architecture* into

Figure 6.5 The admittedly strange stone structures of Mystery Hill, North Salem, New Hampshire, are part of an idiosyncratic site most likely built by colonists in the eighteenth or nineteenth centuries. Some insist that the site is far older, built by European settlers of the New World more than three thousand years ago. (K. L. Feder)

the twentieth century. Ross and Reynolds point out that such stone structures have been built recently enough for living people to remember their construction (1978:103). In the past few centuries farmers in western Europe built root cellars and storage buildings using the same methods people had used centuries and even millennia before when they built ceremonial structures. Some of these farmers migrated to New England in the seventeenth and eighteenth centuries, naming counties and towns after their Celtic homelands and maintaining aspects of their material culture—including the style of their outbuildings. Gradie suggests that the stone structures at sites like Mystery Hill were, indeed, built by Celts, but of a much more recent vintage than Fell asserts.

The Archaeological Verdict

As I stated at the outset of this discussion, archaeological evidence is necessary to assess hypotheses of the ancient pre-Columbian presence of Old World peoples in the New World. Even Mystery Hill's original champion, William Goodwin, agreed that "the modern world of thought lays more stress on proof by archaeology than on oral or written traditions. This is as it should be" (1946:206). What, then, does the archaeological record at Mystery Hill and other sites indicate?

Archaeologists sympathetic to such claims have recognized the fact that such evidence is limited or nonexistent. For example, Stephen Jett (1971, 1992a, 1992b) has listed discoveries of supposed Old World artifacts at New World sites. He admits that:

Since few of these objects or inscriptions have been discovered and reported in a fashion that permits confidence in the dating or even in the genuineness of the sites, these finds cannot be accorded much significance. (1971:30)

Recently, David Kelley (1990) has become one of the few archaeologists to accept Fell's general claims of pre-Columbian Old World exploration of the Americas based on the presence of epigraphic evidence. However, he also clearly recognizes the problem of a lack of expected archaeological evidence for such a presence: "I am greatly bothered by the absence of comparable artifact assemblages in association with the many Ogham inscriptions" (1990:10).

Even those sympathetic to Fell's claims agree that the inscribed rocks cannot be viewed in a cultural vacuum. Claims of an Irish, Chinese, Welsh, Celtic, Egyptian, or Norse presence in the New World before Columbus must be viewed in a broad anthropological context, and there should be other supporting evidence.

Context is crucial. Consider the story archaeologist Dean Snow (1981) relates of the remarkable discovery of an ancient Roman coin in California. Does such a discovery provide support for a hypothesis of pre-Columbian Roman settlement of the west coast of North America? The context of the coin argues otherwise; it was found in a parking meter in downtown Los Angeles.

Without consideration of archaeological context and implications, inscribed stones (or Chinese anchors, stone forts, or sculpted heads) mean little. We know from the archaeological record that human groups, especially when they settle in large numbers, leave much more than enigmatic graffiti. They lose and discard stuff that is unique to their culture, and we archaeologists should be able to find it. Using the context as a guide, we can determine when it was deposited and trace it to a particular group of people.

If Fell's Celts were here in the numbers he claims and for the length of time he suggests, the evidence would be at least as clear, as obvious, and as recognizable as that seen for the Frobisher, Coronado, and de Soto expeditions discussed earlier in this chapter. What, then, does the archaeological record indicate for Fell's hypothesis?

Unfortunately for Goodwin and Fell, there are no archaeological artifacts at all to bear witness to the presence of pre-Columbian interlopers at Mystery Hill or other similar sites. If the people Goodwin or Fell claims were here actually were here in the numbers implied, they had to have been the

neatest people ever to grace the planet. They picked up everything, leaving nothing for the archaeologist to recover and analyze. This represents, by itself, a fatal blow to the arguments of Fell and his supporters.

For example, while on a visit to Mystery Hill, I asked the guide why their small museum had one large glass case of stone artifacts found at the site and clearly of local Indian manufacture and one glass case filled with the pottery, brick, and iron nails of nineteenth-century inhabitants, but no case filled with the European bronze tools of the supposed "Bronze Age" European settlers of the site? The guide responded, "You don't think those ancient people would have left all those valuable bronze tools just lying around, do you?" I responded that they most certainly had left "all those valuable bronze tools" lying around in Europe; that's how we know it was the Bronze Age—archaeologists find such objects. In other words, I was simply asking that the archaeological context be considered. I was told, in essence, that there was no archaeological context.

It has even been reported that this clear lack of any conventional archaeological evidence has been used to indicate the ritual significance of the site. An excavator of Mystery Hill, after fruitlessly searching for any confirming evidence of a Celtic presence at the site, commented in this way: "It's spooky; I've never seen a site as clean as this one" (as reported by Tarzia 1992:6). Thus, a lack of any evidence whatsoever is interpreted as enormously significant, indicating the obvious ritual significance of the place.

To be sure, Fell maintains that some archaeological evidence exists to support his hypothesis about Mystery Hill and other sites. For example, he claims that Old World bronze tools have indeed been discovered in North America. He shows some of these artifacts in a figure on page 96 of *America B.C.* and labels them "bronze weapons." Since American Indians in North America did not manufacture bronze, such items "must represent European imports." But the tools Fell pictures are, in fact, not bronze, but copper—a metal well known to many Indians who used pure deposits of the element (see Chapter 7). How could Fell not have known this (Sullivan 1980:46–47)?

An archaeological excavation was conducted at Mystery Hill. In the 1950s the organization that controlled the site, The Early Sites Foundation, hired Gary Vescelius, a Yale University graduate student in archaeology, to excavate. Their hope was that artifacts would be found that would support the hypothesis that the site had been built and occupied by ancient European immigrants to the New World. In hiring an archaeologist to excavate at the site, they were recognizing that an archaeological context was necessary. They were admitting, in a sense, that architectural similarity was not enough, that it merely suggested the possibility of a connection between the Old and New Worlds. Archaeological evidence of the kind of people who lived at the site was necessary to support the hypothesis—the kind of evidence discussed in Chapter 5, including entire complexes of artifacts found

only in ancient Europe, the skeletal remains of identifiable Europeans, and artifacts made of raw materials from European sources, all in a context that could be dated to before Columbus.

Vescelius (1956) found nothing of the kind. He recovered some seven thousand artifacts in his excavation. They all were clearly of either prehistoric Indian manufacture (dating to an occupation of the site before the stone structures were built) or nineteenth-century European manufacture—ceramics, nails, chunks of plaster, and brick fragments. The archaeological evidence clearly pointed to a nineteenth-century construction date for the site. Precisely the same results were derived from excavations at *Gungywamp*, in Groton, Connecticut, a similar site that Fell claims is of ancient Celtic vintage (Jackson, Jackson, and Linke 1981). All the artifacts found at Gungywamp were of a much more recent date.

Finally, regional surveys have been performed on sites in Massachusetts (Cole 1982) and Vermont (Neudorfer 1980), where stone structures suggested by some to be of ancient Celtic origin are found. Both projects show quite clearly and definitively that the stone structures were part of historic, colonial patterns of land use and construction.

Cole found absolutely no archaeological evidence in the thirteen sites he investigated that the stone structures were built by pre-Columbian settlers; all the structures were part of a known pattern and most were, in fact, parts of complexes of buildings and features (farms, mills, a hotel) known to date to the nineteenth century.

Neudorfer (1980) conducted a 3-year project, examining forty-four stone chambers in Vermont, taking measurements and searching for historic contexts for the structures. She found that with one exception, all the structures, *including seven specifically identified by Fell as being Celtic temples*, were associated with eighteenth- or nineteenth-century farm complexes (p. 56). In one case she was even able to come up with the name of the actual nineteenth-century builder of one of the chambers Fell maintains is ancient Celtic in origin.

Neudorfer found that the stone chambers, far from being enigmatic, were a common part of farm culture in historic New England. She found in some cases that the style of masonry of the chambers was identical to that of the foundations of nearby historic farmhouses. Further, she found eighteenth- and nineteenth-century publications describing the best methods for building such structures for cold storage of fruits and vegetables. Whereas Fell claims that the southerly or easterly orientation of the chamber entrances reflects ancient Celtic ceremonies, the farm publications Neudorfer located advised eighteenth- and nineteenth-century farmers to orient the openings of their root cellars to take advantage of the position of the winter sun in the southern sky, thereby preventing freezing in the cellars.

Perhaps the most significant contribution of Neudorfer's work rests in her showing the historic context of the stone chambers. Could ancient Celts have traveled to New England and built stone temples? Certainly it is possible, but it is also *possible—and far more probable*—that these structures were eighteenth- and nineteenth-century farm buildings. As archaeologist Dena Dincauze (1982) points out, Occam's Razor should be applied here. The chambers fit in with everything we know about historic farmers in New England, and this explanation requires no other assumptions. As Dincauze states, Neudorfer's argument and evidence "shifts an apparently immovable burden of proof onto the shoulders of those who would claim otherwise" (1982:9–10).

Finally, Neudorfer points out that the mystery associated with the stone chambers of New England is a product of a sort of cultural amnesia. Common, everyday aspects of life like the stone chambers have been forgotten and now appear to be enigmatic. They are a reflection of a time not so distant by absolute chronological measurement, but hugely distant from the modern world of computers, space shuttles, and fax machines. As a result, for example, common nineteenth-century tools for converting lye to soft soap (Swauger 1980) have become sacrificial altar stones for some (as stated in the pamphlet distributed at Mystery Hill), even though artifacts similar to the so-called sacrificial stone can be found in museums devoted to New England farm life (Figure 6.6). In the same manner, animal-powered bark mills have been transformed into mysterious temples, even though photographs exist of bark mills in operation—and they look remarkably similar to the feature in question at the Gungywamp site (Figure 6.7; Warner 1981). We are so removed from these once common architectural features that today we need primers to remind us of what was part of everyday life (Sanford, Huffer, and Huffer 1995). Unfamiliar they may now be, but mysterious, alien, or ancient they are not.

The Viking Discovery of America

The Viking *sagas* are compelling tales of adventure and discovery, life and death. The sagas were handed down orally for generations and recorded hundreds of years after the events they celebrated actually transpired. Among the tales told in the sagas are a number concerning the Viking discovery, exploration, and settlement of Iceland and Greenland. Also described in the sagas is a story of the discovery of another new country. That country, it has been claimed, was North America.

Two sagas in particular tell the story of this new land: The *Greenlander's Saga* and *Eirik the Red's Saga*. The *Greenlander's Saga* relates the following tale (*Eirik the Red's Saga* differs in some particulars but describes essentially the same events); the summary is based on the English translation of the sagas by Magnusson and Paulsson (1965).

Soon after A.D. 980, Eirik Thorvaldsson, known as Eirik (Erik) the Red, was banished from his home on Iceland for having killed two men (his

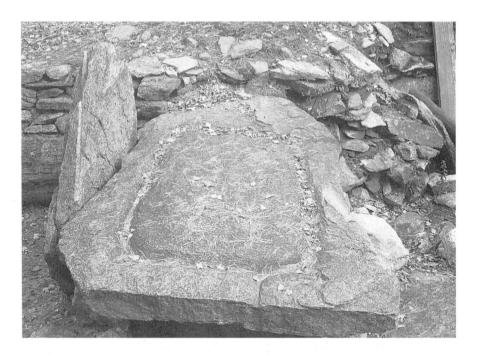

Figure 6.6 The so-called sacrificial altar stone at Mystery Hill (top) is presented by some as a unique and romantic artifact, evidence of a population of pre-Columbian interlopers practicing ceremonial sacrifices. However, the grooved stone platform at Mystery Hill is anything but unique; it is a common artifact found in historical New England farming communities, used in the rather unromantic production of soap. The similar "lye stone" in the bottom image is located at the Farmer's Museum in western Massachusetts. (K. L. Feder)

Figure 6.7 Some claim that the seemingly mysterious circle of stones at Gungywamp, Connecticut (top) has mystical significance within an early European religious context—proof, therefore, that pre-Columbian Europeans had settled Connecticut. However, other, similar historically documented—and photographed—features are known to have been used by more recent settlers of New England as bark mills for the extraction of chemicals for hide tanning (bottom).

father before him had been banished from Norway for the same offense). The dispute had likely resulted from the growing struggle for land and power on the island nation (McGovern 1980/81). Discovered in A.D. 860 and settled initially by the Vikings in A.D. 870, Iceland's population had grown to nearly fifty thousand, and land was at a premium (Jones 1982).

Outlawed because of his crime, Eirik left his home on Iceland and sailed westward, searching for and verifying the existence of a land that had previously been sighted. Eirik, in an attempt to reestablish a land and power base, returned to Iceland, encouraging people to follow him to this newly discovered land. He called it *Greenland*. Though it was largely covered by glacial ice, Eirik gave the land its name in an early case of deceptive advertising; as the saga writers stated, "People would be more tempted to go there if it had an attractive name" (Magnusson and Paulsson 1965:50).

Established in A.D. 985–86, the Greenland colony attracted many disaffected with the political turmoil of Iceland and grew to a population of about five thousand (McGovern 1982). The Norse succeeded in carving out a life for themselves in Greenland for five hundred years; their archaeological sites are plentiful, represented by the remains of some four hundred farmsteads and seventeen churches clustered in two major settlements (the Western and Eastern) (Ingstad 1982:24). The archaeological remains of the Greenland Norse provide a model for what such a colony in the New World might look like.

In Greenland the Norse stubbornly adhered to a traditional dairy farming economy in a place ill-suited to this way of life. They essentially refused to change their mode of subsistence, ignoring local resources—fish, for example—and declining to adjust to native conditions. The mystery of the Greenland colony is not why it failed but, as archaeologist Tom McGovern points out, how it survived for five hundred years (Pringle 1997). Recent paleoclimatological research has shown not only that the climate was marginal for the Norse when they arrived but that things got substantially worse, with summers getting colder between A.D. 1343 and 1362. It is not surprising then that a Norwegian priest sailing to the Western Settlement in 1361 found the entire community abandoned. All of the Norse were gone from Greenland by A.D. 1500.

A New Found Land

The same year the Greenland colony was established, a Viking ship captained by Bjarni Herjolfsson got lost in a storm on the journey from Iceland to Greenland. After about four days of sailing he sighted land. Bjarni could not identify the country and continued to sail, sighting at least two other lands before finally reaching Greenland by sailing *east*. Bjarni and his men did not set foot on these new unidentified lands. Later, he was to be criticized for not exploring these possibly valuable territories. Bjarni was more a farmer than an explorer, yet this relatively unknown Viking is likely the first European to have sighted America.

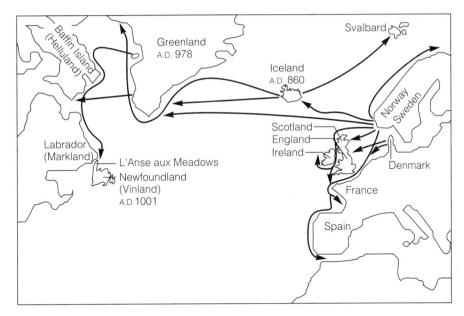

Figure 6.8 Map of Viking explorations of the North Atlantic, including their probable route to the New World in the late tenth and early eleventh centuries A.D.

Despite the fact that the Greenland settlement was prospering and growing at the end of the tenth century, or maybe because of its success and growth, the possibility that new lands might be found to the west intrigued many. Eirik's son, Leif, spoke to Bjarni about his accidental discovery and even purchased his boat. He set sail with thirty-five men around A.D. 1000 to search for these new lands. According to the *Greenlander's Saga*, following Bjarni's directions backwards, Leif made landfalls on the three new lands. He called them *Helluland* (flat-stone or slab land), *Markland* (forest land), and *Vinland* (wine land) (McGovern 1980/81). On Vinland, Leif built some sod houses (called *booths*) and used these as a base from which Vinland could be explored (Figure 6.8).

After this initial exploration, Leif returned to Greenland and told of the richness of Vinland; there were salmon in the rivers, wild grains (probably wild rice) in the meadows, abundant grapes, and so on. Soon thereafter, Leif's brother, Thorvald, traveled to these newfound lands and investigated them for about a year. He encountered natives of the new land, called them *Skraelings*, and was killed in a battle with them. He was buried on Vinland, and the rest of his men returned to Greenland.

In A.D. 1022, Thorfinn Karlsefni led at least 65 and perhaps as many as 160 colonists from Greenland to attempt a permanent settlement of Vinland. Families came, and farm animals were brought along. They built homes and began farming the land. After about a year, however, following a bitter battle with the Skraelings, the colony was abandoned. This first attempt to

establish a permanent European settlement in the New World failed, according to *Eirik the Red's Saga*, because "although the land was excellent they could never live there in safety or freedom from fear, because of the native inhabitants" (Magnusson and Paulsson 1965:100). History might have been substantially different had this not been the case. One final attempt was made to settle Vinland, but this too ended in failure.

Where Was Vinland and Who Were the Skraelings?

McGhee (1984) points out that the sailing directions in the sagas, as well as the geographical and environmental descriptions of the islands Leif explored, suggest quite strongly that Helluland is Baffin Island, Markland is Labrador, and Vinland is Newfoundland, all in Canada. The Skraelings, then, were American natives, most likely Indians rather than Eskimos (Fitzhugh 1972:191–95; Jones 1986:130–34).

There is one unexplained mystery though. Vinland is named for the wine that could be made from the wild grapes that grew there, and there are a number of references to such grapes in both the *Greenlander's Saga* and *Eirik the Red's Saga*. Newfoundland was too far north, however, for wild grapes to grow even when the climate was warmer a thousand years ago. Analysis of pollen preserved at ancient sites in Newfoundland indicates that the flora during Viking occupation was not that much different from today, when grapes cannot grow (Henningsmoen 1977). Explanations for this have varied (Jones 1986:123–24). Nevertheless, wherever Vinland actually was, the sagas seem to indicate quite clearly that the Vikings indeed discovered, explored, and attempted to settle the New World about five hundred years before the Columbus voyages.

The Vinland Map

When the so-called Vinland Map first surfaced (or resurfaced), many historians and cartographers believed it to be genuine, dating to about A.D. 1440, more than fifty years before the first voyage of Columbus to the New World. It was initially believed that the map was a copy of an even older work based on Viking knowledge of the geography of northern Canada (Skelton, Marston, and Painter 1995). Greenland and Vinland are shown and named on the map.

Some, however, were skeptical of the map's authenticity, and famed microscopist Walter McCrone was brought in to examine it. Using a polarized light microscope to assess its visual characteristics, McCrone (1976, 1988) found that the black ink used to outline the various continents and islands depicted on the map appeared to have diffused as a yellow band around the line itself. This is typical for old inks and normally takes hun-

dreds of years, so its presence seemed to argue for the map's antiquity. However, McCrone determined that this yellow band around the ink line was not, in reality, diffused ink, but rather a separately drawn, wide band of chemically distinct yellowish ink. The thin black line had been drawn over the yellow band along its center across most of the map. In other words, under the microscope it appeared that a clever forger had known that an old map would show a creeping of the ink out along the margins of the map lines. The forger could not wait, of course, for hundreds of years for this yellow band to appear, so he or she simply drew a yellow band first, and then drew the black ink line over it, simulating an appearance of antiquity.

When McCrone analyzed the chemical makeup of the yellow band with a scanning electron microscope and electron and ion microprobes, he found the presence of titanium dioxide, the chemical name for a slightly yellow pigment called anatase or titanium white. This pigment was not manufactured until 1917 and required a technology unknown until that time. The Vinland Map was drawn, according to McCrone, not in the fifteenth century but in the twentieth; it was a fake.

The story does not end here, however, as a subsequent analysis by Thomas Cahill (1987) using a different set of high-tech instruments (particle-induced x-ray-emission spectroscopy) failed to support McCrone's identification of the twentieth-century pigment anatase. Cahill found only trace amounts of titanium and claimed that other, authentic documents also had trace amounts of titanium. McCrone vigorously disputes Cahill's analysis.

And there it stands; a highly contentious and sometimes nasty argument over authenticity of the map. Though the authenticity of the map is of great concern to cartographers and to Yale University (the current owner of the map), its significance relative to the question of a Viking presence in the New World actually has diminished over the years. After all, as is described in the "Current Perspectives" section of this chapter, we know for certain from the archaeological record of northeastern Canada that the Norse explored and attempted to settle the New World five hundred years before Columbus. Whether or not they drew a map of their exploits is, at least in this regard, largely beside the point.

Archaeological Evidence of the Viking Presence

The ultimate arbiter in the argument concerning precisely where the Vikings explored to the west of Greenland is the archaeological record. Unfortunately, with just a few exceptions, the physical evidence for the Viking presence in the New World is either meager or highly suspect, and usually both.

Bearing little witness to a Viking presence in the New World, most of the supposed Viking artifacts found in North America are instead a reflection of hoaxes and misinterpretations born of ethnic pride. As archaeologist Brigitta Wallace (1982) points out, it is likely not coincidental that a distribution map

of such discoveries corresponds quite well with the distribution of historical Scandinavian settlements of the United States.

For example, a large stone slab with ostensible Viking writing, or *runes*, was found near Kensington, Minnesota, by Olof Ohman in 1898 (Wallace 1982). The stone contained a short message concerning a journey from Vinland and bore a date of A.D. 1362. Though the precise source of the stone has never been established, Wallace points out that the language on the stone is a *modern* Swedish dialect spoken only in the American Midwest, and the runes are of recent vintage as well.

Beyond this, consider the historical context. By 1362, the Vinland colony had long since been abandoned. As a result of climatic deterioration, mentioned previously, the Viking world was contracting. The Viking settlement on the west coast of Greenland, from which all saga-described explorations to the west took place, was empty in A.D. 1361. It is highly unlikely that, after this, Vikings were sailing to Minnesota. The Kensington stone is clearly a fake.

The Newport Tower

The Newport Tower in Newport, Rhode Island, has been proposed as an ancient Viking construction (Figure 6.9). It is singular in appearance, at least in the New World, and has been the focus of both inquiry and speculation.

There is a significant problem, however, with the hypothesis that the tower is Viking and predates the accepted period of European settlement of the region. The English settled the area around Newport in A.D. 1639, and there is no mention made by these settlers of a mysterious and already existing stone tower. They almost certainly would have noted it had there been one.

However, there was enough controversy about the possibility of a pre-Columbus Viking connection to the tower that an archaeological investigation was conducted around and *under* the tower (Godfrey 1951). Most of the artifacts were pieces of pottery, iron nails, clay tobacco pipes, buttons, and buckles. All of these items can be traced to Scotland, England, or the English colonies in America and were manufactured between the seventeenth and nineteenth centuries (Hattendorf 1997). The investigators even found the preserved impression of a colonial bootprint in the soil beneath the stone foundation of the tower. For a seventeenth-century bootprint to have been left under the tower, the tower must have been built either sometime during or sometime after the seventeenth century.

Finally, the lime mortar bonding the stones used to build the tower has been radiocarbon dated. The carbon date matches quite precisely the historical record and the artifacts recovered, A.D. 1665 (Hertz 1997). The mysterious tower turns out to be, in actual fact, a windmill likely built by the then-governor of Rhode Island, Benedict Arnold, the grandfather and name-

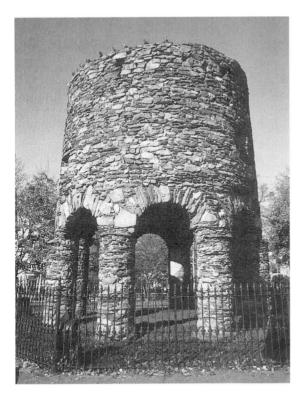

Figure 6.9 The Newport Tower in Newport, Rhode Island, claimed by some to be an ancient Viking church. Historical and archaeological evidence indicates quite clearly that the tower was built during colonial times.

sake of the famous traitor (it is even mentioned in his will, dated to 1677). The architecture of the tower turns out not to be unique after all; it is a close match for a windmill built in A.D. 1632 in Chesterton, England (Hertz 1997). The senior Benedict Arnold was brought up within just a few kilometers of Chesterton; perhaps he liked the unique design and decided to have a copy built on his property in Rhode Island.

🖒 Current perspectives 🔮

The Norse Discovery of America

Historical or legendary claims of the discovery of "new" lands are notoriously hard to assess. Attempting to force ancient tales to fit our modern knowledge of geography may be an interesting exercise but often falls short of acceptable levels of proof. Also, as stated at the outset, the ultimate arbiter in this discussion must be solid, physical evidence of the presence of nonnative people in the New World that dates to before the Columbus voyages. Because the period to which we are referring is many hundreds and perhaps even thousands of years ago, the evidence that is needed to assess such claims is archaeological.

Such archaeological evidence, or lack thereof, points to one conclusion: besides the ancestors of modern American Indians, the only group for whom there is concrete evidence for exploration and settlement of North America is the Norse.

Some of that evidence has been found at the archaeological sites of Native Americans. This physical evidence of trade or contact between Native Americans and the Norse has been summarized by the archaeologist Robert McGhee (1984). For example, a Norwegian penny minted sometime between A.D. 1065 and 1080 was found at an archaeological site in Maine. The site has been dated to between A.D. 1180 and 1235 (McKusick 1979). The coin had been perforated, perhaps to facilitate use as a pendant. It was the only Viking artifact found at the site; all of the other artifacts were clearly Indian in style and material. The fact that many of the stone tools found at the site were made of a kind of chert found only on northern Labrador may indicate that the "Norse penny," along with the chert, reached the Maine coast by trade from the north.

On Baffin Island, a wooden figurine was unearthed during the excavation of a prehistoric Eskimo winter house (Sabo and Sabo 1978). Though the style of the figurine is typical for the so-called *Thule* Eskimo, it depicts a person in European clothing—a long robe with a slit up the front—with an apparent cross carved onto the chest. This figurine, almost certainly executed by an Eskimo, likely represents a Viking either seen by, or described to, the artist. On Ellesmere Island in Arctic Canada, the discovery of links of medieval chain-mail armor and iron boat rivets attests to the presence of Vikings there in the early fourteenth century (Schledermann 1981).

L'Anse aux Meadows

Though several other artifacts indicate the Norse presence in the New World, the most compelling information comes from the only known Norse settlement in North America: L'Anse aux Meadows in northern Newfoundland. In fact, the site at L'Anse aux Meadows may be the settlement initially established by Leif Eirikson in about A.D. 1000.

In 1960 writer and explorer Helge Ingstad (1964, 1971, 1982), convinced that Newfoundland was the Vinland of the sagas, initiated a systematic search of its bays and harbors for evidence of the Viking settlement. At least the sizable colony of Karlsefni would still be archaeologically visible less than one thousand years after its abandonment. If the sagas were based on an actual attempt at colonization, the site could be found. It was only a matter of figuring out where it actually was.

On a promontory of land, at the northern tip of the northwestern peninsula of Newfoundland, Ingstad made his remarkable discovery. There he located the remains of what appeared to be eight typically Norse turf houses (Figure 6.10). Between 1961 and 1968 the site was excavated under the direction of Ingstad's wife, archaeologist Anne Stine Ingstad (1977, 1982).

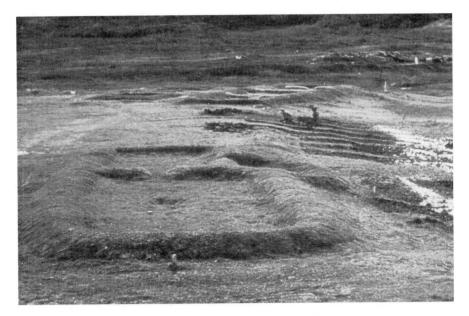

Figure 6.10 House remains at L'Anse aux Meadows, Newfoundland, Canada. Archaeological evidence at this site, including the house patterns, artifacts like soapstone spindle whorls and iron nails, as well as radiocarbon dates, supports the hypothesis that this was a genuine Viking settlement of the New World some five centuries before Columbus. (Photo by B. Schonback, courtesy Brigitta Wallace, Canadian Parks Service)

The archaeological evidence was more than sufficient to identify the site at L'Anse aux Meadows as Viking. This interpretation was based not on vague similarities between the excavated structures and those known from Viking colonial settlements on Greenland but on detailed identities of the artifacts and structural remains.

Along with the turf houses—the so-called *booths* of the sagas—they found four Norse boatsheds, iron nails and rivets, an iron smithy where local bog iron was worked into tools, a ring-headed bronze pin (Figure 6.11), and a soapstone spindle whorl used in spinning wool. As the local prehistoric Eskimos and Indians did not build boatsheds, smelt iron, produce bronze, or spin wool with spindle whorls, the evidence of an alien culture was definitive.

In the floor of one of the house structures the excavators discovered a small, stone-lined box. Called an "ember box," it was for storing embers of the night fire. Remains of a very similar ember box have been found at Eirik's farmstead on Greenland (A. S. Ingstad 1982:33). Twenty-one carbon dates provide a mean age of A.D. 920 ± 30 for the settlement—a bit old by saga accounts, but this may simply be a problem in the application of the dates. Some of the burned wood used for dating purposes likely was driftwood that already was old when used by the Viking settlers (A. S. Ingstad

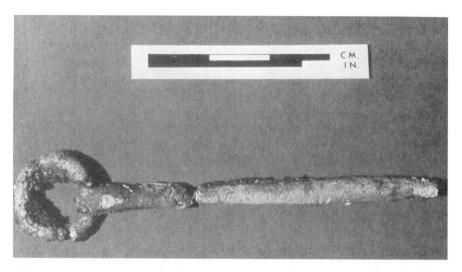

Figure 6.11 A ring-headed bronze pin found at L'Anse aux Meadows. The raw material of the artifact and its form are purely Norse. Its recovery within an overall archaeological pattern that matches Viking sites in Greenland and Iceland and its clear association with a turn-of-the-eleventh-century date further support the hypothesis that the site is Viking. (Photo by G. Vandervloogt, courtesy of Brigitta Wallace, Canadian Parks Service)

1977:233). Nevertheless, a number of the carbon dates fit the chronology of the sagas quite well.

Was L'Anse aux Meadows the settlement initiated by Leif, occupied by his brother Thorvald, and expanded in the hope of permanency by Karlsefni? The archaeological data do not conform perfectly to the sagas. No human burials were found, though the sagas indicate that a number of Vikings died in Vinland. No evidence of European domesticated animals was recovered in the excavations, though the sagas relate that such animals were brought by the settlers. It will likely never be known for certain whether L'Anse aux Meadows is the archaeological site of Eirikson's and later Karlsefni's settlement, but perhaps this is not so important. What is important and what is indisputable is the archaeological evidence at L'Anse aux Meadows of a Viking settlement, the westernmost outpost of their farflung world. The settlement was planted in the fertile soil of America. It withered and died for reasons largely beyond the control of those hardy folk who attempted it: a worsening climate that would render Greenland uninhabitable for Viking farmers and render the voyage from the west coast of Greenland to Vinland virtually impossible, and a native population willing to fight to protect themselves and their lands. In the final analysis, the saga of the Vinland settlement may be a tragic story of failure. But, most important in terms of the focus of this chapter and perhaps in terms of human history as well, the physical evidence indicates quite clearly that it was a drama played out on the world stage five hundred years before Columbus set sail.

→ frequently asked questions �

1. How could the Vikings navigate to the New World without devices like a compass or a sextant?

The Vikings navigated by ocean currents, winds, and positions of stars in the sky. It was a knowledge informed by centuries of exploration. Using Viking technology and knowledge, adventurer W. Hodding Carter recently crafted a replica of a Viking ship, a knarr, and attempted with his crew of twelve to replicate Leif Ericsson's 3,200-kilometer (2,000-mile) voyage to Vinland as it is laid out in the sagas. Their knarr was powered only by wind and muscle, the crew ate only dried food and whatever fish they could catch, and drinking water was collected from icebergs. The point of the experiment was to confirm what we already know—albeit in an exciting way—that the Norse possessed the navigational ability to bridge the gap between the Old and New Worlds five centuries before Columbus. The crew set sail on July 16, 1997, for what was supposed to be a two-month trip. Unfortunately, after only a little more than a month at sea the rudder support and frame broke in rough seas. The sailors could no longer steer the knarr, and the experiment was abandoned—for now. Carter expressed optimism that the experiment will be successful when they once again attempt the voyage in the summer of 1998.

2. Are there any examples of a group of foreigners moving through a territory and leaving little or no archaeological evidence?

Certainly, a small group of people moving relatively quickly through an area may leave evidence that is difficult, though not impossible, to detect. An excellent example of this is the twenty-eight-month expedition of Meriwether Lewis and William Clark through the American West in 1803–1806. There were just thirty-three members of this well-known expeditionary force. They were constantly on the move and rarely stayed more than a single night at the more than six hundred places where they made camp. Nevertheless, archaeologist Ken Karsmizki has identified at least four sites that may represent the explorers' camps. Artifacts have been found, and fireplaces have been excavated and radiocarbon dated to the right time period (Saraceni 1998). The lesson here is that the archaeological visibility of the presence of an alien group in a region depends on the number of foreigners and the duration of their stay at any one place. Archaeologists must admit that it may be quite difficult to document the presence of a very small, very mobile group, but the evidence of the Lewis and Clark expedition indicates that careful research ultimately reveals such evidence.

🕀 critical thinking exercise 💠

In Chapter 6 we assessed legends of transatlantic and transpacific contact between the Old and New Worlds by reference to the archaeological record.

Best of the Web

CLICK HERE

http://parkscanada.pch.gc.ca/parks/newfoundland/l'anse_meadows/l'anse_meadowse.htm

http://www.viking1000.org/

http://home.sol.no/~anlun/tipi/gruppe5.htm

http://www.pitt.edu/~dash/vinland.html

We can apply the same rules of analysis when testing any other claim that a group of people moved into or through, or lived in an area. Consider this actual scenario of the Tasaday people of the Philippines.

When first "discovered" by the outside world in 1971, the Tasaday were an anthropological bonanza. Their small band of about twenty-five people were living an apparently pristine way of life in their rain forest caves, completely uncontaminated by any elements of Western civilization or even of their agricultural neighbors living just a few miles away. They were living a completely "natural life," the equivalent of philosopher Jean-Jacques Rousseau's "noble savages." They knew nothing of violence, war, or hatred—they didn't even have words for these concepts in their language. They were simple, naive, happy, kind, and completely ingenuous. People in the West found them charming and riveting, fulfilling all of our 1970s fantasies about the superiority of a simple, uncluttered, nontechnological, pacifistic, communal society. They were, in fact, as one recent wag has put it, "paleo-hippies," and many of us wished we were Tasaday.

Right from the beginning, however, some suspected that the Tasaday were a hoax; their neighbors were quite close by, and it seemed unlikely that the Tasaday had no contact with them or other people living in the rain forest.

How might archaeological analysis help in assessing the legitimacy of the Tasaday as a genuine anthropological phenomenon? Were they really living in those caves; did they really have no contact with modern technology? (Hint: think about the kinds of physical evidence required to support scenarios of European, African, or Asian pre-Columbian exploration and occupation of the New World as discussed in this chapter.)

The Myth of the Moundbuilders

Today, the intriguing culture archaeologists know as the Moundbuilders is one of the best kept secrets in the study and teaching of American history. That a complex American Indian society with great population centers, powerful rulers, pyramids, and fine works of art evolved in the midwestern and southeastern United States comes as a surprising revelation, even to those in whose backvards the ruins lie.

Yet the remnants of these ancient inhabitants of North America are nearly ubiquitous. The most obvious manifestation of their culture is their earthworks (Figures 7.1 and 7.2): conical mounds of earth, up to nearly 100 feet in height, containing the burials of perhaps great rulers or priests with fine grave goods in stone, clay, copper, and shell; great flat-topped pyramids of earth, up to 100 feet in height, covering many acres, and containing millions of cubic feet of earth and on which ancient temples once stood; and effigy earthworks in the shapes of great snakes, birds, and bears.

Few of us seem to be aware of the remarkable cultural legacy of this indigenous American culture. This became sadly clear to me when attending an archaeology conference in St. Louis a few years ago. Much of my excitement about the conference resulted from its location. The largest and most impressive Moundbuilder site, Cahokia, an ancient settlement with thousands of inhabitants, sits on the Illinois side of the Mississippi River, just east of St. Louis. Wishing to take advantage of my proximity to the site, I asked the gentleman at the hotel front desk how I might get to Cahokia. The response: a blank stare. He had never heard of it. "You know," I explained, "the big Indian site." "No, no," he responded, "There haven't been any Indians around here for many years."

No one in the hotel had heard of Cahokia, and even at the bus station people thought I was just another confused out-of-towner. Luckily, I ran into a colleague who knew the way, and I finally got to the site.

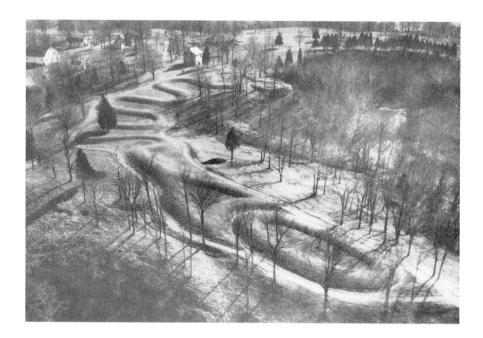

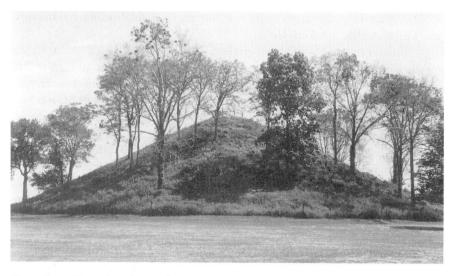

Figure 7.1 Examples of mounds: Serpent Mound, an effigy earthwork in southern Ohio in the form of a coiled 1,500-foot-long snake (top). A huge, conical burial mound close to 100 feet high in Miamisburg, Ohio (bottom). (Serpent Mound courtesy of Museum of the American Indian, Heye Foundation)

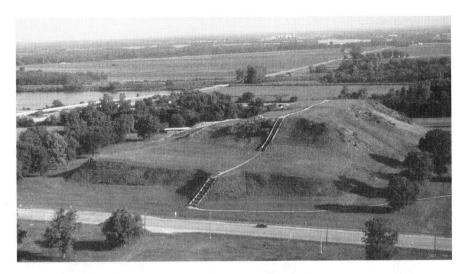

Figure 7.2 Aerial photograph of Monk's Mound, an enormous, tiered pyramid of earth at Cahokia in Illinois. Monk's Mound served as a platform on which a temple once stood. (Courtesy Cahokia Mounds State Historic Site)

It was worth the trouble. About 70 of the 120 or so original mounds remain. Several of these demarcate a large plaza where ceremonies were likely held during Cahokia's peak between A.D. 1050 and 1250. Monk's Mound (see Figure 7.2), containing more than 20 million cubic feet of earth, is one of the largest pyramids in the world (including those of Egypt and Mesoamerica). It dominates the plaza. The highest of its four platforms is raised to a height of 100 feet, where it once held a great temple. Surrounding the central part of this ancient settlement was a massive log wall or palisade with evenly spaced bastions and watchtowers. The palisade enclosed an area of about 200 acres in which eighteen of the largest and most impressive of Cahokia's earthworks were built. The log wall itself may have been the most monumental of the many large-scale construction projects undertaken by Cahokia's inhabitants; it consisted of some twenty thousand logs and was rebuilt virtually in its entirety at least three times during the site's occupation.

Cahokia must have been a splendid place with thousands of inhabitants, its artisans producing works in shell, copper, stone, and clay. Cahokia was a trading center, a religious center, and the predominant political force of its time (Pauketat 1994). It was, by the reckoning of many, an emerging civilization created by American Indians whose lives were far different from the stereotype of primitive, nomadic hunters too many of us envision (Figure 7.3).

From atop Monk's Mound one can peer into two worlds and two different times. To the west rests the modern city of St. Louis, framed by its

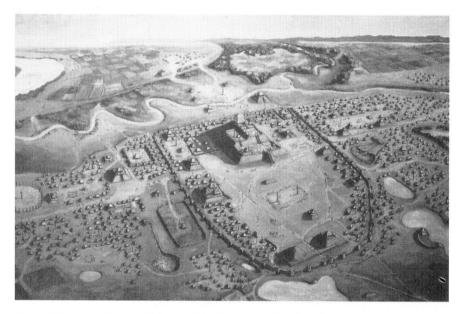

Figure 7.3 An artist's rendition of Cahokia at its cultural peak. With a population estimated in the thousands, Cahokia was a virtual prehistoric American Indian city on the Mississippi River more than seven hundred years ago. (Painting by William Iseminger, Cahokia Mounds State Historic Site)

Gateway Arch of steel. Below rests the ancient city of Cahokia with its monuments of earth, shadows of a long-ignored Indian culture.

How could people not know of this wonderful place? Suffice it to say that if people twenty minutes from Cahokia haven't heard of it, most New Englanders, Californians, Southerners—in fact, most Americans—are completely unaware of it and the archaeological legacy of the indigenous American society that produced it and hundreds of other sites.

Cahokia and Moundbuilder culture, however, were not always an invisible part of the history of this continent. In fact, the remains of their culture once commanded the attention of the American public and scientists alike. It was not only that the mounds themselves, the fine ceramics, sumptuous burials, carved statues, and copper ornaments were so impressive, though this was part of the fascination. Unfortunately, much of the intense interest generated by the remains of this culture resulted from a supposed enigma perceived by most; the Moundbuilders clearly lived before Columbus, the Indians were the only known inhabitants of North America before the coming of the Europeans, and it was commonly assumed that the Indians were simply incapable of having produced the splendid works of art and monumental construction projects that characterized Moundbuilder culture. With the rejection of the possibility that American Indians had produced the culture, the myth evolved of an ancient, vanished American race

(see especially Silverberg 1989 for a very useful and succinct account of the evolution of the Moundbuilder myth).

The myths of a petrified giant (Chapter 3) and of a human ancestor with a modern brain and simian jaw (Chapter 4) were based on hoaxes, clever or otherwise. People suspended their critical faculties and were fooled by these frauds. The Moundbuilder myth, in contrast, was not predicated on a hoax (though, as you will see, hoaxes did play a role) but rather on a nearly complete and sometimes willful misunderstanding of genuine data.

The Myth of a Vanished Race

The myth of a vanished race of Moundbuilders was accepted by many Americans in the eighteenth and nineteenth centuries. Five basic arguments were presented to support the notion that American Indians could not have been the bearers of Moundbuilder culture. Let's deal with each in turn.

1. Indians were too primitive to have built the mounds and produced the works in stone, metal, and clay attributed to the Moundbuilder culture.

The attitude of J. W. Foster, president of the Chicago Academy of Sciences, was prevalent. Describing the Indian, he states:

He was never known voluntarily to engage in an enterprise requiring methodical labor; he dwells in temporary and movable habitations, he follows the game in their migrations. To suppose that such a race threw up the symmetrical mounds which crown so many of our river terraces is as preposterous, almost, as to suppose that they built the pyramids of Egypt. (1873, as cited in Silverberg 1989:117)

In his 1872 work, *Ancient America*, J. D. Baldwin is even more direct: "It is absurd to suppose a relationship or connection between the original barbarism of these Indians and the civilization of the mound-builders" (as cited in Thomas 1894:615).

These arguments can be fairly characterized as racist and unfortunately held sway among many people.

2. The mounds and associated artifacts were very much more ancient than even the earliest remnants of Indian culture.

Though the analysis of soil layering known as stratigraphy was not to become an established part of archaeology until later in the nineteenth century (for example, Dall 1877), in 1820 Caleb Atwater used a simple form of stratigraphic analysis to support the notion that the Moundbuilders were from a period far before the Indians arrived in the New World. He maintained in his book *Antiquities Discovered in the Western States*:

Indian Antiquities are always either on, or a very small distance below the surface, unless buried in some grave; whilst articles, evidently belonging to that people who raised our mounds, are frequently found many feet below the surface, especially in river bottoms. (1820:125)

The evidence of the annual growth rings of trees also was used in the argument that the mounds were quite ancient. In 1786, the Reverend Manasseh Cutler counted the rings on a tree he had cut down on a mound in Marietta, Ohio. He found 463 rings and calculated that the mound must have been built before A.D. 1300 (Fagan 1977). Others went further, suggesting that large trees presently growing on mounds must have been preceded by several generations of trees, indicating that the mounds were more than 2,000 years old.

3. Stone tablets were found in the mounds that bore inscriptions in European, Asian, or African alphabets.

The best known of such artifacts were the Grave Creek Mound Stone from West Virginia (Schoolcraft 1854), the Newark Holy Stones from Ohio, the Bat Creek Stone from Tennessee, and the Cook Farm Mound Tablets in Davenport, Iowa (Putnam 1886). Because American Indians north of Mexico were not known to have possessed a writing system before European colonization, the presence of writing in the mounds seemed to provide validation of the hypothesis that a non-Indian culture had been responsible for their construction. Where characters from specific alphabets could be discerned, sources for Moundbuilder culture could be, and were, hypothesized.

4. American Indians were not building mounds when first contacted by European explorers and settlers. When queries were made of the local Indians concerning mound construction or use, they invariably professed complete ignorance.

Very simply, the argument was presented that if Indians were responsible for the mounds, they should have been building such earthworks when Europeans first came into contact with them. At the very least, living Indians, if no longer building mounds, should remember a time when their ancestors had built them. The supposed fact that Indians were not building mounds when first contacted by Europeans was seen by many as definitive, empirical evidence against any claim of Indian responsibility for Moundbuilder culture.

5. Metal artifacts made of iron, silver, ore-derived copper, and various alloys had been found in the mounds.

Historic Indian cultures north of Mexico were not known to use metal other than copper, which could be found in pure veins and nuggets in parts of Michigan; silver, also found in pure, natural deposits that required no further metallurgical refinement; and iron from meteorites. Smelting ore to produce copper, silver, or iron and techniques of alloying metal (mixing copper and tin, for example, to produce bronze) were unknown. Therefore, the discovery of artifacts of these materials in the mounds was a further indication that a people other than and more technologically sophisticated than American Indians had been the Moundbuilders.

With these five presumably well-supported "truths" in hand, it was clear to the satisfaction of many that Indians had nothing to do with mound building or Moundbuilder culture. This left open the question of who, in fact, the Moundbuilders were.

Who Were the Moundbuilders? Identifying the Vanished Race

From our vantage point in the latter part of the twentieth century, it is extremely difficult to imagine how intensely interested many were in the origins of the mounds and Moundbuilder culture. The fledgling Smithsonian Institution devoted several of its earliest publications to the ostensible Moundbuilder enigma. Another government agency, the Bureau of American Ethnology, whose job it was to preserve information concerning rapidly changing Native American cultures, devoted a considerable part of its resources to the Moundbuilder issue. Influential private organizations like the American Philosophical Society also supported research into the question and published works reporting on such research.

The mystery of the mounds was a subject that virtually all thinking people were drawn to. Books, pamphlets, magazine pieces, and newspaper articles abounded, written by those who had something to say, sensible or not, on the question that seemed so important to answer: "Who had built the mounds?" Though few could agree on who was responsible for construction of the mounds, there was no lack of opinions.

In one of the earliest published conjectures, Benjamin Smith Barton wrote in 1787 that the Moundbuilders were Vikings who had long ago journeyed to the New World, settled, and then died out. Josiah Priest in his 1833 work variously posited that the mounds had been built by wandering Egyptians, Israelites, Greeks, Chinese, Polynesians, or Norwegians (Silverberg 1989:66). Others suggested that the mounds had been fashioned by Welshmen, Belgians, Phoenicians, Tartars, Saxons, or Africans, or even by refugees

from the Lost Continent of Atlantis (Donnelly 1882; see Chapter 8 of this book). Even a work believed by Mormons to be the most recent testament of Jesus Christ (commonly called *The Book of Mormon* and first published in 1830) maintains that the mounds were built by Indians who had migrated from the Middle East in the sixth century B.C.

The Walam Olum

One of the favored themes underlying the Moundbuilder myth was that, whatever their ultimate geographical source, they had created a splendid and peaceful civilization in the dim mists of antiquity. They had been overrun and eliminated in a much more recent invasion by a wild, violent, and barbaric people. In this version of the myth, the barbarians were the ancestors of the American Indians.

One nineteenth-century hoaxster went so far as to concoct an entire epic story that followed this scenario. In 1836 Constantine Samuel Rafinesque claimed that ten years earlier he had located and deciphered an ancient historic text engraved on wooden tablets by the ancestors of the Lenape (Delaware) Indians of eastern North America (Oestreicher 1996). Rafinesque called the story he had "discovered" the *Walam Olum*. The tablets themselves had disappeared (of course), but Rafinesque claimed to have translated the saga they told of the migration of American Indians from northeast Asia 3,600 years ago across a frozen wasteland that had once connected the Old and New Worlds. There is a certain irony in this; this part of Rafinesque's fake tale bolstered part of a scenario we now know to be true—that is, humans first entering the New World from Asia across a land bridge in the far north—although his timing is far too recent (Chapter 5).

In Rafinesque's fantasy the Moundbuilders had migrated to the New World long before the arrival of the Indians. Rafinesque went on to have his fictitious migrants overwhelm and then defeat the Moundbuilder people in battle. Where did the Moundbuilders come from in this story? According to the Walam Olum, the Moundbuilders originated on the Lost Continent of Atlantis (see Chapter 8)! Many Lenape people rejected the authenticity of the Walam Olum, and researcher David Oestreicher (1996) has shown that the hieroglyphs in which the document was written were cobbled together using a jumble of Egyptian, Chinese, and Mayan characters. The Walam Olum was an elaborate hoax, one of a series of hoaxes surrounding the mystery of the Moundbuilders.

Archaeology of the Myth

Caleb Atwater, an Ohio lawyer, performed a detailed analysis of the earthworks in his state in an attempt to establish the identity of the vanished race. Though Atwater's conclusions were typical for the time, his methods were

far more scientific than the speculations of some of his contemporaries. In his work *Antiquities Discovered in the Western States* (yes, Ohio was then considered a "western" state), Atwater divided the archaeological remains found there into three categories: Indian, European Colonial, and Moundbuilder. The last of these he ascribed to "a people far more civilized than our Indians, but far less so than Europeans" (1820:120).

To his credit, Atwater was not an armchair speculator concerning the Moundbuilders. He personally inspected many sites in Ohio and produced detailed drawings and descriptions of artifacts and earthworks. But his myopia about American Indian cultural achievement clearly fashioned his view:

Have our present race of Indians ever buried their dead in mounds? Have they constructed such works as described in the preceding pages? Were they acquainted with the use of silver, iron, or copper? Did the North American Indians erect anything like the "walled town" on Paint Creek? (Atwater 1820:208)

For Atwater the answer to these questions was a clear "no." American Indians simply were too primitive. He concluded his discourse on the question by suggesting that the Moundbuilders had been "Hindoos" from India.

To be sure, there were a few prescient thinkers on the question of the origin of Moundbuilder culture. Perhaps the first to approach the question objectively was Thomas Jefferson, framer of the Declaration of Independence and third president of the United States. Jefferson was curious about the ancient earthworks on and adjacent to his property in Virginia. Not content to merely speculate about them, Jefferson conducted what is almost certainly the first archaeological excavation in North America, carefully digging a trench through a mound that contained many human skeletons (Willey and Sabloff 1993). Jefferson would not hazard a guess as to the identity of the Moundbuilders, justifiably calling for more information. As the president of the American Philosophical Society, he later would encourage others to explore this question.

Interest in the mounds and debate over the source of the culture that had produced the tens of thousands of these earthworks continued to increase during the nineteenth century as white settlement expanded into the American Midwest, the heartland of Moundbuilder culture. American archaeology developed as a discipline largely in response to questions about the mounds (as well as to questions concerning the origins of the Indians; see Chapter 5).

In their chronicle of the history of American archaeology, Willey and Sabloff (1993) select 1840 as the benchmark for a shift in American archaeology from a period of speculation to one characterized by research whose goal was description and classification. The work of Ephraim G. Squier and Edwin H. Davis on the Moundbuilder mystery is a good example of this shift in emphasis. Squier was a civil engineer and writer from Connecticut.

Davis was an Ohio doctor. Both were interested in the Moundbuilder culture and between 1845 and 1847 carried out intensive investigation of some two hundred sites. They conducted excavations and produced detailed maps of the sites and drawings of the artifacts. Their research culminated in a book, *Ancient Monuments of the Mississippi Valley*, which was selected as the first publication of the recently established Smithsonian Institution.

Squier and Davis approached their task without many of the preconceptions and pet theories of their predecessors on the Moundbuilder question: "With no hypothesis to combat or sustain, and with a desire only to arrive at truth, whatever its bearings upon received theories and current prejudices, everything like mere speculation has been avoided" (1848:xxxviii).

Ancient Monuments of the Mississippi Valley is a descriptive work, with more than two hundred drawings in its three hundred or so pages. Squier and Davis were quite systematic in their investigations. Generally, they classified the various kinds of earthworks according to the empirical data of form and content as deduced from their detailed surveys and excavations. However, they also made unwarranted assumptions concerning the function of the different earthwork types.

In any event, they arranged and described the earthworks as follows:

- 1. *Defensive enclosures*—earth embankments surrounding high, flat plateaus
- 2. Sacred enclosures—earth embankments surrounding areas of from a few up to more than 50 acres (Figure 7.4); also, effigy mounds (mounds in the shapes of animals; see Figure 7.1 top)
- 3. *Altar mounds*—tumuli within sacred enclosures, with burned layers showing possible use as sacrificial altars
- 4. *Sepulture or burial mounds*—conical mounds, 6 to 80 feet in height overlying human burials that contained grave goods (see Figure 7.1 bottom)
- 5. *Temple mounds*—truncated pyramids, some enormous, with pathways leading to the top where flat platforms, sometimes of a few acres, were found and where temples may have stood (see Figure 7.2)
- 6. Anomalous mounds—oddly shaped or unique mounds

Squier and Davis describe in great detail and depict in beautifully rendered drawings the artifacts that are found in association with the mounds: ceramics, metal implements and ornaments, stone and bone objects, sculptures, and inscribed stones. In a number of places in their book, they compare these objects with those found in other parts of the world, but never attempt to make a direct connection. Nevertheless, Squier and Davis are explicit in maintaining that the quality of artwork found in the mounds is "immeasurably beyond anything which the North American Indians are known to produce, even to this day" (1848:272).

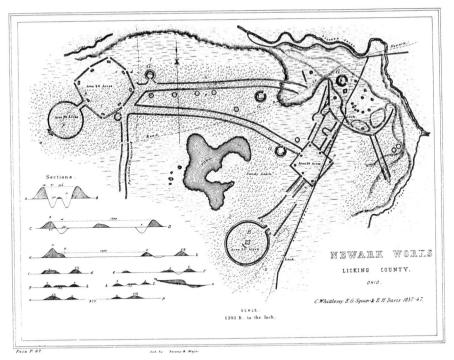

Figure 7.4 Ephraim Squier and Edwin Davis conducted a detailed survey of the mounds of the Ohio Valley and "western" United States in the 1840s, producing beautiful drawings of earthworks like these enclosures in Newark, Ohio. (From *Ancient Monuments of the Mississippi Valley*, AMS Press and Peabody Museum of Archaeology and Ethnology, Harvard University)

Squier and Davis conclude their report by suggesting a "connection, more or less intimate" (p. 301) between the Moundbuilders and the civilizations of Mexico, Central America, and Peru. Ultimately, it seems, they do subscribe to the idea that the Moundbuilders were a group separate from and culturally superior to the North American Indians. At least they ascribe an indigenous, New World source for the Moundbuilders and refrain from speculating about who, precisely, they might have been and where, ultimately, they came from.

The Moundbuilder Mystery Solved

The late nineteenth century saw a continuation of interest in the Moundbuilders. Then, in 1882, an entomologist from Illinois, Cyrus Thomas, was hired to direct a Division of Mound Exploration within the Bureau of American Ethnology. An amendment to a federal appropriations bill in the U.S. House of Representatives directed that \$5,000 of the \$25,000 B.A.E. budget

be devoted solely to the solution of the Moundbuilder mystery. With this funding, Thomas initiated the most extensive and intensive study yet conducted on the Moundbuilder question. The result was more than seven hundred pages submitted as an annual report of the Bureau in 1894 (Thomas 1894).

Above all else, Thomas's approach was empirical; he thought it necessary to collect as much information as possible before suggesting hypotheses about mound function, age, origins, and cultural affiliation. Whereas Squier and Davis focused on about two hundred mounds mostly in Ohio, Thomas and his assistants investigated two thousand mound sites in twentyone states. He collected over 40,000 artifacts, which became part of the Smithsonian Institution's collection. After collecting so much information, Thomas was not afraid to come to a conclusion on the Moundbuilder mystery. Whereas Squier and Davis devote 6 pages to their conclusions regarding the mounds, Thomas provides a 136-page discussion on the identity of the Moundbuilder culture. Thomas's work was a watershed, both in terms of answering the specific question of who had built the mounds and in terms of the development of American archaeology.

For Thomas the important question was simple and succinct: "Were the mounds built by the Indians?" (1894:21). He went about answering this question by responding to the arguments against identifying Indians as the Moundbuilders presented earlier in this chapter.

1. Indian culture was too primitive.

To the claim that Indians were too primitive to have attained the level of civilization reached by the Moundbuilders, Thomas responded that it was difficult to conceive

why writers should so speak of them who had access to older records giving accounts of the habits and customs of the Indian tribes when first observed by European navigators and explorers . . . when the records, almost without exception notice the fact that . . . they were generally found from the Mississippi to the Atlantic dwelling in settled villages and cultivating the soil. (p. 615)

For example, de Soto's chronicler, known to us only as the "Gentleman of Elvas," mentions great walled towns of as many as five or six thousand people encountered by these explorers (1611:122). It is clear from his descriptions of Indian settlements that there was a large, sedentary, "civilized" population in the American Southeast in the sixteenth century.

In another example, William Bartram, a botanist from Philadelphia, began his travels through the Southeast in 1773. In his book enumerating his experiences, he also describes scores of heavily populated Indian towns; in one case he mentions traveling through

nearly two continuous miles of cultivated fields of corn and beans (1791:285). He estimates the population of a large town called *Uche* to be as many as fifteen hundred people (p. 313), and he was very much impressed with how substantially built their structures were.

So, in Thomas's view and in fact, evidence indicated that at least some Indian cultures were agricultural and sedentary, with people living in large population centers. They clearly would have been culturally and practically capable of constructing monumental earthworks.

2. Mound culture was older than Indian culture.

In reference to the presumed great age of the earthworks, Thomas denigrates the accuracy of dating the mounds on the basis of tree-ring counts. In fact, though, the age of at least some of the mounds may have been more accurately estimated by some of the ancient race enthusiasts. Thomas incorrectly thought many had been built after European arrival in the New World. Ultimately, however, the age of the mounds was only a problem if one accepted the thencurrent notion that the Indians were relatively recent arrivals. We now know that Native Americans first arrived in the New World more than thirteen thousand years ago (see Chapter 5), and the mounds are all substantially younger.

3. There were alphabetically inscribed tablets in the mounds.

Thomas had quite a bit to say concerning the supposed inscribed stone tablets. Though the myth of a vanished race of Moundbuilders was based largely on misinterpretation of actual archaeological and ethnographic data, hoaxes involving inscribed tablets also were woven into its fabric.

For example, in 1838, during an excavation of a large mound in Grave Creek, West Virginia, two burial chambers were found containing three human skeletons, thousands of shell beads, copper ornaments, and other artifacts. Among these other artifacts was a sandstone disk with more than twenty alphabetic characters variously identified as Celtic, Greek, Anglo-Saxon, Phoenician, Runic, and Etruscan (Schoolcraft 1854). Translations varied tremendously and had in common only the fact that they were meaningless. The disk was certainly a fraud.

Given the popularity of the notion that the Indians may have descended from one of the Lost Tribes of Israel (Chapter 5), it is not surprising some suggested that the Moundbuilders themselves represented a group of ancient Jewish migrants from the Holy Land. The so-called Newark Holy Stones (Figure 7.5) seemed to support this notion (Applebaum 1996).

Figure 7.5 The Decalogue, one of the so-called Newark Holy Stones (top; courtesy of the Johnson-Humrickhouse Museum), and the "Calendar Stone," one of the Davenport Tablets (bottom; Proceedings of the Davenport Academy of Natural Sciences, No. 1), were fraudulent artifacts that both took advantage of and contributed to confusion about the origins of Moundbuilder culture in the nineteenth century. The Decalogue's Hebrew inscription and the Calendar Stone's mixture of Old World scripts both seemed to point to a non-Indian origin of the mounds.

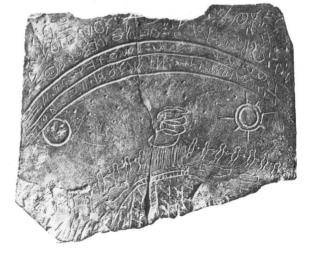

While exploring an area on the edge of a group of mounds in Newark, Ohio, in 1860, David Wyrick, a land surveyor and an amateur archaeologist, discovered a 6 inch by 2½ inch rather crudely made stone with what appeared to be Hebrew letters etched on its surface. Wyrick was quite excited by the find, but some language experts questioned its authenticity, recognizing almost immediately that the writing on the rock—called the "Keystone"—was in modern, not ancient, Hebrew. Then, several months after the discovery of the Keystone, none other than David Wyrick discovered yet another stone with writing on it at the same mound site. This stone—named the "Decalogue" when its translation revealed it to be a version of the Ten Commandments—was a fine piece of stone work, and this time the Hebrew letters were not of modern vintage.

What was going on in Newark? Were these artifacts proof of an ancient Jewish presence in Ohio and a connection with the mounds? In a wonderful piece of detective work, archaeologist Brad Lepper (1992) has traced the cast of characters in this story and unraveled what clearly was a hoax. In an attempt to prove the biblical story of the Lost Tribes of Israel, a group led by a local Episcopal bishop appears to have had the first stone made and planted at the mound site, and then to have led the naive and unknowing Wyrick to its discovery. Because the first stone generated so much skepticism, the perpetrators of the hoax had a second, better thought-out artifact manufactured. Though the intention was to convince the skeptics, it merely served to create more embarrassing questions. If both stones were legitimate, how is it that ancient Jews in North America were writing in two different versions of Hebrew at the same time and place? Or, if the first stone was a fraud—as seemed clear, having been written in modern Hebrew—how likely was it that a genuine stone with ancient Hebrew writing would coincidentally be found at exactly the same spot?

All this does not even begin to approach the broader cultural issues. For instance, there is no ancient (or modern) Jewish practice of constructing burial mounds, yet it was being proposed that ancient Jews had built the thousands of burial mounds found in North America. Also, neither the Keystone nor the Decalogue bear any resemblance whatsoever to any artifact found associated with Jewish culture. As Lepper suggests, it is probably no coincidence that Elijah Sutton, a local stone carver in Newark at that time, worked in a style remarkably similar to that of the Decalogue stone. When Sutton was contracted to carve David Wyrick's gravestone, ironically, but almost certainly not coincidentally, the style of the carving and lettering was quite similar to the Newark Holy Stones. There had been no

ancient Israelites in Ohio, only nineteenth-century hoaxsters intent on convincing people of the accuracy of a Bible story.

In another hoax, the Reverend Jacob Gass discovered two inscribed slate tablets, in 1877, in a mound on a farm in Davenport, Iowa (McKusick 1991). One of the tablets had a series of inscribed concentric circles with enigmatic signs believed by some to be zodiacal. The other tablet had various animal figures, a tree, and a few other marks on one face. The reverse face had a series of apparently alphabetic characters from half a dozen different languages across the top, and the depiction of a presumed cremation scene on the bottom (see Figure 7.5). Gass discovered or came into possession of a number of other enigmatic artifacts ostensibly associated with the Moundbuilder culture, including two pipes whose bowls were carved into the shape of elephants.

The discoveries in Davenport generated great excitement. However, the fact that such a concentration of apparently conclusive finds regarding the Moundbuilder controversy had been discovered by a single individual within a radius of a few miles of one Iowa town caused many to question the authenticity of the discoveries.

Thomas launched an in-depth investigation of the tablets. Evidence from Gass's excavation indicated clearly that the tablets had been planted only recently in the mound on Cook's farm. Thomas also believed that he had identified the source of the bizarre, multiple-alphabetic inscription. Webster's unabridged dictionary of 1872 presented a sample of characters from ancient alphabets. All of the letters on the tablet were in the dictionary, and most were close copies. Thomas suggested that the dictionary was the source for the tablet inscription (1894:641–42).

McKusick (1991) reports a confession by a Davenport citizen who alleged that the tablets and the other artifacts were frauds perpetrated by a group of men who wished to make Gass appear foolish. Though there are some significant problems with the confession (most notably the fact that the confessor was too young to have been an active participant in the hoax), the Davenport tablets were certainly fraudulent. Beyond this, McKusick (1991) has discerned the presence of lowercase Greek letters on the Davenport tablet. Lowercase Greek letters were not invented until medieval times. McKusick has also identified Arabic numbers, Roman letters, musical clefs, and ampersands (&) on the Davenport tablet. Their presence is clear proof of the fraudulent nature of the stone. In fact, no genuine artifacts containing writing in any Old World alphabet have ever been found in any of the mounds (see Chapter 6 regarding the authenticity of other supposed ancient inscriptions in North America).

4. Indians were never witnessed building mounds and had no knowledge of who had built them

We next come to the claim that Indians were not mound-builders at the time of European contact, nor did they know who had built the mounds in their own territories. Thomas shows that this is nonsense. De Soto's chronicler, the Gentleman of Elvas, mentions the construction and use of mounds almost immediately in his sixteenth-century narrative. Describing the Indian town of *Ucita* he writes, "The lordes house stoode neere the shore upon a very hie mount, made by hand for strength" (1611:25).

Garcilaso de la Vega compiled the notes of some of the 311 survivors of the de Soto expedition. He describes how the Indians constructed the mounds on which temples and the houses of chiefs were placed: "They built up such sites with the strength of their arms, piling up large quantities of earth and stamping on it with great force until they have formed a mound from twenty-eight to forty-two feet in height" (cited in Silverberg 1989:19). Beyond this, sixteenth-century artists depicted Indian burial practices that included building mounds for the interment of chiefs (Figure 7.6).

Nearly two hundred years later, at the turn of the eighteenth century, French travelers lived among the Natchez Indians at the mouth of the Mississippi River. They described the principal town of these agricultural Indians as possessing a mound 100 feet around at its base, with the houses of leaders located on smaller mounds (Du Pratz 1774). William Bartram, at the end of the eighteenth century, mentions the fact that the houses of chiefs are placed on eminences. Even as late as the beginning of the nineteenth century, the explorers Lewis and Clark noted:

I observed artificial mounds (or as I may more justly term graves) which to me is strong evidence of this country being once thickly settled. The Indians of the Missouris still keep up the custom of burying their dead on high ground. (Bakeless 1964:34)

There clearly was ample historical evidence of Indians building and using mounds. The reason for the demise of at least some of the mound-building cultures of the Southeast was that de Soto accidentally introduced smallpox into these populations (Ramenofsky 1987). Exposed to this deadly disease for the first time, the indigenous people had no immunity to it and died in great numbers. Large mound sites were abandoned as a result of the tragic consequences of this deadly epidemic.

5. Metal objects found in the mounds were beyond the metallurgical skills of the Indians.

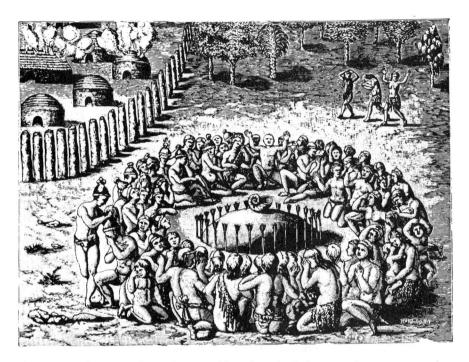

Figure 7.6 The notion that Indians could not have built the mounds was supported by the contention that no historical Indian group had ever been observed building or using earthworks. Yet such a claim was clearly inaccurate. A number of written reports and even artistic depictions, like this one produced by Jacques Le Moyne in northeastern Florida in the 1560s, bore witness to mound use—here in a burial ceremony—by indigenous tribes. (From *Report on the Mound Explorations of the Bureau of American Ethnology*, by Cyrus Thomas)

Thomas carefully assessed the claim that some mound artifacts exhibited a sophistication in metallurgy attained only by Old World cultures. Not relying on rumors, Thomas actually examined many of the artifacts in question. His conclusion: all such artifacts were made of so-called *native copper* (Figure 7.7). Certainly this implied extensive trade networks. Michigan was the source for much of the raw material used in metal artifacts found as far away as Florida. There was no evidence, however, for metallurgical skills the Indians were not known to have possessed.

Thomas clearly had marshaled more evidence on the Moundbuilder question than had anyone before him. In a rather restrained fashion, he comes to this conclusion: "It is proper to state at this point, however, that the author believes the theory which attributes these works to the Indians . . . to be the correct one . . . " (1894:610).

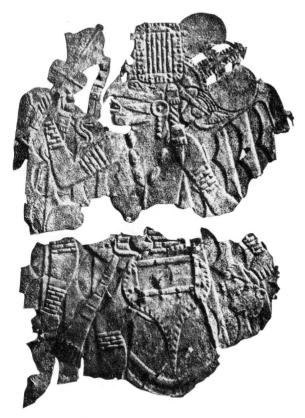

Figure 7.7 Moundbuilder metallurgy was restricted to the use of naturally occurring, pure copper without smelting, casting, or alloying. This photograph shows a hammered copper sheet depicting what may be a shaman or a priest in a bird costume. This artifact was found at a well-known mound site, Etowah, in Georgia. (Smithsonian Institution)

With the publication of Thomas's *Report on the Mound Explorations of the Bureau of American Ethnology*, Moundbuilder archaeology had come of age. Its content was so detailed, its conclusions so reasonable that, though not accepted by all, the myth of a vanished race had been dealt a fatal blow.

Rationale for the Myth of a Vanished Race

The myth of a non-Indian, vanished race of Moundbuilders was predicated not on a hoax or series of hoaxes but on ignorance and selective acceptance of the data. Silverberg's thesis that the vanished race myth was politically motivated is well founded; it was, as he says, "comforting to the conquerors" (1989:48).

If the Indians were not the builders of the mounds and the bearers of a culture that impressed even the rather ethnocentric European colonizers of America, it made wiping out the presumably savage and primitive natives

less troublesome. And, if Europeans could further convince themselves that the Indians were very recent interlopers—in fact, the very invaders who had savagely destroyed the gentle and civilized Moundbuilders—so much the better. And finally, if it could be shown that the Moundbuilders were, in actuality, ancient European travelers to the Western Hemisphere, the circle was complete. In destroying the Indian people, Europeans in the eighteenth and nineteenth centuries could rationalize that they were only giving back to the Indians what they had meted out to the Moundbuilders and, in a sense, were merely reclaiming territory once held by ancient Europe. The Moundbuilder myth was not just the result of a harmless prank or a confusing hoax. It was part of an attempt to justify the destruction of American Indian societies. We owe it to them to set the record straight.

→ CURRENT PERSPECTIVES &

The Moundbuilders

An enormous amount of research has been conducted on the Moundbuilder culture in the last hundred years. We now realize that there was no one Moundbuilder culture but several (Figure 7.8). The oldest evidence for mound building in North America has been found at the Watson Brake site in Louisiana and dates to 5,400 to 5,000 years ago (Saunders et al. 1997). There, a people reliant on hunting and gathering for their subsistence constructed a complex of eleven earthworks, including mounds and enclosures. The largest among the mounds is 7.5 meters (25 feet) in height. The great antiquity of Watson Brake is a clear indication that mound building has a very long history in North America. It also is geographically widespread, with ancient earthworks found throughout the American Southeast, Midwest, and northern plains.

The conical burial mounds that developed in the Ohio River valley have been divided into two cultures: the *Adena* and the *Hopewell* (Lepper 1995a). These both involved burial cults, long-distance trade, and the production of fine crafts and artwork and are differentiated on the basis of certain artifact types. Adena is earlier, dating to as much as 2,800 years ago. Hopewell emerged from Adena about 2,200 years ago and likely represents what is essentially a flowering of Adena culture, though there is extensive chronological overlap between the two patterns. (In other words, not all of those we call Adena developed into Hopewell at the same time.)

Adena and Hopewell people lived in small towns located across much of southern and central Ohio and surrounding states to the south and west. Though we usually think of Native American subsistence as based on corn, very little evidence for that crop has been found at either Adena or Hopewell sites. The Hopewell people especially are known to have relied on the cultivation of local seed plants like sunflower, knotweed, maygrass, goosefoot,

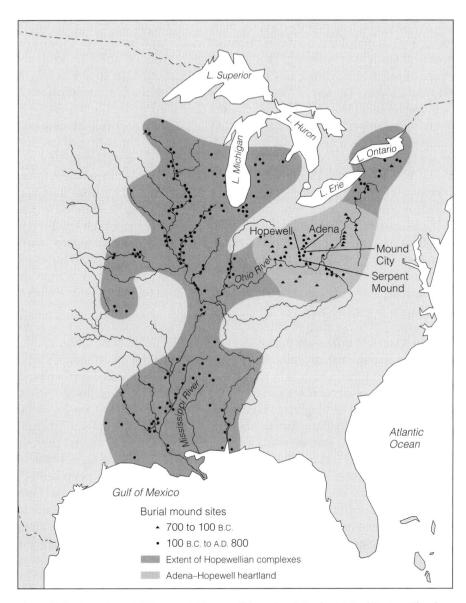

Figure 7.8 Location of Adena and Hopewell heartlands in the United States. Clearly, the geographical focus of Moundbuilder culture was the river valleys of the American Midwest and Southeast.

and marsh elder, as well as squash, crops that were part of an indigenous agricultural revolution that took place before the movement of corn into the region from Mexico (Smith 1995). Hunting and gathering wild plant foods continued to contribute to the subsistence quest.

The burial mounds themselves mark the remains of either individuals or groups of people, almost certainly the "important" religious, social, and political leaders of Adena or Hopewell society. Some of these mounds are quite impressive, covering several acres and reaching 70 or 80 feet in height. Mound 25 at the Hopewell Mound Group in Ohio is particularly impressive; it is 150 meters (500 feet) long, 55 meters (180 feet) wide, and 9 meters (30 feet) high (Lepper 1995a). Mound City in Chillicothe, Ohio, is another significant site, a virtual necropolis or "city of the dead," consisting of twenty-three burial mounds surrounded by an earth embankment (Figure 7.9).

A widespread trade network brought natural resources to the Adena/Hopewell from all over the United States: copper and silver from the Great Lakes region were made into finely crafted goods and placed in the graves of those buried in the mounds; turtle shells, pearls, and conch shells from the Gulf of Mexico traveled up the major river systems of eastern North America and were also included in the burials of the Adena and Hopewell; obsidian from the Rocky Mountains, and quartz crystals and mica from the Appalachian Mountains made long journeys into the hands of the elite of Adena/Hopewell society.

Some of these sites of extensive earthworks include earthen wall enclosed spaces of unknown purpose. For example, in Newark, Ohio, a series of long, narrow, earthen walls about 5 feet high enclose an octagonal plot of more than 40 acres, which is in turn connected by two parallel earthen walls to an enormous circular area of more than 20 acres, also enclosed with an earth wall several feet high (see Figure 7.4). This large earthwork is located at the endpoint of what appears to have been a 60-mile long ceremonial road demarcated by two earthen walls approximately 200 feet apart and perhaps as much as 8 to 10 feet in height (Lepper 1995b). Connecting sacred or ceremonial mound sites and enclosures, these "roads" may have been used by pilgrims visiting the sites for religious observances—perhaps burial ceremonies or worship services. The earthworks located along these ceremonial roads appear to have been aligned in reference to important locations along the horizon, places where the sun and moon rise and set at certain dates during the year. Archaeologist Brad Lepper (1998) suggests that these astronomical alignments are not coincidental but indicate a detailed knowledge of the movements of the sun and moon, perhaps incorporated into calendar ceremonies practiced by the mound-builder people. These sites and the ceremonial roadways are examples of the ability of the Adena/Hopewell to organize a large labor force and produce works of monumental proportions.

Later developments in the Mississippi River valley and the American Southeast represent a different pattern. During this period, called the Mississippian, the major temple mound sites were not just places of burial but were the central places or capital towns of increasingly complex societies, called "chiefdoms." The labor of a sizable population was conscripted by the leaders of temple mound societies to construct large, truncated (cut off at the top) pyra-

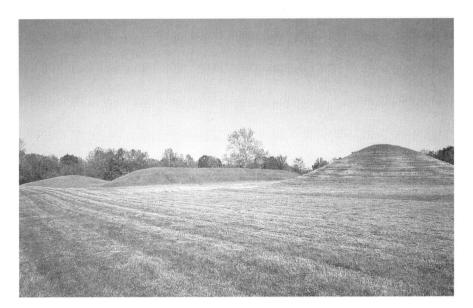

Figure 7.9 Mound City in Chillicothe, Ohio, is a virtual city of the dead. The site consists of twenty-three burial mounds—a few of which can be seen here—within a thirteen-acre enclosure demarcated by an earth embankment. (K. L. Feder)

mids of earth. Cahokia was the largest and most impressive of these—and the only one with a resident population of a size and density that approaches an urban character. There were, however, many others like Etowah in Georgia and Moundville in Alabama that, though smaller in size and complexity, with fewer and smaller monumental earthworks, nevertheless represent development of complex, indigenous societies in the period after A.D. 1000.

The temple Moundbuilders grew maize and squash and later added domesticated beans to their diet. They fished in the rivers and hunted in the forests and continued to gather wild plant foods including acorn and hickory. The enormous food surplus made possible by agriculture likely allowed for the support of a class of priests and the attendant nobility and artisans.

Old World civilizations such as those of ancient Egypt and Sumer and New World civilizations including the Aztec and Maya are marked by stratified social systems. Kings, emperors, or pharaohs ruled with the help of noble and priestly classes. The nature of social stratification is exhibited quite clearly in the archaeology of their deaths; the tombs of pharaohs and kings are large and sumptuous with concentrations of finely crafted artwork, rare or exotic (and presumably expensive) materials, and even the presence of retainers—people killed and buried with the ruler to accompany him or her to the afterlife.

Cahokia, too, has evidence of just such a burial (Fowler 1974:20–22, 1975:7–8). Mound 72 represents the interment of members of a royal family

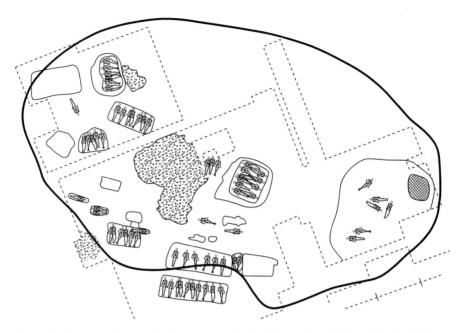

Figure 7.10 Map showing the location of the burials at Mound 72 at Cahokia. The primary burial is that of a young man, laid out on a bed of more than twenty thousand mother-of-pearl shell beads. The great wealth reflected in the materials with which he was buried, and the likelihood that some of the secondary burials represent human sacrifices, suggests that the primary burial in Mound 72 was that of an important person, perhaps a ruler of ancient Cahokia. (Courtesy William Fowler)

of Cahokia (Figure 7.10). A young man was laid out on a platform of twenty thousand perforated mother-of-pearl shell beads that had, perhaps, been woven into a burial cloak. A cache of more than one thousand stone arrowpoints had been placed in his tomb (Figure 7.11). Nearby, three women and three men were buried, accompanied by stone weapons made from materials imported from Oklahoma and Arkansas as well as by sheets of mica from North Carolina. A 2-by-3-foot sheet of copper from Michigan had also been included in their burial.

Another part of the mound contained the burials of four men, decapitated and with their hands cut off. Close by were the remains of fifty women, all in their late teens and early twenties. These likely were all individuals whose lives were sacrificed for the presumed needs of the rulers in their lives after death.

The evidence at Cahokia and other temple mound sites, as well as at sites of the Adena and Hopewell cultures, is clear. American Indians produced cultures of great sophistication and complexity. The only mystery that remains is why more Americans are not aware of the legacy of these indigenous civilizations.

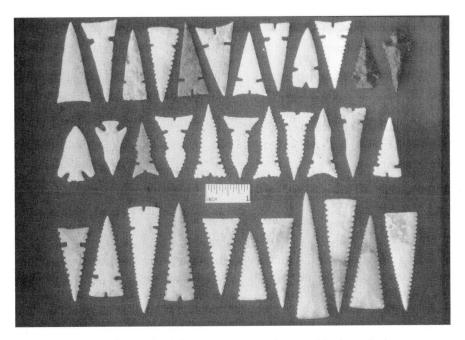

Figure 7.11 A small sample of the more than one thousand finely crafted stone projectile points buried with one of Cahokia's leaders in Mound 72. (Cahokia Mounds State Historic Site)

♠ FREQUENTLY ASKED QUESTIONS <</p>

1. Some of the mounds are huge. Where did all the dirt come from to build the mounds?

The dirt came from the immediate vicinity of the mounds. Huge quantities were excavated using wooden shovels and stone- and shell-bladed hoes. The dirt was carried by basket. In the vicinity of some of the larger mounds, enormous borrow pits (extensive, but not terribly deep) represent the source areas for the dirt used to build the mounds.

2. How long did it take to build a mound?

The time it takes to build a mound depends on how many people are working and the size of the mound being constructed. In the early 1980s an experiment was conducted in mound building at the Kampsville campus of the University of Illinois. About twenty-five people constructed a small mound, transporting and piling up more than six hundred basket loads of dirt. They did not have to dig the dirt up; it had already been loosely piled for them. This certainly saved them quite a bit of time and effort. It took this group the better part of an afternoon to construct a mound about 5 feet high with a diameter of about 20 feet at its base for a volume of a little more than

Best of the Web

CLICK HERE

http://medicine.wustl.edu/~mckinney/cahokia/cahokia.html

http://www.nps.gov/crweb1/aad/feature/builder.htm

http://www.geocities.com/~kithutch/

http://www.cviog.uga.edu/Projects/gainfo/mississ.htm

http://www.usd.edu/anth/cultarch/ltribes.html

500 cubic feet. Compare this to Monks Mound at Cahokia, with its volume of 20 million cubic feet. Certainly large mounds were an enormous undertaking, demanding the labor of large numbers of people for extended periods of time.

♠ CRITICAL THINKING EXERCISE <</p>

Using the deductive approach outlined in Chapter 2, how would you test these hypotheses? In each case, what archaeological and biological data must you find to conclude that the hypothetical statement is an accurate assertion, that it describes what actually happened in the ancient human past?

- The mounds found throughout the American Midwest and Southeast were the product of an indigenous people.
- The mounds found throughout the American Midwest and Southeast were the product of invaders from Europe who later were displaced by the ancestors of American Indians.

Lost: One Continent—Reward

It was a beautiful land. Its people, gentle and fair, artistic and intelligent, created the most wonderful society the world has ever known. Their cities were splendid places, interwoven with blue canals and framed by crystal towers gently arching skyward. From its seaports, ships were sent out to the corners of the globe, gathering in abundant raw materials needed by its artisans and giving in return something far more valuable—civilization. The wondrous achievements of the archaic world can be traced to the genius of this singular ancient land. The cultures of the ancient Egyptians and the Maya, the civilizations of China and India, the Inca, the Moundbuilders, and the Sumerians were all derived from this source of civilization.

But tragedy was to strike down this great nation. In a cataclysmic upheaval of incomprehensible proportions, this beautiful land and its people were destroyed in a day and a night. Earthquakes, volcanic eruptions, and tidal waves, with forces never before or since unleashed by nature, shattered the crystal towers, sunk the great navy, and created a holocaust of incalculable sorrow.

All that remains are the traces of those derivative cultures that benefited from contact with this most spectacular source of all culture. But ancient Egypt, the Aztecs, the Maya, the Chinese Shang, the Moundbuilders, and the rest, as impressive as they were, could have been only the palest of shadows, the most tepid of imitations of the source of all human civilization.

This is the great irony of prehistoric archaeology; the most important of ancient cultures is beyond the grasp of even those archaeologists who investigate the corpses of great civilizations. For the original civilization of which I speak, the source of all human achievement, is Atlantis, the island continent civilization that was obliterated beneath the seething waters of the Atlantic more than eleven thousand years ago. Atlantis the fair; Atlantis the beautiful; Atlantis the source. Yes, and Atlantis the myth. It simply did not exist.

Atlantis: The Source of the Legend

Unlike many legends, the source of the Atlantis story is quite easy to trace. It all started with the Greek philosopher Plato. Plato was born in 429 or 428 B.C. He became a disciple of another great philosopher, Socrates, in about 410 B.C. and established his own school in 386 B.C. He was well known in his own time and is, of course, still studied and considered a great thinker more than two thousand years after his death.

Plato apparently believed that the best way to teach was to engage his students in dialogues. Plato wrote many of his philosophical treatises in a dialogue format as well. Readers who insist that the entire Atlantean dialogues are genuine history may be unaware, however, that even the context of Plato's dialogues is fictitious. The dialogues were largely imaginary conversations between Socrates and his students. The actual discussions Plato reported on never really took place; the published dialogues were not simply stenographic records. They usually included real people, but some of them lived at different times.

Entertainer and writer Steve Allen once produced a fascinating television show using a similar device. In *Meeting of the Minds* actors and actresses portraying famous historical figures discussed and debated important philosophical issues. On a given night Abraham Lincoln, Cleopatra, Ghengis Kahn, and Mohandas Ghandi would all discuss one issue, for example, slavery. Each of these historical figures was portrayed by an actor or actress well-versed in the perspective of the individual he or she was playing. Of course, the real people being depicted never actually discussed slavery with each other; they lived in different parts of the world at different times. The point was to imagine how such a conversation might have gone. Plato used a similar technique to challenge, teach, and entertain his readers.

It has been suggested that Plato used this format to present sometimes quite controversial ideas of his own without getting in trouble with the authorities—he could always claim that the opinions were not his but those of the people engaging in the dialogues (Shorey 1933). The format also allowed Plato to argue both sides of an issue without taking a stand himself.

The story of the Lost Continent of Atlantis was presented in two of Plato's dialogues: *Timaeus* and *Critias*. These dialogues are referred to by the names of the individuals who play the most significant roles in the discussions.

The Timaeus Dialogue

The Timaeus dialogue begins, oddly enough, with Socrates taking attendance. Socrates then refers to the previous day's discussion of the "perfect" society. It is clear in this context that the discourse Plato is referring to is his most famous dialogue, the *Republic*, actually written several years before

Timaeus. Here, we are being asked by Plato to go along with the fiction that the *Republic* dialogue, where the nature of a perfect society had been discussed in great detail, was the product of yesterday's conversation.

Socrates next summarizes the characteristics of the hypothetical perfect culture presented in the *Republic*. Artisans and husbandmen would be separated from the military; and those in the military would be merciful, would be trained in "gymnastic" and music, would live communally, and would own no gold or silver or any private property.

Socrates, however, then despairs of hypothetical discussions, like the one presented in the *Republic*, of such a perfect society:

I might compare myself to a person who, on beholding beautiful animals either created by the painter's art or, better still, alive but at rest, is seized with a desire of seeing them in motion or engaged in some struggle or conflict to which their forms appear suited. (Hutchins 1952:443; all quotes from Plato's dialogues are from this translation)

Socrates next gives what amounts to an assignment:

I should like to hear some one tell of our own city [his hypothetical perfect society] carrying on a struggle against her neighbors, and how she went out to war in a becoming manner, and when at war showed by the greatness of her actions and the magnanimity of her words, in dealing with other cities a result worthy of her training and education. (p. 443)

Socrates even explicitly instructs his students to engage "our city in a suitable war" to show how the perfect society would perform. One of those present, Hermocrates, tells Socrates that a fellow student, Critias, knows the perfect story. Critias then begins to give the account: "Then listen, Socrates, to a tale which though strange, is certainly true . . ." (p. 444).

Critias says that he heard this "true" story from his grandfather, who related the tale at a public gathering on a holiday that Plato scholar Paul Friedlander refers to as a kind of April Fool's Day (1969:383) when prizes are awarded for the best narrative. Critias's grandfather (also named Critias) said that he heard it from his father, Dropides, who heard it from the Greek sage Solon, who heard it from some unnamed priests in Egypt when he was there shortly after 600 B.C. So at best, when we read Plato, we are reading a very indirect account of a story that had originated more than two hundred years earlier.

According to the tale told by Critias, the Egyptian priests told Solon that the Greeks are little more than "children" and know nothing of the many cataclysms that befell humanity in ancient times. They then go on to tell him of ancient Athens, which "was first in war and in every way the best governed of all cities" (p. 445). In fact, it is this ancient Athens of ninety-three hundred years earlier, which in Critias's story will serve as the model of the perfect state.

The priests tell Solon of the most heroic deed of the ancient city of Athens; it defeated in battle "a mighty power which unprovoked made an expedition against the whole of Europe and Asia" (pp. 445–46). They continue by describing and identifying the evil power that so threatened the rest of the world: "This power came forth out of the Atlantic Ocean . . . an island situated in front of the straits, which are by you called the Pillars of Heracles" (p. 446). (Today they are called the Straits of Gibraltar.) The Egyptian priests told Solon the name of this great power in the Atlantic Ocean: the island nation of Atlantis.

Ancient Athens was able to subdue mighty Atlantis, which had held sway across northern Africa all the way to Egypt. After her defeat in battle, all of Atlantis was destroyed in a tremendous cataclysm of earthquakes and floods. Unfortunately, ancient Athens also was destroyed in the same catastrophe.

After outlining the Atlantis story, Critias remarks to Socrates:

When you were speaking yesterday about your city and citizens, the tale which I have just been repeating to you came into my mind, and I remarked with astonishment how, by some mysterious coincidence, you agreed in almost every particular with the narrative of Solon. (p. 446, emphasis mine)

Of course, it was no coincidence; it was how Plato worked Atlantis and ancient Athens into the dialogue.

Following this brief introduction to the story, Critias cedes the floor to Timaeus who provides a very detailed discussion of his theory of the origins of the universe. In the next dialogue, *Critias*, details of the Atlantis story are provided.

The Critias Dialogue

Critias appears to have listened well to his teacher's description of the perfect society; for in his tale ancient Athens, even in detail, matches precisely the hypothetical society of Socrates. According to the story Critias told, in ancient Athens, artisans and husbandmen are set apart from the military, military men owned no private property and possessed no gold or silver, and so on.

Only after first describing ancient Athens does Critias describe Atlantis. He relates that Atlantis was originally settled by the Greek god Poseidon and a mortal woman, Kleito, who bore him five sets of male twins. All Atlanteans were descended from these ten males. The Atlanteans became quite powerful and built a 15-mile-wide city of concentric rings of alternating land and water, with palaces, huge canals, towers, and bridges. They

produced artworks in silver and gold and traded far and wide. They possessed a great navy of twelve hundred ships and an army with ten thousand chariots. Their empire and their influence expanded exponentially.

After a time, however, the "divine portion" of their ancestry became diluted and the human portion became dominant. As a result, their civilization became decadent, the people depraved and greedy. The dialogue relates that Zeus, the chief god in the Greek pantheon, decides to teach the inhabitants of Atlantis a lesson for their avarice and prideful desire to rule the world. Zeus gathers the other gods together to relate his plan. The dialogue ends unfinished at just this point, and Plato never returned to it, dying just a few years later.

The Source and Meaning of Timaeus and Critias

Though briefly summarized here, this is the entire story of Atlantis as related in Plato's dialogues. All else written about Atlantis is derivative or invented.

It is ironic, however, that this source of the popular myth of Atlantis, while having spawned some two thousand books and articles (de Camp 1970) along with a number of periodicals (*Atlantis, The Atlantis Quarterly*, and *Atlantis Rising*), isn't really about Atlantis at all. The lost continent is little more than a plot device. The story is about an ostensible ancient *Athens*. Athens is the protagonist, the hero, and the focus of Plato's tale. Atlantis is the antagonist, the empire gone bad in whose military defeat by Athens the functioning of a perfect society as defined by Socrates can be exemplified.

Now consider the story that Plato tells: a technologically sophisticated but morally bankrupt, evil empire—Atlantis—attempts world domination by force. The only thing standing in its way is a relatively small group of spiritually pure, morally principled, and incorruptible people—the ancient Athenians. Overcoming overwhelming numerical and technological odds, the Athenians are able to defeat their far more powerful adversary simply through the force of their spirit.

Sound familiar? Plato's Atlantean dialogues are essentially an ancient Greek version of *Star Wars!* Think about it: Plato placed Atlantis nine thousand years before his time, off in the little-known (to the ancient Greeks) Atlantic Ocean. *Star Wars* takes place "A long time ago, in a galaxy far, far away." Atlantis, with its sophisticated military and enormous navy, parallels the Empire with its Stormtroopers and Death Star. The Athenians are the counterparts of the ragtag group of rebels led (eventually) by Luke Skywalker. The rebels and the Athenians both are victorious, certainly not because they are militarily superior, but why?—because "the Force" is with them both. One more connection can be made; if nine thousand years from

now people ask if the *Star Wars* saga is actual history, not fiction, it would not be too different from today suggesting that Plato's story of Atlantis really happened. Both stories are myths, used to entertain and to convey moral lessons. They are both equally fantastical.

Who Invented Atlantis?

Atlantis was supposed to have been destroyed more than ninety-three hundred years before Critias tells the story (about 9600 B.C.), but no reference to Atlantis or to anything even remotely resembling the Atlantis story has ever been found that dates to before Plato's writing of these dialogues in about $350\,\mathrm{B.C.}$

There are no records of the Atlantis story in Egypt, where Solon is supposed to have been told the tale, or anywhere else. Though the story was allegedly first told at a public gathering and though Critias claims in the dialogue that bears his name that his great-grandfather possessed a written version of the story, there is no mention of Atlantis anywhere else in Greek literature.

The appearance of the name *Atlantis* in *Timaeus* is the first historical reference to the place. The ninety-three hundred years or so between the supposed destruction of Atlantis and Plato's *Timaeus* are completely silent concerning the supposed lost continent.

Plato did, however, have Critias assert that the story of Atlantis was true. Is this evidence that Plato believed he was relating genuine history? Absolutely not. As historian William Stiebing Jr. states, "Virtually every myth Plato relates in his dialogues is introduced by statements claiming it is true" (1984:51). It is not only the Atlantis account but also tales about heaven and hell (Isles of the Blessed and Tartarus) in *Georgias*, immortality and reincarnation in *Meno*, antiquity in *Laws*, and the afterlife in the *Republic* that are prefaced with statements attesting to their truth (Stiebing 1984:52).

Remember also that the story Critias relates here is the direct result of Socrates having asked his students the previous day to come up with a tale in which his hypothetical perfect state is put to the test by warfare. Critias relates the story of a civilization conveniently enormously distant from his Athens in both time and space, whose remnants are below the Atlantic, certainly beyond recovery or testing by the Greeks of Plato's time. He also has ancient Athens, which would not have been beyond the purview of contemporary Athenians to study, conveniently destroyed. Finally, though maintaining it is a true tale, he admits that "by some mysterious coincidence," it matches Socrates' hypothetical society almost exactly. As A. E. Taylor has said, "We could not be told much more plainly that the whole narrative of Solon's conversation with the priests and his intention of writing the poem about Atlantis are an invention of Plato's fancy" (1962:50).

Where Did Plato Get the Story? A Minoan Source

The final question to be asked is, "If the Atlantis story is a myth, was it at least based on a real event or a series of events?" In other words, did Plato base elements of his story—a great civilization destroyed by a cataclysm—on historical events, perhaps only dimly remembered by the Greeks at the time he was writing? The answer is almost certainly yes; in a sense, all fiction must be based on fact. All writers begin with knowledge of the real world and construct their literary fantasies with the raw material of that knowledge. Plato was no different.

One logical, possible model for Plato may have been the ancient civilization of Minoan Crete (Figure 8.1). The spectacular temple at the Minoan capital of Knossos was built beginning about thirty-eight hundred years ago. At its peak the temple covered an area of some 20,000 square meters (more than 210,000 square feet or about 5 acres), contained about one thousand separate rooms, and had a central courtyard with a pillar-lined hallway, a ceremonial bath, and grand staircases. Some parts of the temple were three and even four stories tall. The walls of some of the living quarters and large halls were covered with artfully produced fresco paintings of dolphins and bulls. Where the Minoans depicted themselves in these paintings, we see a graceful and athletic people. Altogether impressive, the Greeks of Plato's time were aware of this even more ancient culture.

A key element in the possible connection between Plato's fictional Atlantis and the historical Minoan civilization rests in a catastrophe that affected the island of Crete sometime around 3420 B.P. At that time, a volcano erupted on the island today called Santorini (the ancient Greeks called it Thera), 120 kilometers (72 miles) north of Crete (Figure 8.2). The explosive force of the eruption of Thera was four times as powerful as that of Krakatoa in the Dutch East Indies in 1883 (Marinatos 1972:718), which killed some thirty-six thousand people.

It should come as no surprise that the obliteration of Thera had a major impact on the Minoan civilization (Marinatos 1972). The eruption itself, accompanied by severe earthquakes, badly damaged many settlements on Crete. Devastating waves, or tsunamis, produced by the eruption of Thera wiped out Minoan port settlements on the north coast of Crete.

The Minoan civilization developed, at least in part, as a result of trade. The loss of ports through which trade items passed and the probable destruction of the Minoan fleet of trading vessels must have had a tremendous impact on the Minoan economy. Also of great significance for the Minoans over the long term was the thick deposit of white volcanic ash that blanketed the rich farmland of Crete, interrupting for a time the agricultural economy of the Minoan people.

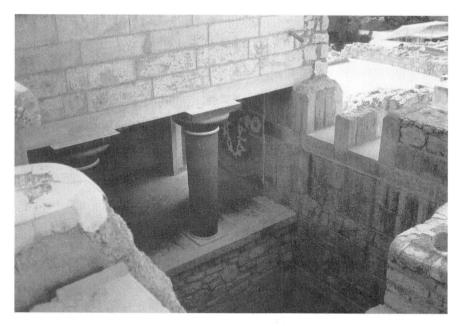

Figure 8.1 Those who support the hypothesis that the eruption on Thera is the source of the story of the destruction of Atlantis have suggested that the Minoan civilization on Crete was the historical model for Atlantis culture. Pictured here is the ancient temple at Knossos on Crete, dating to Minoan times. (M. H. Feder)

As early as 1909, a scholar at Queen's University in Belfast suggested a connection between historical Minoan Crete and the Atlantis legend (cited in Luce 1969:47). Using more recent archaeological evidence, researchers Spyridon Marinatos (1972), J. V. Luce (1969), and Angelos Galanopoulos and Edward Bacon (1969) have expanded on Frost's suggestion, arguing rather persuasively that Plato based at least elements of his Atlantis story on historically accurate aspects of Minoan civilization. They propose that the dating, distances, and proportions in Plato's account are erroneous as a result of mistranslation and off by a factor of ten. They claim that when this is corrected, Plato's story fits the Thera explosion.

A key element of the Atlantis story is its absolute obliteration at the end of the tale. Herein lies one major problem with identifying Minoan Crete in its totality as Atlantis. Though adversely affected by the eruption of Thera, archaeological evidence clearly shows that Minoan Crete was not immediately destroyed by it. As historian William Stiebing (1984) points out, there is plenty of evidence of destruction on Crete coinciding with the eruption of Thera, but equally plentiful evidence of repair work afterward. There is new evidence of construction of Minoan structures on top of the volcanic deposit soon after the eruption (Bower 1990). But it also seems clear that the Minoans never fully recovered from the devastation wrought by the eruption on Thera.

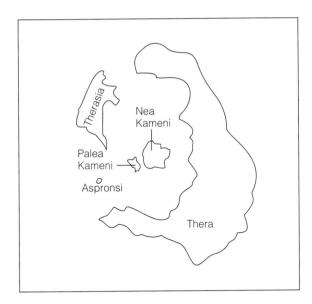

Figure 8.2 The island of Thera in the Mediterranean today is the remnant of a volcano that exploded some fifteen hundred years ago. It has been suggested that the historical explosion of the volcano served as a model for Plato's story of the destruction of Atlantis.

There is another major problem with identifying Minoan Crete as the single source for Plato's Atlantis. Significantly, the major theme of Plato's story, the defeat by Athens of a great military power, remains unexplained here. Minoan Crete did not suffer a major military defeat at the hands of Athens. If Minoan Crete was Plato's inspiration for the Atlantis story, this key aspect of the tale was entirely fictional.

Another possibility is that Thera itself may have been more directly Plato's model (Pellegrino 1991). An impressive Minoan settlement on that island was destroyed completely by the eruption. Its story, perhaps even more than that of the Minoan homeland on Crete, may have been passed down and used by Plato in his Atlantis dialogues.

Ultimately, we can conclude that Minoan Crete was not Atlantis, at least not entirely. Certainly, however, elements of the story of the eruption of Thera and its impacts on Minoan civilization likely contributed to Plato's fanciful account of the lost continent.

Plato's *Timaeus* and *Critias* are not historical accounts of actual events involving a real place and similarly are not the slightly jumbled accounts of genuine history. They are, instead, part of a fantasy concocted by the philosopher, but anchored in his reality. That reality likely included some knowledge of the destruction of Thera and, just as important, knowledge of the actual historical defeat by Athens, largely alone, of Persian invaders of Greece in 492–479 B.C. (Hartmann 1987). If we focus our attention too closely on the issue of which, if any, historical events Plato used to create the Atlantis story, we are missing the point. Plato was not writing history, but philosophy. For Plato, the historical accuracy of the Atlantis story was never

the key issue. What was crucial were the lessons the story taught about the ability of a righteous, well-run society to overcome great odds. Ultimately, it must be admitted, as Plato scholar Paul Shorey concludes: "Atlantis itself is wholly his [Plato's] invention, and we can only divine how much of the detail of his description is due to images suggested by his reading, his travels, and traveler's tales" (1933:351).

After Plato

After Plato died, leaving the Critias dialogue and the Atlantis story incomplete, we find no mention of the lost continent for more than three hundred years (de Camp 1970:16). We have to rely on later writers like the Greek geographer Strabo, who was born in about 63 B.C., for some insight into what those who followed Plato thought about his account of a lost continent. Strabo claimed, for example, that, in reference to Atlantis, Plato's best-known student Aristotle said, "He who invented it also destroyed it" (as cited in de Camp 1970:17). It seems that many, though not all, who followed Plato viewed Atlantis as an invention, part of a story whose moral is, as A. E. Taylor has said:

... transparently simple. It is that a small and materially poor community [ancient Athens] animated by true patriotism and high moral ideals can be more than a match for a populous and wealthy empire [Atlantis] with immense material resources but wanting in virtue. (1962:50)

It was not until the Age of Exploration and the discovery of the New World that consideration of the veracity of the Atlantis story became popular. For example, as we saw in Chapter 5, Huddleston (1967) points out that in 1552 the Spaniard Lopez de Gomara suggested that American Indians were a remnant population of emigrés from the Lost Continent of Atlantis. Gomara based his interpretation on a linguistic argument concerning a single word; in the Aztec language of Nahuatl, the word *atl* means water (Huddleston 1967:25).

Later, in 1572, Pedro Sarmiento de Gamboa maintained that the great civilizations of the New World were partially derived from Atlantis. In the seventeenth century, maps were drawn placing Atlantis in the Atlantic Ocean (Figure 8.3). Some, like Englishman John Josselyn (1674), even identified the New World *as* Atlantis.

Diego de Landa, the Spanish bishop of the Yucatán, contributed to the confusion concerning the Atlantis controversy. He incorrectly determined that the written language of the Maya was alphabetic. Though we know the Mayan written language was hieroglyphic, with individual signs representing complete words, names, concepts, or sounds, de Landa constructed an alphabet of genuine Maya hieroglyphs, artificially assigning them letter des-

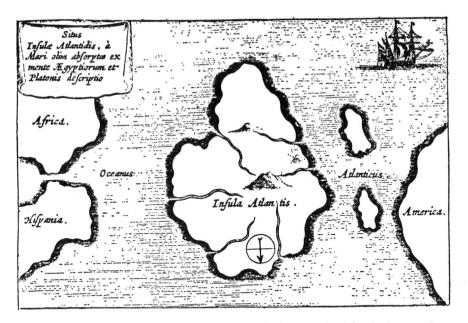

Figure 8.3 This 1644 map shows the location of Atlantis in the Atlantic Ocean. Note that south is to the top of the map. (From *Mundus Subterraneus* by Athanasius Kircher)

ignations. Based on this complete misrepresentation of the Mayan language, a French scholar, Abbé Charles-Étienne Brasseur (called de Bourbourg) "translated" a Maya book, the Troano Codex, in 1864. It was a complete fantasy and contained elements of the Atlantis story, particularly destruction by flood. Using the same delusional alphabet, Augustus Le Plongeon also translated the Codex, coming up with an entirely different story, connecting the Maya to the ancient Egyptians. It was all complete fabrication, but it kept alive the notion that perhaps the civilizations of the Old and New Worlds could somehow be connected and explained by reference to Atlantis.

Ignatius Donnelly: The Minnesota Congressman

Speculation concerning the possible reality of Plato's Atlantis story might have ended in the eighteenth or nineteenth centuries, as other myths were abandoned when scientific knowledge expanded (see Chapter 5). We have one man to thank, or blame, for this not happening: Ignatius Donnelly.

Donnelly was born in 1831. He studied law, and at only twenty-eight years of age became the lieutenant governor of Minnesota. He later went on to serve several terms in the federal House of Representatives and twice ran for vice-president of the United States.

By all accounts, Donnelly was an exceptional individual, a voracious reader who collected an enormous body of information concerning world history, mythology, and geography. Clearly, however, he was less than selective in his studies and seemingly was incapable in his research of discriminating between the meaningful and the meaningless. Donnelly is the father of modern Atlantis studies and, as writer Daniel Cohen (1969) has aptly put it, Donnelly's book *Atlantis: The Antediluvian World*, published first in 1882, is the "bible" of belief in the legend. (It is interesting to note that in his book *The Great Cryptogram*, Donnelly is also an early source for the claim that Sir Francis Bacon wrote all of Shakespeare's plays.)

Donnelly's *Atlantis: The Antediluvian World* is an amazing piece of inductive scholarship. While being obsessive in his collecting of "facts," Donnelly had very little of a scientific, skeptical sense. His approach was indiscriminate. Essentially, he seems never to have met a claim about Atlantis that he didn't like and accept.

He begins by asserting he will prove that the Atlantis story as told by Plato is not legend but "veritable history" (1882:1); that Atlantis "was the region where man first rose from a state of barbarism to civilization" (p. 1); and that it was the source of civilization in Egypt, South America, Mexico, Europe, and North America, where he specifies the Moundbuilder culture (Figure 8.4).

Donnelly's argument is a confusing morass of disconnected claims and ostensible proofs. He does little more than enumerate supposed evidence; this is diagnostic of the purely inductive method of reasoning he employed. Nowhere does he attempt to test the implications of his hypotheses—what must be true if some of his specific claims also are true. To be sure, we cannot fault Donnelly for failing to apply to the argument data unknown during his lifetime. We can, however, fault his general approach and do what he failed to—test the implications of his claims.

For example, he cites numerous flood legends in various world cultures, all of which he presumes are part of some universal memory of the destruction of Atlantis. His reasoning is that lots of legends referring to a similar event must indicate that the event actually happened. If this were true, we should be able to show that the legends were all independently derived stories that match, at least in terms of their important generalities. This turns out not to be true. Several of his supposed corroborating myths sound quite similar, not because they relate to an actual historical event but because they can be traced to the same source.

For example, the biblical flood story (Donnelly says it is really about the cataclysm that destroyed Atlantis) and the Babylonian flood story are quite similar in their particulars because the ancient Hebrews spent time in Babylonia and picked up the older flood legend from local people. When American Indian tribes related flood stories, they often did so to missionaries who had already instructed them in Genesis. Some tribes already pos-

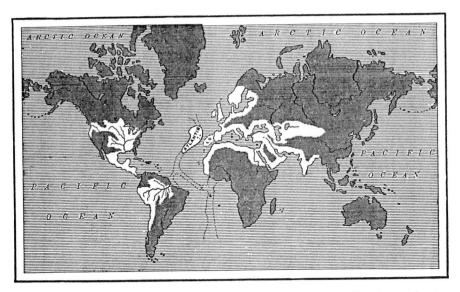

Figure 8.4 Ignatius Donnelly saw all of the world's ancient civilizations as having been derived from that of Atlantis. Here, Donnelly maps (in white) the extent of Atlantis's influence, including the cultures of ancient Egypt, Mesopotamia, Mesoamerica, and the Moundbuilders of the United States. (From *Atlantis: The Antediluvian World*, by Ignatius Donnelly)

sessing flood stories could easily have incorporated the details of Genesis into their mythology. Applying Occam's Razor here, which is the simpler explanation? One requires a lost continent for which there is no evidence; the other simply presumes that Indians would have incorporated new stories told them by missionaries into their own myths.

Although Donnelly spends quite a bit of time arguing that catastrophes like those that presumably befell Atlantis could and did happen, this is not the crux of his argument. Reasoning based on *cultural* comparisons is central to his methodology. He maintains: "If then we prove that, on both sides of the Atlantic, civilizations were found substantially identical, we have demonstrated that they must have descended one from the other, or have radiated from some common source" (1882:135).

This argument for the significant role of *diffusion* in cultural development was common in anthropology in the late nineteenth and early twentieth centuries (Harris 1968). The presumption seems to have been that cultures are basically uninventive and that new ideas are developed in very few or even single places. They then move out or "diffuse" from these source areas. It was fairly common to suggest that Egypt was the source of all civilization, that agriculture, writing, monumental architecture, and the like were all invented only there. These characteristics, it was maintained, diffused from Egypt and were adopted by other groups.

Donnelly was a diffusionist. For him the common source of all civilization was Atlantis, rather than Egypt, Sumer, or some other known culture. In his attempt to prove this, he presents a series of artifacts or practices that he finds to be identical among the civilizations of the Old and New Worlds. In these comparisons, Donnelly presents what he believes is the clearest evidence for the existence of Atlantis. His evidence essentially consists of trait list comparisons of the sort discussed in Chapter 5. Let us look at a few of these and do what Donnelly did not—test the implications of his claims.

1. Egyptian obelisks and Mesoamerican stelae are derived from the same source (Donnelly 1882:136).

Donnelly finds that the inscribed obelisks of Egypt are virtually identical to the inscribed stelae of the Maya civilization. He does little more than make this assertion before he is off on his next topic. But it is necessary to examine the claim more closely and to consider the implications. If it were, in fact, the case that Egyptian obelisks and Maya stelae were derived from a common source, we would expect that they possessed similarities both specific and general. Yet, their method of construction is different; they are different in shape, size, and raw materials; and the languages inscribed on them are entirely different (Figure 8.5). They are similar only in that they are upright slabs of inscribed rock. It is not reasonable to claim that they must have been derived from a common source. They are simply too different.

2. The pyramids of Egypt and the pyramids of Mesoamerica can be traced to the same source (Donnelly 1882:317–41).

Here again, if this hypothesis were true, we would expect that these pyramids would share many specific features. The pyramids of the Old and New Worlds, however, do not look the same (Figure 8.6). New World pyramids are all truncated with flat tops, whereas Egyptian pyramids are pointed on top. New World pyramids have stairs ascending their faces; Egyptian pyramids do not. New World pyramids served as platforms for temples, and many also were burial chambers for great leaders. Egyptian pyramids had no temples on their summits and all were burial chambers for dead pharaohs or their wives. Construction methods were different; most Egyptian pyramids represent a single construction episode, whereas Mesoamerican pyramids usually represent several building episodes, one on top of another. Finally, if Mesoamerican and Egyptian pyramids are hypothesized to have been derived from the same source (Atlantis or elsewhere), they should date from the same period. But Egyptian pyramids were built between about five thousand and four thousand years ago. Those in Mesoamerica are all less than three thousand years old-most are considerably

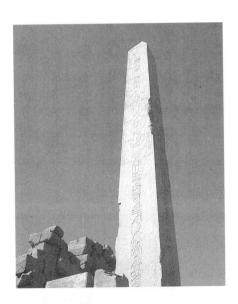

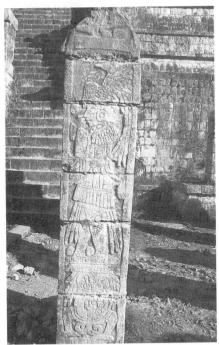

Figure 8.5 Donnelly thought that Egyptian obelisks and Mava stelae were so similar that they must have originated in the same place—Atlantis. Yet here it can be seen that obelisks, like these from Karnac in Egypt (top; M. H. Feder), were inscribed, four-sided columns, whereas stelae, like this one from the Temple of the Warriors at Chichén Itzá (bottom; K. L. Feder), were flat blocks of inscribed limestone. They are quite different and do not warrant any connections via a lost continent.

younger, dating to less than fifteen hundred years ago. All pyramids date to well after the supposed destruction of Atlantis some eleven thousand years ago.

3. Ancient cultures in the Old and New Worlds possessed the arch (Donnelly 1882:140).

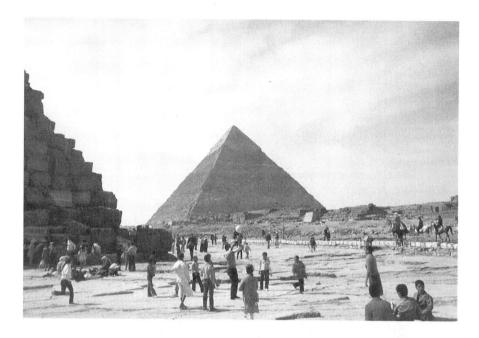

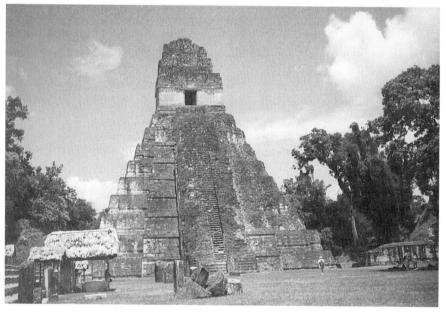

Figure 8.6 Egyptian pyramids, like this one from Gizeh (top; M. H. Feder), and Mesoamerican pyramids, like this one from Tikal (bottom; Cris Wibby), are quite different in construction, form, function, and chronology. Donnelly was thoroughly unjustified in claiming a connection—via Atlantis—between pyramid building in the Old and New Worlds.

This is simply not true. Cultures in the Old World possessed the true arch with a keystone—the supporting wedge of stone at the top of the arch that holds the rest of the stones in place. New World cultures did not have knowledge of the load-bearing keystone (Figure 8.7).

4. Cultures in the Old and New Worlds both produced bronze (Donnelly 1882:140).

This is true, but Donnelly does not assess the implications of the claim that Old and New World metallurgies are derived from a common source. For this to be the case, we would expect the technologies to share many features in common. Bronze is an alloy of copper and some other element. Old World bronze is usually an alloy of copper and tin. In the New World, bronze was generally produced by alloying copper and arsenic (though there is some tin bronze). With such a basic difference in the alloys, it is unlikely that there is a common source for Old and New World metallurgy.

5. Civilizations in both the Old and New Worlds were dependent on agricultural economies for their subsistence. This indicates that these cultures were derived from a common source (Donnelly 1882:141).

It is almost certainly the case that cultures we would label "civilized" are reliant on agriculture to produce the food surplus necessary to free the number of people required to build pyramids, produce fine artworks, be full-time soldiers, and so on. But again, for this to support the hypothesis of a single, Atlantean source for Old and New World agriculture, we would expect there to be many commonalities, not the least of which would be the same or similar crops. That this was not the case certainly was known to Donnelly. Even during his time, it was established that cultures in the Old World domesticated one set of plants and animals, whereas people in the New World domesticated an entirely different set.

We now know that even within the Old World, different ancient societies relied on different mixtures of agricultural crops for their subsistence. In the Middle East, wheat, barley, chick peas, lentils, and vetch were most significant (Henry 1989; Hole, Flannery, and Neely 1969). In the Far East, foxtail millet and rice were major crops (Crawford 1992; Solheim 1972). In Africa, sorghum, pearl and finger millet, and a host of tropical cultigens like the cereals fonio and tef, as well as the bananalike enset, provided subsistence to agricultural people (Harlan 1992; Phillipson 1993). In the Old World, animals like sheep, goat, cattle, and pigs added meat to these various diets.

The list of crops used aboriginally in the New World is just as varied and is entirely different from the lists of Old World domesticates. In Mesoamerica, maize (corn), beans, and squash were predominant

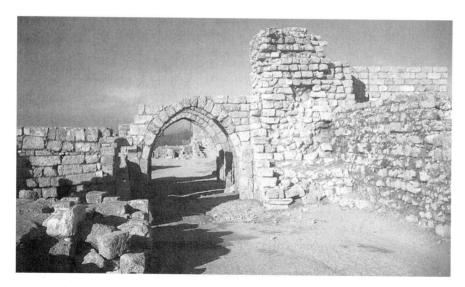

Figure 8.7 Though Donnelly claims that the arch was present in ancient buildings in both the Old and New Worlds, and that this architectural feature had a single source on Atlantis and spread out from there, even the first assertion is not true. Although the true arch with a "keystone" was present in the ancient Old World, as shown in this ancient Israeli building (top; M. H. Feder), the true arch was unknown in the pre-Columbian New World. A corbelled arch was used by Native American architects, like this one found at the Maya site, Chichén Itzá, in Mexico (bottom; K. L. Feder).

with crops like tomato, avocado, chili pepper, amaranth (a grain), and even chocolate rounding out the diet (de Tapia 1992; MacNeish 1967). In South America, maize and beans were important, as were a number of other crops including (most significantly to our modern diets) potato, but also less well-known crops like oca, jícama, and ulluco (Bruhns 1994; Pearsall 1992). In North America, native people produced their own agricultural revolution, domesticating such crops as sunflower, sumpweed, pigweed, goosefoot, and a local variety of squash (Smith 1995). In Mesoamerica, guinea pigs and dogs were raised for meat, and in South America, llamas and alpacas provided meat. The llama was also a serviceable pack animal, and the alpaca was a source of wool. Muscovy ducks and turkeys also were domesticated in ancient South America.

It is readily apparent that the agricultural bases of Old and New World cultures were entirely different. This is far more suggestive of separate evolution of their economies than of their having been derived from a common source.

Archaeological investigations have further supported this fact by showing that, in both the Old and New Worlds, agriculture evolved in place over thousands of years. In several world areas after twelve thousand years ago—notably in southwestern Asia, southern Europe, eastern Asia, Africa south of the Sahara, Mesoamerica, the North American midwest and midsouth, and South America—lengthy evolutionary sequences reflect the slow development of agricultural societies. The archaeology in these areas has revealed long periods during which people hunted wild animals and gathered wild plants that later became domesticated staples of the diet.

The physical evidence in these areas in the form of animal bones and carbonized seeds similarly reflects the slow development of domesticated species. Over centuries and millennia, human beings "artificially selected" those members of wild plant communities that produced the biggest, or densest, or quickest maturing seeds, allowing only those that possessed these advantageous (from a human perspective) characteristics to survive and propagate. Similarly, the ancient people in these regions selected those individuals in an animal species that were the most docile or that produced the thickest wool or the most meat or milk, again allowing only those that possessed these features to survive, breed, and pass these traits down. The continuum through time visible in the archaeological record of increasing seed size, decreasing size of dangerous animal teeth or horns, and so on is clear evidence of the evolutionary process that resulted in fully agricultural people. Agriculture does not simply appear in the archaeological record. It has deep roots and a lengthy history. Clearly agriculture was not introduced wholesale from Atlantis; rather, it was developed separately in many world regions (Smith 1995).

By failing to consider the implications of his claims of connections between the cultural practices of Old and New World civilizations, Donnelly was easily led astray by their superficial similarities. Ever-hopeful and convinced of the legitimacy of his argument, Donnelly ended *Atlantis: The Antediluvian World* by stating:

We are on the threshold. Scientific investigation is advancing in great strides. Who shall say that one hundred years from now the great museums of the world may not be adorned with gems, statues, arms, and implements from Atlantis, while the libraries of the world shall contain translations of its inscriptions, throwing new light upon all the past history of the human race, and all the great problems which now perplex the thinkers of our day? (p. 480)

It has been more than one hundred years since Donnelly wrote these words, and Atlantis the fair and the beautiful is as distant as it was when Plato constructed it out of the stuff of his imagination more than two thousand years ago.

Atlantis After Donnelly

Donnelly was the most important of the Atlantis scholars, but he was not the last. Although today we may criticize his reasoning, it is far superior to that of many who followed him. Scottish mythologist Lewis Spence (1926), for example, eschewing the "tape-measure school" (p. 2) of archaeology, opts for "inspirational methods" (p. 2). Where Plato placed one imaginary continent in the Atlantic, Spence put two; he added an Antilla to accompany Plato's invention. Spence suggests that not one but a series of cataclysms befell Atlantis. One of the first of these occurred about twenty-five thousand years ago. It resulted in the earliest settlement of Europe by modern humans. Spence identifies so-called Cro-Magnon Man, the oldest fossils of completely modern-looking humans in Europe, as refugees from Atlantis (1926:85). Spence identifies the famous cave paintings and sculptures of ancient Europe (see Figures 12.2 and 12.3 of this book) that date to sometime after twenty-five thousand years ago as reflecting the artwork of the displaced Atlanteans.

Among the most extreme Atlantis speculators were the *Theosophists*, members of a strange sect founded by Helena P. Blavatsky (1888) in the late nineteenth century. Their philosophy included peculiar beliefs about stages of human evolution—they called them "root races." In one stage we humans were, apparently, astral jellyfish and, in another stage, four-armed, egg-laying hermaphrodites. The fourth stage or race lived on Atlantis, where they flew around in airplanes, bombed their enemies with explo-

sives, and grew a form of wheat imported from extraterrestrial space aliens. They also believed that there was a Pacific counterpart to Atlantis called *Mu*. Blavatsky and her followers—not surprisingly, I think—made little effort to support the veracity of such claims.

The web of Atlantis fantasies continues to be spun in the twentieth century. Self-proclaimed psychic Edgar Cayce claimed that knowledge gained from Atlantean texts (Cayce 1968; Noorbergen 1982) enabled him to predict the future and effect cures on terminally ill people. That his Atlantis-derived predictions were not terribly accurate can be shown by the following fact: speaking in the 1940s, Cayce predicted that great upheavals, including the destruction of much of the eastern coast of the United States, would accompany the reemergence of parts of Atlantis. When was this to happen? In 1968 or 1969 (Cayce 1968:158–59).

More recently, a self-professed trance channeler, J. Z. Knight, has claimed to be a conduit for an ancient spirit called Ramtha, who was born on Atlantis more than thirty-five thousand years ago (Alcock 1989). Ramtha provides platitudes and investment counseling to the paying faithful.

Indeed, the legend of Atlantis did not die with Plato, nor did it die with Donnelly. It seems constantly to shift, filling the particular needs of the time for a golden age when great warriors, ingenious scientists, astral jellyfish, or spirits with stock market tips walked the earth. Ultimately, in trying to convey a rather simple message, one of the great rational minds of the ancient world produced fodder for the fantasies of some of the less-than-great, non-rational minds of the modern world. If only we could trance channel Plato, I wonder what he would say? I doubt that he would be pleased.

→ CURRENT PERSPECTIVES 《

Atlantis

According to Plato's story, Atlantis was defeated in battle by a humble, but quite advanced Athenian state some eleven thousand years ago. What does modern archaeology tell us about ancient Greece from this period? Is there any physical evidence in the Atlantic Ocean for the civilization of Atlantis? What does modern geology tell us about the possibility of a lost continent in the Atlantic?

Ancient Greece

Simply stated, there was no Athenian state eleven thousand years ago. Such a statement is based not on legends and stories but on the material remains of cultures that inhabited the country. South of Athens, for example, a site has been investigated that dates to around the same time as the claimed Athenian defeat of Atlantis. The site, Franchthi Cave, has been excavated by archaeologist Thomas Jacobsen (1976).

More than ten thousand years ago the inhabitants of the cave were not members of an "advanced" culture. They were simple hunters and gatherers, subsisting on red deer, wild cattle, and pigs. They also collected mollusks, snails, small sea fish, and wild plant foods, including barley and oats. They were a Stone Age people and obtained obsidian—a volcanic glass that can produce extremely sharp tools—from the nearby island of Melos. It is not until 6000 B.C. that there is evidence of the use of domesticated plants and animals by the inhabitants of the cave. Evidence at other sites in Greece conforms to the pattern seen at Franchthi. Cultures that we would label as "civilized" do not appear in Greece for thousands of years. The Greek world of eleven thousand years ago is nothing like Plato imagined.

Archaeological Evidence in the Atlantic: The Bimini Wall

Claims have been made that there is archaeological evidence of submerged walls and roads off the coast of Bimini in the Bahamas. Just as the self-proclaimed seer Edgar Cayce maintained that the island of Bimini was a remnant of Atlantis, modern Atlantis popularizers have claimed that the features constituted direct empirical evidence for the existence of the lost continent (Berlitz 1984).

Apparently in the 1960s some divers indeed found tabular limestone blocks that they interpreted as being parts of a road and wall as well as supposed columns from a submerged building. However, on close inspection, geologists and archaeologists determined that the so-called wall and road were natural features (Harrison 1971; McKusick and Shinn 1981). What had been interpreted by the divers as the interstices of masonry blocks were nothing more than the natural joints of limestone beachrock that forms rapidly under water. Such rock erodes as a result of tidal forces, and breaks or joints tend to occur at regular intervals and at right angles to each other. Similarly jointed natural beachrock has been observed off the coast of Australia (Figure 8.8; Randi 1981).

Analysis of the so-called columns shows that they are simply hardened concrete of a variety manufactured after A.D. 1800 (Harrison 1971:289). The columns likely resulted when barrels of the dry ingredients of the concrete were thrown or washed overboard. The concrete hardened after mixing with water and the wood barrels decayed, leaving what may appear to some to be fragments of building columns.

The Bimini wall, road, and columns simply are not archaeological artifacts derived from Atlantis. They are, instead, readily understood natural and recent cultural features.

The Geology of the Atlantic

There is no evidence in the Atlantic Ocean for a great submerged continent. In fact, our modern understanding of the geological processes of *plate tectonics* rules out this possibility.

Figure 8.8 Not an artificial construction, these square blocks of stone are the result of natural processes of erosion. Pictured here is an example from the southeast coast of Tasmania (south of Australia). A similar geological feature located off the Bimini coast in the Caribbean Sea has been misidentified by nongeologists as a wall built by inhabitants of Atlantis. (Courtesy of Sonja Gray)

The earth's crust is not a solid shell but consists of a number of geologically separate "plates." The plates move, causing the continents to drift. In fact, we know that the present configuration of the continents was different in the past. More than two hundred million years ago, the continents were all part of a single landmass we call *Pangea*. By 180 million years ago, the continents of the Northern Hemisphere (*Laurasia*) parted company with the southern continents (*Gondwanaland*). The separation of the continents of the Eastern and Western Hemispheres and the formation of the basin of the Atlantic Ocean occurred sometime before sixty-five million years ago. The Atlantic has been growing ever since, as the European and North American plates have continued to move apart, the result of expansion of the seabed along the intersection of the plates. Movement along the Pacific and North American plates resulted in the destructive earthquake that hit the San Francisco/Oakland area in October 1989.

A ridge of mountains has been building for millions of years at the intersection of the two crustal plates that meet in the Atlantic. Material is coming

up out of the plate intersection; landmasses are not being sucked down below the ocean. The geology is clear; there could have been no large land surface that then sank in the area where Plato places Atlantis. Together, modern archaeology and geology provide an unambiguous verdict: there was no Atlantic continent; there was no great civilization called Atlantis.

→ FREQUENTLY ASKED QUESTIONS 《→

1. Could the legend of Atlantis somehow be connected to the mystery of the Bermuda Triangle?

The belief that there are mysterious and inexplicable disappearances of boats and planes—and all the people aboard—in a triangular area with Bermuda at its apex and Puerto Rico and the southern tip of Florida as the other two vertices is a myth, just like Atlantis. Writer Lawrence Kusche (1995) has investigated most of the major disappearances in the Triangle and found that all of these supposedly mysterious incidents had rational explanations. Bad weather, equipment failure, dangerous cargo, and pilot error account for virtually all of the occurrences. There is no evidence that the area enclosed by the Bermuda Triangle has experienced worse nautical or aviational luck than any other similarly sized part of the globe. Atlantis was supposed to be nowhere near the Bermuda Triangle anyway. The only connection between Atlantis and the Bermuda Triangle mystery is the fact that both are myths.

2. *Is there a "lost continent" in the Pacific?*

There is a *legend* of a lost continent in the Pacific Ocean: Mu or Lemuria. Mu is entirely mythological; the geology of the Pacific basin shows that there was no—and could not have been any—large landmass that sunk below the waters in a cataclysmic upheaval.

♠ CRITICAL THINKING EXERCISE <</p>

Using the deductive approach outlined in Chapter 2, how would you test this hypothesis? In other words, what archaeological and biological data must you find to conclude that this hypothetical statement is an accurate assertion, that it describes what actually happened in the ancient human past?

 The civilizations of ancient Egypt and Mexico share many general cultural similarities. This is most likely the result of both of these societies having been influenced by the civilization of the Lost Continent of Atlantis.

Best of the Web

CLICK HERE

http://marlowe.wimsey.com/~rshand/streams/thera/atlantis.html

http://www.scronline.com/public/users/ahefner/mystica/articles/a/atlantis.html

http://www.greektreasure.acun.com/atlantis.html

http://home.fireplug.net/~rshand/streams/thera/atlantis.html

http://www.activemind.com/Mysterious/Topics/Atlantis/index.

html#Top

Prehistoric E.T.: The Fantasy of Ancient Astronauts

Gods in Fiery Chariots

Controversy over ancient astronauts first erupted in 1968 with the initial publication of *Chariots of the Gods?* The Swiss author of the book, Erich von Däniken, proposed that there was indisputable and copious archaeological support for his claim that extraterrestrial aliens had visited the earth in prehistory and had played a significant role in the development of humanity.

In *Chariots of the Gods?* it seemed that the ramblings of the authors of *The Morning of the Magicians* (see Chapter 1) had been blown up into a full-scale anthropological fairy tale (though, curiously, von Däniken never credits that book as the source of his ideas; he never even mentions it in *Chariots of the Gods?*). Where Pauwels and Bergier (1960) limited themselves to a few bizarre suggestions concerning a small number of archaeological sites, von Däniken had constructed an incredible fantasy about the entire prehistory of the human species.

There seemed to be three implicit hypotheses behind von Däniken's ideas (1970, 1971, 1973, 1975, 1982):

- 1. All over the world there are prehistoric pictorial and threedimensional representations—drawings on cave walls, pottery, and sculptures—as well as early written accounts that most reasonably can be interpreted as the drawings, sculptures, or literary descriptions by primitive people of actual extraterrestrial visitors to earth.
- The biological evolution of the human species cannot be understood unless we assume the involvement of a scientifically advanced extraterrestrial civilization.

 Some ancient artifacts and inventions are far too advanced and complex to have resulted from simple, prehistoric human intelligence and ingenuity. These advanced artifacts and great inventions must instead be the direct result of purposeful introduction by extraterrestrial aliens.

Let's assess these claims one at a time.

Hypothesis 1

The first implicit claim concerns the existence of prehistoric drawings or sculptures of aliens from outer space and early writings about their visits. It is an intriguing thought. Hundreds, thousands, even tens of thousands of years ago, flying saucers or spaceships landed on our planet in a burst of fire and smoke. Out came space-suited aliens, perhaps to take soil samples or study plant life (just like E.T. in the Spielberg movie). On completion of their mission, they got back into their spaceships and took off for home.

Secreted in the bushes, behind the rocks, an ancient human sat transfixed, having watched the entire scene unbeknownst to our alien friends. This prehistoric witness to extraterrestrial visitation rushed home to tell others of the marvelous sight of the fiery "chariots" of the "gods" (thus, the title for von Däniken's book) that had come down from heaven. He or she would tell of how the gods or angels had silver skins (space suits), bubble-heads (space helmets), and wielded marvelous devices (communicators, ray guns, and so forth). Artistic renderings would be made on cave walls and pots. Descriptions would be passed down from generation to generation, especially if the space gods came back again and again, reinforcing the entire idea of gods from the heavens. Descriptions would be written of the wondrous spectacle of the gods coming to earth. Our ancestors would wait for their return, as perhaps we wait to this very day.

Fascinating? Undoubtedly! Wonderful, if true? Absolutely! Backed up by inductive and deductive scientific reasoning, evidence, and proof? Absolutely not.

This first von Däniken scenario can be called the *Inkblot Hypothesis*. I am sure you are familiar with "inkblots" used in psychological testing (called Rorschach tests after their originator). The idea is to show a person a series of inkblots (images made by dripping ink on paper, which is then folded and pressed while the ink is still wet) and then ask what they see. The rationale for such an exercise is quite simple. Since there really are no specific, identifiable images in the random inkblot pictures, the image you recognize comes entirely from your imagination. Therefore, your description of what you see in the inkblots should give a psychologist an idea of what is going on in your mind. It might tell him or her something about your personality, feelings, and so on.

Figure 9.1 Applying von Däniken's perspective to artifacts like this antler mask from the Moundbuilder site of Spiro (see Chapter 7) in Oklahoma (right) and this petroglyph (rock carving) in Colorado (below; K. L. Feder), one might conclude that they both represented space-helmeted aliens, complete with antennae. The application of Occam's Razor demands we first consider more mundane explanations. The mask likely was used in ceremonies where a priest or shaman portrayed a deer spirit, and the petroglyph is most likely the depiction of a mythical creature. (Deer mask photo by Carmelo Guadagno. Courtesy of the Museum of the American Indian, Heye Foundation)

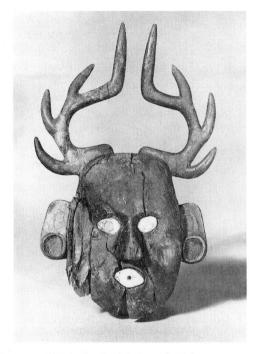

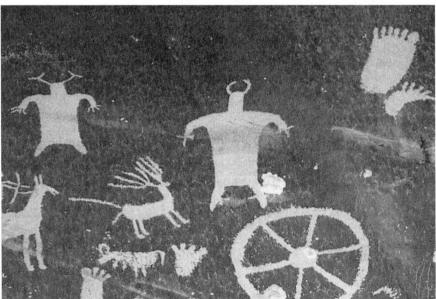

The point is that the picture seen in an inkblot is entirely dependent on the mind of the viewer. The images themselves are not necessarily anything in particular. They are whatever you make them out to be, whatever you want them to be.

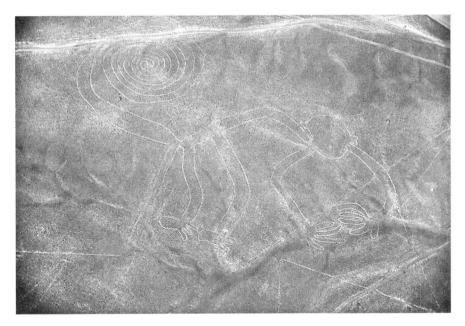

Figure 9.2 This Nazca *geoglyph* or earth-drawing depicts a monkey. Large-scale drawings like those at Nazca are known from a number of places in the world. They likely were intended to please the gods and were constructed with the use of scale models. They certainly did not require the intervention of extraterrestrials—and why would aliens from outer space instruct ancient humans to draw giant monkeys, spiders, snakes, and the like, in the first place? (Photo by Bates Littlehales © National Geographic Society)

Von Däniken's approach is analogous to an inkblot test. Although he is describing actual images, these images belong to a different culture. Without an understanding of the religious, artistic, or historical contexts of the drawings or images within the culture that produced them, von Däniken's descriptions of the images tell us more about what is going on in his mind than about what was in the minds of the ancient artists.

For example, an image identified by von Däniken as an astronaut with a radio antenna might be more easily explained as a shaman or priest with an antler headdress or simply a mythical creature (Figure 9.1). Von Däniken sees spacemen because he wants to, not because they really are there.

Here is another example. On the desert south coast of Peru, prehistoric people called the *Nazca* constructed a spectacular complex of shapes (Kosok and Reiche 1949; McIntyre 1975; Reiche 1978). Most are long lines, etched into the desert surface, criss-crossing each other at all angles. The most interesting, however, are about three hundred actual drawings, rendered on an enormous scale (some are hundreds of feet across), of animals such as fish, monkeys, birds, and snakes (Figure 9.2).

The figures and lines were made by clearing away the darker surface rocks, exposing the lighter desert soil beneath. They are remarkable

achievements because of their great size, but certainly not beyond the capabilities of prehistoric people. Remember, these drawings were not carved into solid rock with extraterrestrial lasers; they were not paved over with some mysterious substance from another world. They were, in essence, "swept" into existence. Science writer Joe Nickell, an investigator of extreme claims whom we will encounter again when we examine the Shroud of Turin in Chapter 11, has duplicated the technique of making Nazca-like designs. With a crew of six people and several bags of lime (the white powder farmers and backyard landscapers use to cut soil acidity; it's also used to lay out lines on athletic fields), Nickell was able to outline a nearly perfect replica of a 120-meter-long (400 foot) Nazca bird in a single day. Their other raw materials were some rope and a few pieces of wood (Nickell 1983).

What does von Däniken have to say about the Nazca markings? Almost yielding to rationality, he admits that "they could have been laid out on their gigantic scale by working from a model and using a system of coordinates" (1970:17), which is precisely how Nickell accomplished it. Not to disappoint us, however, von Däniken prefers the notion that "they could also have been built according to instructions from an aircraft" (p. 17). Relying on the "inkblot approach," he says, "Seen from the air, the clear-cut impression that the 37-mile-long plain of Nazca made on me was that of an airfield" (p. 17).

Please remember Occam's Razor here. On one hand, for the hypothesis that the ancient people of South America built the lines themselves, we need only assume that they were clever. The archaeological record of the area lends support to this. On the other hand, for von Däniken's preferred hypothesis, we have to assume the existence of extraterrestrial, intelligent life (unproven), assume that they visited the earth in the distant past (unproven and not very likely), assume that they needed to build rather strange airfields (pretty hard to swallow), and then, for added amusement, instructed local Indians to construct enormous representations of birds, spiders, monkeys, fish, and snakes. Those assumptions are bizarre, and the choice under Occam's Razor is abundantly clear.

We can go on and deduce some implications for our preferred hypothesis: we should find evidence of small-scale models, we should find the art style of the desert drawings repeated in other artifacts found in the area, and we might expect the Nazca markings to be part of a general tradition in western South America of large-scale drawings. When we test these predictions, we do find such supporting evidence: For example, Wilson (1988) has reported on a more recently discovered set of large-scale earth-drawings in Peru. Archaeological and historical information indicates that the lines were ceremonial roads leading to sacred origin places for families or entire communities. Far from being entirely enigmatic or without any cultural or historical context, they were made and used by some local native groups until fairly recently as a regular part of their religious festivities (Bruhns 1994).

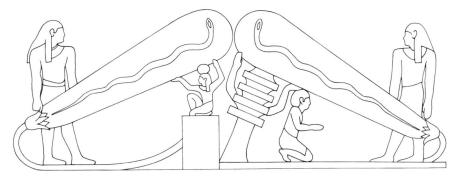

Figure 9.3 Image from a wall deep in the temple of Hathor at Dendera, Egypt. These objects can be interpreted as representations of ancient lightbulbs only by applying von Däniken's inkblot approach. Absolutely no physical evidence supports the claim that ancient Egyptians produced electrically powered lightbulbs.

Consider this example of the inkblot approach from his latest book, *The Eyes of the Sphinx* (von Däniken 1996). Deep in one of the subterranean chambers of the Egyptian temple dedicated to Hathor, goddess of music, love, and dance, located in Dendera, is a relief sculpture depicting two strange objects (Figure 9.3). In each, a slightly sinuous snake emanates from a flower and is enclosed in an elongate object attached to the flower. Altogether, the relief looks like two giant eggplants with enclosed snakes facing off against each other. A strange image, to be sure, but what does it mean?

To answer this riddle, von Däniken considers the challenge of providing enough light for Egyptian artisans to have produced the wall reliefs deep in the temple and postulates an extraordinary light source. Egyptologists assume, rather unimaginatively, that these workers used oil lamps and torches to light their way. From Egyptian sources we know that pieces of linen were soaked in oil or animal fat and then twisted into wicks, which, when lit, provided a bright light. Salt was applied to these wicks to reduce smoke and soot. Lamps that burned oil or animal fat also were used; again, salt was added to the mix to cut down on smoke. Beyond this, the ancient Egyptians made candles to light their way in the darkness of subterranean rooms and pyramid tombs. These candles were manufactured to burn a predetermined amount of time. Pyramid and tomb workers knew their shift was complete when the candle began to burn down to its base. Finally, there also is clear physical evidence that the Egyptians constructed clever arrays of polished metal mirrors to bring reflected light down inside even deep corridors.

Not one to accept such simple explanations, von Däniken complains that absolutely no lamp soot was found on the walls or ceilings and that the light reflected by mirrors would have been too weak. Occam's Razor forces a scientist to suggest the rather mundane possibility that salt was effective in reducing the amount of soot produced and that workers cleaned the soot

that was produced from the chamber's surfaces when they were done. Also, experimental testing of mirror replicas shows that they work quite well, and these produced no soot at all.

Von Däniken, however, is not bound by Occam's Razor, experimental testing, or any other rule of logic or method of science. His suggestion? The snake encased in an eggplant motif is a depiction of an electric lightbulb! The flower is its socket, the snake the filament, and the eggplant its glass enclosure.

Electrically powered lightbulbs in ancient Egypt or anywhere else must have been invented, manufactured, and used within a broader context. What are the deductive implications of the hypothesized existence of such lighting devices in ancient Egypt? What should we find in archaeological excavations to support this interpretation? Even modern lightbulbs burn out or break, so we would expect to find in archaeological excavations in Egypt dead but, perhaps, intact bulbs, fragments of broken glass bulbs, metal sockets, pieces of the necessarily durable filaments, and stretches of the electric cable needed to bring electricity to the bulbs from its source. This last requirement leads us to the most important and most problematic deduction—we also must find evidence for the production of electric power by ancient Egyptians for these lightbulbs.

Little of this seems to occur to von Däniken, although using a thoroughly discredited interpretation of a two-thousand-year-old artifact from Iraq he does claim that electricity was produced in the ancient world (Eggert 1996).

Is there any hard, archaeological evidence that ancient Egyptians produced electricity and manufactured lightbulbs? The answer is "no." In his analysis of the images on the wall in Hathor's Temple in Dendera, von Däniken does not prove that Egyptians had electric lighting but merely that his inkblot speculations have become even more wildly imaginative in recent years.

Because prehistoric pictorial depictions and even early written descriptions are sometimes indistinct or vague and—perhaps more important—because they are part of a different culture and have a context not immediately apparent to those who do not explore further, you can see or read anything you want into them, just as you can with inkblots.

Try this experiment. Using any of von Däniken's books, look at the photographs, but do not read the captions where von Däniken tells you what the item pictured must be (spaceship, extraterrestrial alien, or whatever). Now figure out what *you* think it looks like. You probably will not agree with what von Däniken says. For example, Figure 9.4 is a photograph of a sarcophagus lid from the Maya site of Palenque. Does it evoke in your mind any extraterrestrial images? Probably not. Yet, for von Däniken, the coffin lid is a clear representation of a space-suited alien piloting a spacecraft (1970:100–101).

The inkblot principle is at work again. When you are unfamiliar with the culture, you can make just about anything you want to out of these

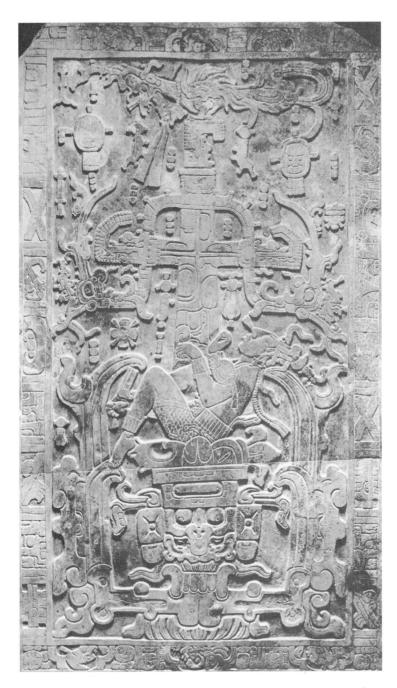

Figure 9.4 Using what we here call the inkblot approach, von Däniken interprets the image on the sarcophagus lid from the Temple of Inscriptions at the Maya site of Palenque as depicting an astronaut with antennae and oxygen mask, peering through a telescope and manipulating the controls of a rocket. Maya archaeologists prefer to interpret this scene within the context of Maya cosmogony—a king poised between life and death in his journey to the afterlife. (Courtesy Merle Greene Robertson)

images, but you are most decidedly not practicing science. Von Däniken does not understand the cultural context of the Palenque artifact. He does not recognize the Maya symbols in the carving of the Ceiba Tree and the Earth Monster. What are mysterious devices for von Däniken are simply common artistic representations of Maya jewelry, including ear and nose plugs. Again, not understanding the context of the artifact, von Däniken does not realize that the person depicted on the sarcophagus lid was a dead Maya king represented in a position between life, the Ceiba Tree above him, and death, the Earth Monster below (Robertson 1974; Sabloff 1989).

As for the individual depicted on the lid and buried in the tomb, he is anything but some mysterious, out-of-place enigma whose origins can be traced to outer space. In fact, we know a great deal about him; the information was provided by the Maya themselves (Schele and Freidel 1990). He was Pacal, ruler of the ancient city of Palenque from A.D. 615 until his death and placement in the tomb at the base of an impressive pyramid in A.D. 683 (Figure 9.5).

Kingship was inherited in the male line among the Maya, but Pacal's father had not been king before him. Pacal's mother, however, Lady Zac-Kuk, was descended from kings. Through his mother, Pacal attempted to legitimize his kingship and that of his own son. Fortunately for students of Maya history, Pacal had a detailed king list inscribed in the temple atop his pyramid tomb, and an additional listing placed on his sarcophagus. We know the names of his ancestors and the names of his descendants. We know what he accomplished during his reign as ruler of Palenque. And we have his physical remains in the coffin. Although he was once the all-powerful ruler of a splendid society, nothing is left of Pacal save his very human bones.

Pacal's story needs no tired speculation about extraterrestrial visitors to earth. Pacal was a dynamic and vibrant historical personage, a real human being who lived, ruled a great city, and died more than thirteen hundred years ago, and whose story has been revealed by archaeology and history.

One needs to be familiar with Maya cosmogony and history to recognize the context of the Palenque stone within Maya culture. Von Däniken, however, is wholly ignorant of Maya beliefs and therefore can come up with such an unsupported speculation concerning the image on the coffin lid.

Once you become familiar with von Däniken's own particular brand of illogical thinking, you can probably guess what he says renderings in ancient art actually represent. Doing so might be fun, but it is in fact just a game of trying to guess the meandering of an illogical mind. That is not scientific archaeology; that is psychotherapy. The Inkblot Hypothesis merely shows how suggestible people are ("Hey, doesn't that cave painting look like a spaceman?" "Gee, now that you mention it, I guess it does.") Inkblots, however, or strange drawings on cave walls, weird creatures on pots, odd sculptures, or mystical visions written down in ancient books can never prove the visitations of ancient astronauts, as much as von Däniken might like them to.

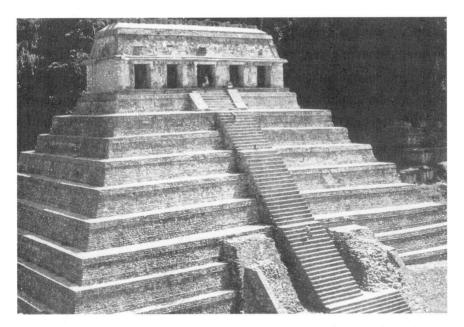

Figure 9.5 The magnificent Temple of the Inscriptions, the final resting place of Pacal, ruler of Palenque. Pacal's tomb with its famous sarcophagus lid was found at the bottom of a staircase leading from the top to a point beneath the pyramid. (AnthroPhoto: Barry Kass)

Hypothesis 2

Von Däniken's second hypothesis suggests that extraterrestrial aliens played an active and important role in the actual biological development of our species. There has been some controversy on this particular point. Von Däniken maintained in an interview on an episode of the public television series *Nova* focusing on his ideas ("The Case of the Ancient Astronauts") that he never really made such a claim. Let's see.

In *Chariots of the Gods?* von Däniken proposed the following scenario. A group of extremely advanced, interstellar space travelers lands on earth, for the first time perhaps millions of years ago. They find a primitive race of creatures, very apelike, with small brains, but with a lot of potential. Then, von Däniken claims, "A few specially selected women would be fertilized by the astronauts. Thus a new race would arise that skipped a stage in natural evolution" (1970:11).

If the previous claim can be called the *Inkblot Hypothesis*, I can call this one the *Amorous Astronaut Hypothesis*.

According to this hypothesis, extraterrestrial aliens have streaked at near light speed to get to earth. The speed of light is fast (186,000 miles per second), but the universe is large, and our spacemen (for von Däniken, the extraterrestrial visitors always seem to be males) have been cooped up in their spaceship, perhaps in suspended animation, for at least four years. The

nearest star to our sun is about four light years away, and so—even traveling at the speed of light—four years is the absolute minimum. Our extraterrestrial friends land, are wakened from their deep sleep, and exit their spaceship to explore the new frontiers of an unexplored planet in an alien solar system. And what do you think they do? They look for females to breed with. The human species is not the product of evolution, but of interstellar miscegenation.

Even von Däniken's most ardent supporters must admit that he has some very strange ideas about the ability of different species to mate and produce offspring. For example, the mummy of ancient Egyptian priestess Makare, daughter of Pharaoh Pingdjem (c. 1075 B.C.), was placed in her tomb with a small mummified bundle. It had been assumed that the bundle was her child until it was x-rayed in 1972. The small mummy turned out to be that of a baboon. This was not so surprising. Egyptians commonly mummified animals, and most Egyptologists assumed that the baboon baby was Makare's pet, or perhaps, a symbolic child entombed with Makare as a surrogate for a human baby. Von Däniken (1996:63) suggests, instead, that Makare may have actually given birth to, what he implies, was a human/baboon hybrid. Von Däniken recognizes that humans and baboons cannot mate and produce offspring, so he proposes that extraterrestrial aliens conducted genetic experiments, hybridizing a wide variety of earth species. Makare's baby baboon is just one example. The many mythological creatures seen all over the ancient world—Pegasus, the Sphinx, griffins—are not mythological at all for von Däniken but are accurate depictions of these hybrids! Why did ancient astronauts conduct these seemingly bizarre genetic experiments? According to von Däniken (1996), it was solely for entertainment: "The extraterrestrials had found a way to keep themselves busy. They merrily invented one monster after another . . . and they observed with much amusement the reactions of the flabbergasted humans" (p. 58).

As Carl Sagan has so astutely pointed out in "The Case of the Ancient Astronauts," the chances of any two different species from even our own planet being able to mate and produce offspring are quite remote. Horses and donkeys are one of the very rare exceptions to this. Even here, when these two very closely related species mate, the offspring are sterile. The possibility of two species that evolved on different planets in two different solar systems even having the appropriately matching physical equipment for mating, much less having matching DNA necessary to produce offspring, is so incredibly unlikely that it is beyond calculation. Yet these are precisely the implications that must be deduced from von Däniken's hypothesis. As Sagan pointed out, a human ancestor would likely have been more successful mating with a petunia than with a creature from outer space; at least the human ancestor and the petunia both evolved here on earth. Extraterrestrial astronauts, amorous or not, simply could not have mated with our ancestors to produce us.

Hypothesis 3

This leads us to the final von Däniken hypothesis, the notion that the archaeological record is replete with evidence of highly advanced artifacts beyond the capability of ancient humans. This can be called the *Our Ancestors, the Dummies, Hypothesis* after Omunhundro (1976). Von Däniken is claiming that our human ancestors were too dumb to have, all by themselves, using their own creative abilities, intelligence, and labor, produced the admittedly spectacular works of engineering, architecture, mathematics, astronomy, botany, and zoology evidenced in the archaeological record.

Mind you, von Däniken is not saying that archaeologists are hiding the physical evidence of ancient flying saucer parts or ray guns found at prehistoric Indian villages or ancient Chinese temples. That would be an easy claim to check scientifically; such artifacts either exist or they do not. No, instead, von Däniken simply points to artifacts such as pyramids or temples, statues, or carvings. He makes reference to prehistoric accomplishments such as the domestication of plants and animals, the development of metallurgy, and especially astronomical abilities—all things for which archaeological evidence is abundant. Von Däniken simply cannot understand how, and therefore doesn't believe that, prehistoric people could have managed all this without some sort of outside help. This help, for von Däniken, comes in the form of aliens from outer space.

In a sense, von Däniken is the ultimate diffusionist. Where some have suggested that all advanced ideas originated in southwestern Asia or Egypt or even Atlantis (see Chapter 8) and spread out from there, von Däniken sees the source for human advancement as being in the stars.

There seem to be two contributing factors to von Däniken's misunder-standing and misrepresentation of the archaeological record:

- 1. He is ignorant of simple archaeological facts.
- 2. There seems to be not just a little European ethnocentrism at work here.

The best place to show how these factors work is in von Däniken's misunderstanding of the archaeological record of ancient Egypt.

Ancient Egypt

Most people are at least passingly familiar with Egypt of the great pharaohs, the enormous pyramids, the mysterious Sphinx (Figure 9.6), the fabulous treasures of the tomb of Tutankhamun, and so on.

Did you ever wonder where the Egyptian civilization came from, how the Egyptians managed to build those fabulous pyramids, and how they accomplished the rest of their spectacular legacy? Archaeologists have

Figure 9.6 The Sphinx, at Gizeh, emblematic of ancient Egypt, is the product of human ingenuity and hard work. It was not built or inspired by ancient astronauts. (M. F. Feder)

wondered and devoted years to unraveling the mysteries of this remarkable culture. Egyptologists have been digging up the past of Egypt for over 150 years now and can construct a fairly detailed scenario for the evolution of this civilization (for example, see Clayton 1994 and Hoffman 1979). However, after a couple of tourist visits to Egypt von Däniken declares that all of those archaeologists are completely misinformed. He says, "If we meekly accept the neat package of knowledge that the Egyptologists serve up to us, ancient Egypt appears suddenly and without transition with a fantastic ready-made civilization" (1970:74).

He further describes the accomplishments of the ancient Egyptians as being "genuine miracles in a country that is suddenly capable of such achievements without recognizable prehistory" (1970:74).

So, what is von Däniken's solution to the archaeological enigma of a great "ready-made" civilization springing up "suddenly" and "without transition" in a land "without recognizable prehistory"? Where did Egyptian culture come from, and whom does he credit for its great architectural, scientific, mathematical, astronomical, and engineering accomplishments? If you guessed that von Däniken says all of these things were made possible by the "gods" from outer space, you are correct.

In one sense, von Däniken is correct; if we hypothesize that Egyptian culture was transplanted full-blown from somewhere else, we should expect that it appeared quickly, without any evolutionary antecedents. However, again considering Occam's Razor, we might want to first consider some possible earthly sources such as the older civilization of Mesopotamia in the Near East (which is, after all, only about 500 miles from the Nile) before we start bringing up the residents of Alpha Centauri.

Nevertheless, one rather important point needs to be brought up here. Von Däniken's claim about the suddenness of Egyptian civilization is absolutely inaccurate. Archaeologists have now traced the ultimate roots of this "sudden" civilization back more than twelve thousand years, when nomadic hunters and gatherers began to settle down along the Nile (Butzer 1976). Recent excavations at sites like Wadi Kubbaniya show that at this time people were living in small villages along the Nile and harvesting the wild wheat, barley, lentils, chick-peas, and dates that abounded there (Wendorf, Schild, and Close 1982). Their villages are littered with the grinding stones, mortars, and pestles they used to make flour. They supplemented their diet with wild game and fish, so they weren't entirely settled or "civilized," but they were on the path toward civilization. By beginning to rely on the crops of wild wheat and barley, they were laying down the roots of an agricultural revolution that was to form the subsistence base of Egypt of the pharaohs.

We have archaeological evidence for small villages along the Nile where the people were living no longer on wild, but on domesticated plants and animals fully eight thousand years ago. Cultivating crops and raising animals provided a more secure, more dependable, and much more productive food base for these people. The archaeological evidence indicates clearly that in response to this, both the number of villages and the population of individual villages grew (Lamberg-Karlovsky and Sabloff 1995). After seven thousand years ago, the shift to agriculture at sites like Merimde, Tasa, and Badari was complete. The inhabitants grew wheat and barley and raised cattle, goats, pigs, and sheep. Eventually these villages began competing with each other for good farmland along the Nile.

Seen from satellite photographs, the Nile is a thin ribbon of green and blue flowing through a huge yellow desert. Clearly, the Nile is the "giver of life" to the plants, animals, and people of Egypt. As the circumscribed, precious, fertile land along the Nile became filled up between eight thousand and six thousand years ago, competition for this rich land intensified.

Some Nile villages were quite successful and grew at the expense of others. One example is *Hierakonpolis*, a town that grew in a very short time from an area of a few acres in size to over one hundred, and from a probable population of a few hundred to several thousand (Hoffman 1979, 1983). A local pottery industry also developed here.

Pottery manufactured in the kilns that archaeologists have discovered at Hierakonpolis can be found at sites all along the Nile. As the demand for the pottery of this successful town grew, so did the wealth of the people who owned the pottery kilns. It is here at Hierakonpolis that we first see large tombs where perhaps these wealthy pottery barons were laid to rest. Their tombs were sometimes carved out of bedrock and covered with mounds or small, crude pyramids of earth. Finely crafted goods were placed in the tombs of these men, perhaps to accompany them to the afterlife.

Figure 9.7 Von Däniken's claims about the "sudden" appearance of the Egyptian pyramid are simply incorrect. The Egyptian pyramid was not introduced by aliens, extraterrestrial or otherwise, but evolved through several phases in Egypt itself. One of these phases is represented by the stepped pyramid of Saqqara, which had itself evolved from the single-tiered *mastabas*. (M. H. Feder)

However, just as the small towns had previously competed for land, Hierakonpolis and other larger villages began to compete for space and wealth. Again, based on the archaeological evidence for this period, we can conclude that power struggles leading to warfare were common after fifty-two hundred years ago. One hundred years later, a ruler of Hierakonpolis, whose name has been passed down to us through later Egyptian writings as *Narmer*, was able through military conquest to subdue and then unify the competing villages along the Nile. Now with the wealth of not just one town but of every town along the Nile to call on, Narmer and his successors lived and were buried in increasingly sumptuous style.

Eventually, the old practice of burying a leader in a bedrock tomb with a small earthen pyramid on top was deemed insufficient for pharaohs. However, the pyramid did not appear "suddenly," as von Däniken would have us believe. Initially, the practice of erecting an earthen mound over the tomb was replaced by construction of a square-block structure called a *mastaba*. As the mastabas over the tombs got larger through time, pharaohs began to build stepped mastabas, with one block on top of another, culminating in a stepped pyramid for the pharaoh Djoser at Saqqara (Figure 9.7). Finally, around forty-six hundred years ago, the first nonstepped, stone-faced, true pyramid was attempted (it was still soil in its core) at a place called Meidum.

The first true, flat-sided Egyptian pyramids were far from perfect, and mistakes evident in their construction rather convincingly demonstrate that

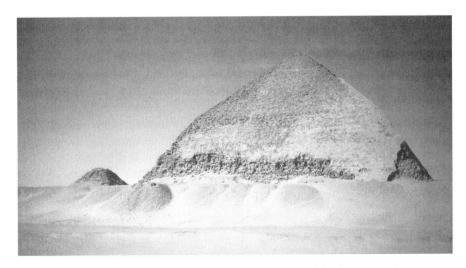

Figure 9.8 The Bent Pyramid at Dashur in Egypt was one of the first pyramids—built before this architectural form had been perfected. Started at too steep an angle, its architects altered this angle midway through construction, leaving a noticeable "bend" in each of the faces of the pyramid. It was an ingenious fix necessitated by a problem that shows clearly that pyramid building evolved through time and was not introduced fully realized by an outside intelligence. (Andrew Bayuk)

they were not built by technologically advanced extraterrestrial aliens. For example, the next pyramid built after the one at Meidum is the so-called Bent Pyramid. In the middle of this pyramid's construction, Egyptian architects realized that its very steep walls, built at an angle of about 55 degrees, were unstable. The builders reacted by lessening the angle of the top half of the pyramid to a slope of a bit less than 44 degrees. It does, indeed, look bent (Figure 9.8; see Mark Lehner's [1997] book *The Complete Pyramids* for a detailed description and history of all the major Egyptian pyramids).

After forty-six hundred years ago, the Egyptians had worked the kinks out of pyramid building and constructed some of the most spectacular monuments the world has ever known. The famous triad of pyramids at Gizeh (see Figure 8.6, top) is both literally and figuratively one of the seven wonders of the world.

Though today the pyramid is the symbol of Egyptian civilization, only about seventy of them were built. They are all spectacular architectural and engineering achievements, built as monumental tombs for great pharaohs. However, as this brief outline of the development of Egyptian civilization has shown, pyramids clearly evolved through time. They were a logical step in the evolution of Egyptian funerary architecture. So much for von Däniken's claim that things such as the pyramids just "shot out of the ground."

Unfortunately, everybody in ancient Egypt knew that the pyramids contained great wealth, and most were broken into soon after the pharaoh

was laid to rest. Eventually the Egyptians gave up pyramid building completely and buried pharaohs—like King Tut—underground, where their tombs might be better hidden and protected.

Remember, in science we propose a hypothesis to explain something, we deduce those things that must also be true if our hypothesis is true, then we do further research to determine if our deduced implications can be verified. Only then can we say that our hypothesis is upheld. Here, our hypothesis is that the ancient Egyptians built the pyramids using their own skill, intelligence, ingenuity, and labor. We can deduce that if this were true, then we should find archaeological evidence for the slow development of these skills and abilities through time.

This is precisely what we have found. Egyptian civilization evolved not "suddenly" but after some twelve thousand years of development marked by

- 1. The adoption of agriculture
- 2. Increasing village size
- 3. Intervillage competition
- 4. Village differentiation
- 5. Concentration of wealth
- 6. Increase in tomb size
- 7. Consolidation under a single leader or pharaoh
- 8. Obvious trials and errors in the development of the pyramid as monuments to their dead kings

Like the Maya at Palenque, the Egyptians kept accurate historical records of their kings. The so-called Royal Canon of Turin contains the names of about three hundred pharaohs (Kemp 1991:23). It is a detailed and virtually complete listing of Egyptian rulers for the first part of their history, providing the duration of their reigns, sometimes to the exact numbers of years, months, and even days. This list traces Egyptian kingship for 958 years, all the way back to Narmer. Not surprisingly, there's not a single extraterrestrial in the bunch; it is, instead, a clearly connected family lineage of descent from father to son, pharaoh to pharaoh.

All of this evidence, both archaeological and historical, supports our original hypothesis: the ancient Egyptians built the pyramids and developed their civilization without help from ancient astronauts.

Von Däniken's Response

What does Erich von Däniken have to say about all this? He claims that the Egyptians by themselves could not have built the pyramids because they

did not have the tools with which to cut the limestone slabs. As shown in "The Case of the Ancient Astronauts," in fact, the stone and copper tools that they did use are recovered routinely by archaeologists and are on display at museums in Egypt.

Von Däniken also says that once the slabs were cut the Egyptians could not have transported them (most weigh about 2,000 pounds each; some weigh considerably more), because they had no wood or rope. Archaeological examples of the wooden sledges and heavily twined rope that they used are on display in the same museums.

Von Däniken estimates that it took one hundred thousand workers to build Khufu's pyramid based on the report of Greek historian Herodotus who wrote two thousand years after its construction. A recent mathematical analysis of the amount of labor it would have taken to build the great pyramid calls this estimate into question. Stuart Kirkman Weir (1996) concluded that a workforce of about ten thousand people working for the entirety of Khufu's twenty-eight-year reign could have completed the task. Von Däniken maintains that there is no evidence for the huts needed to house this enormous city of pyramid builders, but Egyptologists often dig through the mundane residential remains of these workers.

Von Däniken complains that the alignments and proportions of the pyramids are too perfectly executed for an ancient people unaided by some superior intelligence. This is nonsense. Archaeologists have, in fact, recovered a set of perfectly preserved ancient Egyptian measuring tools in the tomb of the architect Kha at Deir el Medina. Their analysis shows that Egyptian builders were certainly capable of constructing the temples and pyramids that so fascinate modern thinkers.

Perhaps most remarkable of all, we must remember that the Egyptians were proud of their accomplishments and recorded their construction projects in actual picture-writing called hieroglyphics as well as in paintings. Anyone who is interested can visit Egypt and see paintings on the walls of ancient buildings and tombs that depict exactly how large construction projects were carried out (Figure 9.9). To say that the ancient Egyptians could not have built the pyramids would be like saying Americans could not have built the Empire State Building in New York City even though there are photographs of its construction.

Finally, a recent episode of the *Nova* science series on Public Broadcasting, titled *This Old Pyramid*, was devoted to an experiment in pyramid building. Using traditional techniques, a Massachusetts stone mason, an archaeologist, and a handful of Egyptian workers were able to reproduce a small-scale pyramid. Though not perfect—and not without disagreements erupting among the participants about the best ways to proceed—the minipyramid was a successful first effort. No extraterrestrial instruction or aid was needed.

Figure 9.9 Von Däniken cannot conceive how the ancient Egyptians were able to build pyramids and move the enormous stone blocks and statues that are a part of the archaeological record of their civilization. But the ancient Egyptians themselves left records like this image copied from a wall panel of how they did it. Here, a crew of 168 men pull ropes attached to a sledge on which sits a statue more than 20 feet tall. A worker on the sledge pours a lubricant—perhaps an oil—onto the ground in front of the sledge.

More Mysteries of Ancient Egypt?

As pointed out in "The Case of the Ancient Astronauts," von Däniken makes many other unsubstantiated claims about ancient Egypt in *Chariots of the Gods?*:

- 1. "The height of the pyramid of Cheops multiplied by a thousand million—98,000,000 miles—corresponds approximately to the distance between the earth and the sun" (p. 76). It does not. The height of the pyramid at Cheops is about 481 feet. Multiply this by 1,000,000,000 and you get 91,098,485 miles. The actual mean distance between the earth and the sun is about 93,000,000 miles, a difference of close to 2 million miles. Not terribly accurate for interstellar travelers. By the way, von Däniken appears to have taken this directly from *The Morning of the Magicians*, where it appears on page 110. Again, he makes no reference to that book in *Chariots of the Gods?*
- 2. Discussing mummification, von Däniken claims that the process was introduced by extraterrestrial aliens to preserve the bodies of Egyptian leaders who could be reawakened when the aliens returned. So it was the aliens who introduced "the first audacious idea that the cells of the body had to be preserved so that the corpse could be awakened to a new life after thousands of years" (1970:81). The only

problem here is that in the mummification process the Egyptian priests disemboweled the body, sticking the heart, lungs, liver, and other organs in jars. These priests also picked out the brains through the nose of the deceased with a pair of tweezers. There could be little hope for bringing somebody in that state back to life.

No, there simply are no laser burns on pyramid stones, no wrecked flying saucers under the Sphinx, no resurrected, 4,000-year-old Egyptian pharaohs walking around (not outside of Boris Karloff in the movie *The Mummy*, anyway). We might expect all of these as deduced implications of von Däniken's hypothesis of extraterrestrial involvement in the development of Egyptian civilization. Instead, all we are left with is the remarkable evidence of the obvious great ingenuity and toil of the culture of ancient Egypt. The lesson of ancient Egypt has nothing to do with spaceships or extraterrestrial aliens. On the contrary, the lesson is one of human abilities, intelligence, and accomplishment.

More Ancestors, More Dummies

Again, in reference to the *Our Ancestors, the Dummies, Hypothesis,* it is not just ancient Egypt that boggles von Däniken's mind to the point where he cannot believe that mere people were responsible for the artifacts that archaeologists find. Here are just a few additional examples.

Extraterrestrial Calendars?

In his third book, *Gold of the Gods* (1973), von Däniken makes reference to the hypothesis of science writer Alexander Marshack (1972). Marshack maintains that some inscribed bone, antler, and ivory tools from Paleolithic Europe, dating from ten thousand to thirty thousand years ago, represent the oldest calendars in the world. He hypothesizes that these first calendars were based on the cycle of changes in the phases of the moon. Amazed as always, von Däniken asks

Why did Stone Age men bother about astronomical representations? It is usually claimed that they had their hands full just to procure sufficient nourishment on endless hunts. Who instructed them in this work? Did someone advise them how to make these observations which were far above their "level"? Were they making notes for an expected visit from the cosmos? (1973:203–4)

Von Däniken has lots of questions, but precious few answers. Let's look at one of these artifacts and see if it indeed looks like something only an extraterrestrial alien might have devised. Probably the most famous of the artifacts in question is the Abri Blanchard antler plaque found in southern

Figure 9.10 Von Däniken sees evidence for knowledge far beyond the capabilities of ancient people in 30,000-year-old bone implements of the Upper Paleolithic. But, perhaps the best known of these, the antler plaque at Abri Blanchard in France, though a compelling argument for the great intelligence of our prehistoric ancestors, is really just the simple depiction of lunar phases. The pattern of lunar waxing and waning was likely well known to these people. (© Alexander Marshack)

France and dated to about thirty thousand years ago (Figure 9.10). This ancient piece of ivory has close to seventy impressions carved into it along a sinuous arc. If you begin in the center of the antler and work your way along the arc, a rough pattern emerges. Each design element appears to be a fraction of a circle. As you follow the arc of impressions, the marks seem to grow in terms of the proportion of a circle represented and then, once a whole circle is produced, to diminish. The similarity between the sequence of impressions and the phases of the moon is apparent. It is Marshack's well-reasoned, though still-debated, hypothesis that this is precisely what these ancient people were trying to convey.

No one can deny that it is fascinating to think that thirty thousand years ago prehistoric people may have looked at the mysterious light in the night sky and wondered about it. Based on this and similar artifacts from the period thirty thousand to ten thousand years ago, it appears quite possible that these ancient people recognized the cyclical nature of the lunar phases. But as interesting as it might be, does the antler plaque look like the calendar of an extraterrestrial alien?

Certainly it took intelligence to watch the nightly change in the moon's phases and conclude that it was not random, that it was patterned and predictable. But remember, these were people who, of necessity, were attuned to the natural world around them. Their very survival depended on their observations of nature, and nature is filled with predictable cycles. Day followed by night followed by day is an unending, constant pattern that is easily recognized. The fact that summer follows spring, is replaced by fall and

then winter, which leads inevitably back to spring, was a cycle that had to be known, followed, and relied on by our prehistoric ancestors. Long before thirty thousand years ago their brains had become as big as ours, and they probably were no less intelligent than we. The fact that they may have recognized the phases of the moon as another cycle in nature and that they recorded these changes to be used, perhaps, as a kind of calendar is a wonderful achievement, but not really so unexpected.

Extraterrestrial Aliens in the Pacific?

Or how about this? On the island of Temuen, in Micronesia in the western Pacific, there is an interesting archaeological site called *Nan Madol*. It is a village of close to one hundred structures, built probably between five and six hundred years ago (Ballinger 1978). The buildings themselves are indeed remarkable. The raw material used in construction consisted of volcanic basalt blocks found on the other side of the island. Von Däniken is amazed by the blocks themselves as well as by the entire construction project. About the individual blocks, he claims:

Until now scholars have claimed that these basalt slabs were formed by lava that had cooled. That seemed like a lot of nonsense to me as I laboriously verified with my measuring tape that the lava had solidified exclusively in hexagonal or octagonal columns of roughly the same length. (1973:117, 119)

Von Däniken is apparently no better versed in geology than he is in archaeology. The octagonal and hexagonal structure of basalt columns at Temuen is a recognized, well-understood geological phenomenon called *columnar jointing*. You don't need to go all the way to Micronesia to see such columns; precisely the same phenomenon can be seen at the Devil's Post Pile National Monument in California. If von Däniken had only gone around to the other side of Temuen Island, he would have seen these columns in their natural outcrop, untouched by human (or, I might add, alien) hands.

On another Polynesian island, von Däniken believes there is evidence of extraterrestrial involvement. Easter Island is one of the most remote places on earth, 3,200 km west of the coast of South America and 2,000 km southeast of the nearest inhabited island. The island was first settled sometime after A.D. 300 by Polynesian explorers from the west.

On the island, 883 large stone statues called Moai have been located, and there may be as many as fifty others not yet recorded (Van Tilburg 1987, 1994, 1995). Carved from a relatively soft volcanic rock called *tuff*, they are impressive indeed. The largest is over 20 meters (60 feet) high and weighs about 55,000 kilograms (60 tons). The "average" statue is over 14½ feet high and weighs 14 tons. Even the smaller statues would have taken considerable labor to quarry, sculpt, transport, and erect (Figure 9.11).

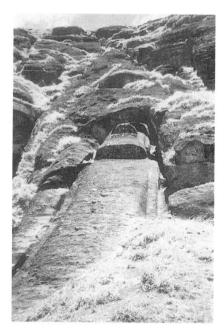

Figure 9.11 The remarkable Moai of Easter Island number in the hundreds and reflect the great intelligence, technical skill, and organizational abilities of so-called primitive people. The photograph on the right shows a Moai that was not finished, still lying in place in its quarry. No laser burns have been found in the quarries, only the stone tools the Easter Islanders used to carve out the statues from the surrounding rock. (Sonja Gray)

Not surprisingly, von Däniken does not believe that the Easter Islanders could have accomplished these tasks by themselves. In *Gods from Outer Space* (1971), he suggests that the statues (or at least some of them) were erected by extraterrestrial aliens marooned on Easter Island. What was their motive for erecting the statues? According to von Däniken, it was simple boredom (p. 118).

Intensive archaeological investigations have been carried out on Easter Island since 1955 (see Van Tilburg 1994 for a detailed discussion of this work). Quarries with partially completed statues have been discovered—along with the simple stone picks, hammers, and chisels used to quarry the rock and carve the images. Roads have been identified on which the statues were transported. Statues accidentally broken during transport have been located along the roads. Experiments have been carried out in techniques of quarrying, carving, transport, and erection (Heyerdahl 1958). Six men roughed out a 5-meter-long statue from the stone quarry in just a few days. A group of several islanders erected an ancient Moai in a short time period, using levers and ropes. Statues have been moved along the old roads using wooden sledges and rope.

More recently, researcher Jo Anne Van Tilburg (1995) has applied computer technology to approach the question of how the statues were moved. In her analysis, the Moai could have been moved either face down or up on a sledge consisting of a large V of two wooden beams about 18 feet long and 10 inches in diameter, connected by a series of wooden cross-braces. According to the computer model, it would have been possible to transport the stone several miles in this way. Then, using ramps, levers, and wedges, the statue could have been slowly tilted upright onto its ceremonial platform called an *ahu*.

The Moai are certainly impressive and show what human ingenuity and labor can accomplish. But there should be no mystery about that. The mystery is why von Däniken did not realize that simple fact.

And how were Temuen, Hawaii, Fiji, Easter, and all of the other inhabited islands of the Pacific originally populated? In attempting to answer this question, science has focused on archaeological evidence on the islands themselves, analysis of the watercraft used in the Pacific, and study of the superb traditional navigational skills of the native people (Shutler and Shutler 1975; Terrell 1986). Computer models have been developed that show the likelihood of the success of ancient explorers of the Pacific given certain parameters of wind, current, and direction taken (Irwin 1993). From these sources of data, we think we have a pretty good handle on the original human exploration of and migration into the Pacific.

But our answers do not satisfy von Däniken. He finds hypotheses of human intelligence, endurance, and curiosity too outlandish. What is his explanation for how these islands were settled, how the first human inhabitants got there? He says, "I am convinced with a probability bordering on certainty that the earliest Polynesians could fly" (1973:133). There is very little that can be said in the face of such absurdity.

The Archaeology of Mars

If at this point you are wondering "what on earth" motivates von Däniken and his supporters, you might want to rephrase that question less restrictively. It is not just "on earth" that they see archaeological evidence for the presence of extraterrestrial visitors. They also see such evidence on Mars.

In the summer of 1976 the National Aeronautic and Space Administration (NASA) had two unmanned Viking spacecraft in orbit around the red planet Mars. There has been unremitting speculation about the possibility of life on Mars at least since 1877 when astronomer Giovanni Schiaparelli observed rectilinear markings on the Martian surface, calling them *canali* (Italian for channels). American astronomer Percival Lowell became the chief proponent of the claim that Shiaparelli's *canali* were broad bands of vegetation bordering irrigation canals dug by an ancient Martian civilization.

None of the NASA engineers expected anything quite so dramatic as canals, but they were hopeful that some evidence of life on Mars—of a microscopic, not monumental variety—would be found. Viking *Orbiter 1* dispatched a lander to the surface of the planet on July 20. The lander possessed a robotic arm that was able to collect Martian soil samples. Chemical analyses were conducted on board, searching specifically for the presence of organic molecules as well as chemical traces of life, the diagnostic waste products left behind by bacteria and other single-celled organisms. If there were life on Mars, and if it were at all chemically similar to life on earth, these soil tests would have produced unambiguous results.

The letdown was obvious when the NASA scientists announced that the soil tests showed no definitive evidence of life had been found. No organisms or organic molecules were detected. Although some intriguing chemical processes were noted, these were almost certainly the product of ordinary, nonbiological chemical reactions. Our planetary neighbor bore no evidence of life. Our earth remained the only planet known to us in the universe that had produced living things.

But not everyone was convinced. As the result of a single photographic exposure taken from an elevation of about 1,000 miles above the Martian landscape in an area called Cydonia, a few individuals became convinced that, although there might not be any microscopic or chemical evidence for life on Mars now, there is mind-boggling archaeological evidence of monumental proportions for life there in the past (DiPietro and Molenaar 1982). On exposure 35A72, in a grainy pastiche of shadow and light, is the image at the heart of this extraterrestrial archaeological controversy (Figure 9.12). It is called, simply, "the Mars Face," and it is enormous, roughly a mile long from the top of its head to its chin.

Undeniably it does look like a human face, or at least a part of one. But it also seems to be explainable as an interesting and coincidental play of light and shadows, the kind of image trickery that causes us to see faces, animals, or even household appliances in rock exposures, cave formations, and clouds. These images do not really exist except for our mind's tendency to coax familiar pictures out of natural features. I have been in countless underground caverns where the tour guides have pointed out features like "the Capitol Dome," "Two Eggs, Sunnyside Up," and the "New York City Skyline." New Hampshire has the "Old Man of the Mountain." A rock face in Wisconsin presents a lifelike, entirely natural profile of the Indian leader Black Hawk. Yet none of these often astonishingly real-looking images were conjured up by some ancient geological intelligence. They are a product of our own imaginations, another version of the inkblot effect. Most geologists who have viewed the Mars Face photograph ascribe it to just such a cause. "The most recent photos of the Cydonia area merely confirm this diagnosis. The Mars Global Surveyor satellite was positioned precisely over the 'face' in early April, 1998 for another look at this feature that has inspired so much

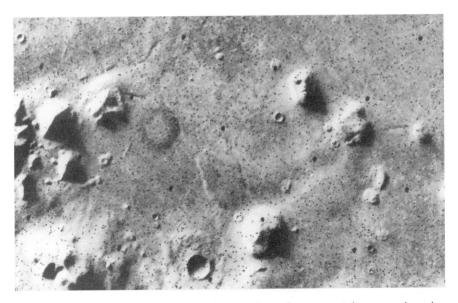

Figure 9.12 The so-called Mars Face (upper right) is almost certainly a natural product of Martian geology—a natural feature of the landscape that happens to look like a human face under the right lighting conditions—and not a monument built by an ancient Martian civilization. (Courtesy of NASA)

dramatic speculation. The new photographs were of far higher resolution than those taken by the Viking orbiter in 1976. The angle of the camera and of the sun were different than in 1976 and, disappointingly (but not surprisingly) the feature that looked like a face now merely looks like a mountain. The face was not the product of some ancient extraterrestrial civilization, but an outcome of stone, light, shadow, and the tendency of our brains to coax the recognizable out of indeterminate images."

Another photo of the Martian surface shows a lava flow that bears a remarkable resemblance to Kermit the Frog (Figure 9.13)! No one has claimed, at least not yet, that this is evidence of an extraterrestrial origin for the Muppets. Yet another feature of the Martian landscape looks like the "happy face" symbol (Gardner 1985), but it is simply a meteorite impact crater. To scientists, the Face, the image of Kermit, and the "happy face" are rare, but by no means unique, images of landscape features on a planetary body; the images look artificial, but they are entirely natural.

This has not prevented some from going far beyond just the supposed human face. Writer Richard Hoagland (1987) has scanned a series of the Viking photographs and views the Face as just the tip of an extraordinary extraterrestrial iceberg. Hoagland views the Face as just one feature in the ruin of a vast and ancient Martian city filled with huge pyramids, fortresses, roads, and other artificial features.

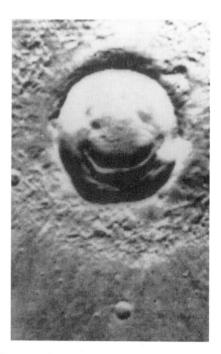

Figure 9.13 Natural features that appear to be patterned, or even those that look like they were made by some intelligent force, are actually quite common on earth as well as on Mars. Two images from Mars show this rather humorously: (left), a remarkable Martian lava flow that bears an uncanny resemblance to the Muppet character, Kermit the Frog. Kermit's eye is a meteorite impact crater; and (right) an 8-kilometer-wide (5-mile) meteorite impact crater NASA refers to as "the largest known Happy Face in the solar system" (the smile and eyes were formed by natural fractures). (Courtesy Jet Propulsion Laboratory, NASA)

Hoagland's claims, if borne out, would represent the most spectacular archaeological *and* astronomical discovery of all time: an advanced and sophisticated extraterrestrial civilization dating to, Hoagland estimates, more than five hundred thousand years ago!

Recently, Mars has again been in the news. In August 1996 a team of scientists announced their analysis of a meteorite found on earth, stating that the meteorite probably originated on Mars and that it contained some tell-tale indications of ancient Martian life in the form of microscopic fossils (Kerr 1996). If this claim is upheld (most scientists do not accept a biological interpretation), it will be the first evidence that life evolved someplace other than earth, truly a momentous discovery. Then, in July 1997 tens of millions of people all over the world watched images of Mars on their televisions while millions more downloaded video loops on the world wide web. In a reality so amazing that it dwarfs the tired speculative fiction of Erich von Däniken, a tiny vehicle superficially resembling a child's remote control car cruised the surface of Mars (Figure 9.14). Controlled by programmers back

Figure 9.14 The Sojourner rover craft, which recently trekked across the surface of Mars, found interesting rock formations but no sign of life, intelligent or otherwise. (NASA; National Science Data Center)

on earth, the artificial eyes and nose of the device named "Sojourner" drove up to a nearby rock to photograph and sniff its chemical composition. Human beings were exploring another planet from the safety of a laboratory back on earth. The discoveries being made in the Mars Rover project are stunning to astronomers and geologists alike, but they have little to do with ancient Martian civilizations. To date, Sojourner has spied no roadways, aqueducts, pyramids, fortresses, or anything even vaguely artificial.

Archaeology is not a discipline that can be fruitfully carried out at a distance. Here on earth, high-altitude aerial photography has proved useful in the discovery of large-scale ancient landscape features produced by people—things like canals, roads, and agricultural fields. But in all of those cases, aerial photography has represented merely the first step suggesting the existence of such features. Archaeologists need to determine the "ground truth" of ostensible cultural features that might actually be the result of naturally patterned features or imaging/computer artifacts. Until a manned mission to Mars puts archaeologists on the ground (I would be happy to volunteer my services), I think it best that we take a skeptical approach and assume

that extraterrestrial archaeology is not going to command the attention of the discipline in the near future.

The von Däniken Phenomenon

Von Däniken again and again underestimates the intelligence and abilities of our ancestors and then proposes an extraordinary hypothesis to explain the past. That is clear. However, what is not so clear is the second reason I have suggested for von Däniken's inability to accept prehistoric peoples' ability to produce the great achievements seen in the archaeological record (the first was simple ignorance). I have already mentioned it briefly—European ethnocentrism.

What I mean by this becomes clear when you read *Chariots of the Gods?* It is curious that von Däniken is ever ready to provide examples as proof of his third hypothesis (*Our Ancestors, the Dummies*) from archaeological sites in Africa, Asia, North America, and South America; but he is curiously and atypically silent when it comes to Europe. My feeling about this was so strong on reading *Chariots of the Gods?* that I actually went through the book and tallied the specific references to amazing accomplishments of prehistoric people that von Däniken believes were too advanced, too sophisticated, or too remarkable for mere humans to have produced. I paid careful attention to where in the world (which continent) these specific examples were from. The following chart resulted (Feder 1980a):

Continent of the Example	Number of Examples	Percentage
Africa	16	31
Asia	12	23
Europe	2	4
North America	11	22
South America	10	20
Total	51	100

The great majority of von Däniken's examples here are from places other than Europe. It appears that he is utterly astounded by the archaeological records of ancient Africa, Asia, and North and South America. He is so astounded, in fact, that he thinks that only through the assistance of men from outer space could those black, brown, yellow, and red people have produced the prehistoric works that archaeologists find on these continents.

It is curious that von Däniken never wonders who helped the ancient Minoans build the great temple at Knossos or the Greeks the Parthenon, or

which spacemen instructed the Romans in constructing the Coliseum. Why not? These monuments are every bit as impressive as those that von Däniken does mention. The temple at Knossos is more than thirty-five hundred years old, the Parthenon is almost twenty-five hundred years old, and the Coliseum is close to two thousand. Even in the case of Stonehenge in England, von Däniken is strangely quiet and only briefly mentions it in *Chariots of the Gods?*—though he finally does get around to Stonehenge in a more recent book, *Pathways to the Gods*.

This may be a key point in von Däniken's success. *Chariots of the Gods?* is listed in the *Publishers Weekly* inventory of all-time best sellers, having sold over seven million copies—that is more than *The Diary of a Young Girl* (Anne Frank), *Catch-22*, or *All Quiet on the Western Front*, for example ("So Big" 1989). It is such an incredibly silly book that we must ask why it has done so well.

Many people are aware of phenomena like the pyramids of Egypt, the ruins of Mexico, and the ancient Chinese civilization. Some, however, may wonder how the prehistoric ancestors of contemporary people whom they consider to be backward and even intellectually inferior accomplished such spectacular things in the past. After all, today Egypt is a third-world nation, the Indians of Mexico are poor and illiterate, and the Chinese are just beginning to catch up with the technology of the modern world. How could the ancestors of such people have been advanced enough to have developed pyramids, writing, agriculture, mathematics, and astronomy all by themselves?

Along comes von Däniken with an easy answer. Those people did not produce those achievements on their own. Some sort of outside help, an extraterrestrial "peace corps," was responsible. If I am correct in this suggestion, it really is a pity; human prehistory is a spectacular story in its own right. All peoples have ancient pasts to be proud of, and there is no place for, nor any need to fall back on, the fantasy of ancient astronauts.

Von Däniken has sold many books; his work has been the subject of movies and television specials; recently a compendium of three of his books was published (von Däniken, 1989); and his writings have inspired an ancient astronant industry (Berlitz 1972; Chatelain 1980; Drake 1968; Kolosimo 1975; Sitchen 1978, 1990; Tomas 1971). Even actress Shirley MacLaine (1983) has championed von Däniken's thesis in her book *Out on a Limb* (of which there have been more than a dozen printings).

Clearly, von Däniken's writings have been quite popular and have had an effect on millions of people. The popularity of his books or of his ideas, however, is wholly irrelevant. Science is not a democratic process. Knowledge depends on the procedures outlined in Chapter 2, not on the popularity of the ideas behind that knowledge. I hope that your decision concerning the evidence for von Däniken's claims is based on the rules of science rather than on inkblots, amorous astronauts, or a low opinion of human intelligence.

FREQUENTLY ASKED QUESTIONS

1. What happened to Erich von Däniken?

Though von Däniken's fortunes have waned, he has not disappeared entirely. He has been published during the last decade, but primarily in German. He has become a popular speaker at UFO conventions and recently gave a keynote address at the conference held commemorating the fiftieth anniversary of the alleged flying saucer crash in Roswell, New Mexico. In a mini-comeback in the United States, von Däniken has published his first English language book in about a decade (*The Eyes of the Sphinx*, 1996) and even more recently has hosted an independently produced one-hour television special for network TV focusing on his ancient astronaut hypothesis (*Chariots of the Gods? The Mysteries Continue*, 1997). Von Däniken's straight man on the show was, rather inexplicably, actor Richard Karn, who is better known for his role as Al Borland on the TV sitcom *Home Improvement* than for his archaeological expertise (which, based on this special, we can confidently conclude is minimal).

2. Is there any evidence for the use of electricity by ancient people?

No, but the claim has been made that a primitive 2,000-year-old electrical battery was found in Iraq. No one knows precisely what this object was used for, but it certainly was not producing any electrical power when it was found in 1936. The so-called Baghdad Battery is a ceramic vase with a closed bottom, a cylindrical tube of copper inserted through the neck, and a rod of iron inside the copper tube. The metals were held in place with a plug of asphalt. A number of modern experiments, often with inaccurate models of this object, have produced mild and short-lived electrical currents when an appropriate electrolyte (liquid that conducts electricity) is poured into the vessel. However, this will happen whenever two different metals are immersed in an electrolyte, and there is no evidence that any such liquid was ever placed into the original jar. Just because it can be used to produce a weak electrical current using modern knowledge does not prove that it ever was used in that way in the past. It is a rather odd artifact, but it in no way proves the use of electricity by ancient people (Eggert 1996).

3. Was there a curse on the tomb of Egyptian pharaoh Tutankhamun that killed people involved with its discovery and excavation?

This question always comes up when discussing ancient Egypt, and the answer is "no." This story got started after the individual who funded the excavation, Lord Carnarvon, died four months after the tomb was opened. It was no great shock at the time. He was old and weak, and he was sick even before the tomb was discovered. In fact, the allegation that the tomb was a death trap can be disproved by simple statistics. The twenty-three people most intimately involved with the opening of the tomb, including Howard

Best of the Web

CLICK HERE

Egypt

http://guardians.net/egypt

http://www.seas.upenn.edu/~ahm/history.htm

http://www.pbs.org/wgbh/pages/nova/pyramid/excavation/lehner.

html

Easter Island

http://www.netaxs.com/~trance/rapanui.html

Marsface

http://barsoom.MSSS.com/education/facepage/face.html

Carter (director of excavations), other archaeologists, photographers, guards, and others, lived an average of twenty-four years (yes, *years*) after the tomb was opened, and their average age at death was 73 (Hoggart and Hutchinson 1995). Carnarvon's daughter, who was with her father when the tomb was first entered, lived for another fifty-seven years, and Howard Carter—the man who discovered the tomb and who would have been the most obvious victim for a curse—lived for sixteen years after entering the tomb, during which time he analyzed and wrote about the splendid objects found in the tomb.

→ CRITICAL THINKING EXERCISE �

Using the deductive approach outlined in Chapter 2, how would you test this hypothesis? In other words, what archaeological and biological data must you find to conclude that this hypothetical statement is an accurate assertion, that it describes what actually happened in the ancient human past?

 The prehistoric record contains evidence of enormous and unexpected leaps forward in science and technology—agriculture, pyramid building, writing, and so on. These leaps are evidence of the introduction of such innovations by extraterrestrial aliens.

Good Vibrations: Psychics, Dowsers, and Photo-Fields

The McLean Game Refuge consists of acres of thickly forested hills marked by deeply incised, meandering streams. There is no obvious indication that the refuge was ever inhabited by ancient people. However, in 1993 a team of archaeologists began to survey this 4,000-acre nature preserve in northcentral Connecticut, and we have located about twenty prehistoric occupations of the refuge.

It may seem like magic, but there is no magic to it. How do archaeologists come into an area like McLean, identify the areas most likely to have ancient buried villages and camps, dig in those very places, and find the material evidence of those prehistoric habitations? We are guided, in part, by experience. Archaeologists are trained to identify the kinds of environmental features that attracted ancient settlement: proximity to fresh water, relatively flat and dry land, and places where the surrounding territory would have supplied basic resources, including food, wood to fuel fires and build dwellings, stone for tools, and clay for pots.

Areas so identified represent hypotheses that need to be tested. The test is in the search for artifacts in those places, the physical objects people made and used, and then lost or discarded. We peppered the game refuge with test pits, shovel-dug holes 50 cm on a side. All of the soil we dug in these test excavations was passed through \%-inch-mesh hardware cloth (screen). Soil passes through the screen, but artifacts like stone flakes, sherds of pottery, burned bone, and charred nut fragments, are caught and represent clear evidence of ancient habitation.

It's not magical, and it certainly is not easy. Much of the survey work is in pretty rough territory, far from the gentle, established trails. Our backpacks are laden with heavy equipment, and we carry shovels and screens that are awkward to negotiate through the dense growth. Mosquitoes, ticks,

Figure 10.1 Archaeological excavations are time-consuming enterprises. Here, at a five-thousand-year-old site in Avon, Connecticut, students slowly scrape back the soil layers, exposing the remnants of an ancient society. (K. L. Feder)

snakes, stifling heat, and thick humidity add to the mix. Certainly, for those dedicated few who devote themselves to this task, the rewards are great when an ancient site whose people lived thousands of years ago is revealed. When we are the first to encounter the remnants of the daily lives of people who lived and died so long ago, it is worth every mile, every mosquito bite, every sprained ankle.

Once sites are discovered, the laborious process of excavation begins. Even a small site such as the prehistoric encampment found in our 1995 survey and excavated in 1996 can take many months to investigate. Scraping back the soil incrementally in 2-meter-square excavation units, passing all soil through hardware-cloth screening, and keeping accurate and meticulous records of the site all take time but are crucial parts of the process. The excavation of a site necessarily involves its destruction, so great care and thorough documentation are absolutely vital if we are to preserve the information about past lives that the site can provide (see Fagan 1991; Feder and Park 1997; Sharer and Ashmore 1993; Thomas 1989, for discussions of survey and excavation methodology; also see Figure 10.1).

Finally, we hope to be able to reconstruct as completely as possible an ancient way of life. To do so, archaeologists have had to devise methods to coax information out of the often meager remains we recover; the artifacts are mute, the bones silent. Detailed examination of stone tools under the

microscope can tell us how they were made and used. Chemical analysis of human bone can provide insight into ancient diets. Physicists can help us to determine the age of sites. Nuclear reactors are used to trace raw materials to their prehistoric sources. Powerful computers are needed to map the distributions of artifacts within sites and of sites within regions to help us illuminate the nature of human behavior. Archaeologists are like detectives of the human past. We try to reconstruct not a crime but a way of life from the fragmentary remains people accidentally and incidentally left behind.

But is there a better, easier way of going about our various tasks? Can we locate sites by simply looking at a map of an area and intuiting their existence? Can we know where to dig at a site simply by walking over the ancient habitation and "feeling" where artifacts are? Can we reconstruct, in exquisite detail, the lives, not just of general "cultures" but of specific, identifiable human beings simply by handling the objects they touched in their daily lives? Is there a methodology that could obviate the tedious and hard work of archaeology and get right at that which interests us most—ancient people and their cultures? Though virtually all archaeologists would wish the answer to this question were "yes," most would realistically answer "no."

Some new methodologies have been suggested, however—mostly by nonarchaeologists—that are alleged to do precisely this.

Psychic Archaeology

For example, some claim that "psychic power" is a tool that can be applied to the archaeological record (Goodman 1977; Jones 1979; Schwartz 1978, 1983). There are many fine books in which the reality of subjects such as telepathy and clairvoyance are assessed with a scientific and skeptical eye (see Table 1.1). A detailed examination of so-called paranormal phenomena is beyond the scope of this book; nevertheless, we can assess the application of such alleged powers in archaeological research.

Remember, whatever one's biases might be for or against the existence of psychic power, hypotheses regarding the reality of such phenomena and their utility in archaeological site survey, excavation, and analysis must be tested just as all hypotheses must be tested—within a scientific, deductive framework. When a psychic predicts the location of a site, we must test the claim archaeologically. When a certain artifact or feature is predicted at a particular spot in a site, such a claim also must be tested by digging. Finally, when a psychic attempts to reconstruct the activities at a site or the behavior of the people at a site, those involved in testing the legitimacy of such an ability must devise a way to test such reconstructions with independent archaeological data.

In such testing, sources of information other than psychic must be controlled for. Here the application of Occam's Razor should be clear. If the in-

formation reported by the psychic is correct but could have been obtained in some more pedestrian way (through such simple avenues as reading the available literature on a site or time period, or through the application of common sense), then Occam's Razor would demand that we accept the simpler explanation before we accept the validity of a paranormal phenomenon. Unfortunately, as you shall see, such tests of psychic archaeology either are not conducted or are conducted so poorly as to render the results meaningless (Feder 1980b, 1995a).

The Roots of Psychic Archaeology

When the Church of England purchased the site and ruins of the ancient Benedictine Abbey of St. Mary at Glastonbury near Bath in 1909, Frederick Bligh Bond, a local architect, was hired to stabilize the standing walls of the abbey, to produce a map of the ruins, and to prepare a guidebook for tourists. Bond studied ancient historical records and conducted archaeology at the site, gathering as much data as he could to better understand the appearance, construction history, and functioning of the church.

Though Bond withheld the information from the Church at the time, he later maintained in a book devoted to his study of the abbey that his archaeological investigation had been directed by a host of dead monks present in its ruins (Bond 1918). Other deceased historical figures who commiserated with him about his work were a Danish warrior, the Abbot Beere, and even Julius Caesar. Bond claimed to have had regular discussions with these ancient spirits who directed the investigators to the best places to excavate.

Bond's claim of a ghostly source for his discoveries exhibits a fundamental problem in testing the validity of psychic archaeology—or any psychic claim—in an uncontrolled setting. Simply stated, it is virtually impossible to eliminate the possibility that prior knowledge on the part of the participants in the study may have directed them to the right parts of the site to dig.

For example, Bond claimed that the spirits of dead monks directed him to the locations of the ruins of two chapels in the abbey—Edgar and Loretto chapels—and also to the foundations of enormous church towers. But Bond was an expert on medieval churches, and we know that he had access to and had examined many of the documents, maps, plans, and drawings of the abbey before initiating field research. Although much of the abbey was a ruin, some walls and foundations were visible at the surface. Previous subsurface investigation had been conducted at the abbey, so areas where little had been found could be, and were, eliminated in Bond's study.

As Marshall McKusick (1982:104) points out, the tall church towers actually were recorded and located in a historical document Bond almost surely had already seen. An early drawing of the abbey, as well as structural remains visible on the surface, provided clues about the location of these towers. The Edgar and Loretto chapels were known to church historians before

Bond began his work and had been generally located in historical documents. Previous searches for the chapels had been unsuccessful, so Bond did not have to look in those same areas. Instead, he searched for and found the chapels in the only reasonable places left for them to be (McKusick 1982:104).

As archaeologist Stephen Williams (1991:288) points out, "Culture is patterned behavior, and medieval cathedrals are some of the most patterned pieces of construction in our culture." Bond's knowledge of the spatial patterning of medieval church construction allowed him to use that pattern as a guide in discovering additional architectural elements in the ruins of the abbey that were not readily apparent on the surface. Modern archaeologists give Bond high praise for his work in the abbey (McKusick 1982; Williams 1991), but they credit his success to his great knowledge and skills, not to any messages from the great beyond.

Stefan Ossowiecki was another spiritualist who became involved in psychic archaeology. Ossowiecki was the subject of a number of experiments conducted between 1937 and 1941 by the ethnologist Stanislaw Poniatowski. The methodology employed was simple. Poniatowski provided Ossowiecki with Paleolithic artifacts about which the psychic had no prior knowledge. Ossowiecki then provided details concerning the sites, time periods, people, and cultures associated with the artifacts.

One might think that the controlled setting of these experiments should render the results less ambiguous than Bond's claims. Unfortunately, this is not the case, and the Ossowiecki experiments are extraordinarily difficult to assess, not the least because the original records kept by the ethnologist disappeared during World War II. Psychic researcher Stephan Schwartz (1978) maintains that a mystery man provided Ossowiecki's wife with those records in 1952, but it is difficult to determine whether these were the original materials documenting the experiments.

Psychic Site Location

The claim is made that psychics can find unknown archaeological sites. The book by anthropologist David Jones (1979), *Visions of Time*, purports in its subtitle to present "Experiments in Psychic Archaeology," and at least some of these experiments involve finding sites. Jones presents psychics with artifacts and photographs from known sites, and then asks them to identify their locations.

In one example, Jones (1979:55) provided a psychic with material from a known site. The psychic did not locate the site on a map but did correctly identify the site's coastal setting. However, it should be pointed out that among the items from the site that the psychic was given were shell fragments and *columella* beads. Certainly this was a large hint as to the habitat in which the site was situated.

Later in the book (pp. 106–14), Jones mails one of his psychic subjects four photographs of sites in Florida. These are all correctly identified by the

psychic as being near water. There is little to be impressed with here, however; virtually all human habitations are near water of some kind, and Florida possesses about 8,000 miles of detailed shoreline and thirty thousand lakes (Feder 1980b:36). One cannot miss by suggesting that the location of an unknown (to the psychic) archaeological site in Florida is near water.

Even when psychics seem to be correct in predicting the location of an archaeological site, their supporters need to show that this was accomplished through the use of paranormal abilities. For example, Stephan Schwartz (1983) led a psychic archaeology project in Egypt. A team of ten self-proclaimed psychics was used to find sites now located under water in the city of Alexandria's harbor. Indeed, sites were found, but, according to Egyptian archaeologists, this was not surprising. The harbor was used in ancient times, and divers had often found ancient remains in the mud at the bottom. The presence of psychic archaeology need not be invoked simply because sites were found in the general area the psychic predicted.

Perhaps in reference to psychic site location, it is most important to consider the fact that archaeologists regularly discover sites by employing some rather commonsense techniques. Human beings—prehistoric, ancient historic, and modern—do not locate their habitations randomly. Among the more important factors considered by a human group when deciding where to settle are distance to potable water, distance to a navigable waterway, topographic relief, defensibility, protection from the elements, soil type, food resources, and the availability of other resources such as stone, clay, or metal for tools.

Using such a list, even an untrained person can examine a map of an area and point out the most likely places where ancient people might have settled. In my own introductory course in archaeology, after lecturing on settlement location choice, I distribute United States Geological Survey maps (1:24,000 scale) of areas in Connecticut where we have conducted archaeological surveys (Figure 10.2). I ask students to peruse the maps and to suggest areas where sites might be located. It is quite common for students to come up with precise locations where, indeed, sites have already been discovered. Therefore, even if a psychic could come up with an accurate prediction for the location of an unknown site, we would have to consider the simple explanation that, consciously or not, the psychic was merely relying on commonsense cues rather than ESP to make the prediction. The lack of control of these variables renders such tests impossible to assess.

Psychic Excavation

In *Visions of Time*, Jones sets out to test the ability of psychics to locate objects at a site before they are excavated. Unfortunately, Jones clearly establishes ground rules that vitiate the scientific testing of hypotheses regarding such abilities. He states, "If the psychic subject stated that a particular artifact was present in the site, the lack of its discovery during excavation would

Figure 10.2 An understanding of the factors that influenced ancient people in settlement location choice helps us find archaeological sites. United States Geological Survey maps (1:24,000 scale) like this section of the New Britain Quadrangle, Connecticut, provide a valuable picture of topography and drainage—significant considerations for people in the past, as well as the present. (U.S.G.S.)

not disprove the presence of the artifact" (p. 101). Such a perspective renders the hypothesis technically *nonfalsifiable* and therefore nonscientific. You could never prove your hypothesis wrong.

In one case, Jones considers a psychic to be quite accurate in listing the artifacts to be found at a site even though, of the artifacts actually found, only two were predicted by the psychic: the eleven projectile points, forty-two flint pieces, fire hearths, shell tools, beads, worked bone, milling stone, and a human burial were not divined by the psychic. In fact, the most abundant artifact found at the site was pottery, with more than five thousand sherds recovered. The psychic does not mention pottery at all until he is taken to the site and given a piece.

Jeffrey Goodman (1977, 1981) claims to have used psychic revelations to locate an outpost of immigrants from the Lost Continent of Atlantis in Arizona (see Chapter 8). Goodman's psychic predicted that excavators would find the following at the "site": "carvings, paintings, wooden ankhs, cured leather, and parchment scrolls with hieroglyphiclike writing" (1981:128). Also predicted among the finds were an underground tunnel system, domesticated horses and dogs, and corn and rye (p. 134). Goodman admits, "My beliefs may appear to outstrip the physical discoveries at Flagstaff so far" (p. 134), showing that he is nothing if not a master at understatement. *None* of the predicted items was, in fact, discovered at the site. The utility of psychic archaeology as a method for supplementing excavation has not been supported experimentally.

Psychic Cultural Reconstruction

Archaeologist Marshall McKusick (1982, 1984), who played a key role in clearing up the myth of the Davenport Tablets discussed in Chapter 7, has produced useful summaries of the claims of the psychic archaeologists. Regarding the psychic reconstruction of prehistoric cultures, he has come up with the phrase, "the captive-of-his-own-time principle" (1982:100). He uses this phrase to underscore the fact that when psychics have attempted to reconstruct past lifeways, invariably they have done so within the framework of popular notions of those lifeways with all their biases, inconsistencies, and errors. In other words, the "vibrations" psychics allegedly receive by walking over a site, studying a map, or "psychometrizing" an artifact (holding the object to link up in some way with the person who made and used it thousands of years ago) do not come from some other plane of reality but rather from more mundane sources like popular books, newspaper articles, and the like.

For example, McKusick points out that when, in the 1930s, Stefan Ossowieki had visions of the Old Stone Age, they were in line with thencurrent, but now known to be erroneous, perspectives of ancient people. Ossowieki described *Magdalenian* people of the Late Paleolithic as being short with large hands and low foreheads (McKusick 1982:100). McKusick points out that Ossowieki was likely simply providing a commonly held stereotype of Neandertals. But the Neandertals became extinct at least fifteen thousand years before the Magdalenian culture came into existence. Ossowieki should have described a tall people with high foreheads, not short, squat Neandertals. Clearly his description reflects not on his psychic connections but on his own ignorance of Paleolithic archaeology.

As McKusick (1982) shows, when another self-proclaimed psychic and witch, Sybil Leek, tried applying her psychic gifts to ostensible Viking sites in the New World (Holzer 1969), she described the wrong kind of sailing vessel, but one that matched then-current presumptions. When Leek encountered

the ghost of one of the Viking settlers, she identified him by reading a part of his name "... KSON" (Holzer 1969:118). Later, in Leek's dream, the ghost wrote his initial: "E" (p. 126). Presumably we are to believe that the spirit of Leif *Erikson* appeared to Ms. Leek (by the way, at a supposed Viking site in Massachusetts rather than the more likely setting of Newfoundland as discussed in Chapter 6). Also, presumably, we are to believe that this Norse explorer learned Roman letters on "the other side," since in their time Vikings wrote in their own Runic alphabet.

Also in this regard, self-proclaimed seer Edgar Cayce, whom we encountered in Chapter 8, saw his paranormal abilities fail him terribly. In the 1920s, after the discovery of Piltdown, but years before its unmasking as a fraud (see Chapter 4), Cayce obtained information from another plane of reality informing him that *Eoanthropus* was one of a group of ancient Atlantean settlers of England (McKusick 1984:49). Apparently, Cayce's other-worldly sources were not aware that the whole thing had been a fake.

As mentioned in Chapter 8, in the 1940s Cayce predicted that sometime during the 1960s parts of Atlantis would rise from the depths of the ocean, and much of the Atlantic seaboard would be inundated. New York City was to have disappeared, the Great Lakes were to drain into the Gulf of Mexico, and most of Japan would be drowned (Cayce 1968:158–59). During Cayce's career as the "sleeping prophet," he produced some fourteen thousand predictions. With all that predicting, the odds are good that at least some would turn out to be accurate. Obviously, the predictions mentioned here were not among those.

To McKusick's "captive-of-his-own-time" principle, I would add a "captive-of-his-own-ignorance" corollary. The psychics, very simply, come up with descriptions that reflect their own lack of knowledge about prehistory and history. A good discussion of this can be found in *Visions of Time* (Jones 1979).

One of Jones's psychic subjects was given artifacts from the Lindenmeier site in Colorado. This site is quite well known among archaeologists and dates to the Paleo-Indian period (Wilmsen 1965). As mentioned in Chapter 5, Paleo-Indian culture was marked by the hunting of several now extinct big-game animals such as bison, mammoth, and the horse (the horse was extinct in North America before Columbus) with a particular kind of spearpoint, the so-called fluted point, with channels or "flutes" on both faces, probably to facilitate hafting on a wooden spear (see Figure 5.6).

The selection of a Paleo-Indian site to test a psychic's abilities to reconstruct the behavior of the people who lived there is problematic in terms of scientific control relative to nonpsychic sources of information. The Paleo-Indian period is described in virtually every popular book on American prehistory, and fluted points are frequently discussed and illustrated in such books. Anyone with even a passing familiarity with American prehistory

would know immediately on being handed a fluted point what culture was being dealt with.

While "reading" the Lindenmeier artifacts, the psychic states that the spearheads were used "to shoot bison, or an elephant or mastodon or something" (Jones 1979:82). Mentioning extinct animals might sound impressive, but there is a subtle problem beyond the fact that the fluted points gave it away. Here we see an example of a self-proclaimed psychic who either is a captive of his own ignorance or has faulty sources in the spirit world. The fatal error made here concerns a detail of fluted point variability.

Fluted points are among the most distinctive and recognizable stone tools in the world. With the possible exception of one recently discovered projectile point from eastern Siberia exhibiting what may be fluting (King and Slobodin 1996), they are not found anywhere in the Old World, and in the New World they are found in a relatively narrow time band from about eleven thousand five hundred to ten thousand years ago (Haynes 1988). This is the reason why a Paleo-Indian site with fluted points is such a poor choice for a test of psychic abilities to identify an ancient culture. A fluted point is, most simply, a dead giveaway of Paleo-Indian culture.

Anyone, including an erstwhile psychic, can open a popular book on American prehistory and find a photograph or drawing of a typical fluted point. Actually, there are two main varieties of the point: Clovis and Folsom. The Clovis points are older, usually longer (7–12 cm), and the channels ordinarily extend from the base to below the midpoint of the tool (Figure 10.3, left). Folsom points are shorter (5 cm), and here the channels extend nearly the full length of the tool (Figure 10.3, right). The differences are technical, and not as well known to nonarchaeologists as are generalities concerning Paleo-Indian culture.

It is apparent that though the psychic recognized fluted points in the Lindenmeier assemblage, he did not realize the subtle difference between Clovis and Folsom points and the crucial distinction apparent from the archaeological record concerning the hunting patterns of the earlier Clovis and later Folsom hunters. Clovis points are found in association with the bones of extinct elephants, and Folsom points are found in association with the bones of extinct bison; the distinction is perfect (Jennings 1989). Apparently, the woolly mammoth hunted by the Clovis people became extinct; subsistence shifted to a now-extinct form of bison, and the Folsom point was invented.

Lindenmeier was a Folsom site. The spearpoints are clearly recognizable as Folsom, and the list of animals present in the archaeological bone assemblage includes bison (*Bison antiquus*) but not mammoths. Yet the psychic specifies the presence of an elephant or a mastodon (here is another bit of faulty wiring to the other world—mastodons were adapted to woodland habitat and were far more numerous in the East, whereas mammoths, with their quite different teeth, were grassland grazers numerous in the West).

Figure 10.3 The bestknown artifacts of the Paleo-Indians—12.000vear-old fluted or channeled spearpoints. The Clovis variety (left; from the Vail site in Maine) is often found in association with the remains of extinct elephants. The Folsom (right: from the Lindenmeier site in Colorado) is found with the remains of an extinct species of bison. (Courtesy of Michael Gramly and the Buffalo Museum of Science Both points drawn by Val Waldorf)

Whatever the species, no elephant remains have been found at Lindenmeier or any other Folsom site. The psychic later even contradicts himself and asserts that there were no bison at Lindenmeier at all.

What is going on here seems clear. The psychic was passingly familiar with Paleo-Indian culture. In the experiment, he recognized the fluted points and must have remembered, perhaps subconsciously, from his reading (rather than from paranormal channels) that the Paleo-Indians hunted now-extinct animals with such weapons. Clearly, though, he was unaware of the distinction between Clovis and Folsom fluted point traditions and the difference in the subsistence patterns of these two chronologically separate people. So, he mentions the most obvious—almost stereotypical—extinct animal he can think of: the mastodon. There is no paranormal power at work here. Instead, the psychic simply shows himself to be an individual trapped by his own limited knowledge of American prehistory.

Psychic cultural construction is, at its heart, nonscientific if only because the vast majority of such constructions cannot be tested. There simply are no data with which these often detailed descriptions can be judged.

Take Stefan Ossowieki's detailed description of a sexual encounter between two premodern human ancestors:

He makes advances to her. Takes her breasts and pulls to himself . . . he moves around her to and fro. There are no kisses. She strokes his neck, back, he lies down. She sits on him equestrian style. He embraces her with his whole strength, she is active not he. There are no normal movements, they are like monkeys. (In Schwartz 1978:89–90)

This, of course, is nothing more than fantasy. The archaeological record can provide no data that would enable us to assess such a scene. It may be titillating, but it most decidedly is not science.

Psychic Archaeology: The Verdict

As an archaeologist, I wish psychic archaeology worked. As an archaeologist committed to a scientific and skeptical approach, I can only say that wishing doesn't make it so. The verdict on psychic archaeology based on experiments under controlled conditions is decidedly negative.

Dowsing Instead of Digging

Dowsing for subterranean water is a venerable tradition. Using a Y-shaped stick, a pendulum, or two metal wires with a 90-degree bend in each, some claim the ability to walk over the ground and, depending on the motion of the device, identify the location, the depth, and even the flow rate of underground water (Chambers 1969; see Vogt and Hyman 1980 for a skeptical analysis by an anthropologist and a psychologist).

Although "water witching" goes back hundreds of years—the first recorded reference is in 1568 (Chambers 1969:35)—its application to the discovery of archaeological artifacts or buried structures is more recent. Schwartz (1978:108–35) details the alleged abilities of Major General James Scott Elliot in Britain; respected archaeologist Ivor Noël Hume (1974:37–39) describes its use at colonial Williamsburg in Virginia; Bailey (1983) details the use of dowsing in medieval church archaeology in England; Goodman (1977) discusses "map dowsing," where sites are supposedly discovered by using a dowsing technique on maps.

For some (Schwartz and Goodman, for example) dowsing is simply a method for enhancing or facilitating the psychic abilities of the user. Others maintain that the dowsing device allows them to locate, through some unknown but normal process, magnetic anomalies caused by the buried objects. Major General Elliot, as cited in Schwartz (1978), eschews the psychic label; Noël Hume (1974) uses dowsing to find only metal objects ostensibly as a result of their magnetism.

The first part of this chapter was devoted to a skeptical assessment of the use of psychic power in archaeological research. We saw no good evidence for the existence of such a power in archaeological application; no test has been successfully conducted that adheres to the scientific, deductive rules enumerated in Chapter 2. Those negative results, however, do not bear on dowsing if, in fact, that procedure is based on the identification of perfectly mundane magnetic disturbances resulting from the burial of human-made objects.

Small but discernible magnetic effects, indeed, are known to result from human activity and have been used in locating archaeological artifacts or features through a process called *proton magnetometry* (Aitken 1970; Weymouth 1986). In a related approach, the *electrical resistivity* of soil has been

measured and used to locate buried foundations and walls (Clark 1970). In the former case a device called a proton magnetometer can be used to locate anything displaying magnetism that differs from the background magnetism of the earth: iron objects, fired clay, or ancient pits (pit fill is more loosely packed than surrounding soil, resulting in differences in what is called *magnetic susceptibility*). For example, archaeologist David Hurst Thomas (1987) was very successful in using a magnetometer in the search for Santa Catalina, the most important sixteenth- and seventeenth-century Spanish mission in Georgia. In the case of *electrical resistivity surveying*, soil resistance to an introduced electrical current varies depending on the compactness of the soil or medium (rock, brick) through which the current is passing. Buried walls and pits will possess different resistivity to the current than will surrounding soil. Differences can be mapped, and buried objects or features causing the differences in resistivity can be investigated.

Measurable phenomena do exist. But can people detect these without the thousands of dollars of equipment ordinarily considered to be required?

Testing the Dowsers

A number of experimental tests of water dowsing have been performed by skeptics; in one case the president of the American Society of Dowsers was involved (Randi 1979, 1984; Martin 1983/84. Nineteen dowsers from all across Europe were tested in 1990 by the German Society for the Examination of Parasciences (König, Moll, and Sarma 1996). A test was even performed on the ABC television newsmagazine program 20/20. In each case the self-proclaimed dowsers agreed to the scientific controls imposed and to the design of the experiment. All maintained that they could easily detect flowing water under test conditions (water flowing in randomly selected routes, through buried or covered pipes).

In all cases here cited, the dowsers failed utterly. They simply could not detect flowing water using their rods, sticks, or pendulums, even when a prize of \$110,000 was at stake (the prize, recently increased by another \$30,000, jointly offered by Australian Dick Smith and American magician, writer, and debunker James Randi, will be awarded to anyone who can, under controlled conditions, produce a paranormal phenomenon—the prize remains unclaimed after many years).

There has even been a test of the ability of dowsers to locate buried archaeological objects (Aitken 1959). Martin Aitken, pioneer in the use of proton magnetometry and electrical resistivity surveying in archaeology, tested dowser P. A. Raine of Great Britain. Raine could not successfully dowse the location of an archaeologically verified buried kiln that had been initially identified by magnetometry (it had produced extremely high readings). Aitken concluded from this that dowsing for archaeological remains simply did not work.

Then why, it might reasonably be asked, do some people swear by the ability of dowsers to find water or archaeological sites in the field? An answer can be found in a simple statistic. The regional government of New South Wales, Australia, keeps accurate records of the several thousand water wells drilled in its territory, including those located by local dowsers. According to these records, the dowsers were very successful, with about a 70 percent hit rate; about seven out of every ten of the wells they directed drillers to produced water (Raloff 1995:91). This sounds impressive until you compare the dowsers' success rate with that of all other (nondowsing) methods for locating wells. Here the hit rate was 83 percent (p. 91).

That dowsers seem to be almost as successful as geologists and others at finding water is not so surprising. As Robert Farvolden of the Waterloo (Ontario) Centre for Groundwater Research pointed out in an interview, "In most settled parts of the world it is not possible to dig a deep hole or drill a well without encountering groundwater" (in Raloff 1995:91). So you will be right more often than not, whether you locate a well by dowsing, geological and hydrological principles, ESP, tea leaves, or anything else.

Like their success at locating water, dowsers (as well as psychics—and even psychic dowsers) will often be right in locating archaeological sites. This might sound provocative, but really means little. Archaeological remains are not nearly as rare as many people assume. In some favored locales, buried archaeological materials may be virtually continuous. In some places, even along lengthy transects it is almost impossible to dig a test pit without exposing archaeological remains. In such places, a dowser might direct an archaeologist to dig in a particular spot and artifacts will be found. But virtually anyone using virtually any technique could have accomplished the same feat in these archaeologically rich zones. So, without success in the lab, under controlled conditions, the efficacy of dowsing cannot be upheld and will not become part of the archaeologists' repertoire.

Electromagnetic Photo-Fields

If dowsing, though failing in rigorous tests, nevertheless potentially involves a genuine phenomenon in search of a methodology, the analysis of *electromagnetic photo-fields* (EMPFs) seems to be a methodology in search of a phenomenon (Plummer 1991).

Karen A. Hunt, her master's degree in anthropology in hand, has apparently singlehandedly discovered the EMPF phenomenon, which physicists are wholly unaware of. According to Hunt, any humanmade, aboveground structure or change in the environment (like a road or fence) absorbs or blocks out "minute particles from outer space or light with which the earth is constantly bombarded" (1984:2). Hunt does not discuss precisely what "particles" are blocked or absorbed and how their effects are preserved

after the structure that did the blocking is long gone. Nonetheless, she maintains that if the structure/environmental change existed for six months or longer, its three-dimensional photo-field pattern "is infinite and cannot be destroyed by ordinary means such as burning, plowing, buldozing [sic], blowing up, or removing it and the soil beneath it, or covering the site up . . ." (p. 2).

In practice, the EMPF survey in its particulars sounds suspiciously like dowsing—one walks over the ground, interpreting the movements of bent wires held in the hands. Hunt is careful, however, to distinguish the two procedures: (1) EMPFs are detected with metal rods instead of a stick (she apparently is unaware that many dowsers use metal rods); (2) few people can successfully dowse for water, whereas practically everyone can quickly learn to locate EMPFs; (3) dowsing involves finding things below the surface, whereas an EMPF survey involves below- and above-ground features.

EMPFs are an interesting phenomenon indeed; physicists have never detected them, and no current theory explains them or their infinite property, or even predicts their existence. In the case of dowsing, the question is asked, "Can a magnetic phenomenon that is known to exist and is detectable with instruments, be detected by individuals simply with bent wires or sticks?" For EMPFs we are asking, "Can a physical phenomenon not known even to exist and *not* detectable by instruments be detected by individuals using bent wires?" Beyond this, if, in fact, above-ground objects leave discernible EMPFs or any other kind of invisible pattern, don't trees and rock formations do the same? How could one distinguish an EMPF pattern of a house that was present for, say, fifty years, from previous rock formations present in the same spot for fifty million years, glaciers for tens of thousands of years, or even trees for hundreds of years—especially if, as Hunt maintains, the longer an object was in place, the stronger the EMPF?

As shaky as EMPFs sound, a local government in Australia was intrigued enough to pay Hunt \$1,800 in expenses for her to come to Australia and divine the layout of a now-destroyed historic homestead in a public park. Walking over the ground with her bent wires, Hunt located 129 buildings, structures, fences, and pathways; 25 burials; and a number of aborigine huts, none of which exhibited any surface evidence.

After sixteen days of fieldwork, Hunt submitted her report. Her benefactors were said to be quite pleased and felt they got a good deal; a *real* archaeological and historical investigation of the old homestead would have cost upward of \$10,000 (Austen 1985). The perspective of the local government officials who deemed an EMPF survey worthy of tax dollars seems to be not unlike that of the emperor concerning his invisible new clothes in the children's story. These same government officials confirmed that there was no plan to test with hard data any of Hunt's EMPF revelations (Money 1985).

At the same time, Hunt's rather cluttered EMPF map of the homestead was assessed by Michael McIntyre, director of a local archaeological survey project. He stated that Hunt's drawing of the site based on EMPF analysis

looked nothing like an Australian settlement but did resemble a nineteenthcentury American Midwest town.

In June 1985, Mark Plummer, then president of the Australian Skeptics, challenged Hunt to a scientifically controlled test of EMPFs. Hunt was to conduct her EMPF analysis on a site that had once contained structures of which there were no longer any surface traces. A particular area was selected for which there were clear photographs and ample documentation of the buildings that had been on the site so that the accuracy of Hunt's EMPF-based drawings could be fairly and accurately assessed. Hunt's expenses were to have been covered by a television producer who would film the proceedings. If Hunt turned out to be accurate, she was to have been awarded a prize of about \$24,000.

In July 1985, Hunt initially agreed to the test, but apparently, after extensive negotiations concerning the protocols of the experiment, she declined to participate. This is perplexing. It should have been quite simple for her to have shown her abilities. It would have cost her nothing and, if she was so confident in EMPF analysis, it seems she could have pocketed an easy \$24,000. That she did not participate seems to reflect on the validity of the technique. There the matter stands, with an open offer still of \$10,000 (and now she will have to cover her own expenses) (Plummer 1991).

Hunt is from Missouri—ironically the "show me" state. Hunt, of course, has shown nothing about archaeological methodology, but perhaps more about the cynicism of government officials in their attempt to save money by preventing the necessary and proper archaeological and historical investigation to be carried out.

Archaeology Without Digging

All over the world archaeologists are leaving many of their traditional tools—shovels, trowels, brushes, and screens—back in the lab and tool shed, at least in the initial phases of some projects. Deeply buried artifacts, the outlines of ancient farmers' fields, human burials, houses long since turned to dust, and enclosed sacred spaces are being found—all without moving a cubic centimeter of dirt.

These archaeologists are not involved in an occult movement, nor are they applying paranormal procedures to extract secrets from the earth. They are not relying on dowsing, ESP, or other unsubstantiated phenomena. Instead, these archaeologists are employing new and sophisticated technologies to perform a cutting-edge, noninvasive, and nondestructive kind of archaeology that allows us to produce an image of what is entombed in the ground beneath our feet without digging it up.

For example, in an archaeological survey conducted at Fort Benning, Georgia, at the historic Creek Indian village of Upatoi, Frederick Bruier, Janet Simms, and Lawson Smith (1997) used a *proton magnetometer* and *ground penetrating radar* (GPR) to scan the subsurface to determine patterns of activity in the eighteenth-century native settlement. The proton magnetometer measures local changes in the earth's magnetic field that may be caused by metal artifacts, buried walls, or alterations in the soil caused by previous disturbance resulting from excavation of old irrigation canals or even the digging of human burials. In GPR, an electromagnetic pulse is transmitted into the ground. The nature of the return signal is a factor of the medium through which the pulse travels and can be interpreted as the result of some previous activity that involved disturbing the ground. In both instances, measurements are taken at regular intervals on the surface with no disturbance of the soil.

It may sound like dowsing, but there are major differences: proton magnetometry and GPR are based on known, understood natural phenomena—and they work. After taking a series of readings at fixed intervals by walking across the area where a part of the Upatoi village had already been located, these researchers located six probable human burials that can now be protected without any further disturbance.

In another instance, researchers Daniel Larson and Elizabeth Ambos (1997) investigated hill forts in Northern Ireland in what is called the Navan archaeological complex of ritual sites dating to as much as 2,400 years ago. Using a proton magnetometer, they were able to delineate precisely an earth berm that enclosed one of the forts but was no longer discernible to the eye at ground level. They also were able to locate and identify an additional double-ring of an earth enclosure that could no longer be seen even when standing on top of it.

Elsewhere, GPR has been used to locate an entire buried Viking ship in Norway that may be the ninth-century tomb of Halfdan the Black, the father of Norway's first king (Bjornstad 1998). Here, and in the other examples cited, noninvasive archaeology through geophysical prospecting may never entirely replace digging. We still need to test the "ground truth" of the clues suggested by the application of magnetometers and radar. Nevertheless, these new procedures can be incredibly useful in isolating those areas where digging will be fruitful, an accomplishment that psychics, dowsers, and readers of photo-fields can only promise, but not deliver.

♠ FREQUENTLY ASKED QUESTIONS <</p>

1. Didn't the "prophet" Nostradamus accurately predict future events, including things that have happened in the twentieth century?

Though the allegedly accurate prognostications of sixteenth-century prophet Michel de Notredame (Nostradamus was his pen name) are beyond the scope of this book, I get this question so often in class that a brief answer is in order—no.

Specifically, Nostradamus was a physician and writer who became quite popular in France for his supposed prophetic abilities. Nostradamus made a name for himself with his book *Centuries*—a reference not to time but to the nine groupings of 100 predictions of four lines each (quatrains) contained in the book (the final edition published during his lifetime had 940 quatrains).

The vast majority of the quatrains are incredibly obscure, dense, vague, and incomprehensible. You may read that Nostradamus accurately predicted the rise of Napoléon Bonaparte, actually naming the French emperor more than two hundred years before he was born. You may also read that Nostradamus predicted World War II and even named the German leader Hitler nearly four hundred years before the fact. Neither of these claims is true. In the former case, the Nostradamus quatrain in question states (translations are taken from James Randi's book, *The Mask of Nostradamus* [1993], a terrific place to learn the truth behind the legend):

PAU, NAY, OLORON will be more in fire than in blood. Swimming the Aude, the great one fleeing to the mountains. He refuses the magpies entrance. Pamplona, the Durance River holds them enclosed.

This seems like gibberish, and what it has to do with the ascendance of Napoléon is anybody's guess. PAU, NAY, and OLORON (uppercase in the original) are three towns located in southwestern France, near the Spanish border. The tortured attempts by Nostradamus boosters to coax Napoléon's name out of the letters of these town names is pretty lame.

The so-called Hitler quatrain is no better:

Beasts mad with hunger will swim across rivers, Most of the army will be against the Hister. The great one shall be dragged in an iron cage When the child brother will observe nothing.

This is more meaningless prattle, but what about "Hister?" It is very close to "Hitler," and even though the meaning of the quatrain is completely obscure, does this hint that Nostradamus actually had prophetic abilities? No. On ancient Roman maps of Austria, the lower reaches of the Danube River were named the "Hister." Nostradamus certainly is referring to some unnamed army encamped or trapped against the Lower Danube River.

Even Nostradamus could not have predicted the extreme measures his twentieth-century followers have taken to force his quatrains to match

Best of the Web

CLICK HERE

http://www.science.uwaterloo.ca/earth/waton/dowsing.html#dowsing

http://ourworld.compuserve.com/homepages/ctskeptic/Dowsing.htm

recent events. Unfortunately, it is all a sham. Nostradamus exploited the gullibility of a jaded nobility; he was the "psychic friends network" of his day. He predicted nothing.

Design an experiment to test each of these claims.

- After a self-proclaimed psychic successfully locates a previously unknown archaeological site, the claim is made that archaeological sites can be discovered, excavated, and interpreted by the application of psychic power.
- After a dowser successfully locates a previously unknown archaeological site, the claim is made that archaeological sites can be discovered by dowsing.
- After a person using bent wires successfully locates a previously unknown archaeological site, the claim is made that archaeological sites can be discovered by electromagnetic photo-fields.

Old Time Religion— New Age Harmonics

Imagine scientists in a remote corner of the globe, scraping away the soil surrounding a remarkable discovery, peering through a microscope at a previously enigmatic artifact, or examining their computer printouts, and scarcely believing what they perceive. Incredulous, they realize that there is no other rational explanation; in the artifact they hold before their eyes, in the magnified image of their discovery, or in the results contained in their printouts, the remarkable truth is impossible to deny. The scientists have uncovered concrete proof of a miracle and, at least indirectly, proof of the existence of God.

This may sound like a potential theme for the next installment of a popular movie series. After all, Indiana Jones did manage to recover the Ark of the Covenant—the receptacle for God's word as described in the Old Testament—from the Nazi band that wished to control the enormous power contained within. Maybe Indy's next adventure could involve archaeological proof of the God of the Bible.

But the imaginary scene I've described is not a movie scenario. It reflects actual claims made on a number of occasions by self-styled scientists. Although the purpose of this book is certainly not to assess the veracity of anyone's religious beliefs or to judge the philosophical basis of anyone's faith, when individuals claim there is physical, archaeological evidence for a basic belief of a particular religion, the argument is removed from the field of theological discourse and placed squarely within the proper boundaries of scientific discussion.

We can assess such a claim or claims as we have assessed all other claims made in the name of the science of the past—within the context of the scientific method and deductive reasoning. This is precisely what I will do in this chapter for claims of the existence of Noah's Ark, the validity of biblical chronology as evidenced by the contemporaneity of dinosaur and human footprints, the reality of the Shroud of Turin, and esoteric information encoded in the calendar and writing of the ancient Maya Indians.

Scientific Creationism

You may have heard of the so-called "Scopes Monkey Trial," which took place in Tennessee in 1925. That trial focused on a high school teacher, John T. Scopes, who broke Tennessee state law by teaching Darwin's theory of evolution in a public school classroom—a law that stayed on the books until 1967. The celebrated trial attracted international attention; famous defense lawyer Clarence Darrow served as counsel for Scopes, and thrice-failed presidential aspirant William Jennings Bryan served on the prosecutorial team.

Though Scopes was convicted and fined (he never did have to pay the fine), most presume that the notoriety—and ridicule—that accrued to Tennessee as a result of the trial resulted in a victory for science and the teaching of evolution. As scientist Stephen Jay Gould (1981, 1982) points out, however, this was not the case. Emotions ran high both during and after the trial. To avoid controversy that might hurt sales, most publishers began a practice of regularly ignoring evolution in their high school texts. Generations of American students went unexposed to evolution—the most essential principle underlying the biological sciences.

This changed rather drastically in the 1950s after the Soviets successfully launched Sputnik, the first artificial satellite to orbit the earth. American complacency regarding our superiority in all fields was shaken, and among the results was a revamping of science curricula from elementary school on up. Evolution once again took its rightful place in the biology classroom.

This development, in turn, spawned a new attempt by fundamentalist Christian groups to at least alter the teaching of evolution, a concept that they saw as directly contradictory to their religious faith. Realizing, however, that as a result of constitutional protections religion could not be injected into public education, the fundamentalists attempted a different approach. A new and ostensibly religion-free perspective called *Scientific Creationism* was invented. Herein it was proposed that there was ample *scientific* evidence for the recent (usually dated to within the last ten thousand years) and spontaneous creation of the universe by an intelligent force, the recent and instantaneous creation of human beings by that same force, and the destruction of at least a part of that creation by an enormous, worldwide deluge (Gish 1973; Morris 1974, 1977; Whitcomb and Morris 1961).

Although their beliefs sound suspiciously like the story related in the Book of Genesis in the Old Testament of the Judeo-Christian Bible, Scientific Creationists claim that they do not base their perspective on faith. They claim simply to be scientists with an "alternate" hypothesis for the origins of

the universe, the earth, life, and humanity. Scientific Creationists have founded institutes (for example, the Institute for Creation Research), published books, founded schools, and debated evolutionists. Finally, they have attempted, through legislation on the state level, not to eliminate evolution from the classroom, but to impose what they call a "two-model approach" in teaching. This would involve providing equal time for Creationist models of biology, geology, astronomy, and anthropology in public schools—in other words, ten minutes of Darwin, ten minutes of Creationism.

It should be emphasized that although most Scientific Creationists are Christians, their brand of Christianity does not reflect the mainstream of that religion. As you will see, the strict literal interpretation of the Bible upon which Scientific Creationism is based is not adhered to by most Christian groups. Many Christian theologians believe that Scientific Creationism represents bad theology as well as bad science.

The Creationists have failed virtually whenever their equal time requests have been legislated, carried out, and then litigated. The courts have seen Creationism for what it is: not an alternate scientific model but a restatement of a religious ideology. Statutes passed by state legislatures requiring the teaching of Creationism in public schools have been deemed unconstitutional by the courts in several states, including Arkansas and Louisiana (Scott 1987). The Louisiana statute came before the Supreme Court of the United States in 1987, and seven out of the nine justices agreed that Creationism represented little more than a restatement of a particular religious ideology—that presented in the Old Testament of the Judeo-Christian Bible. Therefore, its teaching could not be mandated in public school science classrooms. (Michael Shermer's book [1997], Why People Believe Weird Things, contains a concise summary of the arguments presented in this Supreme Court case.)

The 1987 Supreme Court decision has not ended attempts by Creationists to inject what the court decided was a religious doctrine into public school classrooms (Schmidt 1996). For instance, in 1995 the Alabama state legislature ordered that a pasted insert be placed in all secondary school biology textbooks stating that evolution has not been proven. In 1996, in a fairly close vote (20 to 13), the Tennessee state Senate voted down a bill already passed by the state House of Representatives that would have provided for dismissal of any public school teacher who taught evolution as a fact. Also in 1996, the Ohio state legislature debated and then defeated a bill that would have required public school teachers to present evidence against evolution. Even though such efforts largely have been unsuccessful, an air of controversy has resulted, and some schoolteachers have revealed that they simply avoid any discussion of evolution in their biology classes (Schmidt 1996:421).

Opting for a slower, quieter, from the bottom up approach, some Creationists have run for positions on their local school boards, in some cases

espousing a "back to basics" academic philosophy that is becoming increasingly popular, while at the same time hiding or at least soft-pedaling their agenda to inject their religious views into public school curricula. This has been a much more difficult phenomenon to track, but in some parts of the country it appears to be widespread.

There are several fine books on the nature of Creationism and the threat it poses to science education in America and elsewhere (Eldredge 1982; Futuyma 1983; Godfrey 1983; Montague 1982). Also, a pamphlet series is available from the American Anthropological Association (1984), and a short publication can be obtained from the National Academy of Sciences (1984). Paleontologist Chris McGowan (1984) provides a lively refutation of Creationism, and writer Michael Shermer (1997) presents a point-by-point refutation of twenty-five Creationist claims. These are all excellent sources on the topic of Creationism. We needn't go into this issue in more depth here.

However, the claimed existence of physical evidence supporting biblical literalism is often used to support the *scientific* underpinnings of Creationism. Such physical evidence falls into the field of focus of this book. The two pieces of ostensible evidence I will assess here are (1) the existence of the "artifact" of Noah's Ark and (2) evidence of the recent creation of the earth in the form of proof of the contemporaneity of human beings and dinosaurs.

Noah's Ark

For there to have been a Noah's Ark, the biblical story of the Flood must be an accurate account of an environmental catastrophe (Figure 11.1). Is there any evidence to support the claim made by many Creationists that a universal deluge, wiping out all human and animal life on the planet except those saved on board the Ark, actually happened within the last six thousand years?

The Biblical version of the flood story was first written down between 500 and 450 B.C., and similar tales had been circulating in the Middle East since at least 1800 B.C. (Cohn 1996). In most versions, an angry and vengeful God decides to destroy his creation in an enormous flood. A single, righteous man (Ziusudra, Atrahasis, Utnapishtim, or Noah) is warned of the impending deluge and is given specific instructions to build a boat with compartments, to coat it with pitch, and to fill it with plants and animals. Even the story of sending first a raven and then a dove out from the boat or ark to search for dry land after the rain ends is found in some of the older versions of the legend. This shows quite clearly that the biblical flood story was not unadulterated history but was borrowed and adapted by the ancient Hebrews from other people in the Middle East.

With this in mind, using a deductive approach as applied elsewhere in this book to nonreligious claims about the past, we can ask the following questions: (1) Could the Ark as described in the Bible have actually been

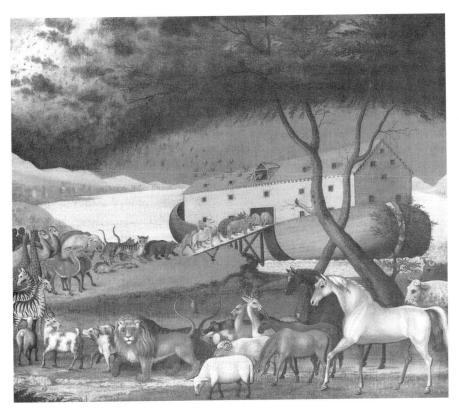

Figure 11.1 An artist's rendition of the gathering of animals boarding Noah's Ark. Geological, biological, paleontological, and archaeological evidence indicates that Noah's Flood was not a historical event. (*Noah's Ark*, 1846, by Edward Hicks. Philadelphia Museum of Art. Bequest of Lisa Norris Elkins)

built? (2) Could the people involved have saved representatives of each animal species? (3) Is there any geological evidence of a universal Flood? (4) Is there archaeological evidence of the Flood? and finally, (5) Are there actual remains of the Ark, itself, resting where the Ark landed after the Flood? Let's consider these questions individually.

1. Could the Ark have been built?

Robert A. Moore (1983) has written a point-by-point examination of the Flood story. He concludes that building the Ark would have been impossible. According to the biblical account, the Ark measured 300 cubits in length and 50 cubits in width. Remember from Chapter 3, in our comparison of the biblical giant Goliath to the Cardiff Giant archaeological hoax, a cubit equals approximately 20 inches. Using this measurement, Noah's Ark, built entirely with hand tools by a few people, would have been about 500 feet long

and more than 80 feet wide! This would have been an enormous ship. The technology necessary to construct a seaworthy ship this size did not exist until the nineteenth century A.D. and would have taken hundreds of people to build, not the four men and four women who made up Noah's family.

2. Could the people involved have saved representatives of each and every animal species on earth?

Noah and his family (his wife, three sons, and their wives) could not have gathered and accommodated all the animals allegedly saved on the Ark—some from as much as 12,000 miles away, from continents not even known to Noah. Beyond this, some of the landmasses that supplied animals to the Ark were separated from Noah's location by enormous expanses of open ocean. How exactly did llamas and alpacas (from South America) or even kangaroos and koala bears (from Australia) manage to get to the Ark in the first place?

We can estimate that, had the Ark housed representatives of every animal species alive in the world before the flood—as the Bible indicates was done—this would mean that 25,000 species of birds, 15,000 species of mammals, 6,000 species of reptiles, 2,500 species of amphibians, and more than 1,000,000 species of insects, all multiplied by two for each kind of the "beasts that are not clean" and seven for each kind of the "clean beasts" (Genesis 7:2), were brought on board and taken care of for about a year (Schneour 1986:312). The small number of people on the Ark could not possibly have fed, watered, and tended this vast number of animals—and imagine cleaning out all those stalls!

Beyond this, even considering the enormous size of the Ark, there would have been less than 1 cubic meter (a stall a little more than 3 feet by 3 feet by 3 feet) for each vertebrate and its food supply (Schneour 1986:313). And remember, as we will see in the next section, many Creationists believe that dinosaurs lived during Noah's time and were among the animals saved on the Ark (Taylor 1985a). Obviously, a 30-ton, 40-foot-tall, 100-foot-long *Supersaurus* would have been more than a little cramped in its quarters.

Further, even in the twentieth century, zoos have trouble keeping some species alive in captivity; their dietary and other living requirements are so finely adjusted in nature that they cannot be duplicated. How did Noah accomplish this?

Finally, though extinction technically occurs when the last member of a species dies, species extinction effectively occurs when numbers fall below a certain threshold. For example, the population of about one thousand pandas left in their natural habitat may be too small a number to prevent eventual disappearance of the species in

the wild (Dolnick 1989). Yet, if the Flood story were true, we would have to believe that the panda and all of the other species we see today were able to successfully survive after their numbers had dwindled to either two or seven of each. Genetic variability is so small with such a limited population size that most species would have disappeared.

3. Is there geological evidence for the Flood itself?

Certainly such a catastrophic event occurring so recently in the historic past would have left clear evidence. In fact, worldwide geological evidence does not support the claim of a great Flood. The vast majority of the features of the earth's surface are the result of gradually acting, uniform processes of erosion repeated over vast stretches of time, not short-lived, great catastrophes (though occasional catastrophic events like asteroid impacts do occur and may have had significant effects—one large asteroid strike may have been the cause for dinosaur extinction about sixty-five million years ago).

For example, paleontologists have long recognized the *bio-stratigraphic* layering present in the earth. Biostratigraphy refers not just to the layering of geological strata but also to the occurrence of plant and animal fossils in these strata. These biological traces are not present in a hodgepodge; they are not randomly associated in the layers but tend to be neatly ordered. That ordering—older species are found in deeper layers, more recent species are found in higher strata—is a reflection of lengthy chronology, not a recent catastrophe.

If a recent, universal Flood simultaneously destroyed virtually all plants and animals, their remains would have been deposited together in the sediments laid down in that Flood. Dinosaurs and people, trilobites and opossums, giant ground sloths and house cats, *Australopithecus* and the Neandertals—all would have been living at the same time before the Flood and should have been killed together during the Flood. We should be able to find their fossils together in the same geological layers.

Of course, we find no such thing. Plant remains are found in layers older than those containing animals. Single-celled organisms are found in layers below those containing multicelled organisms. Reptiles are found in older strata than are mammals. Layers containing dinosaurs never show evidence of human activity and are always far older than layers containing human fossils. (See "Footprints in Time" later in this chapter.)

Creationists recognize this powerful contradiction to their view. They speculate that biostratigraphy, instead of representing an ancient chronological sequence, represents differences in animal buoyancy during the Flood. In other words, reptiles are found in lower

strata than are mammals because they don't float as well. Not only is this rationalization weak, it is not even original. Here Creationists are only recycling an explanation put forth by John Woodward (1695) in *An Essay Toward a Natural History of the Earth.* Of course, we can forgive Woodward—he suggested this more than three hundred years ago.

4. Is there archaeological evidence for the Flood?

If a universal Flood occurred between five and six thousand years ago, killing all humans except the eight on board the Ark, it would be abundantly clear in the archaeological record. Human history would be marked by an absolute break. We would see the devastation wrought by the catastrophe in terms of the destroyed physical remains of pre-Flood human settlements. Above all else, we would see sharp discontinuity in human cultural evolution. All advances in technology, art, architecture, and science made up until the point of the catastrophe would have been destroyed. Human cultural evolution, as reflected in the archaeological record, would have necessarily started all over again after the Flood.

Imagine the results of a nuclear war that left just a handful of people alive. Consider the devastation such a war would visit upon human culture. Think about what the remains of the pre- and postwar societies would look like from an archaeological perspective. This is comparable to what the differences would have been between pre- and post-Flood societies and their archaeology.

Unfortunately for the Flood enthusiasts, the destruction of all but eight of the world's people had no discernible impact on ancient culture and left no mark whatsoever on the archaeological record. The cultural records of the ancient Egyptians, Mesopotamians, Chinese, and Native American Indian civilizations show no gaps in development. Either cultural trajectories in these world areas were affected not at all by the destruction of their entire populations, or there simply was no universal Flood. Applying Occam's Razor, we have to conclude that, based on the archaeological record, there could have been no universal Flood like that described in the Bible.

5. Do remains of Noah's Ark still exist?

Are there archaeological remains of a great ship located on the slopes of a mountain in Turkey? Are these, in fact, the actual physical remains of Noah's Ark? For years various groups associated with numerous fundamentalist organizations have searched for remains of the Ark on Mount Ararat in Turkey (LeHaye and Morris 1976). One of these groups included former astronaut James Irwin. They have, as yet, all been unsuccessful.

Local Kurdish tribesmen who claim to have visited the largely intact Ark on the 17,000-foot peak have been interviewed. Stories have been collected of the Russian discovery of the Ark in 1916. That legend maintains that when the communists took control in the Soviet Union all photographs of the Ark were destroyed, and eyewitnesses of the Ark were executed. Some have circulated stories of an American discovery of the Ark in the 1960s. Here, a joint, secret expedition of the Smithsonian Institution and the National Geographic Society supposedly discovered the Ark but suppressed the information "in order to preserve the dominance of Darwinian theory" (Sallee 1983:2). An obvious question that might have been asked is, naturally enough, "Then why did they go looking for the Ark in the first place?"

Eyewitnesses have invariably been unable to relocate the Ark and bring people to it. Other alleged evidence for the Ark has consisted of photographs and movies. These have always either mysteriously disappeared or turned out to be of images of misidentified rock formations.

In 1959, a French explorer, Fernand Navarra, claimed to have visited the Ark and even brought back wood samples. Unfortunately for the "arkeologists," radiocarbon dating applied to the wood indicated that it dated not to 5,000 years ago as it should have according to biblical chronology, but to between the sixth and ninth centuries A.D. (Taylor and Berger 1980).

One might suppose that with the stunning lack of any corroborative evidence, interest in the Ark would have waned after the years of fruitless searching. It hasn't, but this is because the search for the Ark has little to do with objective, scientific testing of a hypothesis and everything to do with supporting a religious ideology. As one searcher stated: "My motive is just to show to the world that the Bible is God's word, and that the stories in the Bible are truth, not fiction" (Sallee 1983:1).

The desire to find some evidence of the Ark and the Flood remains strong. An example of this was a two-hour, prime-time television special titled *The Incredible Discovery of Noah's Ark*, which aired on CBS in February 1993. It was independently produced and sold to CBS by Sun International Pictures (see Jarnoff 1993 for a brief discussion of the special, and for a detailed exposé see Lippard 1994).

The show was a hodgepodge of unverifiable stories and misrepresentations of the paleontological, archaeological, and historical records. The presentation was filled with interviews of individuals identified as "Noah's Ark eyewitnesses." One particularly convincing (in the dramatic sense) "eyewitness," identified as George Jammal, claimed to have climbed through a hole in the glacial ice atop Mt. Ararat in 1984 and to have dropped down

into the Ark itself. He and his companion "Vladimir" photographed the wooden animal stalls in the huge boat, and Mr. Jammal used his ice-ax to hack out an actual piece of the biblical ship.

Though tragically Vladimir was killed in an avalanche and the photographic evidence lost beneath many tons of ice, Jammal made it back to civilization with his piece of the Ark. "This wood is so precious, and a gift from God," he told the viewing audience as he displayed the remarkable artifact.

There is, however, a significant problem with Mr. Jammal's testimony— it is entirely false. It all began in 1985 when, motivated by little more than a dislike of religion, Jammal contacted the Institute for Creation Research (ICR) in California, telling them the story of his discovery of the ark. A cursory examination of his letter should have alerted any reader with even a modicum of skepticism that it was a sham: pronouncing the names of the individuals who Jammal told the Institute had helped him in his quest—Mr. Asholian, Vladimir Sobitchsky, and, Allis Buls Hitian (Lippard 1994)—should make it clear why.

When Sun International was conducting research for their Ark show, they contacted ICR and were given Jammal's name. Inexplicably, the ICR was much impressed by Jammal's absurd tale, though Jammal had not provided even a shred of evidence to back it up. Biblical scholar Gerald Larue was a friend of Jammal's and had become close enough for Jammal to reveal his fabricated Ark story. Coincidentally, Larue had been interviewed by Sun International for a previous show. He was angry with his treatment on that show and encouraged Jammal to continue his Ark hoax when Sun contacted him.

There had been no trip to Turkey, there were no photographs, and there was no Vladimir Sobitchsky. How about the wood Jammal so reverently presented on camera as a piece of the Ark? It was never tested or seriously examined by Sun International. Had they examined it closely, it should have become apparent that it was just a slab of California pine that had been aged by microwaving it after soaking it in, among other things, teriyaki sauce!

Jammal's story should have been verified by the show's producers. Even simply checking Jammal's passport would have revealed no travel to Turkey, and that should have ended it. Jammal and Larue had intentionally made it easy; in fact, all one had to do was sniff the wood. After all, why would a piece of Noah's Ark smell like an Oriental marinade? The point had been made. If the producers of *The Incredible Discovery of Noah's Ark* could be fooled by a hoax with so many obvious and intentional clues, they certainly could not be trusted on anything else.

When confronted with this, CBS responded rather lamely, "It was an entertainment special, not a documentary." Note the similarity of the excuse CBS is using for presenting the public with patent nonsense to the disclaimers discussed previously (see Chapter 2) that appear in each issue of the Weekly World News and Sun tabloids. It is sad to believe that CBS is comfortable placing some of its "science" programming in this same category.

Footprints in Time

It is a little more than sixty-five million years since dinosaurs thundered across the landscape. Some fundamentalist Christians deny this dating of the extinction of the dinosaurs. In fact, it is their view that the universe, including our world and ourselves, is only about six thousand years old. In 1650, Irish archbishop James Ussher determined that God had created the universe in 4004 B.C. Some fundamentalists still accept the validity of that date and so claim that human beings and dinosaurs walked the earth during the same period, that is, before Noah's Flood.

Creationist Paul S. Taylor (1985a), in a book intended for children, maintains that dinosaurs were taken on board Noah's Ark, because the Bible states that representatives of *all* animal kinds were taken. Dinosaurs, according to Taylor, became extinct only after the Flood.

In the same book, Taylor asks, "Was it dangerous to live with dinosaurs?" He answers, "Dinosaurs would have been no danger to man in the original creation, however, in later years they may have developed into somewhat of a problem" (p. 6). Yes, I imagine that a 50-foot-long, carnivorous *Tyrannosaurus* with a 6-foot jaw filled with razor-sharp 6-inch teeth would have been "somewhat of a problem."

Such a remarkable scenario, although in agreement with some awful Hollywood movies and *The Flintstones* cartoon, stands in contradiction to the accumulated wisdom of the fields of biology, zoology, paleontology, geology, and anthropology. Basing conclusions on the seemingly indisputable evidence of stratigraphy, fossils, artifacts, and radiometric dating, these fields show quite clearly that the last of the dinosaurs died off about sixty million years before the appearance of the first upright walking hominids.

Many Creationists reject all these data in favor of one bit of presumed evidence they claim shows the contemporaneity of dinosaurs and human beings—footprints from the Paluxy River bed in Glen Rose, Texas (Morris 1980).

Fossilized dinosaur footprints along the Paluxy River were first brought to the attention of scientists and the general public in 1939 when scientist Roland Bird (1939) mentioned their existence. In the same article, Bird noted that giant, *fake* human footprints were being made and sold by people who lived in the area of the genuine dinosaur prints (Figure 11.2).

Thereafter, claims were published in a Seventh Day Adventist church periodical that there were *genuine* "mantracks" side by side with, in the same stratum with, and sometimes overlapping dinosaur prints in the Paluxy River bed (Burdick 1950). Similar claims were made in a major Creationist publication purporting to prove the validity of the biblical Flood story (Whitcomb and Morris 1961). Throughout the 1960s, 1970s, and 1980s, Creationists of various denominations and perspectives have conducted "research" in the area, looking for trackways and other evidence that dinosaurs and humans lived during the same recent period of the past—in Texas, at least.

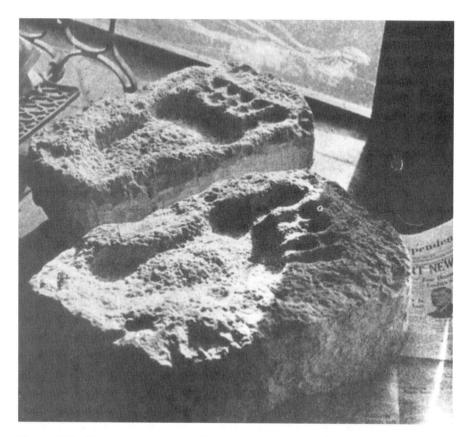

Figure 11.2 These obviously carved human footprints were found by scientist R. T. Bird (1939) in a store in Arizona. He traced them back to Glen Rose, Texas, where he subsequently located a rich deposit of genuine, fossilized dinosaur footprints in the Paluxy River bed. (Neg. No. 2A17485. Photo by K. Perkins and T. Beckett. Courtesy Department of Library Services, American Museum of Natural History)

A film, *Footprints in Stone*, was produced in 1973. Until its withdrawal in 1985 this film was available to the public and likely was seen by thousands of people. One individual who has been involved in the area since 1982, the Reverend Carl Baugh, has gone so far as to purchase land in the vicinity of the footprint finds and has built a small museum there. Baugh intends to raise some \$3.5 million to build a larger museum the size and configuration of Noah's Ark, with a water flume ride that will replicate the hydraulic forces present during Noah's flood (Hastings 1985).

Certainly, the association of dinosaur and human footprints in the same geological stratum in Glen Rose would contradict the biostratigraphic record of the rest of the world and would seem to indicate that human beings and dinosaurs, indeed, were contemporaries.

The footprint data have been most thoroughly summarized from a Creationist perspective by John Morris (1980) in his book *Tracking Those Incredi*-

ble Dinosaurs and the People Who Knew Them. It is clear from his descriptions that there are at least three distinct categories of features in the Paluxy River bed: (1) indisputable dinosaur footprints, (2) indisputably fraudulent, carved giant human footprints, and (3) long (some more than 50 cm; almost 20 inches), narrow, ambiguous fossiled imprints.

Little needs to be said of the first two categories. Physical anthropologist Laurie Godfrey (1985) has shown quite clearly that the fraudulent "mantracks" were known to have been carved and sold by at least one local resident during the Depression. Extant examples of these frauds (see Figure 11.2) bear no relationship to the anatomy of the human foot or the way human footprints are produced (their *ichnology*).

The third category has caused the greatest amount of confusion. Those impressions available for study are invariably amorphous imprints that, while exhibiting only in a very general sense the outline of huge human feet, bear no actual humanlike features (Cole, Godfrey, and Schafersman 1985; Edwords 1983; Godfrey 1985; Kuban 1989a). Interestingly, many of the Creationists who discovered the prints admit that, as a result of erosion, the prints are now unimpressive, while maintaining they were clearly human when first discovered (Taylor 1985b).

Godfrey (1985) shows quite clearly that the elongate fossil impressions are a mixed lot of erosional features and weathered, bipedal dinosaur footprints (Figure 11.3). Most of the prints are vague—even Creationists cannot agree on the length, the width, or even the left/right designation of the same prints. None of the so-called mantracks exhibits anatomical features of the human foot, nor do the tracks exhibit evidence of the biomechanics of human locomotion. As Godfrey points out, humans have a unique way of walking that gets translated into the unique characteristics of our footprints. When we walk, each foot contacts the ground in a rolling motion—the heel strikes the surface first, then the outer margin of the foot, next the ball of the foot, and finally the big toe or *hallux*. Godfrey's analysis shows that the Paluxy "mantracks" do not exhibit these aspects of human locomotion.

Recently, most Creationists changed their minds concerning at least the tracks discovered before 1986 (Morris 1986; Taylor 1985b). Kuban (1989b) discovered that the exposed tracks had weathered, revealing the claw impressions of the three-toed dinosaurs who made the prints Creationists had claimed were made by humans. Though hopeful that earlier, now-destroyed discoveries might have been genuine human footprints or that future discoveries might be made of real "mantracks," most Creationists for a time accepted what evolutionists had been saying all along; there is no evidence for the contemporaneity of human beings and dinosaurs in the Paluxy River bed.

Perhaps not surprisingly, as researcher and writer Glen Kuban (1989a) points out, some Creationists are backtracking on the tracks again. More tracks have been found, and claims have been made that some are the fossilized footprints of human beings who were contemporaries of the dinosaurs. Kuban has examined these tracks and has concluded that they are

Figure 11.3 Creationists have claimed there are fossilized footprints of giant human beings in the same layer with, and side by side with, the dinosaur prints in the Paluxy River bed. These turn out to be misinterpreted portions of genuine dinosaur footprints. Impressions left by three claws can be discerned at the front (left) of this print. (Courtesy © 1985 Glen J. Kuban)

certainly not human. As he states, "Evidently little if anything was learned from past mistakes" (p. 15).

Other Guises of Creationism

Certainly, all Creationists are not fundamentalist Christians. Many ultraorthodox Jews, for example, also reject evolution and take seriously the date on the Jewish calendar, the year 5758 (corresponding roughly to A.D. 1998), as representing the age of the universe—that is, 5,758 years. Not coincidentally, this is pretty close to the age of the universe as determined by Archbishop Ussher.

In a different kind of Creationism with an entirely different time scale. devout believers in the Hindu religion maintain that human beings have been around for millions or even billions of years exactly as we are now, with no evolutionary sequence leading up to the present. Like many Christian Creationists, some Hindu Creationists maintain that paleontological and archaeological evidence supports this religious belief. This anti-evolutionary perspective has been expressed in two books written by individuals affiliated with the Hare Krishnas of the Bhaktivedanta Institute (Cremo and Thompson 1993, 1994). Reflecting their belief in what amounts to a conspiracy of silence on the part of scientists, Cremo and Thompson use terms like "forbidden archaeology" and "hidden history" in the titles of their books (see Feder 1994a and Lepper 1995a for reviews of these books). In what has to be one of the strangest set of bedfellows yet seen in a television special, fundamentalist Christians and Hare Krishnas railed together against the evolutionary perspective on a show called The Mysterious Origins of Man (Cote 1996), seeming not to recognize that their own views differ as much from each other as either does from evolution.

Native American Creationism has also generated publicity of late, with some Indians rejecting evolutionary theory and asserting that the creation

stories told in their religions are historically accurate narratives (Deloria 1995). Of course, there are literally hundreds, perhaps thousands of very different and often contradictory Native American (and native African and native Australian and on and on) creation stories. They can't all be right, and they can't all reflect the way things really happened. In fact, if one of those stories is actual fact, the others must all be false. So, in ordinary terms, there must be as much disagreement among these natives and their stories as there is between each of them and scientists and evolutionary theory.

This unfortunate alliance of the modern followers of various creation myths against science ignores the fundamental difference between myth and science. The myths of Native Americans, native Australians, as well as those of the Judeo-Christian tradition are not hypotheses that have been tested, refined, reformulated and re-tested until they conform closely to reality. Just as important, these myths likely were not intended as actual history. The purpose of myth is not to describe reality in an objective, scientific way but to show people how to live a moral life. This was articulated best by a prominent modern thinker when he said:

Sacred scripture wishes simply to declare that the world was created by God, and in order to teach this truth, it expresses itself in the terms of the cosmology in use at the time of the writer. . . . The sacred book . . . does not . . . teach how heaven was made but how one goes to heaven. (Emphasis mine; as cited in Lieberman and Kirk 1996:3)

This is not a scientist or atheist or secular humanist speaking. These are the words of someone who has devoted his life to God, the Bible, and his Church. You might be surprised to learn that this was written by Pope John-Paul II. If only those arraying religion against science would realize this—and, equally, if scientists stuck to discussions of how the universe and life evolved rather than why—much of the problem would be eliminated. That this has not happened is to the detriment of both science and religion.

The Shroud of Turin

In discussing scientific epistemology in Chapter 2, I pointed out that science does not proceed through a simple process of elimination. We do not simply suggest a number of hypotheses, eliminate those we can, and then accept whichever one is left. Yet just such an approach is at the heart of much of the pseudoscience surrounding the so-called *Shroud of Turin*.

Some presume that this 14-foot by 3½-foot piece of cloth is the burial garment of Jesus Christ. It is further asserted by some that the image on the cloth of the front and back of a man, apparently killed by crucifixion (Figure 11.4), was rendered not by any ordinary human agency but by miraculous intervention at the moment of Christ's resurrection (Stevenson and

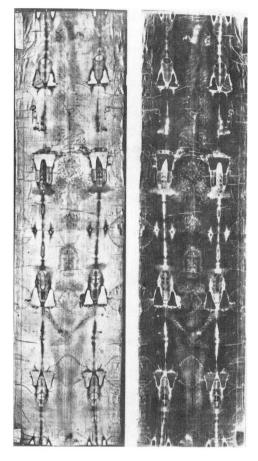

Figure 11.4 Positive (left) and negative (right) images of the Shroud of Turin. Some have claimed that the shroud was the actual burial garment of Jesus Christ and that the image on the shroud was miraculously wrought at the moment of resurrection. However, historical evidence, microscopic analysis, and a recently derived radiocarbon date show that it was the work of a fourteenth-century artist. (Photo by G. Enrie. Courtesy of the Holy Shroud Guild)

Habermas 1981a, 1981b; Wilson 1979). Some of the scientists who participated in the Shroud of Turin Research Project (STURP) in 1978 reached such a conclusion (Weaver 1980).

At least in terms of the technology applied, STURP used a scientific approach in analysis of the shroud. Over five days in 1978, using seventy-two crates of high-tech equipment, they conducted an intensive examination of the shroud. The quality of a scientific investigation, however, cannot be assessed by the tonnage of the equipment brought to bear. The STURP research ultimately was a scientific failure. Even before they began, according to some reports, many of those involved had already made up their minds that the shroud housed in the cathedral in Turin, Italy, was the result of a supernatural occurrence (McCrone 1997; Mueller 1982).

Beyond this, their approach was not consistent with scientific methodology. In essence, they considered a limited number of prosaic explanations for the image on the shroud (oil painting, watercolors, stains from oils used to anoint the dead body). They applied their high-tech equipment in testing these hypotheses and found none of the explanations to their satisfaction. They ended up suggesting that the image was actually a scorch mark created by an inexplicable burst of radiation (Holy Shroud Guild 1978). Though, officially, STURP did not conclude that the image had been miraculously wrought, Mueller (1982) points out that STURP's "burst of radiation" from a dead body would most certainly have been miraculous.

Some STURP members (in particular, Stevenson and Habermas 1981a) were forthcoming in explicitly concluding that the image must have been the result of a miracle. They further maintained that the image is that of a person bearing precisely the wounds of Christ as mentioned in the New Testament (scourge marks, crown of thorns, crucifixion nail holes, stab wound). They finally conclude that the image on the shroud is, in fact, a miraculously wrought picture of Jesus Christ.

Not all were convinced by STURP's official argument or the more religious claims of Stevenson and Habermas. One member of the original STURP team (he subsequently resigned) was the world-renowned microscopist, Walter McCrone. McCrone and his associates examined more than eight thousand shroud fibers and collected data on thirty-two so-called sticky-tape lift samples—samples collected on a clear adhesive-coated tape that had been in direct contact with the shroud (1982). McCrone and his team used a number of techniques including high-power (400X–2500X) optical microscopy to examine the physical characteristics of the image and ostensible bloodstains, and x-ray diffraction, polarized light microscopy, and electron microprobe analysis in determining their chemical makeup (McCrone 1990).

McCrone found that, far from being an enigmatic or inexplicable imprint on the cloth, the shroud body image and the supposed bloodstains contained evidence of two distinct artist's pigments made and used in the Middle Ages. The image itself showed the existence of red ochre, a common historical component of paint. The bloodstains showed the presence of a synthetic mercuric sulfide, a component of the artist's red pigment vermillion. The particular characteristics of the vermillion pigment found on the shroud are consistent with a type made in Europe beginning about A.D. 800. According to McCrone, the alleged bloodstains produced only negative results when a series of standard forensic blood tests were applied. From this he concluded that there was no blood on the shroud, only an artist's red pigment.

Joe Nickell (1987) has suggested a plausible artistic method for the production of the shroud. This involved daubing powdered pigment on cloth molded over a bas-relief of a human being. His method seemed to explain the curious fact that the image on the shroud appears more realistic in negative reproductions; that simply is a product of the technique of image manufacture (as in a grave rubbing). Though his method has been used by European artists for seven hundred years, and his replica of the face on the shroud bears a striking resemblance to the original, not surprisingly his

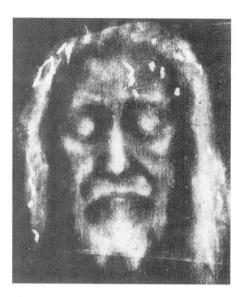

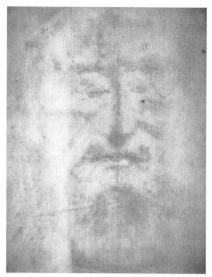

Figure 11.5 Shroud enthusiasts claim that there is no natural explanation for the image on the shroud. However, using different prosaic and entirely natural methods, Joe Nickell (1987) and Walter Sanford (cited in McCrone 1996) have produced reasonable facsimiles of the image on the shroud (Courtesy of Joe Nickell, left; Walter McCrone, right).

suggestion was rejected outright by those who believed that the shroud represented an authentic miracle (Figure 11.5).

Another attempt at replicating the shroud has been conducted recently by forensic scientists Randall Bresee and Emily Craig (1994). Using a technique familiar to medical illustrators called "carbon-dust imaging," they produced a very "shroudlike" image. Whereas Nickell's replica has been criticized on the microscopic grounds that his pigment was present at a much greater depth in the fibers than in the shroud, the Bresee/Craig replica is both macroscopically and microscopically similar to the shroud image.

Walter McCrone's (1996) approach to replicating the shroud uses the simplest technique. He asked the artist Walter Sanford to paint on linen an image of the man on the shroud with a very dilute iron-oxide tempera paint, a formula McCrone produced based on his analysis of the paint residue he found on the shroud. The "negative imaging," the lack of absorption into the fibers of the linen, and the three-dimensional features of the Turin shroud were faithfully reproduced by Sanford and McCrone (see Figure 11.5).

So, was the shroud daubed, dusted, fingerpainted, or brush painted into existence? Or, was it an early, primitive photograph, as some have suggested? Ultimately, the answer to this question is not so important. Whatever process may have been used, it is clear that any assertion that the process that produced the image on the shroud is mysterious or miraculous and cannot be replicated using mundane artistic techniques is simply false.

Testing the Shroud

It must be admitted that if the image on the shroud is miraculous, it is, of course, beyond the capability of science to explain it. Nonetheless, we can apply scientific reasoning concerning the historical context of the shroud. In other words, if the shroud is the burial cloth of Jesus, and if the image appeared on the shroud through some inexplicable burst of divine energy at the moment of resurrection, then we might expect to find that:

- 1. The shroud was a regular part of Jewish burial tradition.
- 2. The shroud image was described by early Christians and, as proof of Christ's divinity, used in proselytizing.
- 3. The Shroud of Turin can be historically traced to the burial garment of Christ mentioned in the New Testament.
- 4. The Shroud of Turin can be dated to the period of Jesus Christ.

We can test these implications of the hypothesis of the shroud's authenticity.

1. Was the shroud a regular part of Jewish burial tradition?

The story begins with the crucifixion of Jesus Christ. Whatever one's perspective concerning the divinity of Jesus, a few things are clear. Christ was a Jew and one among a handful of alleged messiahs about two thousand years ago. As such, from the perspective of the Roman occupiers of Israel, Christ was one in a series of religious and political troublemakers. The Romans dealt harshly with those who directly or indirectly threatened their authority. Crucifixion—execution by nailing or tying the offender to a wooden cross in a public place—was a way of both eliminating the individual and reminding the populace of the cost of defying Roman rule.

As a Jew, Christ's death would have resulted in a Jewish burial ceremony. In fact, the Gospel of John clearly states that Jesus was to be buried in the "manner of the Jews" (19:40). At the time, this would have involved scrupulously washing the body and anointing it with oils, shaving the face and head, and wrapping the body with a burial shroud of linen. According to *halacha* (Jewish law), burial ordinarily should occur within twenty-four hours of death or soon thereafter.

According to the New Testament, Christ was removed from the cross and placed in a cave whose entrance was sealed with a large rock. Christ is then supposed to have risen from the dead, and his body disappeared from the cave.

Taking an anthropological perspective, analysis of Jewish burial custom suggests that a burial sheet or shroud is to be expected in

the case of the death and burial of Christ. But what should that shroud look like? Old Testament descriptions of shrouds seem to imply that the body was not wrapped in a single sheet (like the "winding sheets" used in burials in medieval Europe), but in linen strips, with a separate strip or veil placed over the face. In the Gospel of John, there is a description of the wrapping of Jesus' body in linen clothes and a separate face veil.

The image on the shroud has "blood" marks in various places. Shroud defenders have pointed to these supposed blood marks in an attempt to authenticate the shroud, comparing the wounds on the image to those of Christ as described in the New Testament. But there is an ironic element to such evidence. If the image on the shroud is really that of Jesus produced through some supernatural agency, then the body of Christ could not have been ritually cleaned. Yet this would have been virtually unthinkable for the body of a Jew. The marks alleged to be Christ's actual blood, therefore, contradict the claim that the body of Jesus was wrapped in the shroud; he would already have been ritually cleaned for burial before being placed in his burial clothes. Beyond this, the fact that the shroud image has a full head of hair along with a beard is yet another disparity, since Jewish law as applied in Christ's time dictated that the head and face be shaved before burial.

Further, if the Turin shroud is authentic, then the cloth itself should be of a style consistent with other shrouds and other cloth manufactured two thousand years ago in the Middle East. However, textile experts have stated that the herringbone pattern of the shroud weave is unique, never having been found in either Egypt or Palestine in the era of Jesus Christ (Gove 1996:243).

In sum, there are significant inconsistencies between what the burial garments of Jesus should look like and what the Gospel of John says it looked like on one hand and the actual appearance of the Shroud of Turin on the other.

2. Was the shroud image mentioned in the Gospels?

The Gospel of John states specifically, "took they the body of Jesus and wound it in linen clothes" (19:40). When the disciples entered the tomb, Jesus was gone but his burial garments were still there. Again, the Gospel of John provides a short, but succinct description: "And the napkin, that was about his head, not lying with the linen clothes, but wrapped together in a place by itself" (20:7). This description matches Jewish burial custom—but not the Shroud of Turin.

Certainly the Gospels were not averse to proclaiming the miracles performed by Christ. A miraculous image of Jesus would have been noticed, recorded, and, in fact, shouted from the rooftops. But though the burial linens are seen and mentioned in John, there is no mention of an image on the cloth. In fact, there is no mention of an image on Jesus' burial garments anywhere in the New Testament. This is almost certainly because there was no image.

3. Can the current shroud be traced to the burial of Jesus?

With the preceding argument in mind, can we nevertheless trace the burial linens of Jesus mentioned in the New Testament to the shroud housed in the cathedral in Turin? The answer very simply is, no.

To be sure, other burial shrouds of Christ are mentioned in ancient stories. The earliest may be a second-century account of a shroud; there is a brief mention of it in later, secondary sources. An 8-foot-long burial shroud is mentioned in A.D. 877. But in none of these accounts is there any discussion of an image on the burial linen.

Historical references to miraculous images of the face, but not the entire body of Christ, are fairly plentiful. Probably the best known is called the "Image of Edessa," which dates to the fourth century. Christ is said to have wiped his face on a towel, whereupon a miraculous image of his face appeared. The cloth had healing properties. But this is a story of a supposedly miraculous image of Christ's face alone on a small piece of cloth. The Image of Edessa was called a "mandelion," which means "kerchief"—hardly an appropriate term for a 14-foot-long winding sheet. The Image of Edessa cannot have been the shroud.

The very earliest mention of the current shroud is A.D. 1353. Between the death of Jesus and A.D. 1353, there is no historical mention of the shroud and no evidence that it existed. It makes little or no sense, if indeed a shroud existed with a miraculous image of Christ on it, for it to have gone unmentioned for more than thirteen hundred years. Applying Occam's Razor, a more reasonable explanation might be that the shroud with the image of Christ did not exist until the fourteenth century.

The history of the shroud after 1353 is quite a bit clearer. It has been described in an excellent book, *Inquest on the Shroud of Turin*, by science writer Joe Nickell (1987). Apparently, a church named Our Lady of Lirey was established in 1353 to be a repository for the shroud, and it was first put on view there a few years later. It was advertised as "the true burial sheet of Christ," and admission was charged to the pilgrims who came to view it (Nickell 1987:11). Medallions were struck (and sold) to commemorate the first display of the shroud; existing medallions show an image of the shroud.

The Church in Rome took a remarkably skeptical approach to the shroud. As a result of the lack of reference to such a shroud in the Gospels, Bishop Henri de Poitiers initiated an investigation of the shroud, and a lengthy report was submitted to the Pope in 1359. The report pulls no punches; it concludes that the shroud was a fake produced to make money for the church at Lirey. It was even discovered that individuals had been paid to feign sickness or infirmity and to fake "miraculous" cures in the presence of the shroud. The report goes even further, mentioning the confession of the forger: "the truth being attested by the artist who had painted it, to wit, that it was a work of human skill and not miraculously wrought or bestowed" (as quoted in Nickell 1987:13).

As a result of the Church-sponsored report, Pope Clement VII declared that the shroud was a painted cloth and could be exhibited only if (1) no candles or incense were burned in its presence, (2) no honor guard accompanied it, and (3) the following disclaimer were announced during its exhibition: "It is not the True Shroud of Our Lord, but a painting or picture made in the semblance or representation of the Shroud" (as quoted in Nickell 1987:17).

Even with the disclaimer, the shroud attracted pilgrims and believers. The shroud became an article of commerce, being bartered for a palace in 1453. In 1578 it ended up in Turin, Italy, where it was exhibited in the sixteenth through twentieth centuries.

4. What is the age of the shroud?

Even if the Shroud of Turin turned out to be a two-thousand-year-old piece of cloth, the shroud-as-miracle would not be established. It still could be a fraud rendered two thousand years ago—or more recently on old cloth. However, a final blow would be struck to any hypotheses of authenticity if the cloth could be shown to be substantially younger than the time of Jesus. Recent analyses have shown just this.

The Church agreed to have three radiocarbon dating labs date the shroud. A postage-stamp-sized sample was cut from the shroud. That is all that was needed for all three labs to date the cloth using accelerator mass spectrometry, a very precise form of carbon dating requiring very small samples (see Gove 1996 for a detailed description). A textile expert was on hand to make certain the sample was removed from the shroud itself and not patches added later to cover holes burned in a fire in A.D. 1532. Also, the entire process was videotaped to preserve a chain of evidence from the shroud to each of the labs. In this way, everyone would be certain that the labs actually received material cut from the shroud, and not material substituted for some nefarious purpose. Each lab was also provided with

Table 11.1 Results of Radiocarbon Dating for Historic Cloth Control Samples and Shroud of Turin

	Known Date (historical records)	Carbon Date (three-lab average)
Thread from cloth cape	A.D. 1290 to 1310	A.D. 1273
Egyptian mummy wrapping	60 B.C.	A.D. 35
Nubian tomb linen	A.D. 1000 to 1300	a.d. 1093
Shroud of Turin	not known	A.D. 1325
Silloud of Turni	not known	

Source: Gove 1996.

three control swatches: one small piece from each of three fabrics of known age that they also dated. This was done to determine the accuracy of the dates from each of the labs on known cloth, providing a measure of accuracy for a cloth of unknown age (the shroud).

The shroud dates determined from all three labs indicate that the flax from which the shroud was woven was harvested sometime between A.D. 1260 and 1390 (Damon 1989; Nickell 1989; Vaughan 1988:229). These dates correspond not with the time of Jesus but with the first historical mention of the existence of the shroud.

How accurate is this date? In all certainty the date is very accurate. In dating the samples of known age, the labs were virtually perfect, and there is no reason to believe their shroud dates are any different (Table 11.1). Some have claimed that the shroud sample was contaminated, but Harry Gove, the physicist who is the "father" of the radiocarbon dating technique used, has determined that for a 2,000-year-old cloth to have enough contamination to make it appear to date to the fourteenth century A.D. the sample would have to be at least one-third pure contamination and only two-thirds cloth (1996:265)—an unlikely situation and one that would have been clearly visible to the naked eye. That the Shroud of Turin was a medieval artifact was fairly certain before the dating. After the dating the issue is settled.

Some who wish to believe in the shroud have, however, continued to maintain its miraculous nature while accepting the validity of the radiocarbon dates. Writer John Frodsham (1989:329) maintains that although the shroud cannot have been the actual burial garment of Jesus, it may be a fourteenth-century miracle, the image appearing as a sign from God, "perhaps in response to fervent prayers, during an epoch noted for its mysticism, when the Black death was raging throughout Europe." This is an interesting hypothesis, though perhaps European peasants dying in the tens of thousands might have

better appreciated a more utilitarian miracle on God's part—say, elimination of the Black Plague—than an image on a piece of linen.

New Age Prehistory

On August 16/17, in 1987, people all over the world congregated in various special locations to mark the beginning of a new age. The geographical foci chosen were supposed "sacred sites." Some of the places that were chosen should now be familiar to the readers of this book: Mystery Hill, Serpent Mound, and Cahokia (Peterson 1988). The moment was one apparently resonant with earth-shaking possibilities, for it heralded the beginning of a change in the trajectory of human evolution and history.

It was not simply that August 16, 1987, was the tenth anniversary of the death of Elvis Presley, though that irony (or perhaps it was a joke after all) seems to have been lost on the true believers. No, those days had been

singled out in a very popular book, *The Mayan Factor: Path Beyond Technology*, by José Argüelles. He called that two-day period (conveniently on a weekend so the celebrants wouldn't have to take a day off from work) the *Har-*

monic Convergence (1987:170).

In blunt terms, *The Mayan Factor* masquerades as profundity for the ignorant and the credulous. In a parade of seemingly meaningless statements, using Maya mythology, a sort of Maya numerology, and—as Argüelles admits—"leaps of faith and imagination" (p. 86), he does little more than resurrect von Däniken's nonsense concerning ancient astronauts. Though his prose is quite obscure, the essence of his argument seems to be that the Maya Indians were intergalactic beings who visited the earth. They were not the crude, high-tech types of von Däniken's fantasy, cruising the universe in spaceships. Instead the Maya were beings who could "transmit themselves as DNA code information from one star system to another" (p. 59). (See Chapter 12 of this book for a discussion of Maya archaeology.)

Their purpose on earth is rather obscure (to me, at least):

The totality of the interaction between the Earth's larger life and the individual and group responses to this greater life define "planet art." In this large process, I dimly perceive the Maya as being navigators or charters of the waters of galactic synchronization. (p. 37)

If that doesn't quite clear it up for you, Argüelles adds that the Maya are here on earth "to make sure that the galactic harmonic pattern, not perceivable as yet to our evolutionary position in the galaxy, had been presented and recorded" (p. 73).

Apparently, the Maya, who are actually from the star Arcturus in the Pleiades cluster, materialized in Mesoamerica a number of times as "galactic agents." They introduced writing and other aspects of civilization to the

Olmec, a pre-Maya group, as part of a quite vague plan to incorporate hu-

manity into some sort of cosmic club.

Argüelles maintains that a Maya cycle of time that began in 3113 B.C. will end December 21, 2012 A.D. He states that the Maya are already on their way back to earth via "galactic synchronization beams," traveling by way of "chromo-molecular transport" (p. 169). The date of the Harmonic Convergence was significant, though for rather obscure reasons, relative to the "re-impregnation of the planetary field with the archetypal harmonic experiences of the planetary whole" (p. 170).

In any event, by harmonically converging on that two-day period, we were sending a signal to the oncoming Maya that we humans were ready (for what, I am not sure). Soon, according to Argüelles, there will be no more cancer or AIDS (in reality caused by "radial blockages in our collective bio-electromagnetic field") (p. 182) and no more threat of war (read the newspaper to check out this claim). Then, on December 21, 2012, the Maya will

arrive and reality will be transformed.

Of course, there is no reference to archaeological evidence or any sort of scientific testing for the speculations made by Argüelles. The claims may seem laughable, but at this time in genuine human history, the joke isn't funny. The specter of thousands of people waiting hopefully for some "planetary synchronization" or "harmonic convergence" to cure all the ills that afflict us and our planet is, ultimately, desperately sad.

Arizona in the New Age

Not content simply to wait for the return of the Maya (while listening to Yanni recordings), the New Agers have kept themselves busy. This is perhaps no more obvious than in Sedona, a red rock jewel of a place in northern Arizona.

Having visited there in the summer of 1994, I can personally attest to the immense and incredible visual beauty of the country in which the young community of Sedona is situated. Clean air contributes to a piercingly blue sky. The exposed bedrock, shading from deep brown through magenta to lipstick red all the way to pale pink, has been eroded into endless phantasmagoric shapes. It is no wonder that the area has attracted a wonderful mix

of people.

The Sedona New Agers believe that there is "power" of an indefinable nature in the red rocks of their region, and power and ancient wisdom as well in the remnants left behind by the prehistoric inhabitants of Arizona. New Age Sedonans talk endlessly about vortexes, sacred places, and healing spots—which skeptics might suggest are merely particularly beautiful rock formations, architecturally impressive prehistoric ruins, or interesting ancient rock carvings (petroglyphs) (Figure 11.6).

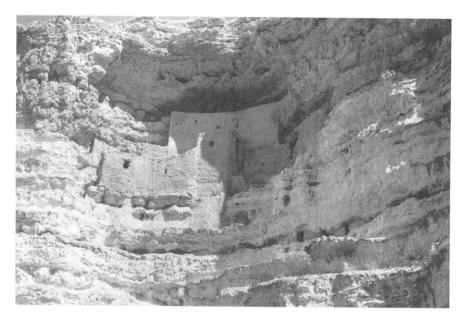

Figure 11.6 The cliff dwellings of the American Southwest reflect the architectural sophistication of the Native Americans who built them. But they were, after all, simply people's homes. Claims by New Agers that sites like these are "power vortexes" are devoid of any scientific meaning. (K. L. Feder)

Tourists can travel into Sedona's back country by taking any one of a number of jeep tours with companies called "Earth Wisdom Tours," "Mystic Tours," "Anasazi Healing Tours," or "Crossing Worlds." Archaeological sites are important elements in these tours. One tour pamphlet suggests that "some will sense the ancient resonance still present at these sites." Other tours promise healing ceremonies, revelation of ancestral secrets of the "Medicine Wheel," and various other cosmic insights. One of the Sedonabased jeep tour companies is run by a group recently investigated on Dateline NBC. According to that report, the tour is used as a recruiting device for an "Aquarian concepts community" in Sedona, an apocalyptic cult led by a charismatic leader, Gabriel. Gabriel—who calls himself "the next planetary prince"—preaches that the end of the world is coming in May 2001 when the flying saucer people will arrive, providing extraterrestrial salvation to members of his Sedona community. Let's hope the members of this community don't try to create their own apocalypse like the thirty-nine members of the Heaven's Gate cult who killed themselves in 1997 in an attempt to expedite their rendezvous with extraterrestrials.

If people wish to read spiritual significance into the ruins of ancient dwellings or artifacts tossed by the inhabitants onto their trash heaps, it may be silly, but harmless. However, some Native Americans are uncomfortable

with the prospect of a group of mostly white, middle-class people romanticizing and appropriating indigenous religious beliefs and native cultural images for their own cosmic salvation. In fact, some are downright hostile.

For example, Rick Romancito, a Taos and Zuni Indian, is unhappy about the New Age fascination with all things Indian. He decries their melding of different beliefs taken from different tribes into an all-inclusive "Indian religion" that never existed among actual Indians (Romancito 1993). He characterizes this as "selectively picking and choosing spiritual concepts from several different Indian religions, as if they're products for sale in a cosmic marketplace" (p. 97). Romancito is far from being alone on this point. The Sioux (Lakota, Dakota, and Nakota nations) have "declared war against exploiters of Lakota spirituality," singling out "non-Indian wannabes, hucksters, cultists, commercial profiteers, and self-styled 'New Age shamans' and their followers" (as cited in Feeney 1998:1,3).

Romancito is especially angry at the cloying New Age assumption that Indians are "repositories of 'indigenous spiritual knowledge'" (p. 97), gurus one and all just ripe for the intellectual picking. He tars such a stereotype of Indians as spiritual mystics with the same brush he does more obviously negative popular images such as "the drunken Indian" or the noble but defeated savage. Though New Agers might accuse Romancito of giving off a lot of "negative energy," his complaint should be heeded.

- → CURRENT PERSPECTIVES

Religions Old and New

Around 1885 a Paiute Indian named Wovoka had a vision in which God came to him and told of a new order that was to come. God instructed Wovoka to teach his people a new dance. If enough Indians from different tribes would only join in, this dance would lead to miracles. All sick or injured Indians would regain their health. All dead Indians from all the ages would come back to life and join in the dance. These countless Indians dancing together would float into the air, and a great flood would decimate the country, destroying in its wake all the white settlers. When the flood waters subsided, the Indians would gently return to the ground to begin a paradisiacal life of plenty, with lots of food, no sickness—and no white settlers (Kehoe 1989; Mooney 1892/93).

The *Ghost Dance*, as it came to be called, was what anthropologists label a *revitalistic movement*. Movements such as the Ghost Dance occur when a people sees its way of life threatened by a terrible, impending calamity. The old ways, including the old gods, seem to have no effect. A new, revolutionary belief system or sometimes simply a return to a previous, "purer" way is seized on as offering a solution.

In the case of the Ghost Dance, Indians faced with cultural extinction at the hands of the European colonists looked for some way out of their terrible predicament. There could be no military solution, and there appeared to be no spiritual recourse. There seemed to be no way out.

Wovoka's vision of salvation gave them a way out. Thousands of Indians in hundreds of groups across the United States believed in Wovoka's vision and joined in the dance.

One cannot help but be struck by the common thread running through this revitalistic movement of a century ago and the spiritual and religious upheavals in the modern world. Fundamentalist Christians and Moslems see all of the modern world's ills as spiritually based; if we could just return to the one true belief, all would be cured. At the same time, New Age beliefs seem to provide spiritual relief for those who perceive the precariousness of modern existence but who do not see the solution in old-time religion.

A century ago Wovoka and the Indian people were faced with the destruction of their way of life and even their own extinction. The terrors of our own century are just as great and include the quick death of nuclear extinction and the slow decay wrought by pollution, terrorism, poverty, drugs, and disease. Science seems to offer little in the way of solution and, in fact, is seen by many as being at the core of the problem.

How comforting to believe that we can change all this simply by returning to a more fundamental belief in the Bible or that the solution to our problems is just a few years away in the guise of godlike extraterrestrial aliens who have been here before and who will save us, ultimately, from ourselves.

It is all the better, then, if the archaeological record can be interpreted as supporting such beliefs. In this perspective, both fundamentalism (of all sorts) and the New Age philosophy can be viewed as twentieth-century revitalistic movements, offering hope to people desperate to believe there is a spiritual solution to our otherwise seemingly insoluble dilemmas.

It is easy to understand why so many Indians embraced the Ghost Dance: Their situation was desperate, and this new religion offered them the promise of salvation. It is no wonder, as anthropologist Alice Kehoe (1989) states, that the religion survived even massacres like that of Wounded Knee where, on December 29, 1890, more than three hundred Indian men, women, and children were slaughtered (Brown 1970). Even though their "ghost shirts" did not protect Indian warriors from the spray of bullets spit out by Gatling guns, the desire to believe the promises of the Ghost Dance was so strong that the religion continued to have followers well into the twentieth century.

It is more difficult by far to empathize with modern, well-off people who seem to be afflicted by little more than existential angst, general depression, or a vague feeling of dissatisfaction with their lives and who then

turn to New Age nonsense. Harmonic convergers, fundamentalists, and the good and kind New Agers of Sedona and elsewhere might do well to heed this message: Revitalistic movements, whether based on a literal interpretation of the Bible, remarkable interpretations of the archaeological record, or a search for enlightenment in beautiful canyons or fascinating rock carvings, can do little to address the real problems facing the world.

→ frequently asked questions 🤄

1. Are all scientists atheists?

No, though it is true that a greater proportion of scientists are nonbelievers than is the case for the general public. A Gallup poll conducted in 1991 indicated that about 87 percent of Americans believe in God, 9 percent do not, and 3 percent say they do not know (Gallup and Newport 1991). A 1996 survey among American scientists revealed that close to 40 percent believe in God, about 45 percent do not, and about 15 percent are agnostics (Larson and Witham 1997). So, although belief in God measures at less than half the level it does among the general public, and a far greater proportion of scientists than nonscientists are atheists, a sizable minority of scientists do believe in a personal God.

2. Aren't religion and evolution irreconcilable?

Again, the answer is no. Two popes, including the current one, six major Protestant organizations, and the Conference of American Rabbis, among others, have all published statements accepting evolution as the process by which God created life (Lieberman and Kirk 1996). They accept the scientific evidence for an ancient and changing earth and accept the evidence for change in plant and animal species.

-> Critical thinking exercise &

Using the deductive approach outlined in Chapter 2, how would you test these hypotheses? In each case, what archaeological and biological data must you find to conclude that the hypothetical statement is an accurate assertion, that it describes what actually happened in the ancient human past?

- The world was all but destroyed in a cataclysmic flood about 5,000 years ago. Only a small group of people and animals were saved.
- Human beings and dinosaurs lived at the same time a relatively short time ago (within the past six to ten thousand years).
- The Shroud of Turin was the actual burial shroud of Jesus Christ.

Best of the Web

CLICK HERE

Creationism

http://www.natcenscied.org/

http://www.talkorigins.org/

Noah's Ark

http://www.talkorigins.org/origins/faqs-flood.html

Claimed Co-occurrence of Dinosaur and Human Footprints

http://members.aol.com/paluxy2/paluxy.htm

The Shroud of Turin

http://www.mcri.org/Shroud.html

Real Mysteries of a Veritable Past

The past never ceases to surprise, fascinate, intrigue, and amaze people. Many are drawn to it and revel in reconstructions of what happened and what it was like to live in the times that preceded our own.

Perhaps it is this built-in interest that makes so many of us susceptible to frauds, myths, and supposed mysteries like those detailed in this book. Note that I have here repeated the book's title but inserted the word supposed, since the mysteries of the Moundbuilders, Atlantis, ancient astronauts, and the rest have been shown to be not mysteries at all but simply confusion resulting from misinterpretation or misrepresentation of human antiquity.

Eliminating the false "mysteries" does not, however, leave us with a dull or mundane human past. There are still plenty of mysteries and some enormously interesting, open questions about what has gone before. Four such examples of genuine mysteries of the past relate to the fifty-threehundred-year-old corpse called the "Ice Man," the Paleolithic cave paintings of Europe, the development—and fall—of the Maya Indian civilization, and the European Megalithic site of Stonehenge.

The Ice Man

He is a visitor from another time. He lay down to sleep more than fifty-three hundred years ago in a shallow gully in what is now called the Tyrolean Alps, in Italy, just a few meters from the Austrian border. He was dressed in a fur cape, leggings, a fur cap, and grass-lined boots. He carried with him a hunting bow, a quiver filled with arrows, a handful of stone tools, a copper ax, a stone dagger, two birch-bark containers, and a pouch containing a firestarting kit. He is called the "Ice Man."

In our imagination, we can look back across the millennia and wonder about his life as well as his death. The cold must have been overwhelming as he huddled in the swale, protected in part from the bitter wind that raged down from the river of glacial ice just above him. We do not know his name. We do not know what brought him to this spot. We do not know his destination. We do know that he never woke up; he froze to death in the icy tomb he hoped might save him. The cold and ice, though his enemies in life, ironically provided the precise conditions necessary for the preservation of his body for more than five thousand years.

The Ice Man was discovered by mountain hikers in September of 1991. Though his voice has long been muted by death, the Ice Man is speaking to us today in a language composed of his own physical remains and the obiects that were a part of his life even as he lay dying on a cold mountain trail (Figure 12.1; Roberts 1993; Siøvold 1992; Spindler 1994). The Ice Man was at least twenty-five years old, and likely closer to forty, when he died. Though relatively young from a modern perspective, x-rays clearly show that he suffered from debilitating conditions today associated with older individuals; his bones show evidence of arthritis in the neck as well as the lower back and right hip. Beyond this, his body exhibits a series of traumas sustained during his life. Eight of his ribs show evidence of healed or healing fractures. Most of these had been broken long before (and, therefore, were probably not contributing factors to) his death (Bahn 1995). One of his toes exhibits evidence typical of frostbite. The single preserved fingernail shows furrows likely representing periods of reduced nail growth attributable to malnutrition or other bodily stress. The Ice Man may have been hungry as well as cold in the last few weeks of his life.

The Ice Man was traveling with a substantial collection of tools needed on his journey. He carried with him hunting equipment; some of the stone cutting tools still bear traces of the blood of the animals the Ice Man butchered including ibex (a wild sheep), chamois (a kind of goat), and deer (Bahn 1995:68). Small fragments of a starchy grain, possibly barley, have been recovered from the copper ax he carried.

He also had with him two spongy balls of birch fungus, threaded onto a fur thong that he likely wore on his wrist. Such fungus is known to contain a natural antibiotic. Two thousand years ago, the ancient Greeks recognized the medicinal qualities of tree fungus. The Ice Man allows us to suggest that ancient people in northern Europe were aware of this as well, more than three thousand years before the Greeks.

Archaeologists are accustomed to working with extremely fragmented and limited remains. It is quite rare to get so clear a snapshot of a life lived so long ago as that provided by the Ice Man. The Ice Man, then, is not so much a mystery as an opportunity. He presents us with a detailed picture of an individual human being—a human who was part of a culture shared perhaps by thousands of others—at a moment in time five millennia ago.

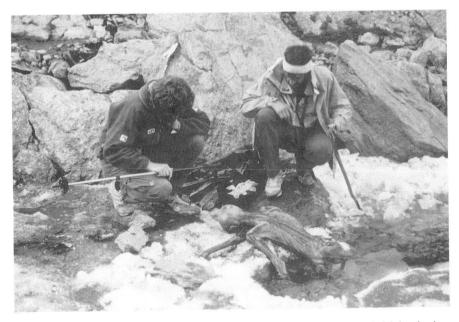

Figure 12.1 The Ice Man, as he was discovered melting out of an ice field that had served as his tomb for fifty-three hundred years. (Gamma Liaison; Paul Hanny)

It is unlikely that archaeologists will ever be able to actually travel back in time to see the people and cultures that populated the human past. But in the discovery of the astonishingly well-preserved fifty-three-hundred-year-old man of the Alps, we have perhaps the next best thing: one of the denizens of that ancient world who, in death, has traveled forward to our present.

The Cave Painters of Europe

Imagine this scene. In the dark, dim, and distant recesses of a cave's narrow passageway, a flickering oil lamp smears dancing shadows on a flat rock wall. A young woman, tall and lithe, her muscular arms coated with a thin layer of grime and sweat, carefully places a dark slurry in her mouth. With one hand she picks up a hollow reed and holds it to her lips. She places her other hand, palm down on the rock face. Aiming the reed at the area around her hand, she begins puffing up her cheeks and blows, spraying a fine mist of pigment out of the end of the reed. Some of the paint thinly coats her hand, but much of it covers the cave wall immediately around the area hidden by her palm and fingers. After a few puffs through the reed, she removes her hand from the cave wall and we see in our mind's eye her remarkable artistic creation: a negative image of her own hand, a signature some twenty thousand years old calling out across time (Figure 12.2).

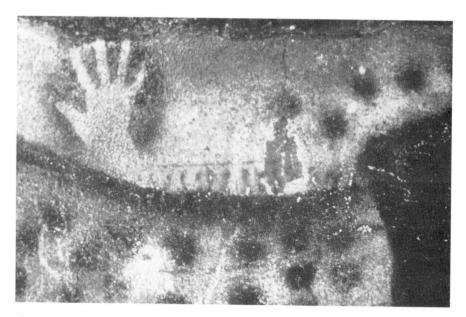

Figure 12.2 A twenty-thousand-year-old "signature" left by a Paleolithic artist; a negative handprint produced by placing a hand flat on a cave wall and then blowing paint through a hollow reed all around the hand. From the cave of Peche-Merle in France. (Musée de l'Homme)

By her side, a young man, tall and broad, with a deeply lined face belying his years, dips a frayed twig into a thick red paste. Using skills of observation and artistry developed during his short life, he conjures up a vision held in a part of his memory as deep as where he now labors breathlessly in the cave.

The horse, wild and free, runs across his mind, her legs leaving the ground as she gallops in her desperate but doomed attempt to flee from the hunters. A deep, red gash on her belly where a stone-tipped spear pierced her hide leaks her life blood. Soon, he remembers, very soon she falls, and his comrades are upon her, thrusting their spears deep into her viscera. Then, at last, she is quiet and still. He shudders, thinking of her spirit now returned to the sky. Then he remembers the taste of her still warm flesh in his mouth. Her life lost, the life of his people maintained. It is the way of life and death in the world that he knows.

Though long dead and no longer of this life but of another world, a world of stories and magic, the mare lives again in a creation of pigment, memory, awe, and sorcery. Once a creature of blood and bone, of sinew and muscle, she is now a creature of color and binder. No longer running across the ice-shrouded plains of western Europe, she now runs and bellows on a flat sheet of rock, straining against her fate and bleeding eternally in the deep recesses of a dark cave. In this incarnation she has lived for twenty

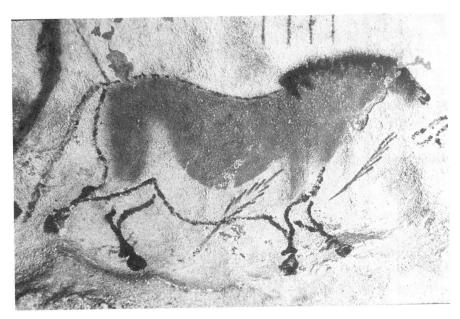

Figure 12.3 The so-called Chinese Horse from the cave of Lascaux in France. The animal was depicted in full gallop by visitors to the cave 20,000 years ago. (© Art Resource, New York)

thousand years, and in this life of pigment and memory and magic, she will live forever (Figure 12.3).

Explaining the Cave Paintings

The scene just described took place more than twenty thousand years ago in the period called the Upper Paleolithic of prehistoric Europe. The individuals described are emblematic of the people who painted the fabulous and now famous depictions of their ancient and extinct world in the deep recesses of more than three hundred caves in western Europe (Conkey 1983).

A veritable bestiary of ancient animals stands frozen in time on the walls of the caves of Lascaux, Altamira, Chauvet, and Niaux. Rendered in pigments of orange, yellow, red, and brown derived from iron oxides, along with black produced from manganese, many of these paintings are astonishingly lifelike, displaying a realism unexpected among a people so ancient and supposedly so primitive (Chauvet, Deschamps, and Hillaire 1996; Clottes 1995; Ruspoli 1986).

There are horses and elk, woolly mammoths and wild cattle, rhinoceroses and bison, all captured in exquisite detail by the ancient artists' skill and talent. Often, the animals are not shown in simple, static poses but in fluid motion. A red horse flees from spears on the cave wall at Lascaux. Two

woolly mammoths confront each other, face to face, on a wall in the cave of Rouffignac. Two spears hang from a dying bison at Lascaux. Four stiffmaned horses graze on the wall at Chauvet; frozen in eternal stillness, they nervously probe for the scent of a predator.

In some caves, there seems to be a clear relationship between the animals depicted on the cave walls and the actual remains of animals killed and eaten by the people who lived at the same time. Small, nonaggressive animals such as reindeer and red deer were important in the diet of the cave painters and were depicted on cave walls in a frequency proportional to their economic importance (Rice and Paterson 1985, 1986).

The ancient artists, however, did not depict only those animals that the archaeological record indicates were hunted for food. Bears, lions, and other carnivores also are rendered. These were often placed on walls far from the central parts of the caves, down long, sinuous, rock-strewn passageways. At Chauvet Cave in southeastern France, paintings of cave bears, cave lions, and an astonishing count of fifty rhinoceroses are among the perhaps more than three hundred images found there that also include wild horses, cattle, and elephants (Chauvet, Deschamps, and Hillaire 1996; Hughes 1995).

And there is more. Animals were not the only objects commanding the attention of Paleolithic artists. Abstract designs, geometric patterns, human handprints, and mythical beasts also adorn the cave walls. Rarely, we even find depictions of the humans themselves. Intriguingly, such "self-portraits" are often vague and indistinct—quite unlike the realistic depictions of the animals with whom our ancestors shared their ancient world.

In the cave paintings, as well as in the rest of what is called "Paleolithic art," rests a mystery. What prompted our ancient ancestors to produce these works on the cave walls? Was it simply "art" done for the sake of beauty (Halverson 1987)? We can recognize the beauty in the work and today can appreciate it as art, but was that the intention of those who produced it (Conkey 1987)?

Was there some more complex reason for painting the images on the cave walls beyond simply a "delight in appearance" (Halverson 1987:68)? Were the cave paintings of food animals sympathetic magic—an attempt to capture the spirit of animals and thereby assure their capture in the hunt (Breuil 1952)? Were the paintings the equivalent of our modern trophy heads—in effect, historically recording the successes of actual hunts (Eaton 1978)? Were the paintings part of a symbolic system that revolved around male and female imagery (Leroi-Gourhan 1968)? Or were the animal paintings part of a system of marking territory by different human groups during periods of environmental stress (Conkey 1980; Jochim 1983)?

And how about the geometric designs—the dots, squares, wavy lines, and the rest? An intriguing suggestion has been made by researchers J. D. Lewis-Williams and T. A. Dowson (1988). They propose that these images are visual artifacts of the human nervous system during altered states of

consciousness. These "visions" result from the structure of the optic system itself and are therefore universal. You can even get some of these visual patterns simply by rubbing your eyes. Perhaps through sleep deprivation, fasting, gazing for hours at a flickering fire, or even ingestion of hallucinogenic drugs, Upper Paleolithic shaman or priests induced these images in their own optic systems. They then translated these images to cave walls as part of religious rituals.

Several prehistorians are focusing on the meaning of the cave art (Conkey 1987 provides a useful summary; see Dickson 1990 for a detailed discussion). There are as yet no definitive answers; there may never be. In that sense, the art of the Paleolithic—though certainly recognizable as the work of ancient human beings and not attributable to refugees from Atlantis or extraterrestrial visitors—is a fascinating legacy of our past and can, indeed, be labeled an unsolved mystery of human antiquity.

The Civilization of the Maya

Chichén Itzá, Uxmal, Tikal, Copán, Sayil, Palenque—the names resound with mystery. These were all cities of the ancient Maya civilization that flourished more than ten centuries ago in the lowlands of Guatemala, Honduras, El Salvador, Belize, and the Yucatán Peninsula of Mexico. Archaeological research in the past few decades has brought to light some of the remarkable accomplishments of this indigenous American Indian civilization (Sabloff 1989, 1994).

The architectural achievements of the Maya match those of any of the world's ancient cultures. The imposing, elliptical Pyramid of the Magician at Uxmal is a stunning piece of architecture and engineering (Figure 12.4). The eighty-eight room "Governor's Palace" at Sayil, with its columned facade and imposing stone staircase, is similarly impressive. The Temple of Inscriptions at Palenque, El Castillo at Chichén Itzá, and the Temple of the Jaguar at Tikal all provide mute testimony to the splendid architecture of the Maya world.

Beyond their ability at construction, the Maya also developed their own hieroglyphic writing system and left a fascinating legacy of written work in the form of relief carvings, paintings, and books called *codices*. Recent advances in translating the written language of the Maya have enabled researchers to begin studying Maya history from a Maya perspective, much in the way we can study European history (Schele and Freidel 1990).

The Maya were precise mathematicians and developed the concept of zero. They also were great astronomers and even built an observatory at Chichén Itzá (Figure 12.5). With their mathematical and astronomical genius, the Maya developed a system of two calendars that together enabled them to chart time more accurately than we do with our standard calendar. In all ways the Maya were a remarkable people.

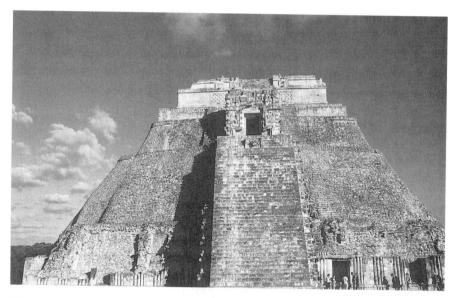

Figure 12.4 The elliptical Pyramid of the Magician at the Maya site of Uxmal, located in the Yucatán Peninsula of Mexico. Unlike Egyptian pyramids, Maya pyramids have steps leading to temples placed at their apexes. (K. L. Feder)

Explaining the Maya

Hypotheses of von Dänikenesque extraterrestrials or harmonically converging intergalactic agents are silly and superfluous for explaining the Maya. Though the story of the Maya is still being written, there is no great enigma or mystery to their origins or history. Maya roots can be traced back more than twenty-eight hundred years. Initially the Maya lived in small hamlets; by 2300 B.P. some settlements, including Nakbe, El Mirador, Lamanai, Cerros, and Tikal in the south and Dzibichaltún and Komchén in the north, had become larger with evidence of public architecture in the form of large stone platforms. Settlements like Cerros, located on a bay by the mouth of a river, became trading centers where raw obsidian and jade, as well as finely crafted goods from these raw materials, were concentrated, adding to the power of the developing elite class of people (Sabloff 1994).

Some of these Maya villages evolved into true urban settlements as their populations increased. A highly productive agricultural system focusing on maize provided food for a growing population. A developing class of Maya leaders had the power to command the construction of monuments like pyramids and temples.

In many regions the Maya practiced slash-and-burn agriculture, cutting and burning forest land to produce fields that were abandoned after only a short period of use and allowed to grow over, to be used again after a

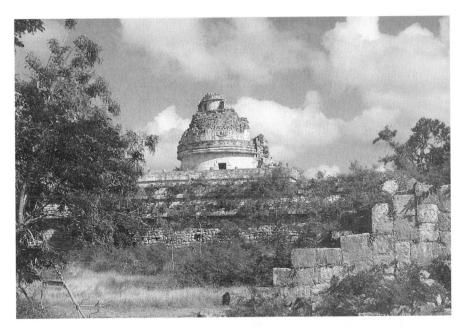

Figure 12.5 El Caracol, or the Observatory at Chichén Itzá. Along with being an impressive piece of architecture, the tower has a number of openings through which, it is thought, Maya astronomer priests observed the night sky. (K. L. Feder)

period of dormancy. This is the primary agricultural technique used by the modern Maya. To this, as archaeologists have documented, the ancient Maya added a number of other, more intensive techniques, including terracing hillslopes, building raised fields in swampy areas (as indicated by radar imaging), planting kitchen gardens, and tree-cropping, the specialized use of tree crops in rainforests and within settlements (McKillop 1994; Turner and Harrison 1983). Of necessity, the Maya relied on a number of techniques, both extensive and intensive, to feed the large and dense populations in their cities.

The inception of what is called the Classic Maya civilization dates to 1650 B.P. (A.D. 300). Copán, Caracol, Lamanai, Palenque, and Tikal, with their temples, pyramids, and palaces, flowered at this time. By about thirteen hundred and fifty years ago Tikal, in Guatemala, had a resident population of at least forty thousand people and perhaps thousands more in the surrounding countryside. Segments of the population at Tikal were devoted to the production of certain fine works of art or craft. Many of these products were included in elite Maya burials (like Pacal's at Palenque, discussed in Chapter 9), reflecting the high status and great wealth of the upper classes.

Though some cities in the southern lowland, Lamanai, for example, continued their regional dominance, after about A.D. 800 the great cities in the southern portion of the Maya realm stopped building temples and pyramids,

and their populations declined dramatically. The geographical focus of the Maya shifted to the north and east where the great cities of Chichén Itzá and later Mayapán developed and thrived.

When the Spanish invaded the Yucatán in the sixteenth century A.D., the Maya world was vastly different than it had been just a few centuries previously, reflecting a decentralized society and a scattered population. The construction of great monuments had all but ceased.

Kantunil, Xocchel, Chapab, and Tahmek are not the names of ancient Maya cities but the names of modern Maya towns in the vicinities of some of the most spectacular of the ancient sites. The descendants of the inhabitants of the great cities still live in the tropical lowlands of Mesoamerica, but the contrast between their lives and those of their ancestors is extreme. Living in poverty, they no longer build pyramids or chart the movement of planets. The mystery of the Maya concerns how and why a great civilization developed in tropical lowlands that today seem unable to support a great civilization, and how and why the ancient civilization that did develop there fell.

One key factor in the rise and fall of the Maya may have been their farming practices. As stated, the Maya relied on a diverse mix of agricultural techniques to feed a substantial population in their tropical lowland habitat. However, one of their primary subsistence practices, slash-and-burn agriculture, requires an enormous amount of land (perhaps 20 acres for each family) and quickly depletes the soil of its nutrients, requiring a long rest or fallow period to allow the soil to regain its productivity. Attempts to obtain a greater yield from a plot of land—for example, by decreasing the fallow time—can seriously deplete the soil, thus actually lowering its overall productivity. Slash-and-burn may simply have been inadequate to feed the growing Maya population, and attempts to increase yields likely resulted in soil depletion and increased erosion.

Adding other, more intensive agricultural techniques—terracing hill-slopes, building raised fields in swamps, planting kitchen gardens, and tree-cropping—helped feed more mouths. For example, by artificially mounding up fields in wetlands, the Maya were able to exploit rich floodplains previously too wet to farm, and to farm the same plots every year. At the Pull-trouser Swamp site in Belize, the Maya essentially reclaimed part of the swamp, building fields into the wetland, producing extremely rich agricultural plots that could have yielded multiple crops each year (Turner and Harrison 1983). Unfortunately, however, even with intensive farming practices evidenced at Pulltrouser Swamp and elsewhere, the Maya seem simply to have surpassed the ability of their land to provide enough food for their growing population.

Ironically, as it was becoming increasingly difficult to feed their growing population, the Maya simultaneously appear to have initiated a boom in temple and palace construction throughout the lowlands. The unfortunately

timed combination of a growing crisis in subsistence and the demands of the elite for more and bigger monuments must have placed a tremendous burden on the common people of the Maya realm. Competition for farmland and even for people (to build the monuments and produce food) seems to have resulted in warfare, for which there is growing evidence both in hieroglyphic inscriptions and in archaeologically recovered data.

The fall of the Maya may be explained, at least in part, as a result of a subsistence system inadequate to meet the needs of a growing population, accompanying environmental degradation, and finally, bloody conflicts. No longer a mystery, the fall of the Maya is instead a challenging puzzle now

being solved through anthropological research.

Stonehenge

In the summer of 1996 I made a pilgrimage, of sorts, returning as an adult to a place that had amazed and inspired me as a teenager. My wife, our two kids, and I spent two weeks in Great Britain, and we made it a point to make the trip from London to Stonehenge.

My family and I were part of a gaggle of tourists from the United States and all over Europe as well who were visiting the ancient monument that day. Reflecting the "world" culture that permeates much of the planet, we were all dressed pretty much alike; most of Stonehenge's visitors were wearing sneakers, jeans, and T-shirts emblazoned with the logos of assorted rock bands, cartoon characters, and software companies. But there alone, amidst the Smashing Pumpkins and Beavis and Butthead shirts was a rather striking looking individual, a woman dressed from head to toe in black. She had on black boots, loosely fitting black pants, a black shirt, and finally, she was enveloped in a long, rather dramatic, black velvet, hooded cape.

She stood still in her solitude, and I watched as she, almost imperceptibly, began to rock back and forth to some internal, inaudible rhythm, her eyes shut and her lips mouthing a silent mantra. I wondered, in a whisper to no one in particular, who she was. Someone answered: "Oh, she fancies herself the reincarnation of a Druid princess." Of course. It was a peculiar sight, indeed, but we were to see many peculiar sights on our trip.

We visited other "stone circles." Stonehenge is an extreme example of an ancient circle laid out in monumental stone sentinels, but there are hundreds in Great Britain, so many, in fact, that there is an atlas/tourist guide of them (Burl 1995). In some we found people meditating in their geometric centers, hoping to focus the ancient and mysterious energy supposedly contained within them. At Avebury, a town encircled by an ancient monument of standing stones, the shelves of the tourist shops were filled with healing crystals, pyramid pendants, and even dowsing rods (pairs of bent brass rods

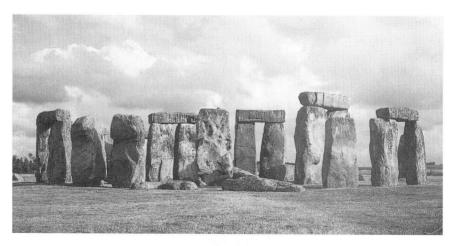

Figure 12.6 Even in ruin, Stonehenge is an evocative monument, reflecting the remarkable abilities of its ancient builders. (K. L. Feder)

going for five pounds, about \$7.50, each) for channeling the "ancient energies" ostensibly focused in the prehistoric monument.

The ancient past of Great Britain has been invaded, or so it seems, by people espousing New Age beliefs. Seeking salvation and redemption in the fabric of antiquity, they congregate at the stone circles of Great Britain. In late June on the summer solstice they descend on Stonehenge to practice so-called ancient, pagan rites. Traditionally, a riot ensues as the local police attempt to protect the site from the scores of ecstatic, sometimes naked, latter-day Druids who have, in the past, climbed the ancient stones of the monument. Too often, the modern, reconstructed Druids revert to the historical behavior of the people they base their worldview on and rain violence down on the local constabulary.

What is Stonehenge, really? Is it some great archaeological mystery? Does it vibrate with some ancient and mystical energy? My then 10-year-old son Josh found "awesome" to be the most appropriate word to describe Stonehenge—and who could argue with his use of that term? Awesome it is. About 4,900 years ago an otherwise simple farming people first excavated a nearly perfectly circular ditch about 100 meters (300 feet) in diameter. At first, this is all that Stonehenge was. Then, 4,500 years ago, the Stonehenge people transported dozens of volcanic stones (called bluestones for their slightly blue hue) to Stonehenge from the Preseli Mountains in southwest Wales, a distance of about 200 km (125 miles). Each of the bluestones weighed up to 4,000 kilograms (almost 9,000 pounds) and they were arranged in a double half-circle in the center of the circle demarcated by the ditch. Moving stones weighing more than 4 tons more than 100 miles and then erecting them was no mean feat for a people with no mechanical con-

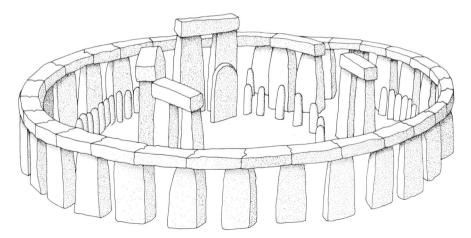

Figure 12.7 Depiction of an intact Stonehenge upon completion 4,000 years ago. Note the precision with which the enormous sarsens and trilithon uprights were connected to each other by their associated lintels.

trivances or draught animals. But even this impressive, early incarnation of Stonehenge was a pale premonition of what it was to become.

Barely a hundred years after building the bluestone semi-circle, major construction commenced on the Stonehenge we all recognize today. Beginning around 4,400 years ago, the builders of Stonehenge began shaping and transporting thirty upright sarsen stones from Avebury in the north, a distance of about 30 km (18 miles). The sarsens dwarf the bluestones and are hard as iron; each was over 3 meters (10 feet) tall and weighed an astonishing 25,000 kilograms (55,000 pounds). The thirty sarsens were erected in a circle within and concentric with the older ditch, 30 meters (100 feet) across (Figure 12.6; Ruggles 1996).

Thirty *lintels*, each weighing about 5,500 kilograms (6 tons), were perched in a continuous ring atop the sarsens. Each lintel was connected to two adjacent sarsens using mortise and tenon joinery. The tops of the sarsens were shaped to produce two nobs (tenons), and two hollows (mortises) were sculpted on the bottom of each lintel. Further, each lintel was shaped precisely, curved on the exterior and interior to match the arc of the circle of the sarsens. What resulted was a smooth circle of stones, precisely positioned and joined together. "Awesome" truly is the only word to describe it (Figure 12.7), and there is more.

Five sets of three stones known as the *trilithons* were erected within the sarsen circle. Arranged in a giant horseshoe shape, the trilithon uprights were the largest stones erected by the builders of Stonehenge. Each trilithon upright stands about 8 meters (24 feet) above the surface, with an additional 2 meters (6 feet) of stone buried in the chalky ground underlying the monument. The largest of the trilithon uprights weighs 45,000 kilograms (50 tons),

Figure 12.8 Four examples of the megalithic monuments of Great Britain: the Swinside (above) and Castlerigg (bottom right) stone circles located in England; Long Meg, a huge upright stone (near right) also located in England; and the Stones of Stenness (upper right) in the Orkney Islands. Scotland, Swinside consists of more than fifty stones and Castlerigg has thirtyeight stones, set in circles nearly 100 feet across. Long Meg is part of an enormous set of originally about seventy stones called "her daughters." The tallest of the Stenness stones looms more than 30 feet above the surrounding surface. (K. L. Feder)

and the associated lintel weighs 9,000 kilograms (10 tons); and remember, each of these 10-ton blocks had to be raised up to the top of its 24-foot-high trilithon upright pair (for the facts and figures behind Stonehenge see Chippindale 1983, and Wernick et al. 1973).

Other concentric rings of smaller stones were at one time contained within the sarsen circle. Other uprights were placed outside the sarsens, including the so-called *heel stone*—a 73,000-kilogram (80-ton) stone located about 80 meters (240 feet) northeast of the center of the sarsen circle.

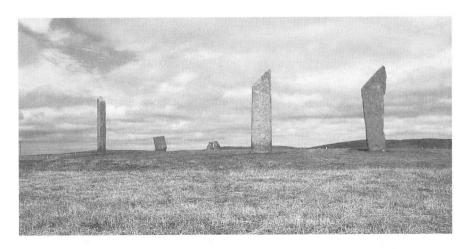

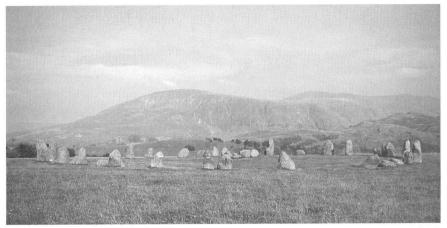

Explaining Stonehenge

Stonehenge has justifiably generated a prodigious amount of interest. How did an ancient and presumably simple farming people construct the monument? How did they quarry the stones? How did they move them? How could they have planned and designed the monument? How did they erect the huge stones? And finally, perhaps the greatest mystery, why did they do it?

Some of the mystery of Stonehenge is a result of our own temporal chauvinism. We find it hard to conceive of ancient people as being inventive, ingenious, or clever. Certainly, it took ingenuity and not just a little hard work to produce Stonehenge and the thousands of other large stone or *Megalithic* monuments that are found in Europe (Figure 12.8). If we can leave our temporal biases behind, we can clearly see that the archaeological record of the human past shows that people, including those from five thousand years ago, are capable of ingenuity and hard work. We need not fall back on lost

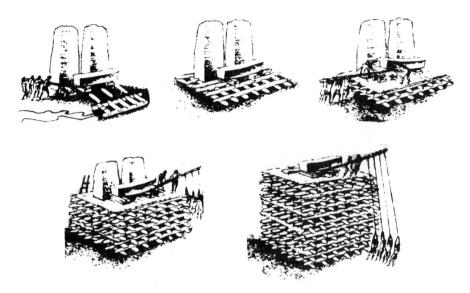

Figure 12.9 Artist's conception of the raising of the lintels at Stonehenge. Through construction of a series of wooden platforms, the heavy stone lintels could have been levered up to their places atop the sarsens and trilithons. (From C. Chippendale, *Stonehenge Complete*, London: Routledge)

continents or ancient astronauts to explain the accomplishments of the Megalith builders or any other ancient human group.

How was Stonehenge built? The stone likely was quarried by taking advantage of natural breaks in the bedrock and using fire, cold water, and persistent hammering to split the stones into the desired shapes. The stones could have been moved on wooden sledges pulled by rope, perhaps using log rollers to quicken the pace. In a recent broadcast of the science series *Nova* (Page and Cort 1997), replicative experiments were conducted in an attempt to discover how Stonehenge might have been built. Two parallel sets of squared-off log beams were placed in the ground, producing a wooden track. A trilithon-sized cement upright weighing 50 tons was attached to a wooden sled that fit onto the long trackway. The crew of fewer than two hundred volunteers certainly pulled some muscles and worked up a sweat, but once the trackway was greased, they were able to move the enormously heavy replica relatively easily.

The upright stones were likely erected using levers and the lintels raised by a combination of levering and the construction of wooden staging around the uprights (Figure 12.9). The accomplishment was—and is—truly remarkable, but certainly was within the capabilities of a large number of dedicated people working diligently toward a desired goal.

That leaves unanswered the question of why the enormous task of Stonehenge's construction was undertaken, and numerous suggestions have been made (Chippindale 1983).

Figure 12.10 An enormous, beautiful, and elaborate pattern made by flattening a crop in a cornfield in Wiltshire, England, in July 1990. As the "crop circles" became more intricate through time, it became increasingly obvious to many that they were the result of pranksters (some of whom later confessed) and not extraterrestrial aliens. (Fortean Picture Library)

Circular Reasoning About Stonehenge

Among the more bizarre hypotheses proposed for Stonehenge is one that explains its appearance as a Neolithic artistic representation of a *crop circle*. The modern crop circle phenomenon peaked in the 1980s and was centered in England, though circles and myriad other, sometimes quite beautiful and complex patterns of flattened wheat and other crops were reported for Canada, the United States, Australia, and elsewhere (Figure 12.10; see Jim Schnabel's [1994] wonderful book, *Round in Circles*, for an in-depth look at the phenomenon).

The mysterious patterns of flattened crops were ascribed to whirlwinds, little understood earth energy vortexes, and even the mating patterns of oversexed hedgehogs. A favorite explanation of the circle watchers concerned UFOs; they believed that extraterrestrial spacecraft hovering over wheat fields induced the patterns through energy emanations from beneath the spacecraft. Because Stonehenge was built in a pattern of concentric circles, some of

the crop circle aficionados saw a connection and suggested that ancient British farmers found crop circles in their own fields, realized they were caused by mysterious floating objects, and then proceeded to replicate the phenomenon in stone by constructing Stonehenge and other circular Megalithic monuments.

There were more than a few problems with this explanation. It quickly became obvious that the circles were not the product of an extraterrestrial version of "prop-wash." Throughout the 1980s, the patterns became increasingly complex and playful; alongside one particularly interesting design was a message produced in flattened wheat reading "We Are Not Alone." When two locals, Dave Chorley and Doug Bower, confessed to the hoax in September 1991, the circle phenomenon petered out. Chorley and Bower showed how they had produced the circles, always staying one step ahead of those who sought to explain them. They made their first circles with a steel bar that Bower used to secure the door to his picture framing shop. They hauled the bar out into a field in the middle of the night, set one end of the bar into the ground, and then by swinging the bar around that end they flattened a circular path whose radius was the length of the bar, in the wheat (or whatever the crop). Next, they moved out to the edge of the circle, following its circumference and using the bar to flatten an additional ring around the original circle. Continuing this process, Chorley and Bower estimated that they could flatten a 30-foot diameter circle in about thirty minutes (Schnabel 1994:268).

Later, they used an approach that employed 4-foot wooden planks. They threaded rope through the ends of the boards. Holding onto the ropes with both hands, they then balanced one foot on the board and, while applying a bit of pressure by pulling on the board, simply walked over the crop, leaving flattened patterns in their wake. For a time, they even used a sighting device attached to a baseball cap to ensure that their lines were straight, their circles round, and their other patterns geometrically accurate.

The biggest blow to those who hypothesized that the entire phenomenon was related to UFOs or mysterious earth energies occurred when Chorley and Bower, in cahoots with a television producer, secretly made a flattened crop pattern in front of television cameras. A number of crop circle experts, unaware of the conspiracy, were invited to examine the circle. They declared it genuine, beyond the capabilities of any mere human hoaxster. Needless to say, their credibility, along with the credibility of their esoteric explanations for the crop patterns, suffered tremendously. It seems that we can safely rule out crop circles as an explanation for Stonehenge.

An Ancient Astronomy?

Perhaps the most interesting theory proposed to explain Stonehenge has been that of the astronomer Gerald Hawkins (1965), who proposed that Stone-

henge was, in effect, an astronomical computer designed to keep track of the sun's position on the horizon at sunrise and sunset, as well as the moon's position on the horizon at "moonrise" and "moonset." He went on to suggest that Stonehenge was even used as an eclipse predictor.

In essence, Hawkins sees Stonehenge as an enormous sighting device. From the center, one's view of the surrounding horizon is limited; one is not afforded a 360-degree vista, since much of the horizon is blocked by sarsens or trilithons. Hawkins hypothesizes (and tests his hypothesis, using a computer to check all of the possible horizon sighting points) that those points on the horizon that one can see from the center of Stonehenge and that appear to be marked by additional stones outside of the sarsen circle are all significant astronomically. Most obvious is the sighting from the center of Stonehenge to the northeast. Hawkins relates this orientation to the rising of the sun.

The sun does not "rise in the east and set in the west" as many think. In fact, the sun's position on the horizon at sunrise and sunset moves slightly from day to day during the course of a year. In the Northern Hemisphere, the sun's position at sunrise moves a little bit north along the horizon each day in the spring until it reaches its northernmost point on the first day of summer—the specific *azimuth* or angle differs depending on one's latitude.

After its northernmost rising, the sun appears to rise a little farther south each day. On the first day of fall, the *autumnal equinox*, it rises due east. It then continues to rise farther south until it rises at its southernmost position on the first day of winter, the *winter solstice*. The sun then appears to change direction and rise a little farther north each day, rising due east again on the first day of spring, the *vernal equinox*. Continuing its apparent motion north, it again reaches its northernmost rising point exactly one year since it previously rose in that spot.

The sun rises at its farthest northern point on the horizon on the longest day of the year, the *summer solstice*. On this clearly demarcated day of the year, from a vantage point in the center of the sarsen circle at Stonehenge, one can see the sun rise directly over the heel stone.

Is this coincidental? As long ago as the early eighteenth century, Stone-henge investigator William Stukeley recognized the orientation of Stone-henge toward the summer sunrise. Hawkins maintains that this orientation of Stonehenge is no coincidence and that too many of the possible solar and lunar sighting points at Stonehenge relate to significant points like the sunrise at the solstice.

Hawkins proposed that Stonehenge began as a simple, though large-scale, calendar for keeping track of the seasons—a valuable thing for people dependent on farming for their subsistence—and evolved over some two thousand years into the impressive monument we see today. Others, however, have questioned Hawkins, particularly in his more extreme and speculative claims concerning eclipse prediction (Atkinson 1966).

Why Was Stonehenge Built?

Most writers about Stonehenge recognize that there is no great mystery surrounding how the monument was built. We have a pretty good idea of how the Megalith builders moved the stones, how they shaped them, how they erected the uprights, and even how they raised the lintels to the top of the sarsens and trilithons. But *why* did the builders of Stonehenge go to such an incredible amount of trouble? To many writers, this is the great unsolved mystery of Stonehenge.

The construction of Stonehenge is no mystery at all, however, if we but look at ourselves. As human beings we revel in the construction of great public edifices. The builders of Stonehenge were no different. Generation after generation, they contributed to a monument whose destiny lay deep in a distant future. There is no mystery in that but only surprise born of an intellectual and temporal conceit on our part. We look back four or five thousand years and see nothing but primitive and alien strangers—this is our fundamental mistake—and from this we contrive a mystery. When we look back at the builders of Stonehenge and the painters of Paleolithic masterpieces and the creators of the civilization of the Maya, what is it that surprises us? Their familiarity! We recognize ourselves in the care, effort, time, and skill reflected in these ancient accomplishments.

Stonehenge is a great cathedral, a colosseum, an impressive temple, a skyscraper. It is a reflection of what humans are capable of. It is a manifestation of our unique understanding that though we are individually ephemeral, our works can be eternal. In this, the builders of Stonehenge were remarkably successful. Stonehenge commands our attention. Millions of tourists, scholars, myth-makers, and fools alike are drawn to this monument. The builders of Stonehenge have attained that which they could have secured in no other way—they have achieved immortality. There is no mystery to this quest, only a remarkable continuity between the past and present.

Conclusion: A Past We Deserve

Obviously, the past no longer exists. It is gone, whether we are contemplating human evolution, the earliest settlement of the Americas, the origins of civilization, the veracity of biblical stories, or any of the past times and events discussed in this book. In this sense, scientists and nonscientists alike are forced always to invent or construct an image of the past in the present. As scientists, of course, we do so in the hope that our constructs reflect the way things really were.

We believe we can construct a past that is veritable, that is accurate in terms of actual past events, because the past has left its mark in the present. But the data of antiquity are often vague, ambiguous, and difficult to interpret. Therefore, many different possible pasts can be constructed. All scien-

tists, in whatever the field, who consider the past history of the universe, the planet, life, or humanity recognize this. The message of this book has been that, although there are many different possibilities, not all of these constructed pasts—not all of the possibilities—are equally plausible.

Ultimately, then, we get the past we deserve. In every generation thinkers, writers, scholars, charlatans, and kooks (these are not necessarily mutually exclusive categories) attempt to cast the past in an image either they or the public desire or find comforting. Biblical giants—some, apparently, walking their pet dinosaurs—large-brained, ape-jawed ancestors, lost tribes, lost continents, mysterious races, ancient astronauts, and intergalactic Maya have all been a part of their concocted fantasies.

But I believe, and have tried to show in this book, that we deserve better—and we can do better. We deserve a veritable past, a real past constructed from the sturdy fabric of geology, paleontology, archaeology, and history, woven on the loom of science. We deserve better and can do better than weave a past from the whole cloth of fantasy and fiction. I hope I have shown in this book that the veritable past is every bit as interesting as those pasts constructed by the fantasy weavers of frauds, myths, and mysteries.

→ Frequently asked questions �

1. How could ancient people have been so advanced as to have built places like Stonehenge and the cities of the Maya?

Based on the size and shape of the brain, human beings have had the same essential intellectual capacity for the last 100,000 years or so. Cultures all over the world and at various times have developed remarkable civilizations. Though twentieth-century western culture is the most sophisticated technological civilization the world has seen, we are no smarter than the ancient people of the Salisbury Plain or the tropical lowlands of Mesoamerica. It really should be no surprise that human beings of long ago developed technologically impressive cultures.

2. When the questions raised about the Ice Man, the cave painters of Europe, the Maya, and Stonehenge are answered, does archaeology run out of mysteries?

Of course not. Human antiquity is a dynamic field of study. We learn more about the history of our species every day. As old questions are answered, new ones are raised: What is the significance of the recently recovered Neandertal mitochondrial DNA? What is the meaning of newly discovered evidence of widespread warfare and cannibalism in the American Southwest? How far back can we trace the first Native Americans—and how did they come to the New World? There will always be questions; there will always be mysteries. With the use of new methods of analysis and the application of new perspectives, we will continue our largely successful attempt to answer and solve them.

Best of the Web

CLICK HERE

Iceman

http://info.uibk.ac.at/c/c5/c504/iceman_en.html

Cave Painters

http://www.culture.fr/culture/arcnat/chauvet/en/gvpda-d.htm

http://www-sor.inria.fr/~pierre/lascaux/

Maya

http://www.d.umn.edu/cla/faculty/troufs/anth3618/mamaya.html

http://www.halfmoon.org/

Stonehenge/Stone circles

http://www.stonepages.com/utenti/dmeozzi/HomEng.html

http://www.amherst.edu/~ermace/sth/links.html

http://easyweb.easynet.co.uk/~aburnham/stones.htm

General Archaeological Frauds and Myths

http://www.usd.edu/anth/cultarch/cultindex.html

http://www.bham.ac.uk/ARGE/themes/fringe.html

-> CRITICAL THINKING EXERCISE &

Using the deductive approach outlined in Chapter 2, how would you test these hypotheses? In each case, what archaeological and biological data must you find to conclude that the hypothetical statement is an accurate assertion, that it describes what actually happened in the ancient human past?

- The Iceman was a shaman or priest who lived more than five thousand years ago.
- The cave paintings of the Upper Paleolithic in Europe served a magical function. Rendering the animals on cave walls represented a spiritual "capturing" of food animals that the ancient artists hoped literally to capture in the hunt.
- The collapse of the ancient Maya civilization was caused by an invasion of outsiders from the Valley of Mexico.
- The function of Stonehenge was as a giant solar calendar.

References

- Adams, R. E. 1991. *Prehistoric Mesoamerica*. Norman, Okla.: University of Oklahoma Press.
- Adams, R. E., W. E. Brown, and T. P. Culbert. 1981. Radar mapping, archaeology, and ancient Maya land use. *Science* 213:1457–1463.
- Adovasio, J. M., J. Donahue, and R. Stuckenrath. 1990. The Meadowcroft Rockshelter radiocarbon chronology—1975–1990. *American Antiquity* 55:348–353.
- Aitken, M. J. 1959. Test for correlation between dowsing response and magnetic disturbance. *Archaeometry* 2:58–59.
- ——. 1970. Magnetic location. In *Science in Archaeology*, ed. D. Brothwell and E. Higgs, pp. 681–694. New York: Praeger.
- Alcock, J. 1989. Channeling: Brief history and contemporary context. *The Skeptical Inquirer* 13(4):380–384.
- American Anthropological Association. 1984. Pamphlet Series. Washington, D.C.: American Anthropological Association.
- Applebaum, E. 1996. Holy stones. The Jewish News. August 23:47–51.
- Argüelles, J. 1987. The Mayan Factor: Path Beyond Technology. Santa Fe: Bear and Co.
- Arnold, B. 1992. The past as propaganda. *Archaeology* 45(4):30–37.
- Arthur, J. 1996. Creationism: Bad science or immoral pseudoscience. *Skeptic* 4(4):88–93.
- Ashe, G. 1971. Analysis of the legends. In *Quest for America*, ed. G. Ash, pp. 15–52. New York: Praeger.
- Atkinson, R. J. C. 1966. Moonshine on Stonehenge. Antiquity 40:262–274.
- Atwater, C. 1820. Description of the Antiquities Discovered in the State of Ohio and Other Western States. Transactions and Collections of the American Antiquarian Society. New York: AMS Press (reprinted in 1973 for the Peabody Museum of Ethnology and Archaeology, Harvard University).
- Austen, G. 1985. Diviner tunes in to park's ghost town. *The Sun*, July 24. Melbourne, Australia.
- Bahn, P. G. 1995. The last days of the Iceman. *Archaeology* 48(3):66–70.
- Bailey, R. 1983. Divining edge: Dowsing for medieval churches. *Popular Archaeology*, Feb.:5.
- Bakeless, J. 1964. The Journals of Lewis and Clark. New York: Mentor Books.
- Ballinger, B. 1978. Lost City of Stone: The Story of Nan Madol, the "Atlantis" of the Pacific. New York: Simon and Schuster.
- Barton, B. S. 1787. Observations on Some Parts of Natural History. London.
- Bartram, W. [1791] 1928. The Travels of William Bartram. New York: Dover.
- Baugh, C. 1987. Dinosaur. Promise Publishing.
- Berlitz, C. 1972. Mysteries from Forgotten Worlds. New York: Dell.
 - . 1984. Atlantis: The Eighth Continent. New York: Fawcett Crest.
- Bird, J. B. 1938. Antiquity and migrations of the early inhabitants of Patagonia. *The Geographical Review* 28(2):250–275.
- Bird, R. T. 1939. Thunder in his footsteps. Natural History 43(5):254-261, 302.

Bird, S. E. 1992. For Enquiring Minds: A Cultural Study of Supermarket Tabloids. Knoxville: University of Kentucky Press.

Bjornstad, T. 1998. Sinking Viking ship. Archaeology 51(1):25.

Blavatsky, H. P. 1888–1938. The Secret Doctrine. Wheaton, Ill.: Theosophical Publishing House (6 volumes).

Blinderman, C. 1986. The Piltdown Inquest. Buffalo: Prometheus Books.

Bond, F. B. 1918. The Gate of Remembrance. Oxford: Blackwell.

Bower, B. 1990. Minoan culture survived volcanic eruption. Science News 137:22.

Bresee, R., and E. Craig. 1994. Image formation and the Shroud of Turin. Journal of Imaging Science and Technology 34:59-67.

Breuil, H. 1952. Four Hundred Years of Cave Art. Montignac, France: Centre

d'Études et de Documentation Prehistorique.

Briuer, F., J. Simms, and L. Smith. 1997. Site Mapping, Geophysical Investigation, and Geomorphic Reconnaissance at Site 9 ME 395 Upatio Town, Fort Benning, Georgia. U.S. Army Corps of Engineers, Miscellaneous Paper EL-97-3.

Brown, D. 1970. Bury My Heart at Wounded Knee. New York: Bantam Books. Bruhns, K. O. 1994. Ancient South America. Cambridge World Archaeology. Cambridge: Cambridge University Press.

Burdick, C. 1950. When GIANTS roamed the earth: Their fossil footprints still visible. *Signs of the Times*, July 25:6, 9.

Burl, A. 1995. A Guide to the Stone Circles of Britain, Ireland, and Brittany. New Haven: Yale University Press.

Butzer, K. 1976. Early Hydraulic Civilization of Egypt: A Study in Cultural Ecol-

ogy. Chicago: University of Chicago Press.

Byrne, M. St. Clere (ed). 1979. The Elizabethan Zoo: A Book of Beasts Fabulous and Authentic (selected from Philemon Holland's 1601 translation of Pliny and Edward Topsell's 1607 Historie of Foure-Footed Beastes and his 1608 Historie of Serpents. Boston: Nonpareil Books.

Cahill, T. 1987. The Vinland map revisited: New compositional evidence on

its inks and parchment. Analytical Chemistry 59:829–833.

Campbell, S. 1994. The UFO Mystery Solved. Headington, Oxford: Explicit Books.

Cardiff Giant, The. 1869. Harper's Weekly, p. 776.

Cardiff Giant, The. 1898. Ithaca Daily Journal, Jan. 4. Ithaca, N.Y.

Case of the Ancient Astronauts (television program). 1971. Nova. Boston: WGBH.

Cayce, E. 1968. Edgar Cayce on Atlantis. New York: Hawthorn Books.

Chambers, H. 1969. Dowsing, Divining Rods, and Water Witches for the Millions. Los Angeles: Sherbourne Press.

Chatelain, M. 1980. Our Ancestors Came from Outer Space. London: Arthur Baker Limited.

Chauvet, J.-M., É. B. Deschamps, and C. Hillaire. 1996. Dawn of Art: The Chauvet Cave. New York: Harry Abrams.

Chippindale, C. 1983. Stonehenge Complete. Ithaca: Cornell University Press. -. 1990. Piltdown: Whodunit? Who cares? Science 250:1162–1163.

Cinque-Mars, J. 1978. Bluefish Cave I: A Late Pleistocene eastern Beringian cave deposit in the northern Yukon. Canadian Journal of Anthropology 3:1-32.

- Clark, A. 1970. Resistivity surveying. In *Science in Archaeology*, ed. D. Brothwell and E. Higgs, pp. 695–707. New York: Praeger.
- Clarke, D. 1978. Analytical Archaeology. New York: Columbia University Press. Clayton, P. A. 1994. Chronicle of the Pharaohs: The Reign-by-Reign Record of the
- Rulers and Dynasties of Ancient Egypt. London: Thames and Hudson. Clottes, I. 1995. Rhinos and lions and bears (oh, my!). Natural History 104(5):
- Clottes, J. 1995. Rhinos and lions and bears (oh, my!). *Natural History* 104(5): 30–35.
- Coe, M. 1968. America's First Civilization. New York: Van Nostrand.
- Cohen, D. 1969. Mysterious Places. New York: Dodd, Mead, and Co.
- Cohn, N. 1996. *Noah's Flood: The Genesis Story in Western Thought.* New Haven: Yale University Press.
- Cole, J. R. 1979. Inscriptionmania, hyperdiffusionism, and the public: Fallout from a 1977 meeting. *Man in the Northeast* 17:27–53.
- ———. 1982. Western Massachusetts "Monk's caves": 1979 University of Massachusetts field research. *Man in the Northeast* 24:37–70.
- Cole, J. R., L. Godfrey, and S. Schafersman. 1985. Mantracks: The fossils say no! *Creation/Evolution* 5(1):37–45.
- Conkey, M. 1980. The identification of prehistoric hunter-gatherer aggregation sites: The case of Altamira. *Current Anthropology* 21(5):609–639.
- ———. 1983. On the origins of Paleolithic art: A review and some critical thoughts. In *The Mousterian Legacy*, ed. E. Trinkaus, pp. 201–227. Oxford: British Archaeological Reports, International Series, 164.
- ——. 1987. New approaches in the search for meaning? A review of research in "Paleolithic art." *Journal of Field Archaeology* 14:413–430.
- Connah, G. 1987. African Civilizations. Cambridge: Cambridge University Press.
- Cote, B. 1996. *The Mysterious Origins of Man*. Shelburne, Vt.: B. C. Video Company.
- Cowen, R. 1995. After the fall. Science News 148:248-249.
- Crawford, G. W. 1992. Prehistoric plant domestication in East Asia. In *The Origins of Agriculture: An International Perspective*, ed. C. W. Cowan and P. J. Watson, pp. 7–38. Washington, D.C.: Smithsonian Institution Press.
- Cremo, M. A., and R. L. Thompson. 1993. Forbidden Archaeology: The Hidden History of the Human Race. San Diego: Govardhan Hill.
- . 1994. The Hidden History of the Human Race. San Diego: Govardhan Hill.
- Dall, W. H. 1877. On succession of shell heaps of the Aleutian Islands. In *Contributions to American Ethnology*, Volume 1:41–91. Washington, D.C.: U.S. Department of the Interior.
- Damon, P. E. 1989. Radiocarbon dating of the Shroud of Turin. *Nature* 337: 611–615.
- Daniel, G. 1977. Review of America B.C. by Barry Fell. New York Times Book Review Section, March 13:8ff.
- Darwin, C. [1859] 1898. On the Origin of Species by Means of Natural Selection. New York: Appleton and Co.
 - ——. [1871] 1930. *The Descent of Man.* London: C. C. Watts and Co.
- Darwin Theory Is Proved True. 1912. New York Times, Dec. 22.
- Dawson, C., and A. S. Woodward. 1913. On the discovery of a Paleolithic human skull and mandible in a flint bearing gravel overlying the Wealden (Hastings Beds) at Piltdown, Fletching (Sussex). *Quarterly Journal of the Geological Society* LXIX:117–151.

Deacon, R. 1966. Madoc and the Discovery of America. New York: George Braziller. de Camp, L. S. 1970. Lost Continents: The Atlantis Theme in History, Science, and Literature. New York: Dover Books.

de la Vega, G. [1605] 1988. *The Florida of the Inca*. Translated by J. G. Varner and J. J. Varner. Austin: University of Texas Press.

Deloria Jr., V. 1995. Red Earth, White Lies: Native Americans and the Myth of Scientific Fact. New York: Scribners.

de Tapia, E. M. 1992. The origins of agriculture in Mesoamerica and South America. In *The Origins of Agriculture: An International Perspective*, ed. C. W. Cowan and P. J. Watson, pp. 143–171. Washington, D.C.: Smithsonian Institution Press.

Dickson, D. B. 1990. *The Dawn of Belief: Religion in the Upper Paleolithic of Southwestern Europe*. Tucson: University of Arizona Press.

Diehl, R. A. 1989. Olmec archaeology: What we know and what we wish we knew. In *Regional Perspectives on the Olmec*, ed. R. J. Sharer and D. C. Grove, pp. 17–32. New York: Cambridge University Press.

Dillehay, T. D. 1989. Monte Verde: A Late Pleistocene Settlement in Chile, Vol. 1: Paleoenvironment and Site Context. Washington, D.C.: Smithsonian Insti-

tution Press.

——. 1997. The Battle of Monte Verde. *The Sciences*. Jan./Feb.: 28–33.

Dillehay, T. D., and M. B. Collins. 1988. Early cultural evidence from Monte Verde in Chile. *Nature* 332:150–152.

Dincauze, D. 1982. Monk's caves and short memories. *Quarterly Review of Archaeology* 3(4):1, 10–11.

DiPietro, V., and G. Molenaar. 1982. *Unusual Martian Surface Features*. Glen Dale, Md.: Mars Research.

Dolnick, E. 1989. Panda paradox. Discover, Sept.:71-76.

Donnelly, I. [1882] 1971. Atlantis, the Antediluvian World. New York: Harper. Doyle, A. C. [1891–1902] 1981. The Celebrated Cases of Sherlock Holmes. London: Octopus Books.

Drake, W. R. 1968. Gods and Spacemen in the Ancient East. New York: Signet Books.

Drawhorn, G. 1994. *Piltdown: Evidence of Smith-Woodward's Complicity*. Paper presented at the annual meeting of the American Association of Physical Anthropologists.

Du Pratz, L. P. 1774. History of Louisiana.

Eaton, R. 1978. The evolution of trophy hunting. Carnivore 1(1):110–121.

Edwords, F. 1983. Creation/evolution update: Footprints in the mind. *The Humanist* 43(2):31.

Eggert, G. 1996. The enigmatic "Battery of Baghdad." Skeptical Inquirer 20(3):31–34.

Eldredge, N. 1982. *The Monkey Business: A Scientist Looks at Creationism.* New York: Washington Square Press.

Elvas, Gentleman of. [1611] 1907. *The Discovery and Conquest of Terra Florida* by Don Ferdinando de Soto and Six Hundred Spaniards, His Followers. The Hakluyt Society. New York: Burt Franklin.

Ewen, C. R. 1989. Anhaica: Discovery of Hernando de Soto's 1539–1540 winter camp. In *First Encounters: Spanish Exploration in the Caribbean and the United States*, 1492–1570, ed. J. T. Milanich and S. Milbrath, pp. 110–118. Gainesville: University Presses of Florida.

- Fagan, B. M. 1977. Who were the Mound Builders? In *Mysteries of the Past*, ed. J. J. Thorndike Jr., pp. 118–135. New York: American Heritage Press.
- ——. 1991. *In the Beginning: An Introduction to Archaeology, 7th ed. New York: HarperCollins.*
- Faulkner, C. 1971. *The Old Stone Fort*. Knoxville: University of Tennessee Press. Feder, K. L. 1980a. Foolsgold of the gods. *The Humanist*, Jan./Feb.:20–23.
- ——. 1980b. Psychic archaeology: The anatomy of irrationalist prehistoric studies. *The Skeptical Inquirer* 4(4):32–43.
- ——. 1981. Waste not, want not: Differential lithic utilization and efficiency of use. *North American Archaeologist* 2(3):193–205.
- ——. 1983. American disingenuous: Goodman's *American Genesis*—A new chapter in cult archaeology. *The Skeptical Inquirer* 7(4):36–48.
 - . 1984. Irrationality and archaeology. *American Antiquity* 49(3):525–541.
- ——. 1987. Cult archaeology and creationism: A coordinated research project. In *Cult Archaeology and Creationism: Understanding Pseudoscientific Beliefs About the Past*, ed. F. Harrold and R. Eve, pp. 34–48. Iowa City: University of Iowa Press.
- ——. 1990. Piltdown, paradigms, and the paranormal. *The Skeptical In-auirer* 14(4):397–402.
- ——. 1994a. Review of Forbidden Archaeology: The Hidden History of the Human Race by Richard A. Cremo and Richard L. Thompson. Geoarchaeology 9(4):337–340.
- ——. 1994b. The Spanish *entrada*: A model for assessing claims of pre-Columbian contact between the Old and New Worlds. *North American Archaeologist* 15:147–166.
- ——. 1995a. Archaeology and the paranormal. In *Encyclopedia of the Paranormal*, ed. G. Steiner, Buffalo: Prometheus Books.
- ——. 1995b. Ten years after: Surveying misconceptions about the human past. *CRM* (*Cultural Resource Management*) 18(3):10–14.
- ———. Perceptions of the past: Survey results—How students perceive the past. *General Anthropology* **4**(2):1, 8–12.
- Feder, K. L., and M. A. Park. 1997. *Human Antiquity: An Introduction to Physical Anthropology and Archaeology.* Mountain View, Calif.: Mayfield.
- Feeney, M. K. 1998. Culture for sale. *The Hartford Courant*. January 5:1F, 3F. Feldman, M. 1977. *The Mystery Hill Story*. North Salem, N.H.: Mystery Hill. Fell, B. 1976. *America B.C.: Ancient Settlers in the New World*. New York: Demeter Press.
- ——. 1980. Saga America. New York: Times Books.
- . 1982. *Bronze Age America*. New York: Times Books.
- Fernandez-Armesto, F. 1974. Columbus and the Conquest of the Impossible. New York: Saturday Review Press.
- Fitzhugh, W. 1972. Environmental archaeology and cultural systems in Hamilton Inlet, Labrador: A survey of the central Labrador coast from 3000 B.C. to the present. *Smithsonian Contributions to Anthropology*, No. 16.
- ——. 1993. Archaeology of Kodlunarn Island. In *The Archaeology of the Frobisher Voyages*, ed. W. W. Fitzhugh and J. S. Olin, pp. 59–97. Washington, D. C.: Smithsonian Institution Press.
- Fitzhugh, W. W., and J. S. Olin (ed). 1993. *The Archaeology of the Frobisher Voyages*. Washington, D.C.: Smithsonian Institution Press.
- Foster, J. W. 1873. *Prehistoric Races of the United States of America*. Chicago: S. C. Griggs and Co.

Fowler, M. 1974. *Cahokia: Ancient Capital of the Midwest*. Addison-Wesley Module No. 48. Menlo Park, Calif.: Cummings.

----. 1975. A Precolumbian urban center on the Mississippi. Scientific

American 233(2):92-101.

——. 1989. The Cahokia Atlas: A Historical Atlas of Cahokia Archaeology. Studies in Illinois Archaeology 6. Springfield, Ill.: Illinois Historic Preservation Agency.

Franco, B. 1969. The Cardiff Giant: A Hundred Year Old Hoax. Cooperstown,

N.Y.: New York State Historical Association.

Friedlander, P. 1969. *Plato: The Dialogues*, Volume 3. Princeton: Princeton University Press.

Frodsham, J. D. 1989. The enigmatic shroud. *The World & I*, June:320–329.

Frost, F. 1982. The Palos Verdes Chinese anchor mystery. *Archaeology*, Jan./Feb.:23–27.

Fuson, R. 1987. *The Log of Christopher Columbus*. Canada, Maine: International Marine Publishing Company.

Futuyma, D. J. 1983. Science on Trial: The Case for Evolution. New York: Pantheon.

Galanopoulos, A. G., and E. Bacon. 1969. *Atlantis: The Truth Behind the Leg-end*. Indianapolis: Bobbs-Merrill.

Gallatin, A. 1836. A synopsis of the Indian tribes within the United States east of the Rocky Mountains, in the British and Russian possessions in North America. *Archaeologica Americana*, Volume 2:1–422. Cambridge, Mass.

Gallup Jr., G. H., and F. Newport. 1991. Belief in paranormal phenomena among adult Americans. *The Skeptical Inquirer* 15:137–146.

Galvão, A. 1962. The Discoveries of the New World from Their First Original Unto the Year of Our Lord 1555. The Hakluyt Society. New York: Burt Franklin.

Gardner, M. 1985. Notes of a psi-watcher: The great stone face and other nonmysteries. *The Skeptical Inquirer* 10(1):14–18.

Gee, H. 1996. Box of bones "clinches" identity of Piltdown paleontology hoaxer. *Nature* 381:261–262.

Gibbons, A. 1993. Geneticists trace the DNA trail of the first Americans. *Science* 259:312–313.

———. 1996. The peopling of the Americas. *Science* 274:31–33.

Gish, D. 1973. Evolution? The Fossils Say No. San Diego: Creation Life Publishers. Gladwin, H. 1947. Men Out of Asia. New York: McGraw-Hill.

Goddard, I., and W. Fitzhugh. 1979. A statement concerning America B.C. *Man in the Northeast* 17:166–172.

Godfrey, L. (ed). 1983. Scientists Confront Creationism. New York: Norton Press.
——. 1985. Footnotes of an anatomist. Creation/Evolution 5(1):16–36.

Godfrey, W. 1951. The archaeology of the Old Stone Mill in Newport, Rhode Island. *American Antiquity* 17:120–129.

Goodman, J. 1977. *Psychic Archaeology: Time Machine to the Past*. New York: Berkley.

——. 1981. *American Genesis*. New York: Berkley.

Goodwin, W. 1946. *The Ruins of Great Ireland in New England*. Boston: Meador. Gordon, C. H. 1974. *Riddles in History*. New York: Crown.

Gottfried, K., and K. G. Wilson. 1997. Science as a cultural construct. *Nature* 386:545–547.

Gould, S. J. 1980. The Piltdown conspiracy. Natural History, Aug.:8–28.

——. 1981. A visit to Dayton. Natural History, Nov.:8ff.

——. 1982. Moon, Mann, and Otto. Natural History, Jan.:4–10.

Gove, H. E. 1996. *Relic, Icon or Hoax? Carbon Dating the Turin Shroud*. Philadelphia: Institute of Physics.

Gradie, R. F. 1981. Irish immigration to 18th century New England and the stone chamber controversy. *Bulletin of the Archaeological Society of Connecticut* 44:30–39.

Gramly, M. 1982. *The Vail Site: A Palaeo-Indian Encampment in Maine.* Bulletin of the Buffalo Society of Natural Sciences, Volume 30.

Greene, J. 1959. The Death of Adam: Evolution and Its Impact on Western Thought, Ames, Iowa; Iowa State University Press.

Griffin, J. B., B. Meltzer, and B. Smith. 1988. A mammoth fraud in science. *American Antiquity* 53(3):578–581.

Gross, P. R., and N. Levitt. 1994. *Higher Superstition: The Academic Left and Its Quarrel with Science*. Baltimore: Johns Hopkins University Press.

Haas, J. 1982. The Evolution of the Prehistoric State. New York: New York University Press.

Halverson, J. 1987. Art for art's sake in the Paleolithic. *Current Anthropology* 28:63–71.

Hanke, L. 1937. Pope Paul III and the American Indians. *Harvard Theological Review* XXX:65–102.

Harlan, J. 1992. Indigenous African agriculture. In *The Origins of Agriculture:* An International Perspective, ed. C. W. Cowan and P. J. Watson, pp. 59–70. Washington, D.C.: Smithsonian Institution Press.

Harris, M. 1968. The Rise of Anthropological Theory. New York: Thomas Y. Crowell.

Harrison, P. D., and B. L. Turner (eds). 1978. *Pre-Hispanic Maya Agriculture*. Albuquerque: University of New Mexico Press.

Harrison, W. 1971. Atlantis undiscovered—Bimini, Bahamas. *Nature* 230: 287–289.

Hartmann, N. 1987. Atlantis lost and found. Expedition 29(2):19-26.

Hastings, R. 1985. Tracking those incredible creationists. *Creation/Evolution* 5(1):5–15.

Hattendorf, I. 1997. From the collection: William S. Godfrey's Old Stone Mill archaeological collection. *Newport History* 68(2):109–111.

Hawkins, G. 1965. Stonehenge Decoded. New York: Dell.

Haynes, C. V. 1980. The Clovis culture. Canadian Journal of Anthropology 1:115–121.

——. 1988. Geofacts and fancy. Natural History, Feb.:4–12.

Hempel, C. G. 1966. *Philosophy of Natural Science*. Englewood Cliffs, N.J.: Prentice-Hall.

Henningsmoen, K. 1977. Pollen-analytical investigations in the L'Anse aux Meadows area, Newfoundland. In *The Discovery of a Norse Settlement in America*, ed. A. S. Ingstad, pp. 289–340. Oslo, Norway: Universitetsforlaget.

Henry, D. O. 1989. From Foraging to Agriculture: The Levant at the End of the Ice

Age. Philadelphia: University of Pennsylvania Press.

Hertz, J. 1997. Round church or windmill? New light on the Newport Tower. *Newport History* 68(2):55–91.

Heyerdahl, T. 1958. Aku-Aku. New York: Rand McNally.

Hoagland, R. C. 1987. *The Monuments of Mars: A City on the Edge of Forever.* Berkeley: North Atlantic Books.

Hoffman, M. 1979. Egypt Before the Pharaohs. New York: Knopf.

——. 1983. Where nations began. *Science 83* 4(8):42–51.

Hoggart, S., and M. Hutchinson. 1995. *Bizarre Beliefs*. London: Richard Cohen Books.

Hole, F. 1981. Saga America: Book review. Bulletin of the Archaeological Society of Connecticut 44:81–83.

Hole, F., K. Flannery, and J. A. Neely. 1969. *Prehistory and Human Ecology of the Deh Luran Plain: An Early Village Sequence from Khuzistan, Iran*. Ann Arbor: University of Michigan Press.

Holy Shroud Guild. 1977. Proceedings of the 1977 United States Conference on the Shroud of Turin. New York: Holy Shroud Guild.

Holzer, H. 1969. Window to the Past. Garden City: Doubleday.

Hopkins, D., J. Mathews, C. Schweger, and S. Young (eds). 1982. *The Paleoecology of Beringia*. New York: Academic Press.

Hoversten, P. 1996. Missing link in explorers' journey perhaps found. *USA Today*. April 15:10A.

Howard, R. W. 1975. The Dawn Seekers. New York: Harcourt Brace Jovanovich.

Huddleston, L. 1967. *Origins of the American Indians: European Concepts,* 1492–1729. Austin, University of Texas Press.

Hughes, R. 1995. Behold the Stone Age. Time 145:52ff.

Hunt, K. A. 1984. *Point Cook Homestead Electro-Magnetic Photo-Field Survey for Melbourne and Metropolitan Board of Works, Melbourne, Victoria, Australia.* Unpublished manuscript.

Hutchins, R. M. (ed). 1952. The Dialogues of Plato, trans. B. Jowett. Chicago:

William Benton/Encyclopaedia Britannica.

Incredible Discovery of Noah's Ark, The. 1993. Sun International Pictures. Ingstad, A. S. 1977. *The Discovery of a Norse Settlement in America*. Oslo, Norway: Universitetsforlaget.

— . 1982. The Norse settlement of L'Anse aux Meadows, Newfoundland. In *Vikings in the West*, ed. E. Guralnick, pp. 31–37. Chicago: Archaeo-

logical Institute of America.

Ingstad, H. 1964. Viking ruins prove Vikings found the New World. *National Geographic* 126(5):708–734.

. 1971. Norse site at L'Anse aux Meadows. In The Quest for America, ed.

G. Ashe, pp. 175–198. New York: Praeger.

——. 1982. The discovery of a Norse settlement in America. In *Vikings in the West*, ed. E. Guralnick, pp. 24–30. Chicago: Archaeological Institute of America.

Irwin, G. 1993. *The Prehistoric Exploration and Colonisation of the Pacific*. Cambridge: Cambridge University Press.

Iseminger, W. R. 1996. Mighty Cahokia. Archaeology 49(3):30–37.

Ives, R. 1956. An early speculation concerning the Asiatic origin of the American Indians. *American Antiquity* 21:420–421.

Jackson, N. F., G. Jackson, and W. Linke Jr. 1981. The "trench ruin" of Gungywamp, Groton, Connecticut. Bulletin of the Archaeological Society of Connecticut 44:20–29.

- Jacobsen, T. W. 1976. 17,000 years of Greek prehistory. *Scientific American* 234(6):76–87.
- James, G. G. M. 1954. The Stolen Legacy. New York: Philosophical Library.

Jarnoff, L. 1993. Phony arkaeology. Time, p. 51.

Jennings, J. 1989. Prehistory of North America. Mountain View, Calif.: Mayfield.
Jett, S. 1971. Diffusion versus independent development: The bases of controversy. In Man Across the Sea: Problems of Pre-Columbian Contacts, ed. C. Riley, J. C. Kelley, C. W. Pennington, and R. L. Rands, pp. 5–53. Austin: University of Texas Press.

——. 1992a. Asian contacts with the Americas in pre-Columbian times: The principal proposals. *New England Antiquities Research Association*

Journal 26:62–68.

- ——. 1992b. Hypotheses of Mediterranean/Southwest influences on New World cultures. *New England Antiquities Research Association Journal* 26:82–85.
- Jochim, M. 1983. Paleolithic cave art in ecological perspective. In *Hunter-Gatherer Economy in Prehistory: A European Perspective*, ed. G. Bailey, pp. 211–219. Cambridge: Cambridge University Press.

Johanson, D., and M. Edey. 1982. Lucy: The Beginnings of Humankind. New

York: Warner Books.

Johanson, D., L. Johanson, and B. Edgar. 1994. *Ancestors: In Search of Human Origins*. New York: Villard.

- Johnson, E. B. 1994. Not all tabloids are created equal, but they sure sell. *National Forum* 74(4):26–29.
- Jones, D. 1979. Visions of Time: Experiments in Psychic Archaeology. Wheaton, Ill.: Theosophical Publishing House.
- Jones, G. 1982. Historical evidence for Viking voyages to the New World. In *Vikings in the West*, ed. E. Guralnick, pp. 1–12. Chicago: Archaeological Institute of America.
- Josenhans, H., D. Fedje, R. Pienitz, and J. Southon. 1997. Early humans and rapidly changing Holocene sea levels in the Queen Charlotte Islands-Hectate Strait, British Columbia, Canada. *Science* 277:71–74.
- Josselyn, J. [1674] 1865. An Account of Two Voyages to New England Made During the Years 1638, 1663. Boston: W. Veazie.
- Kahn, P., and A. Gibbons. 1997. DNA from an extinct human. *Science* 277:176–178.
- Kehoe, A. B. 1989. *The Ghost Dance: Ethnohistory and Revitalization*. New York: Holt, Rinehart, and Winston.
- Keith, A. 1913. The Piltdown skull and brain cast. Nature 92:197–199.
- Kelley, D. H. 1990. Proto-Tifinagh and Proto-Ogham in the Americas. *Review of Archaeology* 11(1):1–10.
- Kemp, B. J. 1991. Ancient Egypt. New York: Routledge.
- Kennedy, K. A. R. 1975. Neanderthal Man. Minneapolis: Burgess Press.

Kerr, R. A. 1996. Ancient life on Mars? Science 273:864–866.

- King, M. L., and S. B. Slobodin. 1996. A fluted point from the Uptar Site, northeastern Siberia. *Science* 273:634–636.
- Klass, P. 1983. The Public Deceived. Buffalo: Prometheus Books.
- ——. 1989. UFO-Abductions: A Dangerous Game. Buffalo: Prometheus Books.

Kolosimo, P. 1975. *Spaceships in Prehistory*. Secaucus, N.J.: University Books. König, R., J. Moll, and A. Sarma. 1996. The Kassel dowsing test. *Swift* 1(1):3–8.

Kosok, P., and M. Reiche. 1949. Ancient drawings on the desert of Peru. *Archaeology* 2(4):206–215.

- Krings, M. A., A. Stone, R. W. Schmitz, H. Krainitzki, M. Stoneking, and S. Pääbo. 1997. Neandertal DNA sequences and the origin of modern humans. *Cell* 90(1):19–30.
- Kuban, G. 1989a. Retracking those incredible mantracks. *National Center for Science Education Reports* 94(4):13–16.
- ——. 1989b. Elongate dinosaur tracks. In *Dinosaur Tracks and Traces*, ed.
 D. D. Gillette and M. G. Lockley, pp. 57–72. New York: Cambridge University Press.
- Kuhn, T. 1970. *The Structure of Scientific Revolutions*. Chicago: University of Chicago Press.
- Kusche, L. 1995. *The Bermuda Triangle Mystery Solved*. Buffalo: Prometheus Books.
- Lafayette Wonder, The. 1869. *Syracuse Daily Journal*, Oct. 20. Syracuse, N.Y. Lamberg-Karlovsky, C. C., and J. A. Sabloff. 1995. *Ancient Civilizations: The Near East and Mesoamerica*. Prospect Heights, Ill.: Waveland Press.
- Larson, D. O., and E. L. Ambos. 1997. New developments in geophysical prospecting and research: An example from the Navan Complex, County Armagh, Northern Ireland. *Society for American Archaeology Bulletin* 15(1).
- Larson, E. J., and L. Witham. 1997. Scientists are still keeping the faith. *Nature* 386:435–436.
- Leakey, R., and R. Lewin. 1992. *Origins Reconsidered: In Search of What Makes Us Human*. New York: Doubleday.
- Lefkowitz, M. 1996. Not Out of Africa. New York: Basic Books.
- LeHaye, T., and J. Morris. 1976. *The Ark on Ararat*. San Diego: Creation Life Publishers.
- Lehner, M. 1997. *The Complete Pyramids: Solving the Ancient Mysteries*. London: Thames and Hudson.
- Lepper, B. T. 1992. Just how holy are the Newark "Holy Stones?" In Vanishing Heritage: Notes and Queries about the Archaeology and Culture History of Licking County, Ohio, ed. P. E. Hooge and B. T. Lepper, pp. 58–64.
 Newark, Ohio: Licking County Archaeology and Landmarks Society.
 ——. 1995a. Hidden history, hidden agenda. Skeptic 4(1):98–100.
- ——. 1995b. *People of the Mounds: Ohio's Hopewell Culture*. Hopewell, Ohio: Hopewell Culture National Historical Park.
- ——. 1995c. Tracking Ohio's Great Hopewell Road. *Archaeology* 48(6): 52–56.
- ——. 1998. Ancient astronomers of the Ohio Valley. *Timeline* 15(1):2–11.
- Leroi-Gourhan, A. 1968. The evolution of Paleolithic art. *Scientific American* 209(2):58–74.
- Lewis-Williams, J. D., and T. A. Dowson. 1988. The signs of all times. *Current Anthropology* 29(2):201–217.
- Lieberman, L., and R. C. Kirk. 1996. The trial is over: Religious voices for evolution and the "fairness" doctrine. *Creation/Evolution* 16(2):1–9.
- Lippard, J. 1994. Sun goes down in flames: The Jammal ark hoax. *Skeptic* 2(3):22–33.

Lowe, G. W. 1989. The heartland Olmec: Evolution of material culture. In *Regional Perspectives on the Olmec*, ed. R. J. Sharer and D. C. Grove, pp. 33–67. New York: Cambridge University Press.

Luce, J. V. 1969. Lost Atlantis: New Light on an Old Legend. New York: McGraw-

Hill.

MacCurdy, G. 1913. Ancestor hunting: The significance of the Piltdown skull. *American Anthropologist* 15:248–256.

——. 1914. The man of Piltdown. *Science* 40:158–160.

MacDonald, G. F. 1985. Debert: A Paleo-Indian Site in Central Nova Scotia. Buffalo: Persimmon Press.

MacLaine, S. 1983. Out on a Limb. New York: Bantam.

MacNeish, R. S. 1967. An interdisciplinary approach to an archaeological problem. In *The Prehistory of the Tehuacan Valley: Volume 1—Environment and Subsistence*, ed. D. Byers, pp. 14–23. Austin: University of Texas Press.

Magnusson, M., and H. Paulsson (trans). 1965. The Vinland Sagas. New York:

Penguin.

Major, R. H. (ed). 1961. *Christopher Columbus: Four Voyages to the New World—Letters and Selected Documents*. New York: Corinth Books.

Marden, L. 1986. The first land fall of Columbus. *National Geographic* 170(5): 572–577.

Marinatos, S. 1972. Thera: Key to the riddle of Minos. *National Geographic* 141:702–726.

Marshack, A. 1972. The Roots of Civilization. New York: McGraw-Hill.

Martin, M. 1983–84. A new controlled dowsing experiment. *The Skeptical Inquirer* 8(2):138–142.

McCrone, W. C. 1976. Authenticity of medieval document tested by small particle analysis. *Analytical Chemistry* 48(8):676A–679A.

———. 1982. Shroud image is the work of an artist. *The Skeptical Inquirer* 6(3):35–36.

——. 1988. The Vinland map. Analytical Chemistry 60:1009–1018.

———. 1990. The Shroud of Turin: Blood or artist's pigment? *Accounts of Chemical Research* 23:77–83.

——. 1996. *Judgement Day for the Turin Shroud*. Chelsea, Michigan: McCrone Research Institute.

——. 1997. Letter dated Sept. 10.

McGhee, R. 1984. Contact between native North Americans and the medieval Norse: A review of the evidence. *American Antiquity* 49:4–26.

McGovern, T. 1980–81. The Vinland adventure: A North Atlantic perspective. *North American Archaeologist* 2(4):285–308.

— . 1982. The lost Norse colony of Greenland. In *Vikings in the West*, ed. E. Guralnick, pp. 13–23. Chicago: Archaeological Institute of America.

McGowan, C. 1984. *În the Beginning . . . A Scientist Shows Why the Creationists are Wrong.* Buffalo: Prometheus.

McIntyre, I. 1975. Mystery of the ancient Nazca lines. *National Geographic* 147(5):716–728.

McKillop, H. 1994. Ancient Maya tree-cropping. *Ancient Mesoamerica* 5:129–140. McKusick, M. 1976. Contemporary American folklore about antiquity. *Bulletin of the Philadelphia Anthropological Society* 28:1–23.

——. 1979. Some historical implications of the Norse penny from Maine.

Norwegian Numismatic Journal 3:20–23.

- ———. 1982. Psychic archaeology: Theory, method, and mythology. *Journal of Field Archaeology* 9:99–118.
- . 1984. Psychic archaeology from Atlantis to Oz. *Archaeology* Sept./Oct.: 48–52.
- ——. 1991. *The Davenport Conspiracy Revisited*. Ames: Iowa State University Press.
- McKusick, M., and E. Shinn. 1981. Bahamian Atlantis reconsidered. *Nature* 287:11–12.
- Meltzer, D. J. 1989. Why don't we know when the first people came to North America? *American Antiquity* 54(3):471–490.
- ——. 1993a. Pleistocene peopling of the Americas. *Evolutionary Anthropology*, pp. 157–169.
- ——. 1993b. *Search for the First Americans*. Smithsonian: Exploring the Ancient World. Washington, D.C.: Smithsonian Books.
- ——. 1997. Monte Verde and the Pleistocene peopling of the Americas. *Science* 276:754–755.
- Millar, R. 1972. The Piltdown Men. New York: Ballantine Books.
- Miller Jr., G. S. 1915. The jaw of Piltdown man. *Smithsonian Miscellaneous Collections* 65:1–31.
- Mitchem, J. n.d. *The Parkin Site: Hernando de Soto in Cross County, Arkansas.* Arkansas Humanities Council. Brochure.
- Money, L. 1985. Down on the farm—in spirit, at least. *The Herald*, July 26. Melbourne, Australia.
- Montague, A. 1960. Artificial thickening of bone and the Piltdown skull. *Nature* 187:174.
- ——. 1982. *Evolution and Creationism*. New York: Oxford University Press. Mooney, J. [1892–93] 1965. *The Ghost-Dance Religion and the Sioux Outbreak of*
- 1890. Chicago: University of Chicago Press.
- Moore, R. A. 1983. The impossible voyage of Noah's ark. *Creation/Evolution* XI:1–43.
- Morison, S. E. 1940. *Portuguese Voyagers to America in the Fifteenth Century.* Cambridge, Mass.: Harvard University Press.
- Morris, H. 1974. *The Troubled Waters of Evolution*. San Diego: Creation Life Publishers.
- ——. 1977. The Scientific Case for Creation. San Diego: Creation Life Publishers.
- ——. 1986. The Paluxy River Mystery. *Impact* No. 151. El Cajon, Calif.: Creation Research Institute.
- Morris, J. 1980. *Tracking Those Incredible Dinosaurs and the People Who Knew Them.* San Diego: Creation Life Publishers.
- Mosimann, J., and P. Martin. 1975. Simulating overkill by Paleo-Indians. *American Scientist* 63:304–313.
- Mueller, M. 1982. The Shroud of Turin: A critical approach. *The Skeptical Inquirer* 6(3):15–34.
- National Academy of Sciences. 1984. Science and Creation: A View from the National Academy of Sciences. Washington, D.C.: National Academy Press.
- Neudorfer, G. 1980. Vermont Stone Chambers: An Inquiry into Their Past. Montpelier: Vermont Historical Society.
- News. 1912. Nature 92:390.
- Nickell, J. 1983. The Nazca drawings revisited. *The Skeptical Inquirer* 7(3):36–44.

- ——. 1987. *Inquest on the Shroud of Turin,* 2nd ed. Buffalo: Prometheus Books.
- ———. 1989. Unshrouding a mystery: Science, pseudoscience and the cloth of Turin. *The Skeptical Inquirer* 13(3):296–299.
- ———. 1993. Looking for a Miracle: Weeping Icons, Relics, Stigmata, Visions and Healing Cures. Buffalo: Prometheus Books.
- . 1994. *Psychic Sleuths: ESP and Sensational Cases.* Buffalo: Prometheus Books.
- Noël Hume, I. 1974. Historical Archaeology. New York: Knopf.
- Noorbergen, R. 1982. Treasures of the Lost Races. New York: Bobbs-Merrill.
- Oakley, K. P. 1976. The Piltdown problem reconsidered. *Antiquity* 50 (March):9–13.
- Oakley, K. P., and J. S. Weiner. 1955. Piltdown Man. *American Scientist* 43: 573–583.
- Oestreicher, D. M. 1996. Unraveling the Walam Olum. Natural History 105(10):14–21.
- O Hehir, B. 1990. *Barry Fell's West Virginia Fraud*. Unpublished manuscript. Omunhundro, J. T. 1976. Von Däniken's chariots: A primer in the art of crooked science. *The Zetetic* 1(1):58–67.
- Ortiz de Montellano, B. 1991. Multicultural pseudoscience: Spreading scientific illiteracy among minorities: Part I. *The Skeptical Inquirer* 16(1): 46–50.
- ——. 1992. Magic melanin: Spreading scientific illiteracy among minorities: Part II. *The Skeptical Inquirer* 16(2):162–166.
- Osborn, H. F. 1921. The Dawn Man of Piltdown, Sussex. *Natural History* 21: 577–590.
- Page, C., and J. Cort. 1997. Secrets of Lost Empires: Stonehenge. Boston: WGBH:Nova.
- Paleolithic Man. 1912. Nature 92:438.
- Paleolithic Skull Is Missing Link. 1912. New York Times, Dec. 19.
- Pauketat, T. R. 1994. *The Ascent of Chiefs: Cahokia and Mississippian Politics in Native America*. Tuscaloosa: University of Alabama Press.
- Pauwels, L., and J. Bergier. [1960] 1964. *The Morning of the Magicians*. New York: Stein and Day.
- Pearsall, D. 1992. The origins of plant cultivation in South America. In *The Origins of Agriculture: An International Perspective,* ed. C. W. Cowan and P. J. Watson, pp. 173–205. Washington, D.C.: Smithsonian Institution Press.
- Peebles, C. 1994. Watch the Skies! A Chronicle of the Flying Saucer Myth. Washington, D.C.: Smithsonian Institution Press.
- Pellegrino, C. 1991. *Unearthing Atlantis: An Archaeological Odyssey*. New York: Random House.
- Peterson, M. A. 1991. Aliens, ape men, and whacky savages. *Anthropology Today* 7(5):4–7.
- Peterson, N. 1988. Sacred Sites: A Traveler's Guide to North America's Most Powerful and Mysterious Landmarks. New York: Contemporary Books.
- Phillipson, D. W. 1993. *African Archaeology*, 2nd ed. Cambridge: Cambridge University Press.
- Plummer, M. 1991. Locating invisible buildings. *The Skeptical Inquirer* 15(4): 386–397.

- Pohl, M. (ed). 1990. Ancient Maya Wetland Agriculture: Excavations on Albion Island, Northern Belize. Boulder: Westview Press.
- Powers, W. R., and J. F. Hoffecker. 1989. Late Pleistocene settlement in the Nenana Valley, central Alaska. *American Antiquity* 54:263–287.
- Pringle, H. 1997. Death in Norse Greenland. Science 275:924–926.
- Putnam, C. E. 1886. The Davenport Tablets. Science 7(157):119–120.
- Quuinn, D. B. (ed.). 1979. New American World: A Documentary History of North America to 1612. New York: Arno Press.
- Raloff, J. 1995. Dowsing expectations: New reports reawaken scientific controversy over water witching. *Science News* 148:90–91.
- Ramenofsky, A. F. 1987. *Vectors of Death.* Albuquerque: University of New Mexico Press.
- Randi, J. 1975. The Magic of Uri Geller. New York: Ballantine Books.
- ——. 1979. A controlled test of dowsing abilities. *The Skeptical Inquirer* 4(1):16–20.
- ——. 1981. Atlantean road: The Bimini beach-rock. *The Skeptical Inquirer* 5(3):42–43.
- ——. 1984. The great \$110,000 dowsing challenge. *The Skeptical Inquirer* 8(4):329–333.
- ——. 1989. The Faith Healers. Buffalo: Prometheus Books.
- ——. 1993. *The Mask of Nostradamus*. Buffalo: Prometheus Books.
- Reiche, M. 1978. Mystery on the Desert. Stuttgart: Heinrich Fink and Co.
- Rice, P., and A. Paterson. 1985. Cave art and bones: Exploring the interrelationships. *American Anthropologist* 87:94–100.
- ——. 1986. Validating the cave art-archaeofaunal relationship in Cantabrian Spain. *American Anthropologist* 88:658–667.
- Roberts, D. 1993. The Ice Man: Voyager from the Copper Age. *National Geographic* 183(6):36–67.
- Robertson, M. G. 1974. *Primera Mesa Redonda de Palenque*. Pebble Beach, Calif.: Robert Louis Stevenson School.
- Romancito, R. 1993. American Indians and the New Age: Subtle racism at work. *The Skeptical Inquirer* 18:97–98.
- Ross, A., and P. Reynolds. 1978. 'Ancient Vermont.' Antiquity 52:100–107.
- Rowe, J. H. 1966. Diffusionism and archaeology. *American Antiquity* 31:334–337.
- Ruggles, C. 1996. Stonehenge for the 1990s. Nature 381:278–279.
- Ruspoli, M. 1986. *The Cave at Lascaux: The Final Photographs*. New York: Abrams. Sabloff, J. 1989. *The Cities of Ancient Mexico: Reconstructing a Lost World*. New York: Thames and Hudson.
- ——. 1994. *The New Archaeology and the Ancient Maya*. New York: Scientific American Library.
- Sabo, D., and G. Sabo. 1978. A possible Thule carving of a Viking from Baffin Island, NWT, Canada. *Journal of Archaeology* 2:33–42.
- Sallee, R. 1983. The search for Noah's Ark continues. *The Houston Chronicle*, Aug. 20, Section 6:1–2. Houston, Texas.
- Sanford, R., D. Huffer, and N. Huffer. 1995. Stonewalls and Cellarholes: A Guide for Landowners on Historic Features and Landscapes in Vermont's Forests. Waterbury, Vermont: Vermont Agency of Natural Resources.
- Saraceni, J. E. 1998. Searching for Lewis and Clark. Archaeology 51(1):20-21.
- Saunders, J. W., R. D. Mandel, R. T. Saucier, E. T. Allen, C. T. Hallmark, J. K. Johnson, E. H. Jackson, C. M. Allen, G. L. Stringer, D. S. Frink, J. K.

Feathers, S. Williams, K. J. Gremillion, M. F. Vidrine, and R. Jones. 1997. A mound complex in Louisiana at 5400–5000 years before the present. *Science* 277:1796–1799.

Schele, L., and D. Freidel. 1990. A Forest of Kings. New York: Quill William

Morrow.

Schick Jr., T., and L. Vaughn. 1999. How to Think About Weird Things: Critical Thinking in the New Age 2nd ed. Mountain View, Calif.: Mayfield.

Schledermann, P. 1981. Eskimo and Viking finds in the High Arctic. *National Geographic* 159(5):575–601.

Schmidt, K. 1996. Creationists evolve new strategy. Science 273:420–422.

Schnabel, J. 1994. Round in Circles: Poltergeists, Pranksters, and the Secret History of Crop Watchers. Buffalo: Prometheus Books.

Schneour, E. 1986. Occam's Razor. The Skeptical Inquirer 10(4):310–313.

Schoolcraft, H. R. 1854. Historical and Statistical Information Regarding the History, Condition, and Prospects of the Indian Tribes of the United States. Part IV. Philadelphia.

Schwartz, S. 1978. The Secret Vaults of Time: Psychic Archaeology and the Quest for Man's Beginnings. New York: Grosset and Dunlap.

—. 1983. The Alexandria Project. New York: Delacorte Press.

Scott, E. C. 1987. Antievolutionism, scientific creationism, and physical anthropology. *Yearbook of Physical Anthropology* 30:21–39.

Severin, T. 1977. The voyages of "Brendan." National Geographic 152(12): 770–797.

Shapiro, H. 1974. *Peking Man: The Discovery, Disappearance, and Mystery of a Priceless Scientific Treasure.* New York: Simon and Schuster.

Sharer, R., and W. Ashmore. 1993. *Archaeology: Discovering Our Past*. Mountain View, Calif.: Mayfield.

Shermer, M. 1997. Why People Believe Weird Things. New York: W. H. Freeman.

Shorey, P. 1933. What Plato Said. Chicago: University of Chicago Press.

Shutler, R., and M. Shutler. 1975. *Oceanic Prehistory*. Menlo Park, Calif.: Cummings.

Silverberg, R. 1989. *The Moundbuilders*. Athens, Ohio: Ohio University Press. Sitchin, Z. 1978. *The 12th Planet*. New York: Avon Books.

______. 1990. *Genesis Revisited*. New York: Avon Books.

Sjøvold, T. 1992. The stone age iceman from the Alps: The find and the current status of investigation. *Evolutionary Anthropology* 1(4):117–124.

Skelton, R. A., T. Marston, and G. O. Painter. 1995. *The Vinland Map and the Tartar Relation*. New Haven: Yale University Press.

Smith, B. D. 1995. *The Emergence of Agriculture*. New York: Scientific American Library.

Smith, G. E. 1927. Essays on the Evolution of Man. London: Oxford University Press.

Smith, J. 1985. *The Book of Mormon*. Salt Lake City: Church of Jesus Christ of Latter-Day Saints.

Snow, D. 1981. Martians and Vikings, Madoc and runes. *American Heritage* 32(6):102–108.

So Big: The All Time Mass Market Best Sellers. 1989. *Publisher's Weekly*, May 26:531.

Solheim, W. 1972. An earlier agricultural revolution. *Scientific American* 226(4):34–41.

Spence, L. [1926] 1968. The History of Atlantis. New York: Bell.

- Spencer, F. 1984. The Neandertals and their evolutionary significance: A brief history and historical survey. In *The Origins of Modern Humans: A World Survey of the Fossil Evidence*, ed. F. Smith and F. Spencer, pp. 1–50. New York: Alan R. Liss.
- ——. 1990. *Piltdown: A Scientific Forgery*. Oxford: Oxford University Press. Spencer, F., and C. Stringer. 1989. Piltdown. In Radiocarbon dates from the Oxford AMS system: Archaeometry Datelist 9, eds. R. E. M. Hedgtes, R. A. Housley, I. A. Law, and C. R. Bronk. *Archaeometry* 31:207–234.

Spennemann, D. 1996. Current Attitudes of Parks Management and Ecotourism Students II: Popular Opinions About the Past. Albury, NSW, Australia: Charles Stuart University.

Spindler, K. 1994. The Man in the Ice. New York: Harmony Books.

Squier, E. G., and E. H. Davis. 1848. *Ancient Monuments of the Mississippi Valley: Comprising the Results of Extensive Original Surveys and Explorations*. Smithsonian Contributions to Knowledge, Volume 1. New York: AMS Press (reprinted in 1973 for the Peabody Museum of Archaeology and Ethnology, Harvard University).

Stevenson, K. E., and G. R. Habermas. 1981a. Verdict on the Shroud. Ann

Arbor, Mich.: Servant Publications.

——. 1981b. We tested the Shroud. *The Catholic Digest*, Nov.:74–78.

Steward, T. D. 1973. *The People of America*. New York: Charles Scribner's Sons. Stiebing, W. 1984. *Ancient Astronauts, Cosmic Collisions, and Other Popular Theories About Man's Past*. Buffalo: Prometheus Books.

Stone, A. C., and M. Stoneking. 1993. Ancient DNA from a pre-Columbian Amerindian population. *American Journal of Physical Anthropology* 92: 463–471.

Stone Giant, The. 1869. The Syracuse Standard, Nov. 1. Syracuse, N.Y.

Stringer, C., and C. Gamble. 1993. *In Search of the Neanderthals*. London: Thames and Hudson.

Stuart, G. 1993. New light on the Olmec. National Geographic. Nov.:88-115.

Sullivan, G. 1980. Discover Archaeology: An Introduction to the Tools and Techniques of Archaeological Fieldwork. New York: Penguin.

Swanton, J. R. [1939] 1985. Final Report of the United States De Soto Expedition Commission. Classics of Smithsonian Anthropology. Washington, D.C.: Smithsonian Institution Press.

Swauger, J. L. 1980. Petroglyphs, tar burner rocks, and lye leaching stones.

Pennsylvania Archaeologist 51(1-2):1-7.

Tarzia, W. 1992. The linguistic behavior of cult archaeologists: Literary approaches to diffusionist texts. Paper delivered at the symposium *Alternative Archaeology: A World of Wonder*. Halifax, Nova Scotia.

Taylor, A. E. 1962. A Commentary on Plato's Timaeus. Oxford: Clarendon Press.Taylor, P. 1985a. Young People's Guide to the Bible and the Great Dinosaur Mystery. Mesa, Ariz.: Films for Christ Association.

——. 1985b. Notice Regarding the Motion Picture "Footprints in Stone." Mesa, Ariz.: Films for Christ Association.

Taylor, R. E., and R. Berger. 1980. The date of Noah's Ark. *Antiquity* 44:34–36. Terrell, J. 1986. *Prehistory in the Pacific Islands*. Cambridge: Cambridge University Press.

This Old Pyramid (television program). 1993. Nova. Boston: WGBH.

Thomas, C. [1894] 1985. Report on the Mound Explorations of the Bureau of Ethnology. Washington, D.C.: BAE (reprinted by Smithsonian Institution Press).

- Thomas, D. H. 1987. The archaeology of Mission Santa Catalina de Guale: Search and discovery. *Anthropological Papers of the American Museum of Natural History* 63(2):47–161.
 - _____. 1989. Archaeology. New York: Holt, Rinehart, and Winston.
- Tobias, P. V. 1992. Piltdown: An appraisal of the case against Sir Arthur Keith. *Current Anthropology* 33(3):243–260.
- Tomas, A. 1971. We Are Not the First. New York: Bantam Books.
- Trento, S. 1978. The Search for Lost America. Mysteries of the Stone Ruins in the *United States*. New York: Penguin.
- Turner, B. L., and P. Harrison (eds). 1983. *Pulltrouser Swamp: Ancient Maya Habitat, Agriculture, and Settlement in Northern Belize.* Austin: University of Texas Press.
- Turner, C. G. 1987. Telltale teeth. Natural History, Jan.:6-10.
- van Kampen, H. 1979. The case of the lost panda. *The Skeptical Inquirer* 4(1): 48–50.
- Van Sertima, I. 1976. *They Came Before Columbus*. New York: Random House. Van Tilburg, J. A. 1987. Symbolic archaeology on Easter Island. *Archaeology* 40(2):26–33.
- ——. 1994. Easter Island: Archaeology, Ecology, and Culture. Washington, D.C.: Smithsonian Institution Press.
- ———. 1995. Moving the Moai: Transporting the megaliths of Easter Island: How did they do it? *Archaeology* 48(1):34–43.
- Vaughan, C. 1988. Shroud of Turin is a fake, official confirms. Science News 134(15):229.
- Vescelius, G. 1956. Excavations at Pattee's Caves. Bulletin of the Eastern States Archaeological Federation 15:13–14.
- Vespucci, A. 1904. The Letters of Amerigo Vespucci and Other Documents Illustrative of His Career. The Hakluyt Society. New York: Burt Franklin.
- Vogt, E., and R. Hyman. 1980. Water Witching U.S.A. Chicago: University of Chicago Press.
- von Däniken, E. 1970. Chariots of the Gods? New York: Bantam Books.
- ——. 1971. *Gods from Outer Space*. New York: Bantam Books.
- ______. 1973. *Gold of the Gods*. New York: Bantam Books.
- _____. 1975. Miracles of the Gods. New York: Bantam Books.
- . 1982. Pathways to the Gods. New York: G. P. Putnam's Sons.
- . 1989. *In Search of the Gods*. New York: Avenel.
- ——. 1996. The Eyes of the Sphinx: The Newest Evidence of Extraterrestrial Contact in Ancient Agypt. New York: Berkeley Books.
- ——. 1997. *Chariots of the Gods? The Mysteries Continue.* Stamford, Conn.: Capital Cities/ABC Video.
- Walker, A., and R. Leakey (eds). 1993. *The Nariokotome Homo erectus Skeleton*. Cambridge, Mass.: Harvard University Press.
- Wallace, B. 1982. Viking hoaxes. In *Vikings in the West*, ed. E. Guralnick, pp. 51–76. Chicago: Archaeological Institute of America.
- Wallace, D. C., K. Garrison, and W. C. Knowler. 1985. Dramatic founder effects in American mitochondrial DNAs. *American Journal of Physical Anthropology* 68:149–155.
- Walsh, J. E. 1996. *Unravelling Piltdown: The Science Fraud of the Century and Its Solution.* New York: Random House.
- Warner, F. 1981. Stone structures at Gungywamp. *Bulletin of the Archaeological Society of Connecticut* 44:4–19.

- Waterston, D. 1913. The Piltdown mandible. Nature 92:319.
- Weaver, K. 1980. Science seeks to solve the mystery of the Shroud. *National Geographic* April: 730–751.
- Weidenreich, F. 1943. Piltdown man. Paleontologica Sinica 129:273.
- Weiner, J. S. 1955. The Piltdown Forgery. London: Oxford University Press.
- Weir, S. K. 1996. Insight from geometry and physics into the construction of Egyptian old kingdom pyramids. *Cambridge Archaeological Journal* 6:150–163.
- Wendorf, F., R. Schild, and A. Close. 1982. An ancient harvest on the Nile. *Science* 82 Vol. 3(9):68–73.
- Wernick, R., and the editors of Time-Life Books. 1973. *The Monument Builders*. New York: Time-Life Books.
- West, F. H. 1981. *The Archaeology of Beringia*. New York: Columbia University Press.
- Weymouth, J. W. 1986. Geophysical methods of archaeological site surveying. In *Advances in Archaeological Method and Theory*, Volume 9, ed. M. Schiffer, pp. 311–395. Orlando: Academic Press.
- Whitcomb, J. C., and H. Morris. 1961. *The Genesis Flood*. Nutley, N.J.: Presbyterian and Reformed Publishing.
- White, T. D., and G. Suwa. 1987. Hominid footprints at Laetoli: Facts and interpretations. *American Journal of Physical Anthropology* 72:485–514.
- Whittaker, J. C. 1997. Red Power finds creationism. Skeptical Inquirer 21(1):47-50.
- Willey, G., and J. Sabloff. 1993. *A History of American Archaeology*. London: Thames and Hudson.
- Williams, S. 1991. *Fantastic Archaeology: The Wild Side of American Prehistory.* Philadelphia: University of Pennsylvania Press.
- Wilmsen, E. 1965. An outline of early man studies in the United States of America. *American Antiquity* 31:172–192.
- ——. 1974. Lindenmeier: A Pleistocene Hunting Society. New York: Harper and Row.
- Wilson, D. 1988. Desert ground drawings in the lower Santa Valley, north coast of Peru. *American Antiquity* 53(4):794–803.
- Wilson, I. 1979. The Shroud of Turin: The Burial Cloth of Jesus Christ? New York: Image Books.
- Woodward, J. 1695. An Essay Toward a Natural History of the Earth. London.

Index

Page numbers in <i>italic</i> indicate	altar mounds, 142
illustrations, figures, or tables.	Alton Giant, 40
, 0	Ambos, Elizabeth, 232
Abbott, Lewis, 73	America B.C. (Fell), 117
Abri Blanchard antler plaque, 203–204,	America discovery, 79-84, 98-132
204	by Africans, 105–111
Acosta, Joseph de, 86–87, 90	by American Indians, 79-80, 84-96
Adena culture, 152–154, 153	by St. Brendan, 102–103
Africa	by Celts, 111, 114–115
agricultural development in, 175	by Chinese, 103-104
discovery of Americas and, 105-111	by Columbus, 79, 80–84, 98
hominid fossils in, 66, 75	critical thinking exercises on, 97,
Afrocentrism, 110	131–132
agnosticism, 263	Fell's claims on, 111–119
agriculture	frequently asked questions about, 96,
American Indian, 152–153, 155	131
Atlantis legend and, 175, 177–178	by Iberians, 80–84, 81, 100–101, 111
Egyptian, 197	sixteenth-century explorers and,
Maya, 272–273, 274	99–101
Olmec, 108–109	by Vikings, 119, 122–130
slash-and-burn, 272-273, 274	Web sites related to, 97, 132
Aitken, Martin, 228	by Welshmen, 104–105
Alabama	American Anthropological Association,
archaeological sites in, 101, 155	238
Creationist legislation in, 237	American Genesis (Goodman), 91–92
Alaska	American Indians
archaeological sites in, 94–95	Atlantis and, 86, 92, 168
See also Bering Land Bridge	Bible and, 84–85
alien beings. See extraterrestrial	Columbus and, 79, 80
astronauts	Creationism among, 248–249
Allen, Steve, 160	European discovery of, 82, 138
Alps, Ice Man of, 265–267, 267	Fell's claims about, 111, 112

American Indians (continued)	pre-Columbian Americas and,
Ghost Dance of, 261–262	115–119
migration to America by, 79–80, 86–87, 87, 90–92	pseudoscience and, 8–10, 11–12 real mysteries of, 265–286
as Moundbuilders, 133–158, 150	science and, 37–38
New Age fascination with, 260–261 origins of, 85–96, 145	tracing origins of Native Americans by, 93–96
Paleo-Indians, 95–96	Viking presence in the New World
racism against, 104-105, 110-111, 137,	and, 125–126
141, 144	von Däniken's hypotheses and, 185,
Vikings and, 123–124, 128	195
Welshmen and, 104–105	arches, 173, 175, 176
American Museum of Natural	architecture
History, 65	Atlantis legend and, 172–175, 173,
American Philosophical Society,	174, 176
139, 141	Fell's claims about, 113–115
American Society of Dowsers, 228	Argüelles, José, 258
Amorous Astronaut Hypothesis, 193	Aristotle, 81, 110, 168
anchorites, 102	Arizona
Ancient America (Baldwin), 137	New Age and, 259–261
Ancient Monuments of the Mississippi	petrified forest in, 43
Valley (Squier and Davis), 142, 143	psychic archaeology in, 223
animals	Arkansas
cave paintings of, 268–271, 269	archaeological sites in, 100, 101
domesticated, 175, 177, 197	Creationist legislation in, 237
erroneous observations of, 17	Armillas, Pedro, 112
extinction of, 31–32, 240–241	Arnold, Benedict, 126–127
migration of, 86, 87	Arnold, Bettina, 10
on Noah's Ark, 239, 240–241	art
anomalous mounds, 142	cave, 52, 267–271, 268, 269
anthropology	Easter Island sculptures, 205–207, 206
biological, 92–93	Egyptian, 201, 202
diffusion of culture and, 171–172	about extraterrestrials, 184, 185–192,
tabloid newspaper stories on, 18–19	186, 187
Antilla, 178	Maya, 191–192, 191
Antiquities Discovered in the Western	Asia
States (Atwater), 137, 141	agricultural development in, 175, 177
antler mask, 186	American Indians and, 85, 90–91,
Ararat, Mount, 242–243	92–93
archaeology	Columbus and, 81, 82–84
Atlantis legend and, 177, 179–180	astronauts
dowsing and, 227–229	gravity experiment by, 23
electromagnetic photo-fields and,	See also extraterrestrial astronauts
229–231	astronomy
experimental, 34	Maya, 271, 273
and the Flood, 242–244	Moundbuilder, 154
and the Ice Man, 266–267	Paleolithic, 203–205
of Mars, 207–212	Stonehenge and, 282–283
Morning of the Magician claims about,	atheism, 263
6–8	Athens, ancient, 161–163, 167,
Moundbuilders and, 140–143	179–180
noninvasive, 231–232	Atlantic Ocean, geology of, 180–182

Bermuda Triangle, 182 Atlantis: The Antediluvian World Bhaktivedanta Institute, 248 (Donnelly), 170, 178 Atlantis, Lost Continent of, 159-183 Bible American Indians and, 84-85 American Indians and, 86, 92, 168 on death and burial of Jesus, 253, Cayce's predictions about, 179, 180, 254 - 255flood story of, 238-244 critical thinking exercise on, 182 giants described in, 40-42, 50-51 current perspectives on, 179–182 literal interpretation of, 51, 237 Donnelly on, 169-178 scientific Creationism and, 236-237, frequently asked questions about, 182 human origins and, 92 maps of, 168, 169 Bimini wall, 180, 181 biology Minoan civilization and, 165-168 tracing people by, 85-87, 89, 92-93 Moundbuilders from, 140, 170 See also evolution Plato's legend of, 160-168 biostratigraphy, 241 Web sites related to, 183 Bird, Roland, 245, 246 Atwater, Caleb, 137-138, 140-141 Bird, S. Elizabeth, 18 Australia bison, and Paleo-Indians, 225 dowsing records in, 229 Black, Davidson, 66 EMPF research in, 230-231 Black Plague, 257-258 Australopithecus africanus, 66, 75 Blakeslee, Don, 100 autumnal equinox, 283 Blavatsky, Helena P., 178 azimuth, 283 Bluefish Caves, Canada, 94 Aztecs, language of, 112, 168 bluestones, 276-277 Bog People of Denmark, 54 Bacon, Edward, 166 Bond, Frederick Bligh, 219-220 Bacon, Sir Francis, 170 Book of Mormon, 140 Baffin Island, Canada, 124, 128 books Baghdad Battery, 214 on scientific method, 38 Baldwin, J. D., 137 skeptical of pseudoscience, 11-12 Barlowe, F. O., 69 booths, Viking, 129 Barnum, P. T., 46, 49-50, 54 Bower, Doug, 282 Barton, Benjamin Smith, 139 Boynton, J. F., 47, 49 Bartram, William, 144, 149 brain Bat Creek Stone, 138 human evolution and, 57-59, 75 Baugh, Carl, 246 intellectual capacity and, 285 Bear Mountain, Connecticut, 15-16, 16 Brasseur, Abbé Charles-Étienne, 169 Beere, Abbot, 219 Brendan, and discovery of America, Behaim, Martin, 81-82 102-103, 103 globe produced by, 83 Bresee, Randall, 252 Belgium, hominid fossils in, 57 Britain. See England beliefs British Medical Journal, 71 New Age, 258-261, 262, 276 British Museum of Natural History, 55, surveys on, 2-4, 5 59, 67, 70 See also religion bronze Benedictine Abbey of St. Mary at Atlantis legend and, 175 Glastonbury, 219-220 tools made of, 117 Bent pyramid, 199, 199 Bruier, Frederick, 232 Bergier, Jacques, 6–8 Bryan, William Jennings, 236 Bering, Vitus, 90 Bureau of American Ethnology, 139, Bering Land Bridge (Beringia), 87, 90,

91,94

burial mounds, 142, 150, 152, 153, 154	cave paintings, 52, 267–271, 268, 269
burials 107 100	Web sites on, 286
Egyptian, 197, 198	Cayce, Edgar, 179, 180, 224
Jewish, 253–254	Celtic exploration
Maya, 191–192	archaeological sites and, 114–115,
Moundbuilder, 150, 155–156	118–119
social stratification and, 155–156	Fell's claims about, 111 See also Ireland
cadaveric material, 28, 37	Central America. See Mesoamerica
Caesar, Julius, 219	Centuries (Nostradamus), 233
Cahill, Thomas, 125	Cerros, Mayas at, 272
Cahokia mound site, Illnois, 133,	Chariots of the Gods? (von Däniken),
135–136, 135, 136, 155–156, 156, 157,	184–195, 202, 212–213
258	Chauvet cave paintings, 270
calendars	Cheops pyramid, 202
Jewish, 248	Chichén Itza, 271, 273, 274
Paleolithic, 203–205	chiefdoms, 154
Stonehenge, 283	childbed fever, 26–28, 33, 34
California	Chile, Monte Verde site, 93, 94
Chinese discovery of, 103–104	China
origin of humans in, 91–92	American Indian origins in, 85
plate tectonics and, 181	Columbus and, 82–84
camels, in South America, 7	discovery of California and, 103–104
Canada	hominid fossils in, 66
archaeological sites in, 94, 128–130	Chippindale, Christopher, 74
Vikings in, 123–124, 128–130	Chorley, Dave, 282
"captive-of-his-own-ignorance"	Christ, Jesus. See Jesus of Nazareth
corollary, 224	Christianity
"captive-of-his-own-time" principle, 223	American Indians and, 84–85 scientific Creationism and, 236–249
carbon dating. See radiocarbon dating	circumcision, 86, 88
carbon-dust imaging technique, 252	civilizations
Cardiff Giant, 42–54, 43, 53	cultural diffusion and, 171–172
critical thinking exercise on, 54	development of, 22, 34–35
discovery of, 42–44	Egyptian, 195–203
exhibition of, 44-46, 45, 46, 51	extraterrestrials and, 195-207
Hull's confession about, 48–49	Maya, 7, 35, 271–275
motive for creating, 50	Minoan, 165–168, 166
reasons for belief in, 50–52	Moundbuilder, 152–156
replicas of, 49–50, 54	mythical, 159–183
skepticism about, 46–48	See also culture
Web sites related to, 54	Clark, William, 131, 149
Caribbean, landing of Columbus in, 80,	Clarke, David L., 88
82–83	Clement VII, Pope, 256
Carnarvon, Lord, 214	cliff dwellings, 260
Carter, Howard, 214–215	Clovis points, 96, 225, 226
Carter, W. Hodding, 131	Clovis Richey Cache site, Washington,
Castlerigg stone circle, 278	95
Catholic Church	codices, 271
American Indians and, 84–85	Coe, Michael, 108
Shroud of Turin and, 256	Cohen, Daniel, 170
See also Christianity	Coliseum, Roman, 213

Colorado	defensive enclosures, 142
petroglyph discovered in, 186	de Landa, Diego, 168
psychic archaeology in, 224–226	Delaware, Holly Oak pendant in, 52–53
Columbus, Christopher, 79, 80–84, 99,	Deloria, Vine, Jr., 91
106	Dendera, Egypt, 188, 189, 190
routes to America by, 81	Denmark, Bog People of, 54
columella beads, 220	dental traits. See teeth
columnar jointing, 205	Descent of Man, The (Darwin), 56
Complete Pyramids, The (Lehner), 199	de Soto, Hernando, 100–101, 149
Connecticut	route of expedition by, 101
archaeological sites in, 32–33, 118,	Devil's Post Pile National Monument,
121, 221, 222	California, 205
highest point in, 15–16	Dezhnev, Semyon, 90
Cook Farm Mound Tablets, 138	dialog format of Plato, 160
	diffusionism, 171–172, 195
Coronado, Vasquez de, 100	
Craig, Emily, 252	Dincauze, Dena, 119 dinosaurs
Creationism	
literal interpretation of the Bible and,	extinction of, 241
51, 237	footprints of, 245–247, 248
scientific, 236–249	fossilized remains of, 31–32, 31
Web sites related to, 264	scientific Creationism and, 245–248
creativity, scientific, 27, 28, 32, 34	in South America, 7
Crete, 165–168	Web site related to, 264
Critias (Plato), 162–163, 167	DNA, analysis of, 93
Cro-Magnon Man, 57, 178	Donnelly, Ignatius, 169–178
crop circles, 281–282, 281	dowsing, 227–229
crucifixion of Jesus Christ, 253–254	critical thinking exercise on, 234
Cuba, landing of Columbus on, 80, 82–83	experimental tests of, 228–229
culture	Web sites related to, 234
diffusion of, 171–172	Dowson, T. A., 270
psychic archaeology and, 223–226	Doyle, Sir Arthur Conan, 73
tracing people by, 87–89	Drawhorn, Gerrell, 70
See also civilizations	Dropides, 161
curragh, 102	Druids, 276
Cutler, Manasseh, 138	Dubois, Eugene, 57
	Duran, Diego, 86
Darrow, Clarence, 236	
Darwin, Charles, 56	earth, spherical concept of, 81–82, 83
Dateline NBC (TV show), 260	earth-drawings, 186–188, 187
dating techniques	Easter Island
flourine, 67	statues of, 205–207, 206
radiocarbon, 52, 77, 126, 129, 256–257	Web site about, 215
stratigraphy, 137–138	economics. See money
tree ring growth, 138	Egypt
Davenport stone tablets, 148	Atlantis and, 164, 172, 173
Davis, Edwin H., 141–143	origins of civilization in, 196-200
Dawson, Charles, 59-65, 68-69, 69	psychic archaeology in, 221
Deacon, Richard, 104-105	pyramids of, 7, 172–173, 174, 190,
De Bry, Theodore, 82	198–201, 198, 199, 202
Decalogue stone, 147	von Däniken's hypotheses and, 188,
deconstructionism, 20–22	189, 190, 195–203
deduction, 24-25	Web sites on, 215

Eirik the Red's Saga, 119	extinction
electrical resistivity surveying, 227–228	of dinosaurs, 241
electricity, ancient use of, 190, 214	of species, 31–32, 240–241
electromagnetic photo-fields (EMPFs),	extraterrestrial astronauts, 184–215
229–231	Argüelles on, 258–259
critical thinking exercise on, 234	calendars and, 203-205
Ellesmere Island, Canada, 128	critical thinking exercise on, 215
Elliot, James Scott, 227	crop circles and, 281–282
ember box, 129	current perspectives on, 212–213
England	Egyptian civilization and, 195–203
crop circles in, 281–282	frequently asked questions about,
expeditions to America from, 99–100	214–215
hominid fossils and, 57	on Mars, 207–212
Piltdown Man in, 59–65	New Age beliefs about, 258–259, 260
psychic archaeology in, 219–220	on Pacific islands, 205–207
Stonehenge in, 275–284	von Däniken's hypotheses about,
Enquirer (tabloid), 18	184–195, 212–213
Eoanthropus dawsoni. See Piltdown Man	Web sites for further research on, 215
epicanthic fold, 89	Eyes of the Sphinx, The (von Däniken),
epigraphy, 112–113	188, 214
epistemology, 15–39	F 402
See also knowledge	Faeroes, 102
Eratosthenes, 81, 82	Fairy Tale: A True Story (film), 73
Eriksson, Leif, 98, 128, 131, 224	fame, as motive for pseudoscience, 9
Essay Toward a Natural History of the	Far East. See Asia
Earth, An (Woodward), 242	Farmers' Museum, Cooperstown, New
ethnocentrism, European, 79	York, 52, 53
Etowah mound, Georgia, 155	farming. See agriculture
Europe	Farvolden, Robert, 229
agricultural development in, 177	Faulkner, Charles, 105
America discovery and, 79–84,	Fell, Barry, 111–119
102–103, 104–105, 111–119	firsthand information, 16–17
cave paintings in, 267–271	Flintstones cartoon, 245
ethnocentrism of, 79, 212–213	flood legends
Ice Man of, 265–267, 267	American Indians and, 170–171
Everest, Mount, 15, 16 evolution	Atlantis and, 170–171
	Noah's Ark and, 238–244, 239 Florida
current perspectives on, 74–77 Darwin's theory of, 56–57, 236	archaeological sites in, 100, 101
extraterrestrial involvement in, 184,	de Soto's landing in, 100
193–194	psychic archaeology in, 220–221
hominid fossil evidence and, 56, 57,	flourine dating, 67
74–77, 76	fluted spear point, 95–96, 95, 224–226
Piltdown Man and, 59–65, 74	Folsom points, 96, 225, 226
religious belief and, 263	footprints
scientific Creationism vs., 236–249	of dinosaurs, 245–247, 248
Examiner (tabloid), 18	fraudulent, of humans, 245, 246, 247
excavation	of giants, 51–52
locating sites for, 216–218, 220–221,	Footprints in Stone (film), 246
231–232	fossils
psychic, 221–223	of dinosaurs, 31–32, 31, 245–247, 248
experimental archaeology, 34	of giants, 42–43, 43
	O

of hominids, 56, 57, 74-77, 76	Gold of the Gods (von Däniken), 203
Foster, J. W., 137	Goliath, 41
France	Gomara, Lopez de, 85–86, 168
cave paintings in, 267–271	Gondwanaland, 181
hominid fossils in, 57	Goodman, Jeffrey, 91–92, 223
prehistoric calendar from, 203–204, 204	Goodwin, William, 114, 115
Franchthi Cave, 179–180	Gottfried, Kurt, 20, 35
frauds	Gould, Stephen Jay, 70, 236
current perspectives on, 52–53	Gove, Harry, 257
motives for perpetrating, 9, 50	Gradie, Robert R., 114–115
Friedlander, Paul, 161	Grave Creek Mound, West Virginia,
Frissell Mountain, Connecticut, 15–16	138, 145
Frobisher, Martin, 99–100	gravity, law of, 23
Frodsham, John, 257	Great Cryptogram, The (Donnelly), 170
fundamentalism, 262	Greeks
Fusang, 103–104	Atlantis legend and, 162–163, 165–168, 179–180
Galanopoulos, Angelos, 166	medicine of, 266
Galileo, 31	spherical earth concept and, 81, 82
Galvão, Antonio, 85, 89, 92	Greenland, and the Vikings, 119,
Gamboa, Pedro Sarmiento de, 168	122–123, 123
Garcia, Gregoria, 87, 111	Greenlander's Saga, 119, 122, 123
Garden of Eden, 92	Gross, Paul R., 21
Gass, Jacob, 148	ground penetrating radar (GPR), 232
General and Natural History of the Indies	gua-nin, 106
(Oviedo), 85	Gungywamp site, Connecticut, 118, 119
geoglyphs, 186–188, <i>187</i>	121
geology	
of Atlantic Ocean, 180–182	Halfdan the Black, 232
and the Flood, 241–242	handprint, negative, 267, 268
historical, 23	haplogroups, 93
of Mars, 208–209	Hare Krishnas, 248
plate tectonics and, 180-182	Harmonic Convergence, 258–259
and von Däniken, 205	Harper's Weekly, 47
Georgia, archaeological sites in, 100,	Hathor's Temple, 188, 189, 190
101, 155, 228, 232	Hawkins, Gerald, 282–283
Georgias (Plato), 164	Heaven's Gate cult, 260
German Society for the Examination of	Hebrews. See Jews
Parasciences, 228	heel stone, 278
Germanus, Donnus Nicholas, 81	Heidelberg Man, 60
Germany, hominid fossils in, 56, 57	Hemocrates, 161
Ghost Dance, 261–262	Hempel, Carl, 26
"Ghost Story, A" (Twain), 50	Herjolfsson, Bjarni, 122–123
giants	Herodotus, 201
biblical accounts of, 40–42, 51, 52	Héspero, King, 85
Cardiff, 42–54	Hicks, Edward, 239
pituitary, 40	Hierakonpolis, Egypt, 197–198
Gizeh pyramids, 174, 199	hieroglyphics, 168, 201, 271
Glen Rose, Texas, 245–246	Higher Superstition: The Academic Left
globe, and Columbus, 81–82, 83	and Its Quarrel with Science (Gross
Godfrey, Laurie, 247	and Levitt), 21
Gods from Outer Space (von Däniken), 206	Hindu Creationists, 248

Ingstad, Helge, 128 Inkblot Hypothesis, 185–192

Inquest on the Shroud of Turin (Nickell),

Hinton, Martin A.C., 71-72 inscriptions historical geology, 23 Fell's claims about, 112-113 Hoagland, Richard, 209-210 Moundbuilder, 138, 145-148, 146 Viking runes and, 126 escaped panda in, 17 See also writing hominid fossils in, 57 Institute for Creation Research (ICR), Holly Oak pendant, 52-53 Hollywood, view of science in, 20, 21 intelligence Holmes, Sherlock, 33, 73 brain and, 285 hominid fossils, 56, 57, 74-77, 76 human evolution and, 57-59 Homo erectus, 57, 58, 66, 75 Internet resources. See Web sites Homo ergaster, 75 Iraq, Baghad Battery of, 214 Hope of Israel, The (Israel), 86 Ireland Hopewell culture, 152-154, 153 and discovery of Americas, 102-103, Huddleston, Lee, 86 103, 111, 114-115 Hull, George, 44, 48-49 proton magnetometry used in, 232 human origins See also Celtic exploration evolutionary theory of, 56-59 Irwin, James, 242 scientific Creationism and, 236-249 Israel, Lost Tribes of, 86, 145, 147 Web site related to, 264 Israel, Manasseh ben, 86 Hume, Ivor Noël, 227 Hunt, Karen, 229-231 Ice Man discovered in, 265-267 hypotheses meteor shower over, 36 skeleton of giant man in, 51-52 multiple working, 29 Ithaca Daily Journal, 44, 46, 47, 48 process of arriving at, 24-25, 32-34 testing, 25-32, 34-35 theories and, 37 Jacobsen, Thomas, 179 Jammal, George, 243-244 Java, hominid fossils in, 57, 66 Iberians, and discovery of Americas, 80-84, 81, 100-101, 111 Java Man, 57, 59, 62, 63, 66 Ice Age (Pleistocene), 87, 91 jaw, Piltdown Man, 61-62, 62, 67-68 Iceland, and the Vikings, 119, 122, 123 Jefferson, Thomas, 141 Ice Man, 265-267, 267 **Iesus of Nazareth** Web site about, 286 death and burial of, 253-255 ichnology, 247 Shroud of Turin and, 249-258 "if . . . then" statements, 25-26 Jett, Stephen, 116 Illustrated London News, The, 64 Jews Image of Edessa, 255 American Indians and, 86, 88 imagination, scientific, 27, 28 burial tradition of, 253-254 immutability of scientific laws, 22-24 Creationism and, 248 Incredible Discovery of Noah's Ark, The Moundbuilders as, 145, 147 (TV special), 243, 244 Jinniushan Man, 77 Indians. See American Indians Johanson, Donald, 75 induction, 24-25 John-Paul II, Pope, 249 information, collecting, 16-18 Jones, David, 220, 221 firsthand, 16-17 Josselyn, John, 168 secondhand, 18-19 Karlsefni, Thorfinn, 123 Ingstad, Anne Stine, 128

Karn, Richard, 214

Kehoe, Alice, 262

Karsmizki, Ken, 131

Keith, Sir Arthur, 69, 71, 74

lightbulbs, ancient, 189, 190 Kelley, David, 116 Kensington stone, Minnesota, 126 Lindenmeier site, Colorado, 224-226 linguistics. See language Kentucky, archaeological sites in, 105 lintel stones, 277-278, 280 Kircher, Athanasius, 169 Little Egypt site, Georgia, 100 Kleito, 162 Loomis II archaeological site, 32–33 knarr, 131 Knight, J. Z., 179 Lost Tribes of Israel, 86, 145, 147 Knossos, 165, 166, 213 Louisiana knowledge archaeological sites in, 152 information collection and, 16-18 Creationist legislation in, 237 Lowell, Percival, 207 scientific, 19-37 study of, 15-16 Luce, Daniel, 46 Luce, J. V., 166 Kodlunarn Island, 99-100 Kuban, Glen, 247-248 Lucy (Australopithecus Africanus), 75 Kuhn, Thomas, 36 lunar calendar, 204-205, 204 Kusche, Lawrence, 182 Luther, Martin, 10 Lvell, Charles, 23 Labrador, and the Vikings, 123, 124 MacCurdy, George Grant, 65 Laetoli footprints, 75 MacLaine, Shirley, 213 language Madoc, Prince, 104-105 Aztec, 112, 168 Magdalenian people, 223 Fell's claims about, 112 Magellan, Ferdinand, 84 Mayan, 168-169 magnetic susceptibility, 228 See also writing Lankester, Ray, 69, 73 magnetism, and dowsing, 227-228 L'Anse aux Meadows, 128-130, 129 Maine, archaeological sites in, 128 Larson, Daniel, 232 Makare, 194 Larue, Gerald, 244 mandible, Piltdown Man, 61-62, 62, 67 - 68Lascaux cave paintings, 269-270, 269 Latin America. See Mesoamerica; South Mantichora, 17 map dowsing, 227 America Marinatos, Spyridon, 166 Laurasia, 181 Laws (Plato), 164 Mars laws of science, 22-24 archaeology of, 207-212, 209, 210, 211 immutability of, 22-24 Web site about, 215 Marsh, Othniel C., 47-48 understandability of, 24 Marshack, Alexander, 203 Leakey, Louis, 71 Leakey, Mary, 75 Martin, Paul, 34 Leakey, Richard, 75, 77 Mask of Nostradamus, The (Randi), 233 Massachusetts, archaeological sites in, Leek, Sybil, 223-224 legends. See myths and legends 118 mastabas, 198, 198 legislation, and Creationists, 237 Lehner, Mark, 199 material culture, 99 Le Moyne, Jacques, 150 tracing people by, 89-90 Lemuria, 92, 179, 182 mathematics, Mayan, 271 Mather, Cotton, 42 Le Plongeon, Augustus, 169 Mayan Factor: Path Beyond Technology, Lepper, Brad, 147, 154 Letter to Sanchez (Columbus), 84 The (Argüelles), 258 Levitt, Norman, 21 Maya Lewin, Roger, 77 agriculture of, 272-273, 274 Argüelles on, 258-259 Lewis, Meriwether, 131, 149 Atlantis legend and, 168-169, 172, 173

Lewis-Williams, J. D., 270

"missing link," 63

Mississippian period, 154–155

Maya (continued)	mitochondrial DNA (mtDNA), 93, 285
civilization of, 7, 35, 271–275	Moai statues, 205–207, 206
human intelligence and, 285	money
language of, 168–169	Cardiff Giant and, 43–46, 50
Spanish invasion of, 274	as motive for pseudoscience, 9, 50
von Däniken's hypotheses and,	Monk's Mound, 135, 135
191–192, 191	Monte Verde, Chile, 93, 94
Web sites related to, 286	Moore, Robert A., 239
McCrone, Walter, 251, 252	Morning of the Magicians, The (Pauwels
McGhee, Robert, 128	and Bergier), 6–8, 184, 202
McGovern, Tom, 122	Morris, John, 246
McGowan, Chris, 238	Mosimann, James, 34
McIntyre, Michael, 230	motives for pseudoscientific claims,
McKusick, Marshall, 219, 223	9–10
McLean Game Refuge, 216	Moundbuilders, 133-158
Meadowcroft rockshelter, 93–94, 94	critical thinking exercise on, 158
Meeting of the Minds (TV show), 160	current perspectives on, 152–156
Megalith builders, 113–114	early research on, 139–143, 143
Meltzer, David, 94	frequently asked questions about,
Meno (Plato), 164	157–158
mental instability, as explanation for	popular misconceptions about,
pseudoscience, 10	137–139
Mesoamerica	solving the mystery of, 143-151, 150,
African influence on, 105-111	151
agriculture of, 108–109, 175, 177	vanished race myth and, 151-152
Atlantis and, 171, 172–178	Web sites related to, 158
pyramids of, 7, 172–173, 174	Mound City site, Ohio, 154
See also America discovery	Moundville site, Alabama, 155
Mesopotamia, 196	Mu, 92, 179, 182
metallurgy	multiple working hypotheses, 29
African, 106	mummification
Atlantis legend and, 175	Egyptian process of, 202–203
Moundbuilder, 138–139, 149–150, 151	natural, 54
in South America, 7	Mundus Subterraneus (Kircher), 169
meteors, 36	mysteries, archaeological, 265-286
Mexico	critical thinking exercise on, 285–286
pyramids of, 7	frequently asked questions about,
See also Mesoamerica	285
Miamisburg, Ohio mound site, 134	Web sites related to, 286
Micronesia, extraterrestrials in, 205	Mysterious Origins of Man, The (TV
Middle East, agricultural development	special), 248
in, 175	Mystery Hill site, New Hampshire,
migration	114–115, 115, 117, 120, 258
of American Indians, 79–80, 86–90,	myths and legends
87, 90	of Atlantis, 159–183
of animals, 86, 87	of discovery of America, 98, 104–105
model for simulating, 34	of Moundbuilders, 137–139, 143–151
Millar, Ronald, 55	of Vikings, 119, 122
Miller, Gerrit S., Jr., 65, 67	0-,
Minoan civilization, 165–168, 166	Nahuatl language, 112, 168

Nan Madol site, 205 Nariokotome boy, 75, 77

Narmer, 198, 200	Norse. See Vikings
Natchez Indians, 149	North America
National Academy of Sciences, 238	agricultural development in, 177
National Aeronautic and Space	arrival of Native Americans in,
Administration (NASA), 207	93–96
nationalism	Moundbuilders, 133–158
hominid fossil discoveries and, 57,	origin of humans in, 91–92
61, 63–64	sixteenth-century explorers to,
as motive for pseudoscience, 9–10	99–101
Native Americans. See American	Vikings in, 102, 119, 122–130
Indians	See also America discovery
native copper, 150	North Salem, New Hampshire, 113-115
Natural and Moral History of the Indies,	Norway
The (Acosta), 86, 90	discovery of ancient penny from, 128
Nature (journal), 59	ground penetrating laser used in,
Navan archaeological complex, 232	232
Navarra, Fernand, 243	Nostradamus, 232–233
Navigatio, 102–103	Nova (TV show), 193, 201, 280
Nazca markings, 186–188, 187	Nueva Cadiz beads, 100
Nazis, misuse of archaeology by, 9–10	
Neandertal Man, 56, 57, 58, 59, 62, 63,	Oakley, Kenneth, 67
66, 76, 223, 285	obelisks, 172, 173
negative-imaging technique, 252	observation, firsthand, 16–17
Nenana Culture, 94	Occam's Razor
neutron activation analysis, 89	explanation of, 30–32
New Age beliefs, 258–261, 262, 276	extraterrestrial astronauts and, 186,
Newark, Ohio mounds, 147, 154	188, 190, 196
Newark Holy Stones, 138, 145–147, 146	flood legends and, 171, 242
Newell, Stub, 42–45, 47, 49	fossilized bones and, 31-32
New England	Mystery Hill and, 119
Celtic discovery of, 114–115, 115, 117,	psychic archaeology and, 218–219
120, 258	Shroud of Turin and, 255
and the Vikings, 128, 224	Oestreicher, David, 140
Newfoundland, and the Vikings,	Ogamic inscriptions, 113
123–124, 128–130	O Hehir, Brendan, 113
New Hampshire, Celtic in, 113–115	Ohio
Newport Tower, Rhode Island, 126–127,	Creationist legislation in, 237
127	Moundbuilder sites in, 134, 147,
newspapers	154
accuracy of information in, 18	Ohman, Olaf, 126
tabloid, 3, 9, 18–19	Olmec culture, 106–109, 107
Newton, Sir Isaac, 36	Ona Indians, 70
New York Herald, 47	Onodaga Giant, The (pamphlet), 46
New York State	On the Origin of Species (Darwin), 56
Cardiff Giant in, 42–54	Origins of the Indians (Garcia), 87
Farmers' Museum in, 52, 53	Orkney Islands, 102, 114
New York Times, 18, 62	Osborn, Henry Fairfield, 65
Nickell, Joe, 187, 251, 252, 255	Ossowiecki, Stefan, 220, 223, 226
Nile River, 197–198	Our Ancestors, the Dummies,
Noah's Ark, 86, 238–244, 239	Hypothesis, 195, 203
Web site related to, 264	Out on a Limb (MacLaine), 213
noninvasive archaeology, 231–232	Oviedo, 85

Pacal, 192, 193	suspects of the hoax, 68–73
Pacific islands, extraterrestrials in,	Web sites related to, 78
205–207	Piltdown Men, The (Millar), 55
pagan rites, 276	pituitary giants, 40
paintings	plate tectonics, 180–182
cave, 52, 267–271, 268, 269	Plato, 160–168
See also art	Pleistocene (Ice Age), 87, 91
Palenque, Mayan site of, 191–192, 191,	Pliny, 17
271	Plummer, Mark, 231
Paleo-Indians, 95–96, 224–226	Poitiers, Henri de, 256
Paleolithic period, 203–205, 269–271	Polynesia, extraterrestrials in, 205-207
Palmer, Eratus Dow, 47	Poniatowski, Stanislaw, 220
Palos Verdes peninsula, California,	population, development of civilization
103–104	and, 22, 272–275
Paluxy River bed, 245–247	Portugal, Americas explored from, 80,
Pangea, 181	81, 111
paradigms, 36–37	Poseidon, 162
Park, Michael, 29–30	pottery, Egyptian, 197
Parthenon, 213	Preseli Mountains, Wales, 276
Pathways to the Gods (von Däniken), 213	Presley, Elvis, 258
Pauwels, Louis, 6–8	Priest, Josiah, 139
Peche-Merle cave paintings, 268	proton magnetometry, 227–228, 232
Peking Man, 57, 58, 75	pseudoscience
Pennsylvania, Meadowcroft	archaeology and, 8-10
rockshelter, 93-94, 94	books skeptical of, 11–12
Peru, geoglyphs in, 186–188, 187	critical thinking exercises on, 13
Peterson, Mark Allen, 18	frequently asked questions on, 13
petrification, 42–43, 53	in Morning of the Magicians, 6–8
petroglyphs, 186, 259, 260	surveys related to, 2–4, 5
Peyrère, Isaac de la, 84	Web sites related to, 14
Pfefferkorn, Ignaz, 90	psychic ability, 218
Philippines, Tasady hoax, 132	of Nostradamus, 232–234
Philosophy of Natural Science, The	testability of, 29, 218-219
(Hempel), 26	psychic archaeology, 218–227
Piltdown: A Scientific Forgery (Spencer),	critical thinking exercise on, 234
55	cultural reconstruction and, 223-226
Piltdown: Who Dunit? Who Cares?	excavation and, 221–223
(Chippindale), 74	roots of, 219–220
Piltdown Forgery, The (Weiner), 55	site location and, 220–221
Piltdown Man, 55–78	verdict on, 227
anatomical features of, 60, 61-62, 64	Web sites related to, 234
books pertaining to, 55	Ptolemy, 81, 82
critical thinking exercises on, 78	Pulltrouser Swamp site, 274
current perspectives on, 74–77	Pycraft, W. P., 69
discovery of, 59-65, 61	Pyramid of the Magician, 271, 272
enigma of, 65–67	Pyramid of the Sun, 7
evolutionary context for, 56-59, 74	pyramids
frequently asked questions about,	Atlantis legend and, 172–173, 174
77–78	Egyptian, 7, 172–173, 174, 190,
lesson of, 74	198–201, 198, 199, 202
psychic archaeology and, 224	Mesoamerican, 7, 172-173, 174, 271,
revealed as a hoay 67-68	272

Moundbuilder, 154–155 von Däniken on building of, 200–201, 202	Royal Canon of Turin, 200 runes, 126 Russia
202	Bering Land Bridge and, 87, 90, 91, 94
races	discovery of Noah's Ark and, 243
Biblical interpretation of, 84–85	
Theosophists' beliefs about, 178–179	sacred enclosures, 142
racism	Sagan, Carl, 194
against Africans, 108, 110	Sanford, Walter, 252, 252
against American Indians, 104-105,	San Francisco earthquakes, 181
110–111, 137, 141, 144	Santa Catalina mission, 228
European ethnocentrism and, 79,	Santorini. See Thera
212–213	Saqqara pyramid, 198, 198
radiocarbon dating, 52, 77, 126, 129	sarsen stones, 277–278
of Noah's Ark, 243	Schiarparelli, Giovanni, 207
of Shroud of Turin, 256-257	Schick, Theodore, 21
See also dating techniques	Schnabel, Jim, 281
Rafinesque, Constantine Samuel, 140	Schwartz, Stephan, 220, 221
Raine, P. A., 228	science
Randi, James, 228, 233	archaeology and, 37–38
Red Earth, White Lies (Deloria), 91	art of, 32–37
religion	atheism and, 263
archaeological bases for, 235–264	books explaining the method of, 38
evolutionary theory and, 263	critical thinking exercises on, 39
frequently asked questions about,	frequently asked questions about, 38
263	as human enterprise, 35–37
giants and, 40–42, 49, 50–52	methods of, 24–28
as motive for pseudoscience, 10,	nonscience compared to, 28–32
50-51	principles of, 19–24
New Age appropriation of Native	pseudoscience and, 1–14
American, 260–261	religion and, 23–24
revitalistic movements and, 261–263	Web sites related to, 39
scientific laws and, 23–24	scientific Creationism, 236–249
Web sites related to, 264	dinosaurs and, 245–248
See also Bible; Creationism	Noah's Ark story and, 238–244
Report on the Mound Explorations of the	politics of, 236–238
Bureau of American Ethnology	Web sites related to, 264
(Thomas), 151	Scopes, John T., 236
Republic (Plato), 160–161, 164	Scopes Monkey Trial, 236
revitalistic movements, 261–263	sculptures
Reynolds, Peter, 113	Cardiff Giant, 43, 46–48, 53
Rhode Island, archaeological sites in,	Easter Island, 205–207, 206
126–127, 127	Olmec, 106–107, 107, 109
ring-headed bronze pin, 129, 130	secondhand information, 18–19
Romancito, Rick, 261	Sedona, Arizona, 259–260
romanticism, as motive for	Semmelweis, Ignaz, 26–28, 29, 34, 37
pseudoscience, 10, 50–51	sepulture mounds, 142
root races, 178	Serpent Mound, 134, 258
Ross, Anne, 113	shamans, 186
Roswell, New Mexico, 214	Shermer, Michael, 29, 237, 238
Round in Circles (Schnabel), 281	Shetlands, 102
Rowe, John, 88–89	Shorey, Paul, 168

shovel-shaped incisors, 92-93	Sphinx, 196
Shroud of Turin, 249-258, 250, 252	Spiro site, Oklahoma, 186
determining the age of, 256-257, 257	Sputnik, 236
history of, 255–256	Squier, Ephraim G., 141–143
testing the validity of, 253–258	Star (tabloid), 18
Web site related to, 264	Star Wars (film), 163–164
Shroud of Turin Research Project	statues. See sculptures
(STURP), 250–251	stelae, 109, 172, 173
shyness effect, 29	Stenness stones, 279
Siena, Italy, 36	
	Stiebing, William, Jr., 164, 166
Simms, Janet, 232 sinodant pattern, 93	stone circles, 275–279, 276, 277, 278, 279
	Stonehenge, 275–284, 276, 277, 280
Sioux Indians, 261	extraterrestrials and, 213, 281, 282
sites, archaeological	human intelligence and, 285
locating for excavation, 216–218, 231–232	method of construction for, 279–280, 280
psychic archaeology and, 218–227	Mystery Hill site and, 114–115, 115
Skara Brae site, 114, 114	reasons for building of, 281–284
Skeptic, The (journal), 10	stone monuments similar to, 278, 279
Skeptical Inquirer, The (journal), 10	Web sites related to, 286
Skraelings, 123, 124	stone tablets, Moundbuilder, 138,
skulls	145–148, 146
evolutionary comparison of, 58	Strabo, 168
of Piltdown Man, 59–65, 60	Straits of Gibraltar, 162
slash-and-burn agriculture, 272–273, 274	stratigraphy, 137–138
smallpox, 149	Stukeley, William, 283
Smith, Dick, 228	summer solstice, 283
Smith, Grafton Elliot, 59, 62, 65–66, 69,	Sun (tabloid), 9, 18, 244
72,77	Sun International Pictures, 243, 244
Smith, Lawson, 232	surveys on beliefs, 2–4, 5
Smithsonian Institution, 65, 67, 112, 139,	Sussex, England, 59–65
142, 144	Sutton, Elijah, 147
smoking, 25–26	Swinside stone circle, 278
Snow, Dean, 116	Syracuse, New York, and Cardiff Giant,
social stratification, and burial practices,	44–45
155–156	Syracuse Daily Journal, 42, 43–44
Socrates, 160–162	Syracuse Standard, 46
Sojourner rover craft, 210–211, 211	cyence cimium, 10
Sollas, W. J., 72–73	tablets, Moundbuilder, 138, 140, 145-148,
Solon, 161–162	146
South America	tabloid newspapers, 3, 9, 18–19
agricultural development in, 177	Tasady people, 132
extraterrestrials and, 186–188, 187	Tasmania, 181
Morning of the Magician accounts of, 7	Taylor, A. E., 164, 168
pre-Clovis migration and, 93, 94	Taylor, Paul S., 245
See also America discovery	teeth
Soviet Union. See Russia	human, 61–62
Spain	species identification by, 74–75
Americas explored from, 80–84, <i>81</i> , 100–101, 111	tracing origins of people by, 92–93
	wear patterns on, 61–62, 64, 68
hominid fossils in, 57	Teilhard de Chardin, Pierre, 60–61, 64, 66,
Spence, Lewis, 178	70–71
Spencer, Frank, 55, 74	temple mounds, 142, 154–155

Temple of Inscriptions, Palenque, 191, universe knowability of, 20-22 laws of, 22-24 Temuen Island, Micronesia, 205 Unraveling Piltdown: The Science Fraud of Tennessee the Century and Its Solution (Walsh), archaeological sites in, 105 Creationist legislation in, 237 Scopes Monkey Trial in, 236 Upatoi Indian village, 232 Ussher, James, 245, 248 Teotihuacán, Mexico, 7 testability of hypotheses, 28-29 Texas, dinosaur footprints in, 245-247 Van Sertima, Ivan, 105-108, 110-111 theories, 37 Van Tilburg, Jo Anne, 207 Vaughn, Lewis, 21 Theosophists, 178 Thera, 165-168, 167 Vega, Garcilaso de la, 149 Vermont, archaeological sites in, 118 They Came Before Columbus (Van Sertima), 106 vernacular architecture, 114–115 Thomas, Cyrus, 143-151 vernal equinox, 283 Verrazano, Giovanni de, 85, 92 Thomas, David Hurst, 228 Thorvaldsson, Eirik, 119, 122 Vescelius, Gary, 117–118 Vespucci, Amerigo, 84 Tilgate Forest, England, 31 Vesuvias, Mount, 36 Timaeus (Plato), 160-162, 164, 167 Vienna General Hospital, 26–28, 33 tombs, Egyptian, 197, 198-200, 214-215 Vikings archaeological evidence of, 125-127, tools bronze, 117 fluted point, 95-96, 95 discovery of Americas and, 102, 119, Topsell, 17 122 - 130Tracking Those Incredible Dinosaurs and the psychic archaeology and, 223-224 People Who Knew Them (Morris), sea navigation by, 131 246 - 247settlements of, 122-124, 128-130 trade, and development of civilization, Viking spacecraft, 207, 208 Vinland, 122-124 22,34-35trait list comparisons, 87-89, 172 ancient map of, 124-125 tree-ring growth, and Moundbuilders, Virchow, Rudolf, 56 Visions of Time (Jones), 220, 221, 224 138, 145 Tres Zapotes, 109 volcanic eruptions, on Thera, 165–168 von Däniken, Erich, 184–214 trilithon uprights, 277-278 Troano Codex, 169 tuff, 205 Wadi Kubbaniya site, 197 Wadlow, Robert, 40 turf houses, 128, 129 Turin, Italy, burial shroud of Jesus from, Walam Olum, 140 Wales, and discovery of America, 249 - 258Turkey, Noah's Ark in, 242–243 104 - 105Walker, Alan, 75 Turner, Christy, 92 Wallace, Brigitta, 125 Tutankhamen, 200, 214-215 Twain, Mark, 50 Walsh, John E., 55 20/20 (TV show), 228 warfare Tyrolean Alps, 265 Egyptian, 198 Maya, 275 Washington State, Clovis Richey Cache UFOs, 281, 282 Underwood, A. S., 69 site, 95 Waterloo Centre for Groundwater United States Geological Survey maps, Research, 229 221, 222

Waterston, David, 65 water witching, 227–229 Watson Brake site, Louisiana, 152 Web sites on America discovery, 97, 132 on Atlantis, 183 on Cardiff Giant, 54 on cave paintings, 286 on Creationism, 264 on dinosaur and human co-existence, 264 on dowsing, 234 on Easter Island, 215 on Egypt, 215 on the Ice Man, 286 on Mars landing, 215 on Maya civilization, 286 on Moundbuilders, 158 on Noah's Ark, 264 on Piltdown Man, 78 on pseudoscience, 14 on scientific method, 39 on Shroud of Turin, 264 on Stonehenge, 286 Weekly World News (tabloid), 9, 18, 244 Weidenreich, Franz, 65 Weiner, J. S., 55 Weir, Stuart Kirkman, 201

White, Tim, 75 Why People Believe Weird Things (Shermer), 237 Wilder, Gene, 21 Williams, Stephen, 220 Wilson, Kenneth, 20, 31 winter solstice, 283 Woodward, Arthur Smith, 59-65, 69-70, 69, 77 Woodward, John, 242 World Wide Web resources. See Web Wounded Knee massacre, 262 Wovoka, 261-262 writing Fell's claims about, 112–113 hieroglyphic, 168, 201, 271 Mayan, 168–169, 271 Moundbuilders and, 138, 145-148, 146 Olmec, 109 See also inscriptions; language Wyrick, David, 147

Young Frankenstein (film), 21

zero, concept of, 271 Zeus, 163 Zhoukoudian cave, China, 66, 75